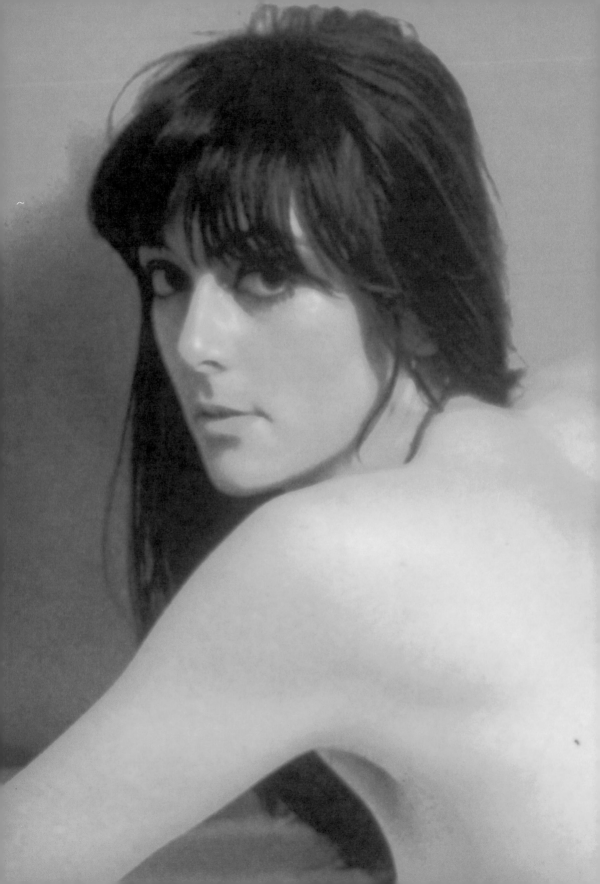

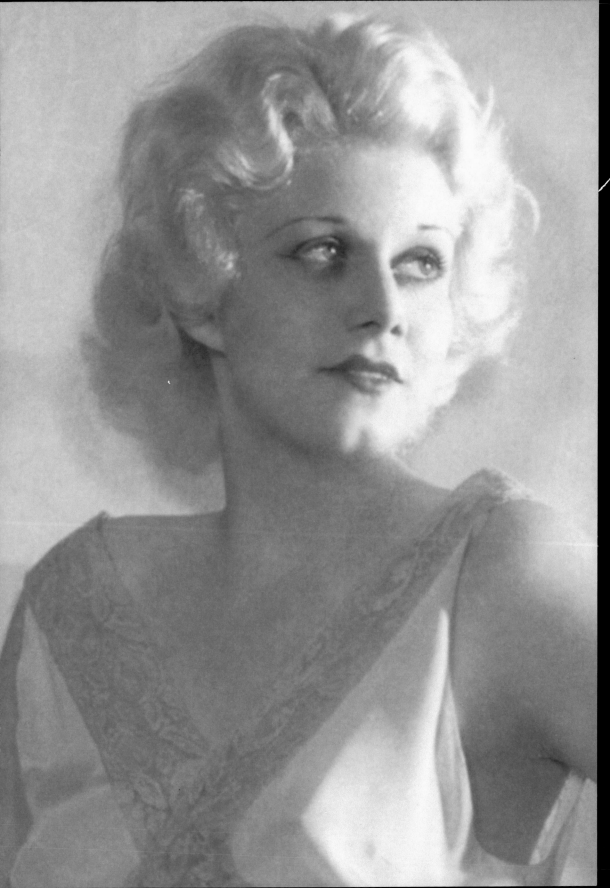

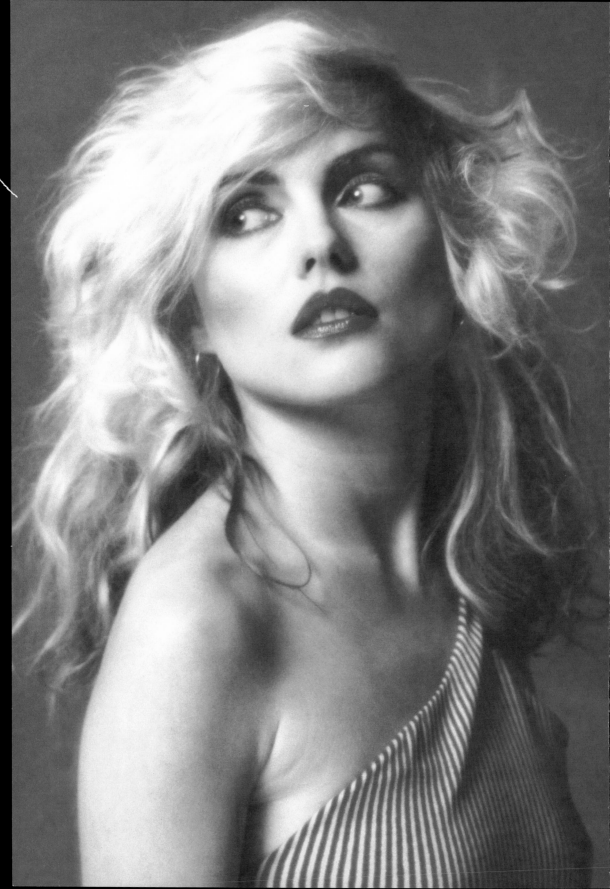

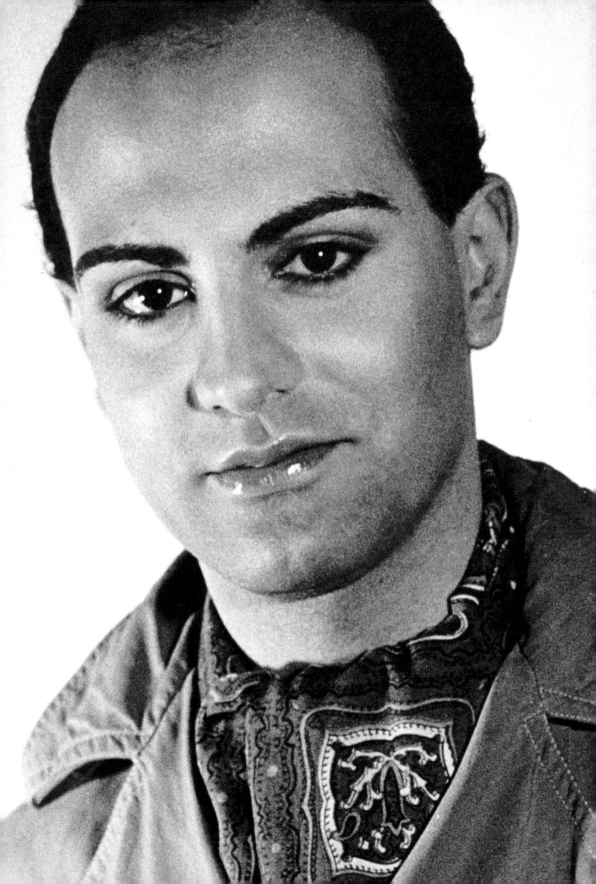

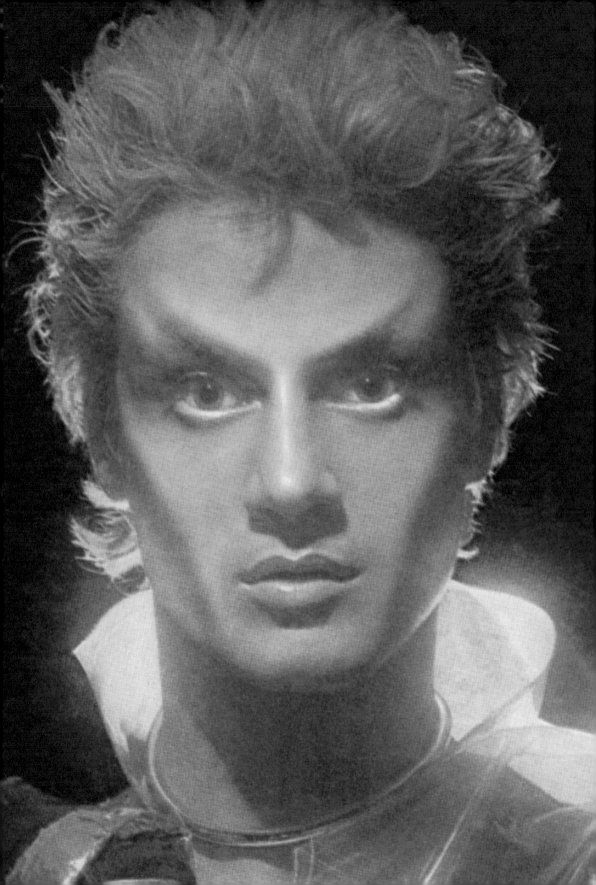

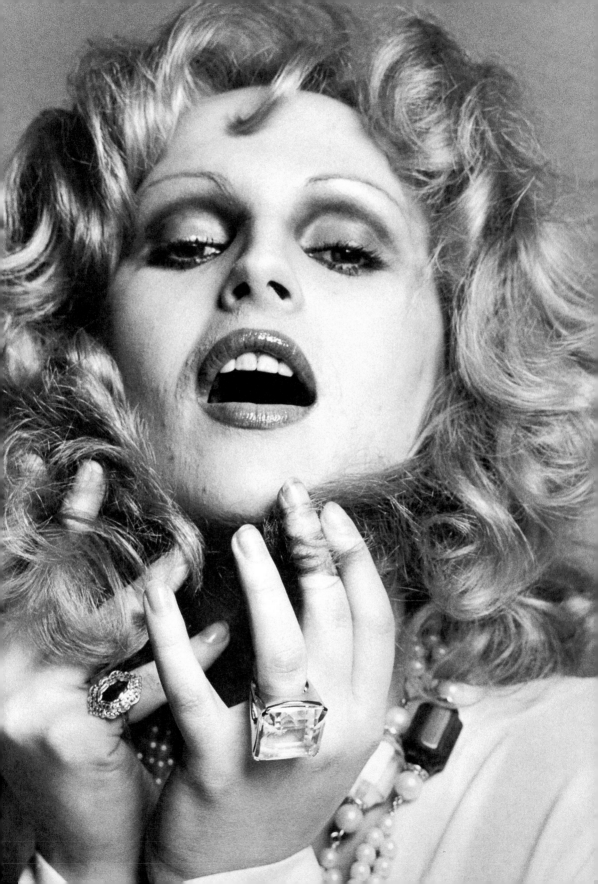

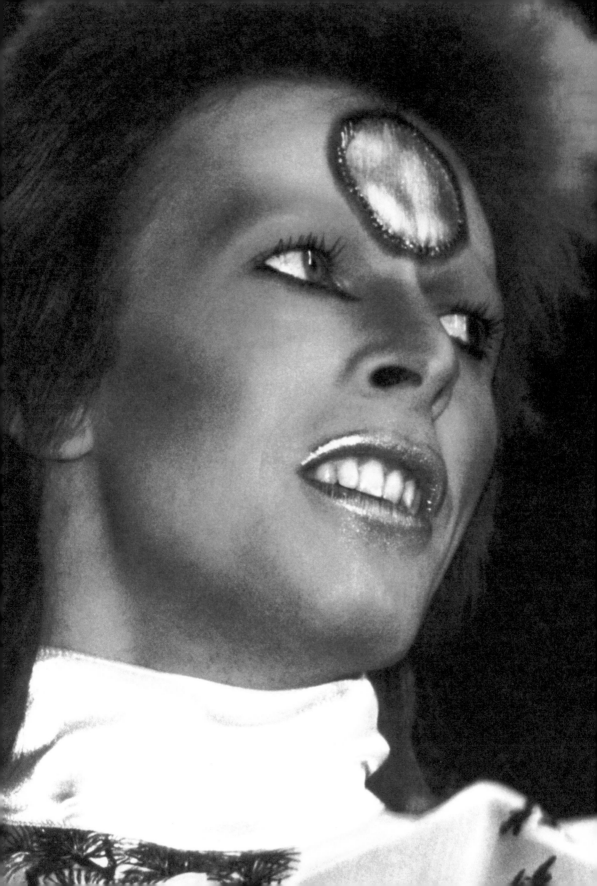

page 1
–
Francesco Vezzoli
*Francesco by
Francesco:
Before & Ever After*
2002

p. 2
–
Michel Auder
Dead Souls (Mostly)
2004

p. 3
–
Brice Dellsperger
Body Double (X)
(Jean-Luc Verna)
2000

p. 4
–
Cosey Fanni Tutti
*Life Forms
(Detail)*
1973–1979

p. 5
–
Vintage Film Still
Jean Harlow
1930s

p. 6
–
Mick Rock
Debbie Harry
1978

p. 7
–
Carlos Pazos
*Voy a hacer de mi
una estrella*
1975

p. 8
–
Jobriath
Jobriath
1973

p. 9
–
Francesco Scavullo
Candy Darling
1969

p. 10
–
Mick Rock
David Bowie
1973

Published
by
/
Herausgegeben
von
–
migros
museum
für
gegenwartskunst
Zurich
&
JRP|Ringier

Editors
/
Herausgeber
–
Tom Holert
&
Heike Munder

With the
assistance of
/
Mit der
Unterstützung von
–
Raphael Gygax

—

THE
FUTURE
HAS
A SILVER
LINING

—

Genealogies of Glamour

Table of contents / Inhaltsverzeichnis

Tom Holert & Heike Munder
–
17
GLAMOUR-GENEALOGIES:
AN INTRODUCTION
157
GLAMOUR-GENEALOGIEN:
EINE (EIN)FÜHRUNG

Ian Penman
–
39
SIGNLESS
181
OHNE ZEICHEN

Terre Thaemlitz
–
49
VIVA McGLAM?
IS TRANSGENDERISM A CRITIQUE OF OUR
CAPITULATION TO OPULENCE-DRIVEN
GLAMOUR-MODELS?
193
VIVA McGLAM?
IST TRANSGENDER-SELBSTDARSTELLUNG EINE
KRITIK AN ODER DIE KAPITULATION VOR LUXUS-
FIXIERTEN GLAMOUR-MODELLEN?

Tom Holert
–
65
SILVER CUBE
213
SILVER CUBE

Tom Holert & Heike Munder

–

GLAMOUR-GENEALOGIES: AN INTRODUCTION

¬ Local boys will spend a quarter/
Just to shine the silver bowl /
Living hard will take its toll/
Illegal fun/
Under the sun

(Steely Dan, "Glamour Profession", 1980)

¬ The exhibition *The Future Has a Silver Lining. Genealogies of Glamour,* has various points of departure. One issue that has remained crucial from the very beginning, however, is the astonishing fact that the history of the relationship between glamour and the visual arts

remains largely untold. Although it would be impossible to clearly define its origins or trace a particular canon, glamour has proved to be an important strategic category for aesthetic practice, whether it is embraced or rejected, criticised or appropriated. Since these functions and denotations have rarely been recognised or analysed, we decided to examine the intrinsic pluralities and contradictions of the relationship between glamour and art. How does art reflect the contentions of mass-cultural models of beauty and superiority? What influence does the media representation of film and music stars have on visual artists' self-image and identity, and what is the influence of the mass media today? How, and under what circumstances, do artistic practice and the construction of commercial forms of glamour cross paths? And to what extent is the engagement with the archives and catalogues of the glamorous a matter for genealogists?

¬ The exhibited works do not offer any simple answers. Instead, they raise an endless array of questions, which, one by one, unearth the complexity of the relationship between art and glamour. There is a glamour of objects, a glamour of personality, a glamour of community. Glamour persistently unites aesthetic and economic data, notions of wealthy lifestyles in conjunction with luxurious clothes, precious accessories, opulent apartments designed like film sets, and limitless sexual possibilities. Evidently, in contemporary popular culture this type of glamorous imagery is unavoidable, even if it increasingly comes across as a routine, compulsory exercise in the conspicuous consumption of goods and personalities.

¬ Glamour is an instrument of neo-aristocratic distinction that can easily cross the boundary of the vulgar and abruptly become a sign of tasteless affluence. The endeavours of those craving glamour are never far from the ridiculous, faux-pas, or sheer collapse. Glamour can backfire, capsize, or fail; it ranges from an attribute of superior beauty and social power through which one can rise above the others, lending an air of privileged access to exclusive secrets, to the attire of a sex worker. Flagrant exploitations of bodies and desires call for equally flagrantly "glamorous" mises-en-scènes.

¬ Does not the desire to partake in glamour evoke even more shame, paranoia, and fear of failure than ever before? However, that said, a silver lining can be found in the most skeptical of artistic projects addressing the effects and affectations of glamour, even if that lining is merely the trace of disappointment resulting from an unfulfilled promise. The following might be read as a guided tour through an exhibition that tried to map these very lining and traces.

–

Expenditure, A State of Exception

–

Glamour becomes the sparkle that refines the commodity, providing it with magical traits that kindle consumer cravings, suggesting gratification upon purchase, as if forever postponing the moment of fulfillment – exchange value sustained by a technology of enchantment, a perfect machine of illusion. But glamour can lead to the very limits of economic rationale and beyond. The loud, the extravagant, the fabulous, along with the exaggerated and excessive, or even the stage show's complete breakdown, are all part and parcel of the repertoire of glamour. Here, the relationship between the aesthetic and the economic may seem completely out of sync, but synchronism is not ruled out, just constantly in motion.

¬ How much can a printed page contain, how much can it sustain? This is one of the issues raised in Cerith Wyn Evans' installation *The sky is as thin as paper here…* (2004). The title is a quote from William Burroughs, and refers to the transgressive, poetic act, to the vigorous cross-referentiality of the dimensions at hand (the paper and the heavens). For this installation, the artist took photographs of pages of books featuring astronomical images *(Catalogue of the Universe)*, and others showing Shinto rituals *(Naked Festival)*. Evans has produced new visual emphases by superimposing these two thematic fields in a slide projection. The stars, as the projection screens that reflect the sun, shine down on the half-naked bodies of the Shinto priests, and, in turn, the physical endeavours of the macho initiation rites stretch out into the endless universe. The projection produces an excess of stars, projected from a mirrored pedestal.

¬ In *The Great White Way Goes Black* (1977), by Katharina Sieverding, the artist strikes a pose before an unidentifiable backdrop of pitch-black darkness. Her left hand on her forehead, the pale muscles of her neck and shoulders clearly discernible and her eye make-up jet-black, Sieverding wears a red cap and a semi-transparent top with red and white stripes; she holds a glass of white liquid. It is the night of July 13, 1977, when the electricity broke down in New York for twenty-five hours, plunging the city into a state of emergency. The artist, acting as her own model, is facing the camera, and seems to be considering the exceptional circumstances of that night and the following day. During the crisis New York became a site of improvised, carnivalesque festivities, of transgression and misdemeanour, and of racist acts of police brutality toward African Americans and Hispanics. The "great white way" of the title has several connotations. It refers to the name the Native Americans gave to Broadway, but also to the "way" of the white US majority. The blackout in the summer of 1977 shattered people's faith in the "great white way" more than any other event before it. Yet at the same time, the chaotic violence of those hours offered an unprecedented opportunity for acts of spontaneous, unexpected glamour, as Sieverding shows in her monumental, four-part photograph. In a pamphlet from the Revolutionary Comunist League, a "brother" was quoted as saying, "for the people, this was Xmas in July".
The work also reflects developments in 1970s fashion photography, when snapshot aesthetics, the "directorial mode", and images with dramatic innuendo appeared on the pages of glossy magazines.

¬ Ever since the 1990s, Sylvie Fleury has, probably more than any other artist, consistently filled the institutional spaces of art with fashion objects, brand names, and actions that seem completely out of place. Fleury has announced that the spaces of art belong to the realm of fashion and consumption. If the Fashion Victim had long been a sidekick to the art world, it was Fleury who gave her a leading role. Fleury, an artist who places the results of her shopping sprees in the white cube, was quickly declared a heroine by an audience weary of the gestures of traditional macho artists, but also of the politicised, Conceptual art, including feminist art, of the

1970s. In the 1990s, in the light of her regular appearances in the lifestyle press, she became the very incarnation of an art world infected by the glamour virus. The Fleury project is now becoming more distinct and recognisable, thanks to an œuvre that is multi-faceted and often surprising. Her work is essentially an (overly) adamant demand for glamour on behalf of art; even if it remains unspoken, the art world's obsession with glamour is still proving a major influence. When Fleury crushes Chanel make-up flasks on a fake Carl Andre with a sledgehammer, as in *Blue Notes & Incognito* (2004), this should indeed be seen as a homage to the Minimalist artist, even if the latter might see things differently. His floor sculpture becomes the object of an aggression that is performed with an arsenal of luxury – an act of transgression from within the boundaries of shopping.

¬ Thanks to his luxurious, enigmatic objects and ceremonial performances which he himself referred to as "plays", James Lee Byars (1932–1997) gained a reputation as an enigmatic magician of moods and atmospheres. Byars' aesthetic economy was one of luxury, the conditions and functions of which he alone could define. He worked with silk, which offers a shimmer and an ephemeral consistency that goes well with the spatial arrangements and self-stagings of this mysterious figure, but also with gold, the density of which forms a contrast to the insubstantiality of silk. Both materials have a mystical aura of alchemy and sumptuousness, as well as the lavish feel of a liturgy of abundance. *Is* (1989), a gilded marble ball, as well as *The Wings for Writing* (1972), shirt cuffs of red silk equipped with long feathers, are artefacts for aesthetic, ritualistic events, and further symbolise the promise of a moment of "perfection".

¬ The film installation *Berlin Files* (2003), also aims for a moment of enchantment or dejection, using eerie, unusual, fictive situations in empty apartments, or in a nocturnal bar. The joint projects of Janet Cardiff and George Bures Miller are multi-layered inquiries into the preconditions of memory and narrative, of real or alienated experience, of authorship and intimacy, of sound and vision. In *Berlin Files,* the screening room, a combination of a

cinema and a Renaissance memory theatre, becomes a place where
the narrative itself begins to wander about in the room, enclosing
the audience acoustically, while on the visual level the images form
a long sequence of associations. The principle of the labyrinth,
the structural paths of computer games, neuro-scientific visualisa-
tions and the warped time/space of science fiction: these are the
contexts for Cardiff and Miller's unusual narrative structures. In this
acoustically challenging environment – ostensibly aiming to have
a physical effect on the audience – the viewer begins to search
these self-stagings for some exceptional, extraordinary moment of
fulfillment (or failure). Mysterious Berlin apartments and frozen
meadows are coupled with snippets of intimate conversations. The
narrative – or absence thereof – culminates with the Karaoke perform-
ance of an elated entertainer in a gold costume. He is performing
a song by David Bowie, while the female protagonist cries in the side
room. Finally, as though in a coda to the work, the projector screens
the white light of a missing slide.

–

Serial Self-Transformation

–

In the days of classic Hollywood, glamour was developed into a tech-
nique of visual production of extraordinary individuality, turning
the ideal of the special, shining personality into a paradoxical and
yet logical standard of Western mass culture. At the beginning of
the 1970s, the early years of the cultural industries and their strate-
gies of individualisation were looked back to with nostalgia, and
musicians in London and New York such as Roxy Music, David
Bowie, Iggy Pop, T. Rex, Queen, Gary Glitter, Alice Cooper, the New
York Dolls, and Jobriath introduced a new aspect of glamour. Glam
rock (or glitter rock) became known for its glittering make-up,
bizarre costumes, theatrical stage shows, and a multifaceted depar-
ture from the rituals of authentic rock. "For a short time", writes
film director Todd Haynes, "pop culture announced that identity and
gender weren't unchangeable, but flowing and arbitrary. Rock'n'roll
put on face paint and turned the mirrors around, twisting every-
thing in sight". The photographer Mick Rock observed the world of

the glam rockers more closely than anyone else. In the picture of David Bowie in his Ziggy Stardust phase (1972/1973) is a major contribution to the majesty of glam.

¬ To the politicised, critical spirits of 1968, with their fondness for Conceptual art, the self-stagings of Urs Lüthi edited and exhibited in series such as *Tell Me Who Stole Your Smile* (1974), were nothing but revolting. Were they not indebted to an old-fashioned ideal of self-absorbed, artistic subjectivity? Due to the obvious influence of on-stage sexual subversions and identity transmutations of glam stars like David Bowie, Lüthi's work was not taken seriously as an artistic statement at the time. This was a mistake, for it was precisely the links to the pop imagery of the time that are today considered an outstanding quality of Lüthi's work. In this series Lüthi, much like Bowie himself, becomes a multiple figure in his own right. Fictionalising his own self he resorted to dizzying and misleading plays on identity. Exhibitionism and masquerade, humour and melancholy, pleasure and longing, all became dramaturgical options. But the issue of social setting does beg the question of who could afford these options at the time, and who can afford them today.

¬ In *Milonga*, produced in 1980 by Carlos Pazos, the exploration and exposure of the self becomes a matter of allegory. Here, neon light – the chief accessory of the cold spatial aesthetics of the years of punk and New Wave, but also of Minimal art and its successors (Dan Flavin, Bruce Nauman) – becomes a key element in a self-portrait in which the artist strikes a melancholic pose at a bar. During the 1970s Pazos, much like Katharina Sieverding, Michel Journiac, Manon, Jürgen Klauke, and Urs Lüthi, focused on the issue of self-staging and auto-transformation, using both performances and photographs as his media. In his body of work entitled *Voy a hacer de mi una estrella* (1975), which initially included performances, Pazos, striving to "make a star of himself", unmistakably refers to Hollywood glamour photographs from the 1920s through to the 1950s. In the 1970s, the reference to the Latin lover and other classic Hollywood prototypes was not only a question of nostalgia, but also one of stimulating possibilities in terms of sexual

politics. A counter-model to predominant social conditions (in this case, the aftermath of Franco's repressive Spain) was developed by drawing on film history, and popular and underground cultural experience. Pazos' queer appropriations of pre-existing glamorous personae emphasise the experience of alienation, but also destabilise conventional notions of identity.

¬ To understand just how radically one can transcend traditional notions of sexual identity, the function of clothing, and performative art conventions, the work of Leigh Bowery (1961–1994) is crucial. The fashion designer, performer, musician, club manager, and all-round eccentric was an excessive and conspicuous personality in London in the 1980s and early 1990s. "Dress as though your life depends on it, or don't bother", was one of Bowery's mottos for his serial transfigurations. His sculptural choreographies, including body dimensions and generous lengths of textiles, took place before the camera, or live audiences, or the painter Lucian Freud, for whom Bowery modelled frequently. A wealth of images documented this working process during the years before his death, and paved the way for Bowery's theatrical persona beyond drag. Today, fashion designers such as John Galliano, Jean-Paul Gaultier, Alexander McQueen, and Vivienne Westwood are still greatly inspired by this maverick figure. The portraits in the exhibition were taken by Fergus Greer, a photographer who worked with Bowery on his self-alterations on a regular basis, and contributes to magazines as *Vogue* and *Vanity Fair.*

¬ Brice Dellsperger re-staged an act of forced seduction in his work *Body Double 15* (2001), which is the reconstruction of a famous sequence from Brian de Palma's 1980 film *Dressed to Kill.* In this scene, Angie Dickinson plays a woman who is followed by a stranger through the New York Metropolitan Museum of Art. The stranger seduces her, after which the woman falls victim to a serial killer in drag. Dellsperger reconstructed this pursuit in the Wiesbaden Museum. He himself plays the role of both hunter and hunted, so that it is no longer a question of a man chasing a woman, but of two identical figures, a story of *doppelgängers.* Thanks to this doubling, not only is the artist (virtually) duplicated, but sexual

difference is also effaced. Dellsperger becomes a double-body, turning the spaces of a modern art institution into a stage for his own drama in drag.

–

Architecture, Design, Display

–

Among the principle prerequisites for fantastic and fantastical acts of glamour are buildings, stages, and other specific sites, such as luxurious hotels, opera houses, discotheques, rock venues, clubs, catwalks, film sets, shop windows, the white cube of modern art, or private apartments. *Painted White in a Spirit of Rebellion* (2002/2003) by Julian Göthe, is an enigmatic hybrid, part sculpture, part commercial display, halfway between pure form and virtual application. Made of wire and paper, the object evokes contradictory emotions and associations – from a creature-like fragility to male-volent or even gratifying aggression. The references range in terms of both form and content from the bizarre *stile novo* of Italian furni-ture designer Renzo Zavanella, to the corporeal architectures of body building. The blinding white colour is reminiscent of the white "clothing" of Le Corbusier's architecture, and the – only recently acknowledged – connection between fashion and modernity. More-over, the equal visibility of the front, side, and back of the work, reveals that which usually remains invisible in such spatial arrangements, but which nonetheless structures and informs the viewer's desires.

¬ *Single Disco (Whisperclub)* (1999), by Bernhard Martin iro-nically comments on the contradiction between collective disco experience and acute isolation. The one-man discotheque is a funny, yet desperate solution to an unsolvable social dilemma. Can you enjoy yourself alone in a hedonistic pressure box? What part does the community – or the idea thereof – play in the reconstruction of the experience of glamour? Is this the appropiate box for a self-reflexive Ecstasy trip? Martin's Ikea cupboard, with its built-in enter-tainment compartment, raises the issue of the architectonic-spatial conditions under which glamour can emerge in the first place.

¬ The *Brutalist Bulletin Board* (2001), by Tom Burr, is another contribution to the discussion of the architectural components of glamour. His juxtaposition of images of Jim Morrison's virile body/leather spectacles with photographs of the so-called "Brutalist" postwar architectural style, widely used in car parks and social housing, turns the rock star into a sexual, even sexy form of architecture. To visualise this hypothesis, and without making the slightest attempt to transcend the ambiguous nature of his analogy, Burr uses the structure of the bulletin board. Since the latter is also reminiscent of cultural historian Aby Warburg's *Picture Atlas,* this piece might be seen as a study of (pop) modernist myths of the twentieth century.

¬ Following Ronald Reagan, Arnold Schwarzenegger is the second Hollywood star to be elected governor of California, the highest political post in the State. Does this shift from the entertainment industry to politics offer a paradigmatic aspect? In *The Governator* (2003), Jonathan Horowitz, who has been studying the manipulative strategies and dehumanising effects of the mass media for years, underlines the sexist, authoritarian subtext of Schwarzenegger's career. By means of added citations from the star, the notion of superior masculinity conveyed in the images of Schwarzenegger as a combat robot, or as the primary "super-human", is stripped of all irony. One of Horowitz' unsettling conclusions is that Schwarzenegger's political success may well be indebted to the most reactionary clichés of masculinity.

¬ *French Junkies* (2002), by Nicole Wermers, is somewhere between a living-room accessory and a sculpture. The defunctionalised, standing ashtray is at once a container and a reorganisation of utilitarian design. Wermers "cuts" significant formal elements and material samples out of commercial environments such as boutiques or hotel lobbies, and reassembles them according to the principles of collage, creating various examples of "metadesign". She does not deny her fascination for design that attracts, seduces, and raises profits, as well as for its surfaces, colour scales, and the outlines of its original materials. And yet, thanks to her collage technique, she leaves room for subtlety and critical distance.

¬ Josephine Meckseper reflects on transitions between politics and fashion, activism and glamour. Photographs, videos, refashioned textiles, projections of magazine pages, and suspended assemblages such as *Shelf No. 11b* (2003), expound the role of advertising, fashion, and pop aesthetics in her transformation of the concepts and images of the political. From this viewpoint the formal language of protest culture, but also that of established political parties, seems to be largely emptied of any content, and can be understood more and more easily in terms of the parameters of glamour production. In *Shelf No. 11b,* the juxtaposition of images of demonstrations with the elegantly decorative, plastic architecture of commercial displays, forms a seamless narrative. Was the "politics of style" succeeded by a "political style", *tout court?* Where do collectivity and individualist, narcissistic experience meet?

–

Repertoire, Archive, Memory

–

The exploration of the hybrid topographies of glamour – theatrical, commercial, and artistic in character – is usually conducted along the lines of an inventory, and a reconstruction of historical or futuristic models. Rather than a creation *ex nihilo,* glamour is always derived from something else. Glamorous sensations occur only thanks to the memory of real or fictive happenings, to the collection or rearrangement of (lost) objects and experiences. *Partial Eclipse* (1980–2003), a work that includes 180 slides by Marc Camille Chaimowicz, is a meditation on the loss of memories of interiors, bodies, smells, emotions. Her act of remembrance is structured by visual fragments, still life images of plants, people, and furniture. Chaimowicz made these pictures – used in slide show installations since 1980 – over a long period of time. They have been presented, in different versions, as parts of performances that included sound. The attempt to hold on to faded memories with the help of aesthetic surrogates including fetish-like substitutes, is closely linked to a notion of glamour that contrasts the magic of intimate scenes with the louder, rougher regimes of the glamorous. Here Chaimowicz partakes in the tradition of dandyism, as well as literary

recollections of bygone atmospheres and sentiments, such as can be found, for example, in Marcel Proust.

¬ An untiring visual historian over many years, Michel Auder began his work in 1970 when the first portable video cameras became available. He started to assemble an extensive archive of images of New York's underground bohemia, in the form of video chronicles. In the late 1960s Auder was a member of Zanzibar, a group of Parisian filmmakers including Philippe Garrel, who were referred to as the "Dandies of 1968". Auder then came in contact with Andy Warhol and his entourage, and moved to the Chelsea Hotel in New York, together with Viva, one of the "superstars" of the Factory. Using his camera, he interacted with protagonists such as Taylor Mead, Gerard Malanga, Ondine, Warhol, Donald Cammell, and Alice Neel. Jonas Mekas describes how Auder's video camera was "always there, always going, a part of the house, a part of his life, eyes, hands". In many cases, the material was only reworked and screened many years later. Countless hours of material from these video chronicles, showing everyday goings-on, banal details, walks, or conversations are still waiting to be viewed. For this exhibition, Auder assembled contact strips of selected scenes from his chronicles into a piece entitled *Dead Souls (Mostly)* (2004), extracts from a private-public archive of glamorous gestures.

¬ In his films T. J. Wilcox combines found footage with anima-tion sequences and other 8 mm material that he shoots himself. These are copied and reworked on video, after which a 16 mm copy is produced. The material traces of this extended process, the added slow-motion effects, and the casual screening conditions all play an important role in Wilcox's attempts to produce audio-visual renditions of personal and collective histories. *The Funeral of Marlene Dietrich* (1999) assembles imagery that is very dear to Wilcox, entwining past, present, and future into a cinematic recon-struction and a re-fictionalisation of fantasies concerning Dietrich's funeral, fantasies that Dietrich may even have entertained herself. A dreamlike voice-over, witty and somewhat satirical, invokes memo-ries of the star, along with her own self-mystification. *Stephen Tennant Homage* (1998), combines nostalgia, reportage, and celluloid-

materiality in a similar manner; here Wilcox draws our attention to Stephen Tennant, an icon of twentieth-century dandyism.

¬ According to witnesses, "Jackie 60" was among the last of the truly glamorous New York clubs. It shut down in 1999, but was captured on film in 1996 by photographer Allen Frame. The two individuals in *John and Alba* seem to perfectly embody the refined atmosphere and exclusive company around them. And yet the viewer senses a longing for some lost moment in time. Like many documents of glamour, Frame's photography rebels against this loss, but reaffirms it in that very aesthetic moment itself.

¬ As a chronicler and stylist, Christian Flamm looks for emblematic as well as resistant moments of style and stylistic awareness. His *Relindis Agethen* (2004), a delicate wall pattern of black thread, represents a hand holding a rose. As with embroidery, the formal repertory is reduced to a minimum. Flamm uses needlework as well as paper cutouts, developing a whole grammar of poses and gestures that blend contemporary underground cultural formations with traditions of bohemianism and dandyism. Flamm recontextualises the romantic motif within a pictogram that is elegiac while verging on the kitsch, and which symbolises dandyish grace and elegance.

¬ Whether deliberately or not, all stagings of glamour lead back to the big film studios of the 1920s, 1930s and 1940s. According to Diana Vreeland, the success of Hollywood laid in the "total concentration on one single matter", and this matter was "the word 'glamour'". To a large extent, the formula was developed and put into practice by photographers hired by studios to make behind-the-scenes shots on the film sets, as well as publicity shots of the actors and actresses. A history of the construction of celebrity glamour is unthinkable without these first images. More than just an advertising gimmick, these miracles of light and shadow created by bulky glass-plate cameras, played a decesive role in the iconisation of the actor. Very often they were produced independently of the film shoot, and, in a sense, offered a first interpretation of the films in question. Christoph Schifferli's selection, drawn from his rich collection of vintage film stills, often strays from the canon of glamour

photography largely associated with photographers such as George Hurrell, Don English, Edward Steichen, Cecil Beaton, and Ruth Harriet Louise.

¬ With his large display case, Daniel Hunziker, who usually intervenes in given spatial conditions as a sculptor, has produced a stage for the *mise-en-scène* of various artworks, consumer goods, and documents, thus offering different renditions and readings of the glamorous. The display case was made especially for the exhibition, and is closely linked to the play *Glamour Eiland,* which was developed by Tim Zulauf and Klassenfahrt/KMU Produktionen for the Theaterhaus Gessnerallee in Zurich in the context of the larger "Doing Glamour" project. Puppets resembling the three actors from the play can be seen in the hollow space underneath the display case. Hunziker's crystalline structure contains collectors' items and artworks by artist John Edward Heys. Heys both witnessed and recorded the history of New York underground glamour from the late 1960s to the late 1990s. As he explained, "he experienced, encountered, created, and lived glamour for over fifty years beginning with the baths he shared with his beloved and beautiful mother from the ages three through nine years old, and continuing with his personal Italian stallion foot fetishist who performed as such usually on early Sunday mornings as the sun was rising over the artists's East Village penthouse in the late 1990s in N.Y.C. Concurrent genealogies include being beaten into excellence by the genius Charles Ludlam, acting with the legendary Ondine in the revival of 'Glamour, Glory & Gold', consuming cocktails with Jackie Curtis and Lucy on the swan bed on 14th Street, and moonlight rides with Alba Clemente."

¬ Hunziker's display case also includes a selection made by the curators of the exhibition, including publications and artworks by Cecil Beaton, Man Ray, Edith Head, Gilles Larrain, Larry Levian, Jobriath, Meret Oppenheim, Shannon Bool, Mark Leckey, General Idea, Jeffrey Vallance, and Wols. This subjective use of the annals of glamour forms a common referential denominator running through the exhibition as a whole – a premonition of an archive, a sort of toolbox, offering proof of the diversity of glamour genealogies, taking in Surrealism as well as camp aesthetics and queer pop culture.

Homage
–

Homage is an undeniable part of archival intervention, a form of
remembrance and admiration combined with the wish to inscribe
the figures in question within both personal and collective memory
in an enduring manner. Manon has erected an idiosyncratic pan-
theon with a floor of black hushcloth, containing eighteen black
caskets on black pedestals; the work, *La Stanza Delle Donne* (1990),
is devoted to eighteen women who all, in some way, made a lasting
impression on her, including Nico, Rita Sackville-West, and Jane
Bowles, among others. The caskets are lined with silk, each woman
being accorded a different colour.

¬ The black-and-white portraits of celebrities in the series
Untitled (2003) by Cerith Wyn Evans are taken from the 1959
picture dictionary *Portrait of Greatness* by Yousuf Karsh. Although
this encyclopaedic display of "greatness" and "fame" does resemble
a homage, the repetition of figures presented in a rigid, standard-
ised procedure of picture taking de-subjectivises the gesture of
the homage. Short biographies are printed on the flip side of these
portraits (not visible to the exhibition visitor) that do not correspond
to the figure in the photograph, since the page layout is subject
to the text/image chronology of the book as a whole Evans' interest
in the two-dimensionality and materiality of the printed pages,
further underscored by circular cutouts, reflects the ambivalence
of the cultural construction of celebrities. The stars represented
here are drawn from different cultural and aesthetic contexts,
for example, the directors René Clair and Walt Disney, the poet
Robert Frost, and the British royal couple Queen Elisabeth II and
Prince Philip.

¬ Diana Vreeland, longtime editor-in-chief of the US *Vogue,*
and undisputed high priestess of chic, was photographed in her
apartment by Peter Hujar (1934–1987) in 1975, the genres of homage
and portraiture complementing each other in one picture. Hujar,
along with Robert Mapplethorpe and Nan Goldin, was arguably one
of the most important New York-based photo artists of the 1970s
and 1980s. He worked as a commercial fashion as well as a portrait

photographer. An important protagonist of the East Village scene, where he took pictures of fellow members of the queer underground, using the style of classic portrait photography. The black-and-white shot of Vreeland, hovering between the fashion establishment and underground bohemia, underscores her legendary, aristocratic authority, but also her age. The combination of the striped covering of her divan and the pattern of her dress offers a complex blend of personal traits and decorative elements.

¬ _An Embroidered Trilogy_ (1997–1999) is a video installation by Francesco Vezzoli that refers to three films shot by three different directors, John Maybury, Lina Wertmüller, and Carlo DiPalma. Each film honours an Italian _grande dame:_ Iva Zanicchi, host of the TV game show "OK! The Prize Is Right"; comedian Franca Valeri, who specialised in theatrical parodies of actresses like Silvana Mangano; and Valentina Cortese, a quintessential diva in roles such as the one she played in François Truffaut's _Day for Night_ (1973). In all three films, the young artist appears in the same room as the adulated women. As the actresses sing or strike theatrical, desperate poses to pop music in the background, Vezzoli sits concentrating on his stitching, bent over in silent awe. Recently asked why he devoted himself so ardently to artistic exercises in embroidery, Vezzoli said: "I think it has to do with my obsession with beauty, craving for love, and homosexual identity". The opulent settings of the films become spaces of utopian intimacy between star and fan. Vezzoli methodically moves from reverence to cooperation, convincing these icons of cinema, opera, and TV to participate in his own fantasies. Even though these fantasies seem to cater to clichés of feminine masochism, this impression is offset by a forceful sense of Vezzoli's admiration.

¬ _Francesco by Francesco_ (2002), Vezzoli's collaboration with Francesco Scavullo (1929–2004), also speaks of the desire to integrate an idol into an artistic practice. Scavullo was a master of photographic glamour. For three decades he was responsible for the monthly cover picture of _Cosmopolitan,_ and also worked on commissions for _Vogue, Harper's Bazaar,_ and, in the 1970s, for Andy Warhol's _Interview._ Ever since the 1940s, Scavullo has skillfully used

many different glamour idioms, until his own style developed to a point where glamorisation and "Scavulloization" were widely considered synonyms. His exhibition presents his photographs of celebrities from the pop mainstream as well as the underground (Divine, David Bowie, Grace Jones, Candy Darling, among others).

–

Critique of the Beauty Ideal

–

If a photographer like Scavullo was working at the forefront of the creation of the beauty cult during his entire life, from the perspective of those who are subjected to – and ideologically marked by – this shifting norm, that is, for the "subjective" individual, the situation looks very different.

¬ Sanja Iveković has played a significant role in feminist media art and representational critique since the 1970s. In contrast to most other artists in this exhibition, Iveković does not come from an American or Western European context, but began her career in Tito's socialist Yugoslavia. And yet her collage series *Eight Tears* (1975–1978) and *Before and After* (1975/76), as well as the video *Make-Up/Make-Down* (1976), all reflect on the capitalist production of images of femininity in advertising and the cosmetics industry which were hard to ignore even in Zagreb in the 1970s. Iveković combines the visage of a Helena Rubinstein advertisement with its decorative tear, with symbols of "motherhood", "family", or "profession", also taken from magazines. Using pictures that deny any before-and-after logic, she deconstructs advertising's promise of a perfect appearance through cosmetics. In the video, she shows the elaborate daily ritual that goes into the production of a "feminine" face, but without showing the end result of the process.

¬ What is the everyday experience of women who wear wigs in Turkey? This is the subject matter of the video installation *Women Who Wear Wigs* (1999), by Kutlug Ataman. In four simultaneous projections, women explain the different motives for their ersatz hairdos (the aftermath of chemotherapy, the disguise of a political dissident, the work of a transsexual prostitute, and the needs of a

Muslim woman who is required to take off her headscarf at Turkish universities). For Ataman, the oral narratives of his interlocutors form a historiography of social norms. The wig can be a subterfuge for identity, or a means of complying with predominant rules of attraction. But in all four narratives the wig is a prosthesis for survival, an instrument of both conformity and alteration.

¬ In the body of work entitled *Looking for Love* (1996–2004), Daniele Buetti makes use of the surfaces of magazine photography using the models' skin, onto which he engraves ornaments, logos, and brand names that look like ritual scarifications, neo-tribalistic brandings, or rather disquieting injuries. The uncaring demeanor of the photographed subjects forms a stark contrast to Buetti's seemingly "painful" interventions: the tattoos are not even noticed, or appear to be injuries long overcome. Buetti then photographs the "wounds" he has inflicted, so that the surface of the picture appears unscathed, and it can once again enter the cycle of supply and demand.

¬ In the 1970s, Franz Gertsch painted impressive, Photo Realist pictures of evidently glamorous people and situations. Gertsch was an observer and chronicler of a community of adolescent bohemians, whom he often portrayed enjoying their own sex appeal in their private spaces as they were getting ready to go out, a generation caught between political awareness and popular culture. Gertsch's pictures, with their monumental visual format, were underestimated for a long time. His comparatively small portrait of *Irène III* (1981), a delicately nuanced black and white painting, shows a woman's three-quarters profile – a former up-market Zurich prostitute – the light appearing to both surround and emanate from within her.

¬ "I've never really identified myself with 'femininity'; even when I worked as a photo model and a striptease dancer, I never had the feeling that I really fitted in", says Cosey Fanni Tutti. Cosey Fanni Tutti became internationally known with the Industrial/ Noise band Throbbing Gristle, prior to which she had been a member of the Performance/Mail-Art group COUM, later to become TG in the early 1970s. COUM provoked the British art scene with sexual and political transgressions culminating in the controversial

exhibition *Prostitution* at the London ICA in 1976. *Life Forms (Detail)* (1973–1979) documents her work as a performer, a professional stripper, and a nude model, with three colour photographs each. In separate captions, Cosey Fanni Tutti describes her situation within these fields, all of which contribute to the institutionalisation and objectification of female bodies and "femininity" in their own way. Tellingly, the term "glamour" has a specific function in the sex industry. Since the 1940s, glamour has been associated with nude, pinup photography. Today, "glamour photography" is used as a euphemism for the hardcore pornography business.

–

Coda

–

Something of the ambivalence of glamour's categorisation as a concept is suggested in the exhibition title: in the background of the closing scene of Paul Verhoeven's *Robocop* (1987), a billboard says: "The Future Has a Silver Lining". In the wake of the film's post-human, apocalyptic, science-fiction urban panorama, in which this message is brandished like the last gasp of utopian spirit, it is hard to imagine a future with a silver lining. The dull, steel gleam of Robocop's techno-body represents a destructive type of glamour that has visibly absorbed and destroyed all other types of glitter; the phrase "The Future Has a Silver Lining", by contrast, offers the hope of a future with a promising sparkle. Just like the dystopian moment, this utopian dimension always coexists with experiences of glamour. Glamour always has a (social, economic, aesthetic) price, usually paid by those who are most eager and devoted. Glamour is an investment in the future, however, it pays off only on the rarest of occasions.

–

Translation Tirdad Zolghadr

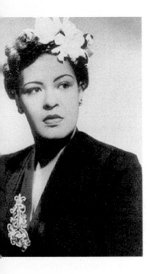

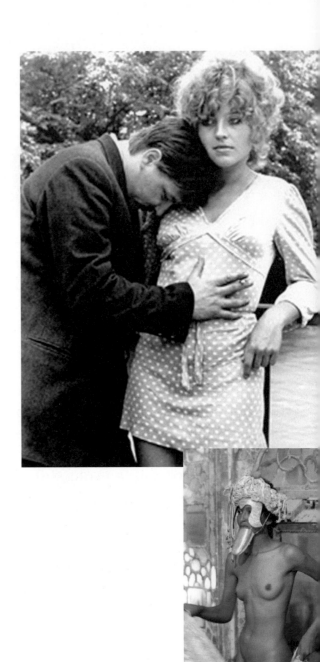

From left to right:
Billie Holiday ¬ Hanna Schygulla in *Katzelmacher*, directed by R. W. Fassbinder ¬ Rita Hayworth ¬ Still from *Katzelmacher*, directed by
R. W. Fassbinder ¬ Alain Delon in *Le Guépard*, directed by L. Visconti ¬ Paris Hilton ¬ Still from *L'Avventura*, directed by M. Antonioni ¬
Anna Karina ¬ P. Pasolini, *Il fiore delle mille e una notte* ¬ *Accatone*, directed by P. Pasolini ¬ Billie Holiday ¬ Rita Hayworth

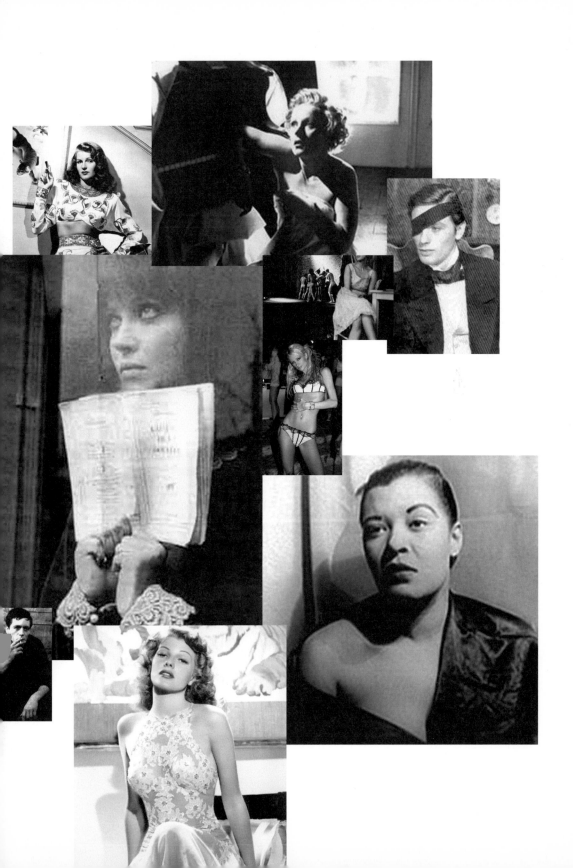

Ian Penman

—

SIGNLESS

I wrote her:

¬ I've lost my way here, I really have. Believe me, this is no joke.

¬ I've been working on this thing (our thing: Glamour) all year practically, and have amassed a book's worth of material – notes, speculations, case studies – but I feel like it's slipping further from my grasp every day, that it's turning into some kind of pathological detour that will never end or might consume me whole. I lose my way time after time, turn after turn, trying too hard to remember that essence rare,

sucking the tiny paper cuts on my fingers gotten from getting too close to the grain…

¬ How I wish you were here and we could just look at a Wong Kar Wai film and agree on this one thing at least (doesn't *In The Mood For Love* come into your mind if I say the word Glamour?), and it would all become clear to me once again like it was before.

¬ (What if there were a "repressed" of Glamour, and that was one of the things I was working against or was working against me? Then, something like the suicide of Leslie Cheung would be the proper object of a study like this, and we could get down to what we really do best: the work of Mourning. What was that other film you loved and made me seek out; it was a female director, and the way she filmed young male bodies in the clear North African midday sun… just for a moment you felt you were watching something fresh, or new; glamour seen from the Other side as it were, not a clichéd shot in the whole resplendently ascetic thing…)

¬ But I seem to have lost any hope of securing this bright plastic thing, of tying it up for the night in any kind of adequate conceptual harbour; it's like I'm trying to write on an outgoing wave…

¬ And suddenly no reply from my distant Other, who always used to speak to me or through me at times like this. Last year she wouldn't stop speaking or singing: about Andy Warhol, about Nina Simone, about Roxy Music – each of them an exemplary form of Glamour in their own singular way. Then, in mid-September, she just stopped, without so much as a defeated sigh, and has been silent ever since. I don't know why she's gone; I have a feeling it's something to do with something like an overload or overdose; or what Derrida might call (with all due precautions) an "apocalypse" of glamour. Maybe trying to take on the War has ultimately defeated me: I should never have moved off of my normal (trivial, pop cultural, glamorous) beat. I feel sick from talk of beheadings, and torture, and human remains, I really do. I feel like everything is slipping away, and –

¬ Each time I try to focus on some image of glamour, all those other images from Iraq shut me down. Today, an online video of a beheading. The bartering of human remains. Dogs snapping at genitals. Something widespread is going on here – the inauguration of a new epoch, in which so-called "war" is a competition amongst images, films, videos, stagings, snaps. Contemporaneous with the nu glamor epoch. Are they one and the same? Different faces of the same epochal shift? GLAMWAR.

●

I admit, the temptation is just to disappear for good, sometime soon, leaving no trails behind me. If I'm honest, that's the one thought that comforts me right now; even if you of all people know how honesty never was anything like my strong suit. (Can one be "honest" and also love Glamour?) Remember my Chet Baker anecdote? About the faked tears? Once upon a time, that was my very idea of a kind of dark glamour (and one, it must be said, that doesn't reflect particularly well upon me). But then you… no, maybe this is not the place for such confessions, for such "honesty"! And not before we've even begun to define our terms. (Anyway, if one of my big problems with what I shall call nu glamor is its unearned but undeniable status of global omnipresence, is there really any mode of disappearance through which I could truly escape it?)

¬ But even just impersonating your voice makes me feel more real; I might even manage to process a little bit of sense out of these monstrously ALL-inclusive notes. (You wouldn't believe how much I have secreted away now: like a whole folder of our secret email communiqués) out of this world wide ebb, or "multi-task" vacuum, or emptied lot, or persecutory All that is the atrocious global spell of nu glamor 2004 (don't you feel there should be a TM mark there, here, at the end of it all? Or even… AS the end of it all?).

●

Start again from a different place.

¬ OK, someone comes, and they say to me: DO YOU BELIEVE IN MAGIC?

¬ I do. I say YES, yes to GLAMOUR. I always have. Until the past few months, at any rate; but that's a different story – and precisely the one I'm trying (and doubtless failing) to tell here. It's precisely this difference that defeats me, in advance, I think. Because I never had any trouble before inhabiting a certain idea of glamour. But now that glamour has become something global, given, expected, predictable, appliquéd onto any waiting surface by a team of professionals, something which is all surface and no subtext… well, it feels like there's no longer any subjective position within its realm that I would feel comfortable speaking from. In the past, I could find common cause with someone as different from me as Genet, or Pasolini, or Nina Simone, or Grace Jones… because "glamour", as such, was the space inside which we translated each other's desires into echoes of our own.

¬ How many, then?
Starting with three broad strokes, at least.

¬ GLAMOUR as in:
the theory and practice of MAGICK.

¬ About which I'm going to say nothing, as is the traditional form. But, you know: from Dr. Dee to Aleister Crowley to Coil: you know. And if you don't… well, then the whole point, as you will come to realise, is how you get (t)here, through your own work. In this respect, getting in touch with your "glamour" may turn out to be the hardest thing you'll ever do, the hardest won thing

in the world: this world, or the next, or any other. We'll of necessity return to this point; or find its return necessarily opening up before us, like a yellow trick road.

¬ GLAMOUR as in:
popular work and works of ENCHANTMENT.

¬ … which, once they have captured you, may own you for life. In my case: Billie Holiday, noir movies, Francis Bacon, Fassbinder, the first three Roxy Music LPs, and so on. These are things that as far as I can tell I AM NEVER GOING TO RECOVER FROM. I will be haunted for the rest of my life. (And glad for it: a "glam-our", amongst other things, can be the best shield in the world.) But yes, YES, the working out of the mean-ings & forces at work in these early seductions might easily (easily?) occupy me for the rest of my tip-tap life. How one gets from H to … G. Or from B to … H. One minute an eye trolling the surface of a sublime image; the next, shooting up in a corner, all the essence of glamour gone, in sixty seconds, into your arm … (the-sameoldstory: glamour can be a downfall, as well as a look UP). But such examples – Billie's unique, inim-itable, unexpected tone; Fassbinder standing naked and scared in his portion of *Germany in Autumn* – still resonate for me, in a way I find impossible to ignore. The improbably (even excessively) personal tone of these words, here, today, is one obvious result. This is what glamour can be: unearthing an intimate tone ALL YOUR OWN.

¬ GLAMOUR as in:
… well, you, my dear!

¬ "You're highbrow, holy, with lots of so melan-choly … shimmering". In other words – as other as hu-manly possible – what used to be called one's "real" or "personal" life. Where I have looked into your eyes, and moving so as to wipe away your next Sunday morn-ing tear, have known, rather suddenly, the glamour of an unbelievable or sublime – no, I'm really not ready to disclose any of this; not here, not now. Glamour as a wound in the face, a tolling inside the chest, a falling inside your bloodstream; no more masks except this ONE MASK WE BOTH FIND OURSELVES IN, a current in our memory like a snapped power cable swinging free and dangerous in the inky red night …

¬ I remember this one night, in the back of a cab. I said something to you, and then wondered where on earth my words had come from. It was as if your face alone had prised or elicited these completely un-premeditated and surprising words from me, and with them a new "I" was being born, like a star giving birth to its own galaxy. Another night, telling you the Chet Baker anecdote, I was staring earnestly into your eyes, just about to reach my tolling "punch line" when … no. I can't just repeat that, without the light of you around me like a forest of dangerously fissionable warmth …

¬ Remember, too, that time we went to see *Eureka?* We met Nic Roeg afterwards. He remembered me from our hilarious drunken interview. It was like Meeting The Magus, wasn't it? You can't plan nights like that, which, even when they do end, feel, when you later look back on them, as if on some plane they've never ended, and never will: some strange arc of light, defying ordinary physical laws …

¬ I have an awful feeling (it actually makes me slightly sick in my stomach) that it will never be as good as that again. No more *Eurekas* ever again. No. Coincidentally, they just re-issued a new print of *Performance* last week. Can you IMAGINE anything like that ever being made now? Talk about a glamour without parallel. Utter singularity. Universe of its own imagining. As if imagining a world might be enough to bring it into being. And isn't that, after all, what al-ways drew us to a certain strand of popular culture? Wasn't that the hope, or promise, or dare? I do know that everything I feel about certain notions of Glamour is contained in that rich, inexhaustible SPELL of a film. Crowley, Anger, LSD, the Stones at their height, cinema as spell-casting, polysexuality, going through the mirror … a dangerous thing, playing with forces like that.

●

 I wrote her:

¬ I feel terminally winded, working off nothing: no fuel, no spark, no spell. If I but had the energy I would relate this out to Lacan, and his theories of the mirror stage and the Gaze between the "I" and its Others, and how that dynamic finds its daemonic exercise in cer-tain powerful works of Glamour; either on a publicstage or on screen. Or in our eyes when we look into one an-other and find questions there we could not envision in any other space … and when that exchange is weak-ened or ignored or lost –

¬ For you, you are SO far away now.
You are a lost HOPE in my heartland.

¬ Do you remember that telling, tolling, prescient line from "Mother of Pearl", Ferry firing on all cylin-ders, almost 30 years ago now: "With every goddess a letdown/Every idol a bring down/It – gets – you – down". A gesture which reaches out to annul the spell of a certain glamour; and only makes itself (shows it-self) to be all the more seductively glamorous … (where have such subtexts gone? Well, the simple answer is: they have been bought out, like so many junk bonds. DISCU$$)

●

 CASE IN POINT:

¬ Rita Hayworth once ruefully commented, "They go to bed with Gilda, but they wake up with me".

¬ (Glamour as a lure which turns back round to bite you, leaving you STRANDED in the morning after's

disillusioning Real. The unveiled truth of Woman as an in-itself "drag" – in ALL senses.)

¬ Did you see? JORDAN (nee Katie Price; OR: substitute a myriad other names) – today's model chat-show model, model ex-glamor now premiere glamour model – has just brought out her Confessions, called *Being Jordan.*

¬ Couldn't we just discuss that "Being" for all the time that remains? I mean, I think I know that in whatever sense "Jordan" – the name? the person? the trademark? the rumour? the image? – has Being, then that could be the sole take-off point of analysis or discusion for this essay about what may have become of what we used fondly to call Glamour. (We dressed up in private and looked in the mirror and saw a dream of POWER. Now the world is a world of INESCAPABLE SURVEILLANCE, and we may have to take refuge in new stagings of Glamour ALL OVER again.)

¬ Anyway, in the person of Jordan, you might think we have a case that invites an easy and revelatory, telling and educational comparison with Rita/Gilda.

¬ Except for two things. (There: yes, it's that easy. Glamour is now a big, big joke, funnier than BEING itself. It's a boob like a clown's outsize shoe, or plastic… nose.) The defining difference – Old Glamour vs nu glamor – is that Rita was an actual actress, and Gilda was a fictional role. (And the "glamour" came from the light that poured into one material body from the other immaterial realm?) But "Jordan" is a role played in real life: there is no on/off screen. There is no screen, in her mind or ours. No screen allowing for fantasy, or damage limitation, or wild, wild aspiration, beyond earthly chores. Instead, a deathly dull "real life" palmed off (a lot of palming off) – with but one minor yet magnifying alteration at the basest level of supply and demand – as a frictional "sexiness" which precisely "takes off" all the glitter of glamour without getting anywhere near its original UNCANNY arc…

¬ Jordan is Gilda trying to learn to play the role of Rita Hayworth: trying to GO DOWN to a less rarefied realm, where the only thing that matters is matter itself. Rather than upgrading our great expectations, it shoves them down to a coach trip moment of drunken desperation or compliance: HERE! LOOK AT MY RUDE BITS! And "boob", here, might be taken to signify another word for Freud's "slip" or parapraxis: what is passed off as "no more than" a punch line, is actually a codified message of terminally lowered expectation: ALL BETS ARE OFF. Dream economy bartered down to LAST FEW DAYS sell-off. Rip off: in both senses of the term. No unveiling, because the act STARTS from the already disrobed. IN YOUR FACE, as all the young operators now say. Glamour used to be about a singular veiling of the material, which led your eye's mind in all sorts of unpredictable directions. Now, it's a hard (core) sell. ALL NUDE GIRLS. The precious model or paradigm of Glamour has become, finally, no more than what the euphemism of "GLAMOR MODEL" used to betoken.

¬ All there "is" to Jordan are her grotesquely out-size breasts: dual billboards made flesh. (If we had but the space here, we might launch a Derridean discussion of the Pair vs the One: whether "perfecting" or enlarging your breasts actually reduces their – call it how you will – power, or glamour, or beauty? Whether a certain powerful notion or spell of Glamour doesn't precisely work off of the punctum of veiled IMperfection[s]? That, in other words, we need an Ordinary to start with, before we can progress to the properly uncanny realm of "true" Glamour.) They radiate nothing, but draw all eyes to their vanishing point like some brutally swooshy TRADEMARK. Or like some optical instrument of torture: YOU MUST STARE AT THIS. A Rita/Gilda (ordinary > uncanny; morning light > noir; ordinary beauty > Glamour) withheld nakedness as a power. There was no reductive site, trademark, signature. The "signature" was a grid or matrix of light. Immaterial, weightless: a liberation of constrained seeing. Our vision, mired in the diurnal real, is suddenly RAISED, dispersed, illuminated… other worlds are implied. Desire implies a world.

¬ Now, looking across to Jordan, we see there a "real" that is the fakest thing imaginable. Except that no imagination is involved. It is rather a reversion to a bald, downgraded notion of what MEN REALLY WANT. In this circus-act staging of sexuality as Pavlovian drool – as ONE way vision – her FALSITY is what is offered as seduction: what you REALLY want. Which places us in a dizzyingly abyssal void of reflectio where the revealed Real is actually so massively pointedly UNREAL, that… well, where are we? What are we looking at? What are we doing? What kind of optical economy is implied here? One that keeps you grounded, rather than thinking otherwise, elsewhere? Just as economically – which we must keep in mind, as parallel reality, at all times – it reduces what used to be amorphous, uncontrollable, the serpentine messiness of Desire, to a plastic mnemonic, a fuzz-free trademark; and I do not think that this is mere coincidence, in what we call the rule of globalisation.

¬ This tabloidy new glamor demands nothing but that we accept that there is nothing but the tyrannically undemanding real of this tabloidy new glamor which… you see? A circularity that describes a perfect O. A perfectly void tornado of "multi-tasking" and "rebranding" that disguises a central, towering vacuum.

¬ And it's not just the girls, either. Just listen to someone like Quentin Tarantino, as he flogs his singular lack of imagination as some kind of breakthrough the cinema has been waiting for for decades. Cut straight to the cut… and wound, and slash, and spurt, and (yes) beheading. But don't worry – it's all just a movie. It's just a cartoon. It's just violence: nothing secret or sacred or unsettling about that. No need to wrap

it inside anything that might make us think twice: just SELL, SELL, SELL all around the world. Decades of cinematic oddity reduced to a handful of easily identifiable trademark "bits". Fast food movies. Nothing to linger on in your unconscious later on that night, nothing like the tears graving down through Anna Karina's b/w cheek. Quentin's idea of female empowerment – a slick chick in a tracksuit cutting a mathematically pornographic series of heads off – is a bit like Britney's notion that "deconstruction" means less clothes to take off before she goes on stage. Britney and her poptart sisters really genuinely BELIEVE (and this is the scary thing: they really DO) that prancing around in a clichéd lingerie get-up is the height and dare and depth of "empowerment". Thus, her pre-teen tweeny girl audience goes home with Britney's second-hand notion that you can lap dance your way to liberation. All economic considerations erased.

¬　Now, there ARE deeper, darker meanings hiding here about what kind of world these children stand to inherit: an economically scary one. The desperation in Britney's every latest scare tactic testifies to this. Britney's "mock" Las Vegas marriage speaks of a world in which you may well have to sell your innermost private life in order to fulfil the terms of an easily withdrawn or rewritten contract. Pop stars used to make disposable culture. Now, a disposable culture makes its pop stars (in its own image). The message behind a millionaire pop star having to revert to lap dance tactics in order to scare up a bit of publicity for her ailing career really IS truly scary, if you pause (button) long enough to think it through. It makes of the formerly untouchable realm of Pop Glamour something like a dumped female corpse in the Mexican hinterlands. Scarily disposable, at the hands of anonymous power brokers. A message, a warning: you are just another slice of meat to be disposed of as and when …

¬　GET REAL … is one thing. But: "get real … or get dropped" is the REAL unvoiced subtext here.

¬　Bling, now, is the supposed measure of everything; but bling is just a fancy way of never having to say you're vulnerable to Big Daddy Kapital, after all.

¬　In the strange logic of bling, you may be dressed up inside a million dollars of flash, and cash, and brandy and champagne … but you still sing or rap about a bottom line world of pimp logic and whore economics. (Scary … or scared?) KEEPIN' IT REAL, they all say – and I could write a book on those three little words, so contradictory, and toxic, and baffling, and dangerous do they seem.

¬　Be it Jordan or Britney or Puffy (or Condy?), certain symbolically evasive, or vaporous, or double-faced notions of the Real are what predominate, in one way or another. Not the Glamour of the Real (of all those moments in life that make us feel like a million dollars), but a "glamor" that rubs your face in the Real of the Market's bottom-line CASH MONEY logic.

Consequently, today's pop kids aspire to the END result of success, its outward signs, without wanting to find any particularly taxing, or interesting, or innovative way of getting there. Bread and circuses. Blood and lingerie. Exit wounds and crotch shots … and a new "box fresh" pair of trainers every day, as the guarantee of distance. NO STAIN ON THIS REAL. And if the Real is stainless –

¬　There is no longer any screen – no "controlling screen of fantasy". There is no "fictional" realm and then somewhere else, buried away (under the bedclothes) the real. Lovely Rita had no trademark as such – except her "aura": an aura of Glamour. This is how it used to be: Rita had Glamour like Indians had raven feathers. It made us feel there were places somewhere, still, where a believably unbelievable light still shone … and, in place of that one, symbolically sturdy Screen, we now have an infinite number of individual screens, which, in admitting anything/everything (unceasing display, upfront, omnipresent), screen out nothing: the work of sublimation is thrown into disarray. Insidious psychic damage of the always already UNveiled.

●

I wrote her:

¬　I guess I still believe in what Benjamin called "profane illumination": in secular versions of a mis- or displaced Sacred that can OPEN OUR EYES as it unties our "I".

¬　You know all my other names, too –

¬　Do you remember? I went to such lengths to get you that book, Klossowski's book on de Sade? A first edition I would have loved to own myself, of course I would. But there is a greater pleasure in THE GIFT – which is I think also what Glamour used to be – of something you possess all the more by GIVING IT AWAY. Some things are beyond calculation – there are types of glamorous exchange that cannot be price tagged, or formalised within already existing economic set-ups. I still think of (I still see) your fingers and eyes inside that book, as if its pages were the sheets of … no.

¬　"Oh, mother of pearl:
I wouldn't trade you for another girl
Oh, mother of pearl:
Lustrous lady of a sacred world."

¬　So, glamour, in the mean time of our shrinking nu world, has been downsized to the shadow of Jordan's breasts. And who wants them, really? People – the "public" so called – apparently demand them; but we know that that is not the same thing at all as individuals having individual moments of actually desiring certain little things in their full, glorious, and imperfectly singular Being, is it? (Not a fair trade, not at all.)

¬　The new glamor is a peremptory GET REAL, without tender or private grammar, which says: this IS all there is. SO … wake up (and PAY UP) to "reality":

something in your face, right in front of you, inescapable, but also somehow strangely forgettable; a visual muzak which is also somehow possessed of the force of a wartime propaganda exercise; a thousand and one pieces of shiny debris. A cold low flame… for cold low times. The old GLAMOUR was a multi-faceted veil; nu glamor is something squirming in a sack.

¬ The old Glamour was magick, directly related to acts of invocation and evocation; of old gods and goddesses, still alight after centuries of Christian repression. The new glamor is a bad magic act… without the magician, without the doves, without the box and its lascivious internal guillotine, with no cut at all: all that remains is a half-naked assistant waving her arms around a now vacated space of vaingloriously conjured disembodiment.

¬ The old Glamour used to be the photograph that made you think twice, except the second time was (also) forever; that made you think, turned feeling into thinking and thinking into feeling, that was a huge sublimation, something uncanny and unprecedented and unpredictable; a fashion photo that felt more like art, or dream, or Oedipal drama; a publicity shot that felt more like a deeply unorthodox icon; a leading man whose awesome indifference lit fires under the rocks of all our eyes…

¬ Whereas, nu glamor: an apocalypse of incessant trivia, 1000 identical poptarts in identically pristine UNIFORM sluttiness, a tabloid front page that doesn't distinguish between fake breasts and fake war footage…

¬ The old Glamour was… no: stop here, stop now. IT RESISTS any & all attempts at definition, at stopping its rule over our time. Almost as soon as I set down terms, as above, I feel uneasy.

¬ YOU CAN BE ANYTHING YOU WANT TO BE… now that I'm no longer watching over you.

●

What was the name of that French photographer you liked so much? He was a 1970s fashion photographer, but his images were as properly erotically uncanny as anything by Duchamp or Klossowski. (What was his name? He's dead now, isn't he? But lives on… everywhere around us, in degraded versions.) It was all so Oedipal; I remember that. His models like dolls: dolls who could scare you into coming… and I find some of those images unforgettable, I associate them with you, with our strange afternoons together, of course, and it's one more way in which our all too constrained time together will never really end, in a way that makes me think of a Blanchot's phrase: "the faraway near". And doesn't that almost sum it all up, three tiny words, all that used to abide under the fine old legend of Glamour? The – faraway – near? Some days I'll be sitting alone at the traffic lights and I'll drift off into one of those images: your elegant hand opens

the book and… we step into this other world, this other life, where – No. Stop. Start again.

¬ Today at the supermarket checkout I was checking out the solemn newspaper front pages and the trashy celebrity magazines while I waited for my transactive, pay-off turn. So here is our world, today, in stereo: a man waiting to have his head chopped off in the newsprint; and SHOCK STAR SWEAT PATCHES on the cover of a magazine called, aptly enough, HEAT. Wasn't all that supposed to end – this is what we were so solemnly informed (as if the unimaginable 11th hour betokened a nu 11th Commandment?) – after 9/11? Hasn't it, rather, gotten more desperate, and more desperately all-consuming?

¬ All this Iraq stuff has been the undoing of me, I see that now: and it's ALL I see: every time I try to focus exclusively on a Jordan or Britney or Beckham for this piece, I keep being interrupted by the return of all those "torture" images. And worse, there are times (seeing Britney lead her ambisexual dancers onstage in paradeground formation, fascisti perfection: in camouflage and g-string) when I can no longer tell the difference between them. It all looks like images FROM THE SAME WAR to me.

¬ But then – from a certain perspective – isn't what I am doing, in my own sweet post-Baudrillardian way, just another addition to this "stereo" confusion? Saying that Britney's lockstep robot dance of SEX-as-SALE is as much a threat to Western ethics as our behaviour in Iraq? I know that neither Britney nor the soldiers there are really individually "responsible": they are both following a pre-ordained shrink to fit SCRPYT… and that, THAT, is somehow a thousand times worse. It bespeaks an even more depressing TOMORROW. One big homogenous world-sized MARKET: in camouflage and/or g-string (… you know what I mean).

¬ The militarisation of sex? The sexualisation of war? The market penetration of espionage and surveillance? Entertainment as a particularly refined form of "torture"? Britney's current show, *The Onyx Hotel*, for instance, is nothing BUT a barrage of unrelated shocks: and not shock as in knowledge, or art, or something genuinely erotic; but shock as in something that leaves you nothing more than NUMB. Shock as something like visually choreographed "torture": hit, hit, hit; slap, slap, slap. This gives a whole new awful overtone to the complaint of pop world "glamour" being "superficial": only on the surface of the skin. The bruises left by the divas of old (Nina Simone, Aretha Franklin, Billie Holiday) were to our souls. Not anymore. Look into the eyes of this new generation of self-proclaimed divas (with them, "diva" seems like some kind of military coup) and shiver at what you find there: NOTHING. They are machines for faking emotion and making money, who only coincidentally happen to be entertainers. This is the bottom line of the "get real" "philosophy"

they all parrot: world market domination or NOTHING. Worse: world market domination FOR nothing. For the value of nothing. For the propagation of nothing. For the aftertaste of nothing. Think of the risk, and hurt, and ambition of songs sung by a Nina Simone … and then look at the robot strut of this new [de]genera-tion. Think of Britney's atrociously cynical "Hit Me" video in porny schoolgirl drag – and try and imagine strong, fighting women like Aretha or even Grace Jones bending so low. Impossible. Impassable! They kept their clothes on and were a thousand times more powerful. There was fold, and reserve, and myriad un-imaginable desiring domains, behind their closed eyes and withheld lives. We never knew where they would take us: what world we would imagine anew. From the surface to the stars.

¬ OK. Back to the drawing board.

●

At a time when things seem to be getting worse we almost cannot imagine anything like a future glamour; so fall back on modernist nostalgia. We think of Louise Brooks, Roxy Music, Walter Benjamin [ET AL …] and imagine: such things will never come again.

¬ But herein lies the saving power, the winning paradox: if glamour is anything it is REVENANCE (which is not at all the same thing as relevance), it is a hauntological thing; so it is impossible to safely con-sign it to an archive of the past. It is its nature to live on (according to the logic of the "survive" delineated by Derrida). And SEEING as one cannot put an end to haunting, therefore, logically, glamour cannot come to an end: there must be more, waiting in the wings. (For more on the saving graces of modernist nostalgia, see recent works by Susan Buck-Morss and Sylviane Agacinski.)

¬ There is always more; there is always a "to come" and/or "what remains" …

¬ There will be no exorcism of nostalgia; it is the guarantee of a certain modernist survival. If I DO keep insisting on a return to certain objects or strands – Benjamin's "The Work of Art In The Age of Mechanical Reproduction"; Roxy Music's *For Your Pleasure* – then it is not helpless, hopeless, passive I GIVE UP nostalgia. It is an actively undeterred detour, uncompleted because uncompletable: the proper work of mourning.

¬ The cliché is correct: true love never dies. It haunts, is mourned, but this is mourning as affirmation, endless hospitality, giving/reception/resuscitation. Logic of the GIFT.

¬ The idea that one might MASTER glamour (or the Uncanny) is a priori perfectly rid-ic-u-lous.

¬ A certain tone, an ADDRESS to the other, the "you", the DEAREST, the irreplaceable, the ENDLESSLY irreplaceable, is proof that glamour isn't something

trivial which occupies only the young or the empty headed, but is a lifetime's Work –

¬ HERE I AM IN MOURNING DRAG AGAIN.

●

I turned on the TV yesterday for some respite, and there on *Children's Hour* is a perky young children's TV presenter, styled (but of course, every-body now is styled, this is what I mean about this new epoch of glamour, this apocalypse of glamour: there is nowhere not already styled, there is an ALL and everywhere of glamour, it is styled to within an inch of its airless omnivorous life: and it is my feeling that when glamour is everywhere, it is truly nowhere) yes, as I say, click, and there is the perky young girl-presenter looking like every other perky young presen-ter, girl group, or actress right now (which is to say, straight blonde hair; ironic nostalgic t-shirt, hipster designer jeans), and in this instance her pink t-shirt looms out of there as if MOCKING me, mocking my project, making mock of my solemn and shiny past, and mocking my very soul: yes –

¬ GLAMOUR, it says.

●

I wrote her:

¬ Remember that time in the hotel room at the edge of the world you asked me a certain something about how I saw myself? And I replied: "Alain Delon in Godard's *Nouvelle Vague,* especially that wonderful moment when she asks him what he does, and he replies "I invite derision" …

¬ Back then, I had all these glamorous – or so I thought – notions about martyrdom and a saintliness of perfect indifference – and you cut me in half there and then and brought me BACK TO EARTH, or let's say back home into a glamour rooted in what one simply might say here and now to the other and want, really want – and everything since has spun out of what you said:

¬ You said: …

¬ But no: those words belong properly to You alone. One day they might even smile on my gravestone like a dismembered rose, but for now –

DEFINITION – TRANSGENDERISM

Transgenderism is the umbrella category dealing with gender variation, and the alteration of one's appearance and/or behavior as it relates to gender norms. Transgendered people commonly include cross-dressers and people in drag; intersex people born with ambiguous or multiple genitals who are often unwillingly subjected to hormone and/or surgical alteration; as well as transsexuals who willingly undergo hormone and/or surgical alteration. The term applies equally to people who are publicly visible (such as professional drag and transsexual impersonators, and community advocates), and publicly invisible (such as people who successfully hide their transgenderism, or people whose gender appearance is so singularly convincing to the public at large that questions of transgenderism do not arise during daily life activities). I also extend this term to people who feel too socially restrained to ever physically act upon their desires to alter or confuse their gender appearance. Such people are commonly dismissed by transgendered communities as "being in denial," and are not advocated for nor recognized as transgendered unless they express a clear interest in "coming out" and pursuing a course of physical gender transition. However, I personally contend that we "self-actualized" transgendered people who physically act upon our desires are the exception rather than the rule, and that ongoing self-suppression is likely the most common form of transgenderism in and of itself. Certainly such specific forms of self-suppression are learned through larger conditions of social repression. The "legitimization" of ongoing self-suppression as a form of transgenderism is an important complication of transgenderism's (not-always-challenging) relation to conventional gender norms, and also reflects the fears and dangers of being publicly associated with gender taboos.

– *Terre Thaemlitz*

Fig. 1

Fig. 2

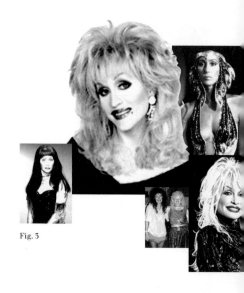

Fig. 3

Fig. 4

Fig. 1
–
Shades of glam.
Left to right: Elizabeth Taylor,
RuPaul and Cher.

Fig. 2
–
Who cares? Strangely, somebody
somewhere… Dolly Parton (left)
with professional impersonators.

Fig. 3
–
Glamour implosion.
(Left to right) Professional trans-
gendered Cher impersonator,
professional transgendered Dolly
impersonator, Cher, Dolly Parton,
home-spun tragic Cher and Dolly.

Fig. 4
–
Bringing a light to the subject.
Anti-smoking posters issued by
the American Cancer Society,
c. 1970.

Terre Thaemlitz

—

VIVA McGLAM?

—

IS TRANSGENDERISM A CRITIQUE OF OUR CAPITULATION TO OPULENCE-DRIVEN GLAMOUR-MODELS?

The English word "glamour" has its roots in the Scottish term *grammar* in the sense of *gramarye,* or magic. As this text will be also published in German, I do not wish to dwell on English semantics, although I believe a connection between glamour and magic is also reflected in the German term *Zaubern.* Let's just say notions of glamour still commonly revolve around bewitching charm,

illusion, mysterious and elusive fascination or allure… and, as with everything magical, glamour is also tied closely to trickery, deceit and misrepresentation. Every society has its keepers of glamour and casters of spells – those who set themselves apart from (and often above) others through largely hollow secrets. In the ancient West, these were originally the pagan and non-Christian practitioners of "the craft" – communal leaders, advisors and healers. Over the centuries they were replaced by Christian magicians, priests, and other minions of the mightiest and still most flamboyant Christian magician, the Pope. Similarly, *gramarye* and divination also played an important role in sustaining the Western ruling class. Like the Vatican, Europe's ruling elite used opulence as an ideological weapon to befuddle the lower classes with glimpses of heaven on earth – a lifestyle so foreign and unattainable that it could only be the result of divination. It was this spell of opulence that led to our current definition of glamour, which is more associated with wealth than magic. This change of definition from the allegorical to the material coincided with changes in how *gramarye* was employed and for what ends. It marked the Western battle for "civilisation", the violence of which we laugh about every April Fool's Day while playing tricks upon one another. Few people realise that April 1 is the traditional pagan new year, one of the most sacred days in the ancient pagan calendar. The term "April Fool" refers to those who believe in that day, the pagans themselves. And the act of pulling pranks on that day stems from the Christian tradition of harassing pagans and disrupting their celebrations.

Let me be clear that, unlike many of my Queer sisters and brothers, I have no romantic affinity with pagans, or Christians, or any other employers of naturalisms and spiritualisms. To me they are all equally tedious, equally dangerous. However, there is no question that the historical persecution of pagans is clearly linked to the persecution of "sodomites" and other "sexual deviants" we would today call Lesbian and Gay, many of whom were tortured and murdered as witches and warlocks. Again, going back to English semantics, it is testimony to the frequency of public burnings of "sexual deviants" that the British-English term for a small twig or kindling, "faggot", has transformed into a derogatory reference to Lesbians and Gays. In this sense, the history of glamour, or *gramarye,* is both a history of oppression as well as resistance – in addition to the opulence-based glamour of today, there was a type of glamour that, at least for a period in time, was considered a threat to monotheism, classism, and the emerging social systems leading to contemporary post-industrial capitalism. Therefore, when

considering the historical and social functions of glamour we are not merely confined to an opposition between the glamorous and the unglamorous, but are confronted with longstanding oppositions between forms of *gramarye* themselves. Within a single society we find multiple shared and conflicting histories. Queer communities reflect this diversity and history as well, from campy glam queens to healer-performers *à la* A. A. Bronson. As a transgendered person myself, when thinking about the relationship between glamour and transgendered communities certain questions begin to arise: is glamour particularly related to gender expression? Is transgendered "glam" a critique or mere capitulation to the social biases of opulence-driven *haute couture* glamour? Given that the majority of both Male to Female (MTF) transgendered people *and* women are not able to achieve an image of glamour, and that feminist visual theories have successfully clarified many social processes behind representations of the female body, can these theories also elucidate representations of transgendered bodies?

–

Is glamour particularly related to gender expression?

–

Ask anyone to name someone they consider glamorous and the chances are they will name a woman – perhaps an actress, singer, performer, or royalty. It seems fair to say that contemporary glamour is more associated with feminine imagery than masculine imagery, and is in that way a feminine construct… and a feminist issue. Many mainstream feminist critiques of unrealistic beauty standards for women have targeted notions of glamour, and in particular the media's use of glamour to objectify the female body. Similarly, much feminist art has taken to particularly anti-glamorous imagery intended to neutralise glamour and present the female body in an unspectacularly flat manner (such as Yve Lomax and Mary Yates), or to counter glamour's spells of allure with elaborate counter-images of grotesque deformity (as in the early 1990s photographs by Cindy Sherman). Meanwhile, those few men we do associate with glamour are also largely associated with feminine imagery, from dandies to glam rockers. When we think of glamorous men we think of fashion designers, hair stylists, actors, musicians, artists, and men of any other profession suspect of overpopulation by flaming queens. Yes, dears, I think it is safe to say that contemporary opulence-driven glamour tilts toward the feminine – a point which becomes important when considering glamour's relation to the body, and attempting to critique or exploit that relation.

It is easy to see that within transgendered communities, the notion of glamour is almost exclusively associated with MTFs and feminine imagery. The connection between MTFs and glamour partly stems from old traditions that barred women from the public stage and required all female parts to be played by men. The flamboyancy of the stage has historically offered MTFs a culturally acceptable point of cultural visibility, even if such acceptance was limited to the stage. On the other hand, the history of Female to Male (FTM) culture is rarely glamorous. FTM culture has largely been about women "passing" as men, for example in the workplace or on the battlefield. Whereas much of MTF culture developed in relation to notions of spectacle and female parody, FTM culture developed in relation to anti-spectacle and male assimilation. Issues of passability among FTMs also differ from MTFs in that they are closely tied to the struggle for women's labour and property rights. The props required for FTMs to enter a men's working class (typically stepping up to an economically low, manual working class) are quite different from those employed by MTFs, many of whom already inhabit that men's working class by day. Therefore, as a material strategy for transforming the body, glamour has little practical application within FTM communities. Additionally, FTMs are usually trying to disassociate themselves from feminine trappings, such as glamorous gowns, accessories, jewellery, or cosmetics. Even when FTMs do take on signs of opulence, as in Japan's *onabe* lesbian host culture where FTMs dress in sleek men's suits while pouring drinks for their feminine-dressed women guests, the magic of their spell is in the *realness* of their presentation as a "normal" man. This is quite a different illusion than that offered by glamour, which employs the image of something unreal or unobtainable. Therefore, in discussions of glamour the absence of FTM content is more complex than MTF show-queens stealing centre stage (an important acknowledgement since the dominance of MTF issues in most transgendered discussions does carry a degree of "male" domination and misogyny within transgendered communities). The spot-light on MTFs may look warm and bright from the audience perspective, but from the stage it burns, scrutinises, and most of all blinds.

–

Is camp "glam" a critique or mere capitulation to the social biases of opulent-driven haute couture glamour?

–

Today, the keepers of glamour within Lesbian and Gay communities are the queens. The divas. The drag queens and MTF transsexuals.

Within these communities, I have always felt alienated by the common tendency to frame their own sense of *gramayre* as a cheap regurgitation of the "truly glamorous" – celebrities and models whose allure emerges from a spell of opulence. It is easy to see that some magicians' *gramarye* is more powerful than others' because of the social systems from which they draw their representational power. In this sense, when it comes to glamour, transgendered communities are second rate. Most people would agree that actress Elizabeth Taylor lives a truly glamorous life, whereas transgendered singer and celebrity RuPaul invokes a different type of glamour. (Perhaps we might plot the source of Cher's powers as residing somewhere between the two.) [Fig. 1] While RuPaul operates in celebrity circles, her open transgenderism and homosexuality disclose something invasive and fraudulent about her glamour. Despite RuPaul's "realness", the image of glamour she projects is never as "real" as Liz' – RuPaul's pop presence creates doubts and tensions which perhaps hint at a past threat – a historical conflict between *gramaryes* through which the transgendered body has become both "outsider" and "loser". In that sense, the pop-glam diva reveals a moment of destabilisation, a social infiltration that discloses a brief challenge to power, and in that flash of a challenge perhaps there is the potential for resistance… That seems to be what we are continually told, in any case.

We are told that the fact that any drag queen has reached pop celebrity status (aside from heterosexual male comedians in women's clothes) is automatically a challenge to dominant culture, and therefore a fabulous cause for celebration. It's a point of Lesbian and Gay Pride TM. It's a sign of public acceptance toward transgendered and Queer issues. It's proof that "we made it" (a declaration of arrival which has always struck me as being in conflict with that other omnipresent Lesbian and Gay slogan, "we are everywhere"). But is this for real? As long as an MTF's public acceptance is gauged by her ability to emulate glamorous body and style requirements that elude most "real women", then I'll have to ask you to pardon this transgendered writer for not feeling "represented"by RuPaul any more than my mother feels "represented" by Marilyn Monroe or Princess Di.

Glamour is suspect as a critical-minded political forum because it is about social distance, not social integration. The promise of the pop-glam diva is not the promise of social transformation, but individual transformation in which the exploited becomes the exploiter. It is a promise of an individual's class mobility, not social betterment or class critique. It is, by and large, the American Dream. A dream whose

spell is not limited to the odd life-ambitions of, say, a transgendered
Dolly Parton impersonator, but which extends to the even stranger
dreams of all those who constitute the market of her employment – the
people who pay to see her. [Fig. 2]

It is important to emphasise that glamour is a *spell* of opulence –
a representational device utilising illusion – and does not mean that
the magician wielding it actually lives the opulent life they project.
Particularly in this Post-Modern age marked by replication and duplica-
tion, the commercial availability of glamorous commodities at bargain
prices points toward the illusory nature of glamour. Glamour is a
signifier of class, but it is not necessarily reflected in class. Case in point:
perhaps the largest glamour-lifestyle industry in the West is sex
work – an overwhelmingly lower-class lifestyle for its participants.
Sex workers, strippers and other "adult entertainers" employ glamour –
via clothing, cosmetics, plastic surgery, glittering lights, and music –
to dupe "tricks" into momentarily participating in a glamorous lifestyle.
Through this social transaction, the sex workers themselves are trans-
formed into glamorous commodities at bargain prices. And, in this
instance, one of the greatest illusions of all is the topsy-turvy way in
which an overwhelmingly exploited sex-working class becomes the
symbolic exploiter with the magical power to entice and corrupt "good
men". Of course, in the end the sex worker's criminal *gramayre* is
powerless against the brunt of societal judgment, and it is overwhelm-
ingly the sex workers who are legally penalised more than the tricks.
In sex work, the effects of glamour are in a state of flux – its illusion
simultaneously empowers and betrays the magician wielding it. From
my experiences as a DJ in a New York transsexual sex-worker club,
it became apparent that even independent girls with no pimps to pay
were still only "leasing" their glamorous bodies, which were constantly
generating debt through medical expenses such as cosmetics, hor-
mone treatments, surgeries, drugs, and other maintenance routines re-
quired to keep up the smoke and mirrors (…and coke and mirrors).
So, while I am an advocate of legalised sex work, the dominant systems
of representation that it employs involving glamour (particularly in
the West) strike me as unrealistic means through which sex workers
can find psychological or material self-actualisation. For many of those
who do lay claim to self-empowerment through sex work, glamour be-
comes the opiate through which they attempt to balance the emotional
and physical hardships.

One alternative to this rather bleak and capitulatory approach
to glamour is camp. Consider the 120 kg comic queen who orders the

world not to take her seriously (although in my experience it is the 120 kg campy drag queens who tend to be the most professional and serious performers). One might argue that she uses satire to twist conventional images of the female body. However, even within this world of camp we find few signs pointing to a world outside of opulence-driven glamour. The camp queen is as driven by commodity fetishism as the "real" glam queen, if not more so (for example, Leigh Bowery). Her model of body representation still focuses on packaging.

And then there is the homespun tragic mess, her bargain sequins failing to conjure up anything but the absence of glamour. She is a *glamour implosion,* wherein the signs of glamour collapse upon themselves. [Fig. 3] Yet again, rather than escaping the allures of glamour, the tragic mess simply states that she is the unglamorous, the unrich, the unprofessional, the unattractive.

Of course, this is the reality for most of us. A society's unrealistic beauty standards for women become even less realistic when attempted by other-than-women. Many transgendered people never leave their homes, only dressing secretly and alone, afraid of the physical and verbal harassment that could come equally from strangers, friends or loved ones. Others hide their transgenderism by joining "safe space" clubs where they can keep their drag clothes and change once they are safely inside. Additionally, despite the still prevalent myth of the upwardly mobile Gay male with no wife or kids to feed and plenty of cash to burn, the reality is that the majority of Lesbians and Gays still live below poverty level, with transgendered people at the bottom and FTMs having it worst of all. In reality transgenderism does not entail much glamour, or *gramarye* – just the workings of a shamed "secret society" filled with mysterious ceremonies in dark corners. When the majority of transgendered bodies remain unseen, even by each other, what does it really mean to discuss representations of a transgendered body? How do we even begin to identify such a body?

–

Given that the majority of both MTFs and women are not able to achieve an image of glamour, and that feminist visual theories have successfully clarified many social processes behind representations of the female body, can these theories also elucidate representations of transgendered bodies?

–

Much feminist visual theory focuses on the subject/object contradiction experienced by women, as outlined in the famous John Berger quote:

A woman must continually watch herself… From earliest childhood she has been taught
and persuaded to survey herself continually. And so she comes to consider the *surveyor* and
the *surveyed* within her as the two constituent yet always distinct elements of her identity
as a woman.
– John Berger, *Ways of Seeing,* UK: BBC, 1972, p. 46

Both MTF and FTM transgenderism also involve a tremendous amount
of self-surveillance, particularly as a result of the social pressure to
"pass" as either a man or woman. In this sense, transgendered identity
involves a similar multiple self-awareness as surveyor and surveyed.
However, a key difference emerges when we consider how the subject/
object formula relates to the physical body.

For women, the physical body remains reconciled with the ob-
ject aims of the act of surveillance. Whether a woman is judged
"womanly" or "unwomanly" the physical woman's body remains visible
and identifiable as the target of such qualitative judgments. However,
in the case of the transgendered body the physical body is not reconciled
with the object aims of the act of surveillance. For example, when a
MTF is judged "womanly" or "unwomanly" ("passable" or "unpassable",
"gorgeous" or "a mess") the target of such qualitative judgments is
not the transgendered body, but the woman's body. Similarly, a FTM's
"manliness" is judged in relation to the ability to invoke images of
a man's body. Both the "success" and "failure" of a transgendered per-
son's appearance point us toward expectations of a physical body
other than the one before us. As transgendered people, we come to sur-
vey ourselves in relation to a foreign body. In this way, the physical
transgendered body exists on a social plane that is both invisible and
unconsidered, by both the transgendered person and other observers.
Despite the many processes of surveillance involved in formulating a
transgendered identity, in most cases the physical transgendered
body itself remains completely *unsurveyed.* Whereas the majority of
identity politics have focused on a disenfranchised social group's strug-
gle for "visibility", within transgendered communities the struggle
for "visibility" seems to be nothing more than the struggle for an alter-
native "invisibility". I find this alternative invisibility inspiring because,
with the proper spin, it implies that the transgendered body has, in
effect, eluded dominant systems of representation and operates below
radar. There is potential freedom in that awareness – perhaps not a
transformational or redemptive freedom, but a freedom of the moment.
A spell to break all spells.

Oddly enough, the seeds of this revelation were planted in me
by a series of rather innocuous public service posters that have stuck in

my mind since childhood. It was an anti-smoking campaign issued by the American Cancer Society (ACS).[Fig.4] The posters were circulated through regional health departments and widely distributed to public schools, libraries, hospitals and civic offices. Unfortunately, the ACS did not keep records regarding the production of this campaign, so there is no specific information regarding the photographer, the people in the photos, or even the date of issue (which seems to be either the late 1960s or early 1970s – I recall still seeing the posters hanging as late as the mid-1980s). It is safe to assume that the ACS intended the posters to be read as a simple contrast between text and images – a contrast that is striking for the use of such bleak sarcasm in a public service campaign. However, upon deeper reflection the series comprises a rather odd triptych containing several overlapping and complex repre-sentational issues, from class to economics to gender – representa-tional issues that stumble in the grey area between dark humour and insensitivity. This tension seems to stem from a lack of clarity as to whether the images are active or passive in the representational games they play... the same question that arises when considering many trans-gendered bodies.

The most obvious representational issue engaged by these posters is class, which is affected by two distinct contexts. The first con-text is the advertising industry. The ACS images are clearly an anti-thetical response to the glamorous Hollywood style merchandising of tobacco products typical of the day. Attacking the field of advertising implies an active attempt to address representational issues. However, if that is the case, the posters fail through their inability to ask: "what is glamorous/debonair/sophisticated?" They do not refute or offer alter-natives to the types of images generated by the advertising industry, but simply show us images that the advertising industry would also agree are *not* glamorous/debonair/sophisticated. Dominant economic and class distinctions remain intact, if not reinforced. This problem is compounded by the second context, which is the social context of presentation. The posters were typically found hanging in depressed public service facilities frequented by lower income people. I dare say, in such a context the class irony of advertising games is lost.

Before continuing I should state that there are two key assump-tions I hold with regard to these posters, both of which may be in-correct (but which I will ask you to go along with for argument's sake). First, since childhood I assumed that the model for both the "Glam-orous" and "Debonair" posters is comedy actor Don Knotts (famous roles include Mr Limpet, Deputy Barney Fife from *The Andy Griffith*

Show, and the landlord Mr Roper from *Three's Company*), whereas the "Sophisticated" poster seems to feature either an unknown model or a documentary "stock" photograph. Second, by extension of the first, the "Glamorous" poster is targeted at women, but is actually a transgendered image. Unfortunately, despite several enquiries, the ACS was not able to conclusively confirm or deny any of this. However, in the absence of hard facts to the contrary, I will justify my assumption that the model in the "Glamorous" and "Debonair" posters is Knotts as follows: both images look like him, from the front and in profile; and having a celebrity do male/female takes seems the most plausible reason to introduce a transgendered image into what would other-wise be a documentary-style photography campaign (especially a public service campaign, which almost always employs a "lowest common denominator" model of audience accessibility). If it is Knotts, the "Glamorous" and "Debonair" photos are in that sense clearly "staged" rather than "documentary". Furthermore, the designs of the "Glam-orous" and "Debonair" posters share a similar text-block size, which hints that they were designed together, whereas the "Sophisticated" poster does not conform to the same design specifications and clearly features a different person in the photograph. The anonymity of the model for the "Sophisticated" photograph also makes it lean more toward documentary imagery. All of this sets the "Sophisticated" poster apart from the "Glamorous" and "Debonair" posters, and even suggests that it could have been a predecessor or follow-up to the other two. So, within this one series we are left with an unusual repre-sentational shift from celebrity to documentary photography, or documentary to celebrity. In either case, the approach toward issues of representation in the three posters is inconsistent – a glitch rarely observed within a single visual campaign. It is a mindless shift that discloses how we "unthink" the processes through which we survey and represent the body, enabling people to make the leap from "fiction" to "non-fiction" without notice or enquiry. This question of whether the images are "documentary" or "celebrity" seems to be at the core of whether the images are addressing issues of representation actively or passively.

The posters are further complicated when considering their re-presentation of gender divisions. Going back to the question of whether glamour is particularly related to gender expression, we here find glamour clearly associated with the feminine. However, what is unusual about this series of images is that the body selected to represent the feminine is not a woman, but a messy drag queen – no make-up, a moppy

wig perched on top of her head, hairline visible underneath. At first glance, the "Glamorous" poster seems to rely upon the same simple oppositions between text and image found in the "Debonair" and "Sophisticated" posters: based upon the text, what is immediately perceived as missing is an image of a glamorous woman. However (and this is where we get to the differences between subject/object contradictions for women and transgendered people mentioned earlier), in a literal sense, the actual opposite of an unglamorous drag queen should be a *glamorous drag queen,* and not a *glamorous woman.* Yet, it is safe to say that most people who see the poster only relate the image to notions of a glamorous woman, and fail to even consider this more literal transgendered opposition. It remains clear that the poster is about surveying women and appealing to women's own processes of self-surveillance, implying, "don't smoke or you will end up looking unglamorous like this". The "Debonair" and "Sophisticated" posters similarly appeal to the male viewer's sense of self-surveillance (a theme sadly omitted by much feminist and gender theory). However, unlike the "Glamorous" poster, the physical bodies of the male models remain reconciled with the object aims of the act of surveillance – the models are men, and the images operate in relation to notions of sophisticated and debonair men.

Through repeated exposure to these posters in doctors' waiting rooms and other places with nothing to do but stare and think, I gradually came to see that processes of representation around transgendered bodies are rooted in deflections away from material bodies, and are therefore more about representing social processes *around* the body than about representing a person's physical body itself. In fact, the historic rift between feminist and transgendered communities stems from this very difference, the standard feminist argument against transgendered communities being that most transgendered people dedicate their lives to emulating patronising and conservative notions of what it is to be a "woman" or "man", and in that sense are terminally politically regressive and undesirable. Of course, there is some credibility to this argument. The majority of transgendered people approach the relationship between their genders and gender identities in disappointingly essentialist terms, such as being "born in the wrong body", etc. The ensuing drive to "restore" their bodies is a drive for "normalisation" with dominant culture, and often leads to a fixation with the most "normal", simple and clear-cut model of their "opposite sex" – the image of which is almost always a regressive cliché.

While I don't care to defend such essentialist outlooks, I can sympathise with them. It is important to realise that from birth transgendered people are indoctrinated with the same dominant cultural ideologies as everyone else, and a transgendered assimilation of such regressive gender models relates to the transgendered person's placement *within* dominant culture. The desire among many essentialist transgendered people to transform (and in most cases transcend) their bodies often involves a good deal of psychological denial about their physical body – in fact, this denial is often culturally mandated in that most countries require transsexuals to submit to a clinical diagnosis of Gender Identity Disorder (GID) before allowing them to undergo surgical alterations. But regardless of the conformist tendencies and conventionality of such transgendered people's body goals, it is important to remember that processes of body transformation also involve a tremendous amount of courage, and risk of failure. To go from husband to housewife, or vice versa, may not sound very feminist to some, but the radical disavowal of "original gender" involved in such a physical and social transformation is an undeniably extreme abandonment of socially prescribed gender roles – even if it results in a retreat to a second socially prescribed gender role. It clearly reflects a commonality with feminism's struggle for "choice". Of course, another commonality between feminism and transgenderism is that both women and transgendered people are conditioned to feel tremendous shame about their bodies. In fact, for "passing" FTMs and MTFs who are too ashamed or afraid to reveal their transgenderism to their partners, the potential for accidental disclosure resulting in violent retribution means that secrecy around genitals during sex acts can even be a matter of life and death. Luckily most people only see what they want to see, and it is in these fragile contexts that the distractions of glamour – heavy make-up, big hair, glittering clothes and accessories – occasionally help "normalise" and camouflage MTF's as "real women". In such instances glamour offers a strange over-performance of gender signifiers – a tenuously woven layer of super-femininity which is so distracting that it successfully hides the transgendered body beneath (as long as there are no other queens around to contextualise the glamour as queer).

It is through the elaboration of specific social contexts such as these that gender discourse and discussions about representing the body may eventually overcome the age-old feminist dilemma of how to get people to understand that gender issues are not limited to "women's issues", but affect society as a whole. One major problem, of course,

is that in the end the overwhelming majority of women approach their "gender issues" in the same essentialist terms as men – they do not question the notion of a definitive female/male binarism which excludes transgendered people, but simply the social codes *around* that binarism which relate to women and men. Transsexuals, intersexed people and other genders are considered mere statistical anomalies, the rarity of which reinforces the biological "normalcy" of defining oneself as a woman or man. All of this goes against the fact that transgenderism presents numerous real, physical conditions which materially disprove the female/male binarism. A second problem is that transgendered communities construct their own essentialisms. Glamour itself becomes a double-sided "meta-essentialism" that simultaneously facilitates one MTF's assimilation and acceptance as a "show queen" within queer transgendered communities, while facilitating another MTF's "normalisation" as a "heterosexual woman" in a non-queer environment. All of these competing essentialisms lead to a lack of cross-communal alliances (not to mention inter-communal alliances).

One way to deconstruct these essentialisms is to pull the plug on the contexts which give them power, cross-wire them into other contexts, and watch how the circuits overload … not to discredit the views of one group or another, but to identify the practical limitations of critical-minded communication and bonding techniques. These limitations may then point to new directions for cross-communal communication. Consider the "vaginal iconology" movement of the 1970s, in which women artists attempted to re-introduce female genitals into art. The effect was not only to challenge the phallocentricity of Western art, but to educate women about their own bodies. For example, erotic artist Betty Dodson's presentation at the 1973 N.O.W. Sexuality Conference in New York proposed a contemporary aesthetic framework for the female genitals. In her presentation she showed slides of her own work, medical and anatomical diagrams of female genitals (many incorrect), and photographs of the genitalia of women who participated in her body workshops (labelled "Classical", "Baroque", etc.). As the story goes, the result was a standing ovation from a thousand women, many of whom had never seen their own vaginas, let alone anybody else's. By making the diversity of women's genitals visible, Dodson effectively dispelled myths about the homogeneity of the female body, and thereby challenged the homogeneity of the feminine gender construct. She did so by tracing backward from her own self-image (her own art), to expectations around women's bodies (clinical imagery), to images of various women's bodies themselves (candid

photographs). Personally, I consider this movement very effective and inspiring (although also a bit flakey and trapped in issues of "mothering" hmm… the same could apply to drag queens…).

But what if we try to adapt the "vaginal iconology" method of deconstructing representations of women's bodies to a "transgendered genital iconology" applicable to transgendered bodies? Can one trace backward from expectations around women's and men's bodies to images of various transgendered bodies, finally granting visibility to the seemingly terminally invisible? Or would we find that the transgendered bodies themselves simply point us back toward idealisations of women and men, as in the self-portraits of the highly passable FTM bodybuilder and photographer Loren Cameron? Given the complex relationship between transgenderism and medicine, what differences in reception can we anticipate between Dodson's employment of medical diagrams of vaginas, versus medical diagrams and photographs of surgically altered transgendered genitals (which involves a higher degree of medical mutilation and patient trauma)? How would such images be seen within the transgendered community itself, which includes non-operative drag queens and kings with no intention of altering their genitals, transsexuals who consent to undergo hormonal and surgical alteration, and inter-sex people born with multiple or ambiguous genitals who were subjected to the surgeon's knife without consent? The mere fact that within the transgendered community surgical alteration is typically the ambition of transsexuals and the abhorrence of inter-sexuals leads us to a convoluted sense of "body" that eludes tracing back to a point of common origin. What is a "natural" transgendered genital? Is it pre-operative? If so, in the case of non-inter-sex people, how would it differ from a man's or woman's genital? Unlike "vaginal iconology", which relies on a naturalist undercurrent that there is a "woman's body" to be represented and celebrated in diversities that unite sisters together, a "transgendered genital iconology" seems to lead us away from naturalism, away from sisterhood, and into diversities that culturally divide.

For myself, the power of transgenderism – if any – rests in this vagueness and divisiveness. It is not a power of distinction or difference from other genders, but rather the power of seeing representational systems of distinction or difference between genders collapse. It is not a power of transformation, but rather the power of transition. It is not a "third gender" offering unity, or a middling of genders. It is, by all means, a threat to the myth of social unity. Within the transgendered community, it is the potential to de-essentialise acts of transitioning

in relation to social process. It is hard reality like a fist in the face (as many of us unfortunately know). The more you attempt to define it, the more it eludes and betrays you.

Of course, glamour is also about illusion (elusion) and betrayal, but for quite different ends. Glamour is the employment of illusion to reinforce a preconception. Glamour feeds on existing desires, and belays the agonies of the status quo. Transgendered glamour seems to represent the ultimate internalisation of such systems by an underclass. Within MTF communities, glamour is reified, consumed and digested without thought. McGlam – that homogenised drive-through drag culture – is found in every Western city (and these days, many Eastern ones too). Like fast food, it's easy to find, even fun in moderation, but definitely not meant for daily consumption. Sisters are getting crazy fat from being fed all this glamour shit… can't we cook up something better in our kitchens? Anybody want to trade recipes?

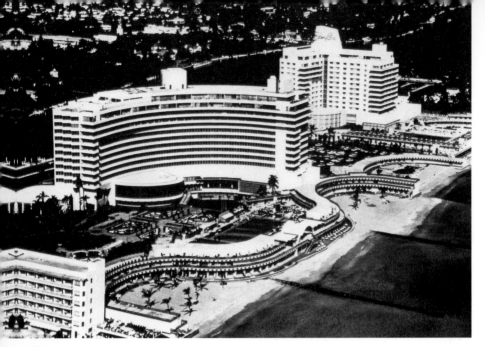

Fig. 1

Fig. 1
–
Morris Lapidus
The Fontainebleau Hotel (1954),
behind it, the Eden Roc (1955),
Miami Beach
(Photograph: Courtesy of the
archive of Morris Lapidus)

Fig. 2
–
Constantin Brancusi
L'Oiseau dans l'espace
(a.k.a.: *L'Oiseau vol*)
1927, b/w photograph

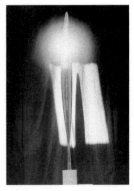

Fig. 2

Tom Holert

—

SILVER CUBE

Transfusion

—

A magnificent photograph by Eve Arnold from 1956 portrays the encounter of two stars from separate worlds on the common ground of New York's Guggenheim Museum. The beautiful Italian film actress Silvana Mangano, at an early peak in her fame, stands before a work by the sculptor Constantin Brancusi, staring with concentration at the gleaming, polished neck of *Mlle Pogany* (1913). The bust rests on a marble plinth and the actress, whose silhouette corresponds with

Brancusi's *Endless Column* (1918) in the background, appears to be involved in a wordless dialogue with the art object. A possible subject for such an exchange could be: what does it actually mean to be a model for a photographer? For it is not only Mangano, the film actress who is staged here before the camera, but also Brancusi's "haute sculpture".[1] Brancusi's sculpture provided a setting for fashion displays as early as 1912, when Paul Pourier decorated his Paris salon with a polished Brancusi bronze and it was used for lavish stagings by the artist himself and other photographers.

Edward Steichen for instance, who constantly moved between artistic and commercial photography, had begun to photograph Brancusi and his sculptures early on. Following his pictorialist period Steichen, in the 1920s and 1930s, did not just photograph models and celebrities from high and popular culture; he also moved onto other subjects, objects and plants, or even Brancusi sculptures, which he began to photograph in the spectacularised modus of the glamour shot.

In this way Steichen (circa 1925) staged an unearthly epiphany of a polished bronze version of Brancusi's *Bird in Space*. The sculpture stretches in a niche of light and shadow toward the light source above – which is either a skylight or a spotlight. The chiaroscuro modelling renders a mystically mysterious, slim sculptural plasticity recalling images of the *femme fatale* or an uncanny villain from films of the period. At the same time the eccentric composition radiates an elegant and opulent composure, foreshadowing the glamour photography Steichen was to produce of stars such as Marlene Dietrich in the coming years.

Brancusi took photographic stagings of his work very seriously, and he not only calculated certain plastic effects with photographic reproduction in mind, he actually composed photographs himself. In Steichen, he found an eclectic all rounder with no qualms about working in the commercial sphere. Both were quite happy to consciously transgress the borders of modern art and the culture industry to blend purism of form with the gloss of the grand entrance. Thirty years later the Magnum photographer Eve Arnold may have been well aware of this connection. At any rate, the manner in which she brought together Mangano and Brancusi in the picture intimates how the two (and the institutional fields they "represent") interact. Like the

[1]
See Reinhold Hohl, "Die 'Haute Sculpture'" (1986), in: *Skulptur. Von der Renaissance bis zur Gegenwart. 15. bis 20. Jahrhundert*, Cologne: Taschen 1999, p. 435.

Jackson Pollock paintings Cecil Beaton photographed with female models a few years earlier for a fashion story about "The New Soft Look" for the US edition of *Vogue*, from March 1, 1951, the work finds itself in the change-inducing area of mass media glamour production, bound into an oddly conspiratorial "conglamouration". Beaton's Pollock photographs are a classic example of the unresolved relationship between artistic and glamorous practice, for a "transfusion" of which the film critic Frieda Grafe has spoken regarding glamour (see below). In retrospect the Pollocks and the *Vogue* models appear to fit far more naturally in with a common image of a period when glamour is being cut adrift from its origins. Even though the tension between art and glamour retains its terseness, it is today, in the wake of the last peak of debate in the 1990s regarding art's relation to fashion,[2] far easier to gain an insight into this reciprocal vampirism, this peculiar partnership in the economy of attention. Nonetheless the relationship remains problematic.

—

No simple relationship

—

"El arte contra el glamour" ("Art versus Glamour"), reads the title of an article in the Spanish cultural magazine *El Cultural*. The accompanying text presaged exhibitions by up-and-coming curators who concerned themselves with Street art and the symbiosis of art and science. "In this time of exhibitions à la mode, of glamorous galerists, of grand openings and curators who have transformed themselves into elegant machines of art commission, it is a relief", sighs the author, "to see young exhibition organisers searching for a truth about art, rather than observing art merely as a medium".[3]

 In this construction of glamour as the Other of art, the fear of a dangerously seductive magic phenomenon makes itself felt, one of the very properties concealed in the actual etymology of the word "Glamour".[4] Where glamour enters into an alliance with art, it stands symbolically for the decline into obsequious commercialism and political opportunism. Glamour becomes a symptom of the collapse of and dissolving into a visual culture determined by economic principles. Art as such can be utilised for advertising and consumerism when a product requires "a connotation of prestige, tradition and authenticity".[5]

2
—
See for instance Jack Bankowsky, "Editor's Letter: The Art/Fashion Thing", and Bruce Hainley, "All the Rage The Art/Fashion Thing", in: *Artforum*, vol. 34, no. 7, March 1996, p. 2, and pp. 70–78.

3
—
"En estos tiempos de exposiciones *fashion*, galeristas glamourosos, *curators* convertidos en elegantes máquinas de comisariat y *vernisages* de buen tono (…)" José Marín-Medina, "El arte contra el glamour", in: *El Cultural*, 22 July 2004, p. 29.

4
—
Webster's Dictionary, 1913: "\Gla'mour\, n. (Scot. Glamour, glamer; cf. Icel. Gl['a]meggdr one who is troubled with the glaucoma [?]; or Icel. Gl[=a]m-s?ni weakness of sight, glamour; gl[=a]mr name of the moon, also of a ghost […] Perh., however, a corruption of E. Gramarye.) 1. A charm affecting the eye, making objects appear different from what they are; 2. Witchcraft; magic; a spell; 3. A kind of haze in the air (…); 4. Any artificial interest in, or association with, an object, through which it appears delusively magnified or glorified (…); a famous definition originated from Sir Walter Scott: 'Glamour, in the legends of superstition, means the magic power of imposing on the eyesight of the spectators, so that the appearance of the object shall be totally different from the reality' (in an annotation for Scott's poem *The Lay of the Last Minstrel* from 1802)."

5
—
Marita Sturken/Lisa Cartwright, *Practices of Looking. An Introduction to Visual Culture*, Oxford: Oxford University Press 2001, p. 213.

An exhibition such as *The Future Has a Silver Lining,* dedicated as it is to the relationship between art and glamour, thus deals with an open secret and moves about in extensive territory that is largely unmapped. For between the institution of art and the aesthetic categories of the glamorous exist relations historic and geographic, between form and content, which are absolutely different from each other.

Glamour can be both a function and effect of the art system. It might describe a quality of a particular art work, but also be the object of an artistic practice and within this practice be aesthetically worked upon. In relation to art from, at the latest, the 1980s, the time when media-savvy artists like Jeff Koons or Damien Hirst began to enter the art world, significantly more is articulated in terms of the "glamour factor" or "glamorisation potential". Such terminologies make of glamour a property with which one actively endows or encompasses, for instance, the concept of "art". Contrary to this understanding of glamour as a detachable accessory is the mute expression on a person's face who has just experienced a personality or an event, in which the glamour is not a visual extra. Instead the gloss, shimmering, or spell (three meanings of the word "glamour"), appear to be inherent even where the make-up is really thick.

This last inherent glamour, which should not be confused with an ominous glamour-from-within but with that which some would call authentic, is far more difficult to produce or control than the rented glamour, with which event managers and other alleged glamour professionals trouble themselves. One of the most interesting contradictions of glamour is contained in the fact that it is on the one hand the synonym for radical artificiality and fabrication, but on the other hand it has long since been impossible to reliably programme – especially when the expectations of a grand entrance have been increased by previous experiences of inherent glamour. Today few would argue against the existence of an art/glamour nexus, even though this relationship is not free from conflict. The art world boldly takes it for granted that it creates "glamorous" situations of the above-mentioned kind, and it is not a rare occasion to witness art serving as the scenery or in fact the "medium" for other, somewhat more political and economic interests. Lavish social stagings in museums and galleries, at trade fairs and

auctions are the order of the day even in times of economic crisis. With the opening of new museum buildings, the staging of a biennale, or a blockbuster exhibition, municipal authorities and sponsors attempt to exploit culture economics to the full. Institutions of high culture make their infrastructures available for fashion, pop music, or film, while the mass media, for their part, are increasingly aware of how they should value the art experience. Today, in magazines or on TV, decades after Pablo Picasso, Salvador Dalí, Jackson Pollock, Yves Klein, Niki de Saint-Phalle or Andy Warhol made their occasional entrance into the jet-set, star artists but also star curators, art commissioners and other protagonists of the artistic field are reported on, and in a way also taken for granted, as part of the celebrity line-up. Glamour has become second nature to art.

–

Motivations

–

However, although the above characterisation appears at first glance to state the case effectively it is, in fact, all too brief. In both cases it concerns entities (of a very different type) that do not cease to change themselves. And in changing they also alter their relationships. This dynamic should not be buried beneath the construction of a linear narrative referring to some origins of glamour or art and their relations. Far more interesting would be to reconstruct the genealogies, the strands of the term glamorous and the various glamour-practices within the cultural texture of the twentieth century without numbing the inner tension or laying the many conflicts to rest.

Yet what motivates such interest and procedures? The deciding factors with which one must be concerned, the pasts and presents, origins and perspectives of the glamorous are to be sought in individual, intimate or (semi-)public experiences of glamour. Many can tell of such experiences: being present in splendid social and spatial surroundings; witnessing an unexpected and risky gesture of resistance against official consensus; encountering "glamorous" personalities either in their immediate presence or on the stage and screen. Events which, for their graceful casualness or breathtaking rarity, remain in the memory: moments in which suddenly everything is right and one no longer needs to question why.

Glamour could function as an ideal of personality, self-assurance and communality to which one is oriented and about which one feels euphoric. Often glamour may not even be located at the centre of attention but instead serves as a kind of supplement. In these cases the glamorous shows itself in retrospect as a feature of distinction by which normality is inscribed with a wonderful deviance, as the "slight slippage" of which Giorgio Agamben speaks in the context of messianism and the "coming community".

Here the decisive changes do not lie in the things themselves but at their edges where it is "shimmering" as a potency similar to the aureole of an elected saint, which radiates a little more but does not signify a substantial difference compared to other aureoles, it merely grants the state of bliss an extra "shimmer" (clarior). [6]

Alongside such minute differences, which empower and provide happiness, and which one can interpret as proof of love, as evidence of a special love and care, deeply distressing experiences are also associated with glamour. Glamour operates continually as a cool-seductive norm under which one is subjugated by a phantom yet intense state of anxiety. As well as the promise of happiness and the blissful dimension of the glamorous, there exists a fatal fascination in which the glamorous proves to be a discipline, a pressure, an ordering power affecting the struggle between art and glamour. A possibility with which to frame this contestation could now lie in stretching the art/glamour relationship on the cobbler's last through amply discussed polarities such as "avant-garde and kitsch" or "high and low". This way one would be tempted to follow the dichotomy of "art versus glamour" all too readily as the ideal solution to a notion of art liberated from the excessive and heteronomous demands of the glamorous.

Thinking of glamour as endangering the integrity of art, however, provides a stimulus of its own. Through this, the category so bound to the surface, which Clement Greenberg, the nestor of modernism, once described as "inhuman", could become one of the central challenges and oppositions of modernism. What if glamour, as the aesthetic adaptation of the principle of "social construction", confronts the autonomy and self-referentiality of the artwork not only with the vulgarity of a display of bodily beauty, social superiority and economic wealth,

6
–
Giorgio Agamben, *Die kommende Gemeinschaft* (2001), translated from the Italian by Andreas Heipko, Berlin: Merve 2003, p. 53.

but at another level puts into question the self-indulged dichotomy of semblance and being? And additionally, begins irritating other problems of the construction and deconstruction of identity.

—

Glamour and semblance

—

In a renowned section of his *Ästhetische Theorie* Theodor W. Adorno discussed the problem of "semblance". Instead of rejecting the aesthetic semblance as mere illusion and mediation, Adorno emphasises the dialectics of modernist art as the attempt to shake off the "character of semblance" like "animals a grown antler".[7] The suspicion of the semblance-loaded artwork refers back to ideas of a literal, substantial, pure art and ignores the immanent character of semblance, the constitutive "phantasmagorical side of artworks" in modernism, which in the age of technological amplification is "the illusion of the being-in-itself of the work".[8] Semblance, for Adorno, is integral to art. His dialectics operate in the dissonance between semblance and the rebellion against it. As they retain and rescue "semblance" they also rescue the work of art by liberating it from the pretensions associated with its own import. The dialectics of semblance reckon with an aesthetic moralism that tries to accuse semblance of stagings, arrangements and lies. And of course Adorno knows of what he speaks, he is after all the sharpest, but also the most understanding critic of the semblance of "autonomy" (of the work of art and the artistic sphere), which resists the "total" or "ubiquitous" semblance of the capitalist social order.[9]

From semblance which puts the abstract, not-being spirit "as the existent" in the artwork "before your eyes",[10] one must distinguish "gloss" ("Glanz"). Both have the same origin in the Old High German "skîn". But the philosophical meaning of "semblance" (especially as Hegel talks of it as the sensually shining idea in the artwork) should not be confused with the meaning of "gloss" which Adorno utilises for his cultural critique. Gloss indicates the commodity form. Glossy is the hall of mirrors in the department store. Glossy and glittery are those spectacular moments in a jazz or swing song which Adorno in 1941 called "musical glamor", those "innumerable passages in song arrangements which appear to communicate the 'now we present' attitude".[11] In fact, the culture itself makes an effort

[7]
—
Theodor W. Adorno, *Ästhetische Theorie*, edited by Gretel Adorno and Rolf Tiedemann, Frankfurt a. M.: Suhrkamp 1973, p. 157.

[8]
—
Ibid.

[9]
—
Ibid., p. 337.

[10]
—
Ibid., p. 165.

[11]
—
Theodor W. Adorno (with George Simpson), "On Popular Music", in: *Studies in Philosophy and Social Science*, vol. IX, 1941, pp. 17–48, here 28.

to acquire gloss. The truth about this "gloss of culture" is, for Adorno, made visible by those who refuse to surrender to the glamour norm who, in defence of the "archetypes of the vulgar", of the "grinning advertising beauties", "blacken the all-too-white teeth". [12]

At the moment he changes from semblance to gloss, Adorno also changes the gender register (which previously had not played any role in his discussion). The critique of the "vulgar", of the "sellable emotion", which is nothing other than "a subjective identification with the objectively reproduced humiliation", activates images of "grinning advertising beauties" and an excessive amount of "female gloss". However, this alleged "female gloss" is, under the premise of technologically amplified phantasmagoria, the domain of the glamour aesthetic which had been developed since the 1920s forming the grammar of the *glamour shot* – by photographers such as Alfred Cheney Johnston, Ruth Harriet Louise, Laszlo Willinger, Ted Allen, Clarence Sinclair Bull, George Hurrell, Otto Dyar and others in Hollywood. In an exchange with the illustrated fan magazines of the movie industry such as *Motion Picture, Movie Life, Movie Star Parade, Photoplay, Screenland or Screen Stars,* the studio photographers hired by MGM or Warner Bros programmed a specific, quasi-sculptural perception of stars as figures born of light and shadow. [15] Centred around the concept (and the code) of "glamour" they started with the "artificial building of 'personality'" which Walter Benjamin has described as the "shrinking of the aura", the means by which – unsuccessfully – the "magic of personality" was to be preserved. [14] In 1939 one of the first sociologists of film, Margaret Farrand Thorp, confirmed on the basis of her research into fan magazines, "that the most important thing for a glamorous star to have today is personality". Thorp adds: "The insistence on this in the midst of a standardised society is touching". [15]

–

Effects of de-familiarisation

–

In a famous photograph that Edward Steichen took of Marlene Dietrich in 1935, the staging of the quintessential representative of Hollywood glamour is organised as a contrast-rich display of black-and-white gradations. The gaze is drawn from the white upholstered chair-back to the black, both anatomically

12
–
See Adorno, *Ästhetische Theorie,* p. 356–7.

13
–
See David Fahey/Linda Rich, *Masters of Starlight. Photographers in Hollywood,* New York: Ballantine 1987, pp. 14–15.

14
–
Walter Benjamin, "Das Kunstwerk im Zeitalter seiner technischen Reproduzierbarkeit", in: Walter Benjamin, *Gesammelte Schriften,* I–2, Frankfurt am Main: Suhrkamp 1974, p. 492.

15
–
Margaret Farrand Thorp, *America at the Movies* (1939), with an introduction by J. P. Mayer, London: Faber and Faber 1946, p. 51.

compressed and seemingly stretched torso of the actress, up to the face, framed by arms and an enormous hat; half-opened eyes, slightly sleepy, hold the gaze as the viewer's belated realisation increases the magnetism of her stare. The fixing point of the composition, however, is the woven, slightly sequined hat, upon which a shimmering light reflects, and continues and concentrates the lascivious, superior expression of Dietrich. It is a sophisticated almost surrealist construction of glamour, which appears virtually de-naturalised or even monstrous. With regards to photography, it seems to correspond perfectly with the iconic-fetishist image of the "isolated, glamorous, displayed, sexualised" woman in the movies, described by Laura Mulvey in her classic essay "Visual Pleasure and Narrative Cinema". The film in which such an image appears is catapulted from the moment of "the sexual impact of the performing woman" into "a no man's land outside its own time and space". The illusion and the narrative would be disruptive in favour of "flatness" or the "quality of a cut-out or icon". [16] Mulvey, however, does not celebrate this moment of the destruction of the filmic time-space as a proto-feminist triumph. Instead she claims that the image of the glamorous woman in the picture triggers either a fetishistic male scopism or a sadistic humiliation – two reactions to cope with the castration anxiety caused by the woman's iconicity.

But just how passive is the image of the glamorous woman or the glamorous image of woman surrendered to the active male gaze, in fact? Do the medium, the technology and the discourse of the glamorous work favour, without exception, a heterosexist, patriarchal, sadistic voyeurism? However justified the feminist critique of the fetishist-sadistic gaze construction in Hollywood films may be, it appears that the glamorous is not sufficiently encompassed, either in its fascination structure or in its actual offers of agency. Mulvey outlines these potentials again when she speaks of the loss of the ego moment in cinema, of the suspension of perspectival illusional space through the presence of glamorously photographed stars. The deception of the glamorous staging overlays the basic deception of illusionism and narrative fiction. This also means: glamour moments can have the effect of de-realising, similar to the de-familiarisation effect, thus transcending the material reality of the apparatus.

16
–
Laura Mulvey, "Visual Pleasure and Narrative Cinema" (1975), in Laura Mulvey, *Visual and Other Pleasures*, Houndmills: MacMillan 1989, pp. 14–26, here 19–20.

Behind this transcending there is a specific conception of (authoritarian) authorship. Glamour is the product of a strong artistic will, a demiurgic force – at least as it appears from the perspective of some glamour producers. Edward Steichen's photograph makes no secret of the intrusion of the photographer and the power he possesses over his models. Josef von Sternberg, the director who "made" Marlene Dietrich ("Marlene, that's me"), talks frankly of the torture required for the calm poses he demanded from his star. But Sternberg also writes that glamour is an "elastic concept" a "visual stimulant" as if made of soap bubbles. It is not the "object before the lens", but rather the artist who manipulates the model and exhibits it in light who is responsible for the "glamour of photography".[17] Not without reason did von Sternberg locate his image of glamour power, of a one-sided and exercised manipulation, and his formulation of glamour as an "elastic concept", as "playfully flowing values" and elaborate arrangements, in a spiritual realm. The relationship of empowerment and disempowerment, of authorship and agency, of activity and passivity in glamour – considered as an "elastic concept" – does not always hand the culture critic the right to dub glamour merely "inhuman" or hold it responsible for deep sensations of envy and subjugation.

Without being a mere apologist for a dubious image of glamour authorship, the film critic Frieda Grafe came closer to von Sternberg in a surprising way. In a 1998 lecture on von Sternberg's *The Devil Is a Woman* (1935) she stated that the director had further developed the "photographic beauty concept" into "glamour", "his camera-produced beauty formula".[18] Although this appears to reduce everything to a technologically produced glow of women, for Grafe the attraction of this glamour is not unambiguous. She discovered something in von Sternberg:

… till then invisible, a kind of condensed aura, which evokes visual effects, which in their fusions are no longer to be described as gender specific and which must come from an externalised interiority. Via mechanical reproduction the unconscious steps into the realm of the visible and thereby achieves the status of consciousness. Assisted by Marlene, with her extremely professional bodily commitment Sternberg produced glamour, creating a new image of femininity which affected both masculine and feminine imagination.[19]

This new sexuality has little to do with diva admiration. In the eyes of her director Marlene Dietrich appears as female impersonator:

[17]
—
"The Von Sternberg Principles", in: *Esquire*, no. 250, vol. 40, October 1963 (translated as: Josef von Sternberg, "Glamor", in: *Filmkritik*, vol. 13, no. 2, February 1969, pp. 130–132.

[18]
—
Frieda Grafe, "Die Haut vom Kino. Zu *The Devil Is a Woman* von Josef von Sternberg" (1998), in: Frieda Grafe, *Filmfarben, Ausgewählte Schriften in Einzelbänden, 1*, Berlin: Brinkmann & Bose 2002, p. 103.

[19]
—
Ibid, p. 104.

"Sternberg always saw her in drag" (Grafe), that is why Dietrich's dresses, her men's suits and her gowns formed an important part of the artificiality of her appearance, but also became "circumstantial evidence of a deeply grounded crisis". "Glamour, in that of Sternberg's achieved uniqueness", writes Grafe, "is bisexual, an effect of opposing principles, for which all possible principles are offered – light/shadow, idea/form, inside/outside – whose transfusion, which occurs through the dynamics of the moving pictures, result in a glittering totality".[20]

The phrase "glittering totality" quite effectively – perhaps particularly in distinction from Adorno's "total semblance" – demonstrates how much that is still unresolved is contained in the concept of the glamorous, and how difficult it is to determine unambiguously the *functions of the glamorous* as well as the *glamorous-as-function*. The glamour transfusions set in motion a transformation of (sexual) identity, or perhaps even its dissolution. The construction of the flat, iconic, cut-out image of which Laura Mulvey speaks, can at the same time be a deconstruction, the opening up of a space of unforeseen subjectivities and communalities.

–

Alien glamour

–

Glamour has been and is, perhaps because of these very possibilities, time and again in the past and present, the reference point of sub-cultural, bohemian, dissident communities, in which those principles of construction are analysed and new effects can be experimented with. Glamour – in particular an historically evolved glamour – can always be a resource for acts of resistance. The American performance artist Jacki Apple in conversation with artist Mike Kelley on feminist art practice of the 1960s and 1970s looks back: "So the question was, could power exist within the same framework as beauty as defined by the culture at large – as glamour?" And the answer lay in a turning back to past models of a "coalition" of power and beauty, "so the place we had to go back to for that coalition, that merging, of power and beauty was basically to the films of the '40s – to the powerful, glamorous movie stars of the '40s".[21]

Searching not for models of power and beauty, but rather for subtexts of classical Hollywood glamour are the underground cinema and performances of Jack Smith. Since the late

20
–
Ibid, p. 106.

21
–
Quoted from Mike Kelley, "Cross-Gender/Cross-Genre" (1999/2000), in Mike Kelley, *Foul Perfection. Essays and Criticism,* edited by John C. Welchman, Cambridge, MA/London: The MIT Press 2003, pp. 102–120, here pp. 118–119 (footnote 41).

1950s Smith has oriented himself, amongst other things, to a "visual revelation", which he found that the old master of glamour fabrication, Josef von Sternberg had always preferred to "storytelling".[22] For Smith, von Sternberg's "visual fantasy world" was precisely not the model of technical perfection but rather of the imperfect, but therefore unique and personal expression of an idiosyncratic value system. Smith's "Montezland" or "Cinemaroc", is an ersatz or meta Hollywood. Not only a fantasy world, but rather a production context, a field of independent practice. Here Smith let his lay actors, his creatures, the immediate preecessors of the superstars of Warhol's Factory, erect tableaux of orgiastic transgression in films like *Flaming Creatures* (1962-63) or *Normal Love* (1963-64). What emerged was "an entirely new form of cine-glamour – one that owed everything and nothing to Hollywood's", as J. Hoberman writes.[23]

Thereby the handed down texts of glamour have been deconstructed – what was concealed in them was turned inside out and emphasised: "visual texture, androgynous sexual presence, exotic locations" (P. Adams Sitney);[24] the result was carnevalesque, but it was also a deeply and seriously intended travesty of glamour: *"Contact with something we are not, know not, think not, feel not, understand not"* and because of which presents itself as *"an expansion".*[25] To think of glamour in this sense, as a medium or method, to detach oneself from the discipline which glamour in fact is, makes of it an aesthetic category of a carnivalist state of exception. "Glamorous Rapture, schizophrenic delight, hopeless naïveté and glittering technological trash!"[26] confronts the aesthetic code, the "grammar" of the manufacture of figures of light and gloss effects, with the suspension of this system of rules and with the disfunctionalisation of the respective knowledge. In this way Jack Smith's admiration of "illegitimate" models like Josef von Sternberg or Maria Montez, paralleling the performances of the bearded cross dressers and hippy women in the San Francisco theatre group The Cockettes during the late 1960s early 1970s, or Charles Ludlam's Ridiculous Theatrical Company, may be considered a project of the redefinition of glamour as the expression of "alien" glamour.[27] Glamorous – at least in the USA – was (and still is) synonymous with undeclared homosexuality, with (European) decadence, with the feminine. Hence glamour, when it broke out of these designated lines, became threatening

22
–
Jack Smith, "Belated Appreciation of V.S." (1963), in: J. Hoberman/ Edward Leffingwell (eds.), *Wait for Me at the Bottom of the Pool. The Writings of Jack Smith*, New York/London: High Risk/ P.S.1 1997, pp. 41–43, here: 42. Ibid., p. 43.

23
–
J. Hoberman, *On Jack Smith's Flaming Creatures (and Other Secret-flix of Cinemaroc)*, New York: Granary/Hips Road 2001, p. 10.

24
–
P. Adams Sitney, *Visionary film: The Avant-Garde 1943–1978*, 2nd Edition, New York: Oxford University Press 1979, p. 353.

25
–
Jack Smith, "The Perfect filmic Appositeness of Maria Montez" (1962), in: Hoberman/Leffingwell (eds.), *Wait For Me at the Bottom of the Pool*, pp. 25–35, here: 34.

26
–
Ibid., p. 26.

27
–
For the connections between queer New York and West Coast underground contexts of the 1950s to the 1970s between Jack Smith, Andy Warhol, the Cockettes, Glamrock and Charles Ludlam, published at the occasion of the symposium/event *Re-Make/Re-model* at the Steirische Herbst in Graz 1999: Diedrich Diederichsen, Christine Frisinghelli, Christoph Gurk, Matthias Haase, Juliane Rebentisch, Martin Saar, Ruth Sonderegger (eds.), *Golden Years. Materialien und Positionen zu Subkultur und Avantgarde zwischen 1959 und 1974*, Graz: Edition Camera Austria (forthcoming).

to a patriarchal, heterosexist societal order. Traditionally the beauty industry directed the appeal of glamour to women; they form the major target group for fashion magazines and cosmetic adverts, for exhortations to dieting and cosmetic surgery intervention; they are manipulated up and down with short-term consumer wish-fulfilment and then denied any recently purchased leisure feeling as soon as a new product has to be bought. Women, as Daniel Harris formulates, are today, through the fashion and the cosmetics industry, objectified into "kinetic sculptures", while "sex appeal" has been substituted by a pure *aesthetic* vision of their selves.[28] One is entitled to agree with such tendentially misogynist observations, should one wish to. Nonetheless, however, this does significantly underestimate the carnevalesque dimension of glamour. For instance, the use of costumes in classical Hollywood has enabled women to parody social differences, reverse them and denaturalise them, as Sarah Berry, writing in a study of the fashion consumer system of the 1930s demonstrated.[29] This is similarly valid for other appropriations of the glamour repertory. From this point of view glamour is not just a technology of social control, but also an instrument of social change.

–

Semantic cycles

–

The astounding contradictoriness and mobility of the glamour concept is also grounded in the history of its wavering acceptance and cultural embedding. "Glamour is a subject that always sells. It is a difficult quality to describe. Ask ten people what glamour is and you'll receive ten different answers."[30] This mild paradox, which even today many people would agree with, was stated by the photographer Peter Gowland who, in the 1950s, produced female pin-ups and in 1957 published *How to Take Glamour Photos.* A handbook for nude photography bearing the idea "glamour" in its very title indicates how the meaning of glamour had shifted from its earlier manifestation – the overall expression of that very aura in which Norma Shearer, Gloria Swanson, Rudolph Valentino, Marlene Dietrich, Greta Garbo, Joan Crawford or Katherine Hepburn lingered as ultimate embodiments of that strangely ungraspable, indefinable quality of the glamorous.

28
–
Daniel Harris, *Cute, Quaint, Hungry and Romantic. The Aesthetics of Consumerism,* New York: Da Capo 2000, p. 230.

29

Sarah Berry, *Screen Style, Fashion and Femininity in 1930s Hollywood*, Minneapolis/London: University of Minnesota Press 2000, p. XXI.

30
–
Peter Gowland, *How to Take Glamour Photos*, Greenwich, CN: Fawcett 1957, p. 5.

That in the 1950s the notion could be taken out of the semantic context of the big Hollywood studios and their god-like Olympian stars and wander into the sleazy sphere of nude photography evidences a significant shift within the aesthetics of mass culture. Glamour had, as a British lexicographer ascertained in 1947, become a "vogue word". With the word one could be talking about a girl or a gigolo, at any rate the press had fallen upon a much more variously useable term: *"Glamour* has paratrooped its way over the stage gossip, film 'pars', and the rest of current journalism".[31] Glamour, one of the key categories with which the culture industry had attempted to describe itself and its products since the 1920s,[32] had obviously undergone a change in function and meaning. At least the notion did not just fit in seamlessly with the traditional semantic, it now covered a wider field of meaning, parallel and in reaction to changes in the media and consumer landscape of the war and post-war years.

Now, approaching the end of the era of the studio system, the beginning of TV, and in concert with an economically burgeoning American middle class, the era of the Gowlands and the photo-amateur and a new type of "natural" film star had arrived. For over two decades one had identified glamour with a perfect and refined staging of bodies and surfaces – a visual technology of photography and filmic images which had produced a radically artificial beauty. At that moment, Hollywood's image aesthetic was in crisis and the symptoms leading to its downfall were the big studios' cultural conception of stars, their Art Deco classicism and the baroque opulence of musicals. Rather than studio photographers like George Hurrell, Edward Steichen or Ruth Harriet Louise, *Life*-reporter and paparazzi of *Naked Hollywood* (the title of the epoch making 1953 book of photographs by Weegee) was taken on board. The pseudo aristocratic stagings of glamour had to give way to a new "more democratic" system of portrayal.[33] Glamour would now be offered at various prices, even at a discount. It entered into genre hierarchies in the cinema at B and C levels becoming more than ever before an advertising pitch for cosmetics and other mass products. In Miami the architect Morris Lapidus built hotels such as the Fontainebleau (1954) – an ensemble of indulgent curving stages for the self-presentation and consumer interests of a new middle class. The architecture was specifically conceived as a film set and attracted the generation that had survived and withstood

31
–
Eric Partridge, *Usage and Abusage: A Guide to Good English*, London: Hamish Hamilton 1947, p. 361 (quoted in Réka C.V. Buckley/Stephen Gundle, "Flash Trash. Gianni Versace and the Theory and Practice of Glamour", in: Stella Bruzzi/Pamela Church Gibson [eds.], *Fashion Cultures. Theories, Explorations and Analysis*, London/New York: Routledge 2000, pp. 331–332).

32
–
"What made Hollywood unique was its total concentration on one thing. That was the word 'glamour' – a word that Hollywood will always evoke." Diana Vreeland, *Romantic and Glamorous Hollywood Design*, New York: The Costume Institute/The Metropolitan Museum of Art 1974, unpaginated.

33
–
See Fahey/Rich, *Masters of Starlight*, pp. 22–24.

the Great Depression and World War II, offering the opportunity to stage themselves in a novel, close relationship to glamour. For glamour was no longer rooted in the exclusive sphere of remote stars but was instead becoming increasingly accessible to a new moneyed class.

In this time of crisis, glamour became the object and focus of the newly emergent phenomenon of camp. The devaluation of glamour launched a now morbid, now melancholy, now frenetic revaluation and recontextualisation of the glamorous. The drag scene began to develop its repertoire through an interpreted appropriation of the now apparently useless glamour archive of Hollywood. Glamour was suddenly available even for *counter-glamorous* movements.

Around the same time and with in part similar intentions to the camp underground, fine artists discovered glamour for themselves. British Pop Art examined glamour at the end of the 1950s – documented by Richard Hamilton's famous list of the ingredients of pop in 1957 [34] – as a constituent part of "pop art", as well as of the "art" of popular culture relevant to the attempt to come to terms with the popular culture surfacing in the fine arts. In the early 1960s Andy Warhol, influenced by Jack Smith, began his decades long construction of a parallel glamour dimension, in which the icons and production sites of the popular entertainment culture were investigated, imitated and deformed. In contrast to the struggle for demarcation from modernist art, Pop Art and postmodernism entered into a phase of continual interaction in the relations between fine art, fashion, film, pop music, adverts, design and identity politics, the dawning of which can witnessed in Surrealism in the work of Man Ray, Dalí or Meret Oppenheim.

–

Meta glamour, counter glamour

–

In autumn 1975 an edition of *FILE Megazine* appeared, which the Canadian art group General Idea had been producing since 1970. The cover bore the words "Glamour Issue", and the three members of General Idea, AA Bronson, Jorge Zontal, and Felix Partz, already well rehearsed in the masking, travestying and appropriation of the representation system of mass culture, promised their readers, "the story of Glamour and the part it has played in our art". [35] Glamour would be defined as a radically

34

–

Richard Hamilton, "Letter to Peter and Alison Smithson", in: *Collected Words 1953-1982*, London 1982, here quoted from: David Robbins (ed.), *The Independent Group: Postwar Britain and the Aesthetics of Plenty*, Cambridge, MA/London: The MIT Press, 1990, p. 182.

35

–

General Idea, *FILE Megazine: Glamour Issue*, vol. 3, no. 1, autumn 1975.

emptied artificiality, without properties and thoroughly immobi-
lising. Using the rhetoric of a lifestyle consultant and the pathos
of an avant-gardist artist's manifesto General Idea explained
that glamour had dissolved Marxism as "the single revolutionary
statement of the twentieth century". Like myth, glamour reduces
reality, makes it visible at a glance. The objectifying function
of glamour refers immediately to the rationality of the economic:
"Glamour acts economically. It erases the complexity of the
human image and human acts, leaving the simplicity of essences".

General Idea's radically anti-authenticism in their usage
of the notion of glamour has to be seen in the context of various
processes of artistic appropriation and political rededication
in queer culture. In previous decades this process permitted it-
self to develop an idea of counter glamour, continually forming
itself anew in the examination of versions of glamour as com-
modity aesthetics *tout court,* thereby producing a space of oppo-
sitional, often somewhat camouflaged aesthetic and economic
activity. Glamour producers in the field of art became, like Andy
Warhol, *art directors* and companies of higher and lower status.
In other words: if one understands, as did General Idea, the
glamour category as knitting aesthetics and economics so closely,
the aesthetic appropriations and rededications of glamour are
also interventions at the level of the economic.

Glamorous stagings can work oppositionally, they are,
with all alleged straightforwardness, also always to be read dia-
lectically. Their shimmering and shining could at the same time
sharpen and prevent the view on the social relationship. Usu-
ally the desire for glamour in thought and deed avoids political
categories. But as soon as its central role in the logic and aes-
thetic of capitalism is recognised and reflected upon, it gains po-
litical valence. Glamour is simultaneously the symbolic surface
of power and wealth like the eternally unfulfilled promise of –
at least symbolically – the redistribution of social prosperity.

All these opposing messages and effects are registered
in the art of the present and its predecessors in the twentieth
century. Occasionally the longing for (past) utopias of glamour
in a present in which glamour is an omnipresent call to self-
optimisation, has become the object and subject of artistic
practice. Then again glamour appears as an untrickable foil to
individual obsessions and dependencies. Between meta glam-
our and counter glamour, between the self-staging as star and

the critique of glamour as fixed subjectivity, there develops in the fine arts a dealing with glamour which, for a moment, a gesture, a glimpse, lifts it from the traffic of commodities and exchange value production. In the artistic production and documents brought together for *The Future Has a Silver Lining* such ephemeral strategies abound: in the gestures of homage (Manon, Francesco Vezzoli, T. J.Wilcox), the reflections of stardom's and glamour's architecture and design (Tom Burr, Nicole Wermers, Josephine Meckseper, Julian Göthe, Bernhard Martin), in the aesthetic analysis of expenditure and states of emergency (Cerith Wyn Evans, Katharina Sieverding, Janet Cardiff/George Bures Miller, Sylvie Fleury), with the archiving of memories of glamorous moments (Marc Camille Chaimowicz, John Edward Heys, Michel Auder, T. J.Wilcox), of serial self-transformation (Urs Lüthi, Carlos Pazos, Leigh Bowery, Brice Dellsperger), the critique of the dominant images of beauty (Sanja Iveković, Kutlug Ataman, Daniele Buetti). So the glance is permitted to wander over the blueprints of the glamorous, its composition, and the labour involved in its manufacturing. For a brief moment…

—

Translation James Rumball

Cerith Wyn Evans, *Untitled,* 2003

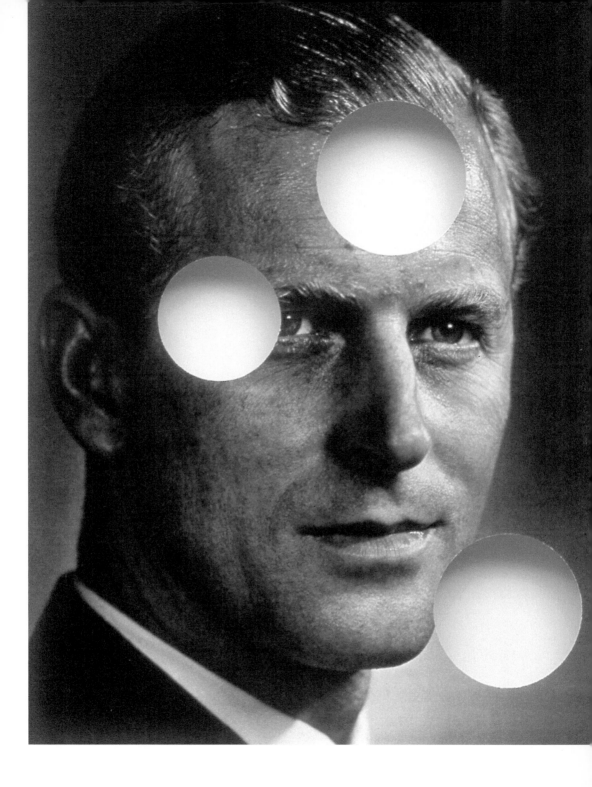

Vintage Film Still, *Linda Winters*, 1930s

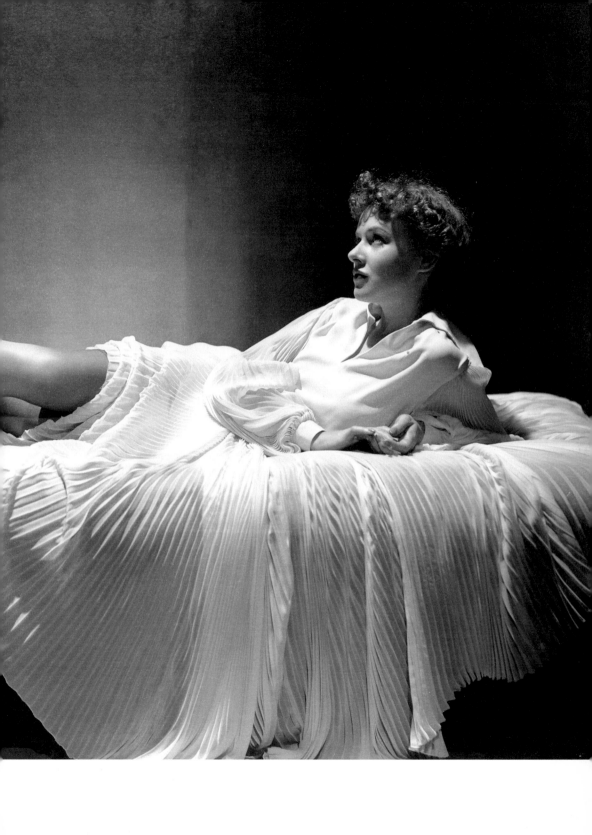

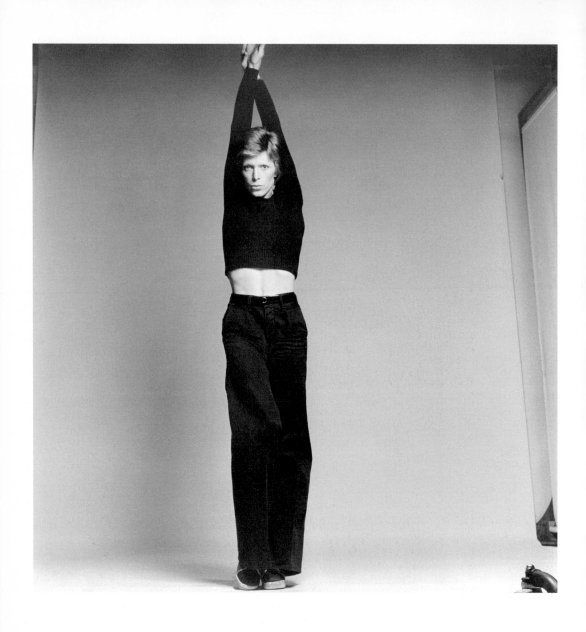

Francesco Scavullo, *David Bowie*, 1974, *Kirk*, 1974

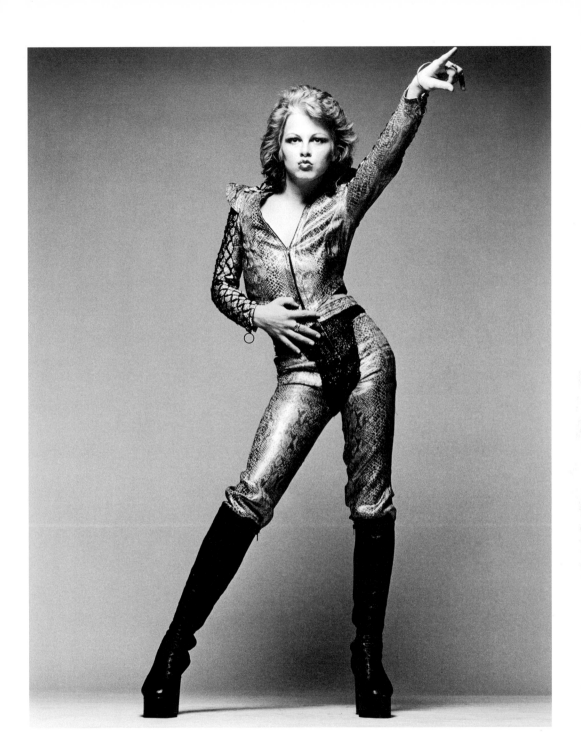

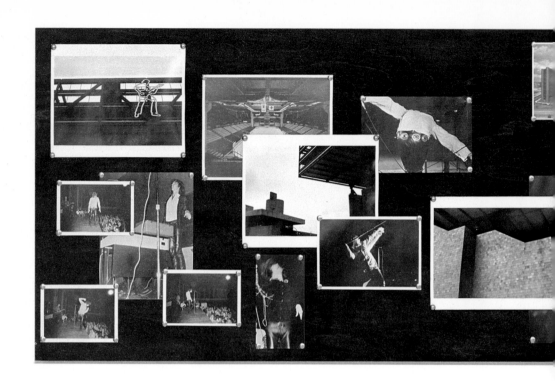

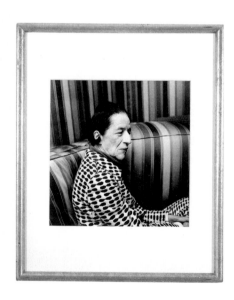

Tom Burr, *Brutalist Bulletin Board*, 2001
¬ Peter Hujar, *Diana Vreeland*, 1975

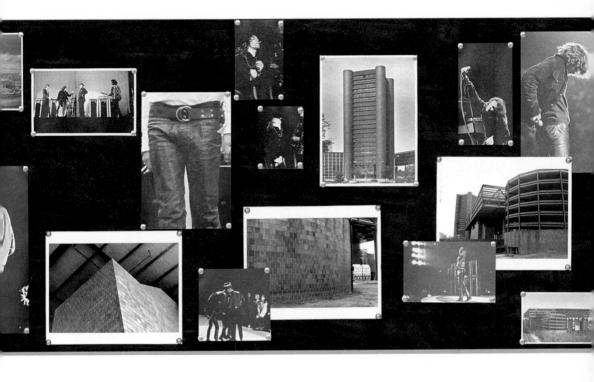

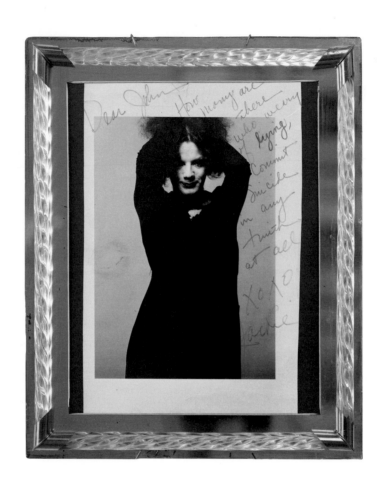

Unknown Photographer, *Jackie Curtis. Goddess. International Superstar,* 1971–1972
¬ Josephine Meckseper, *Shelf No. 11 B,* 2003

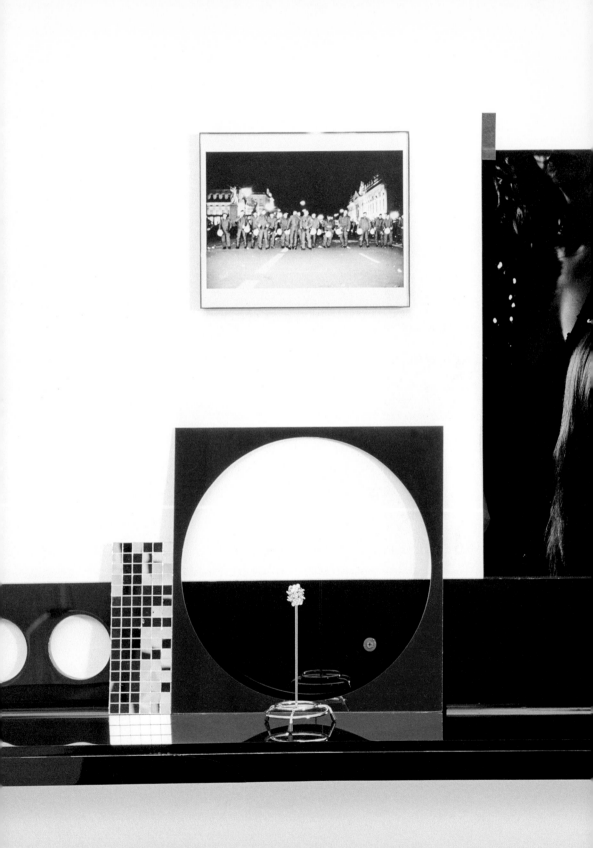

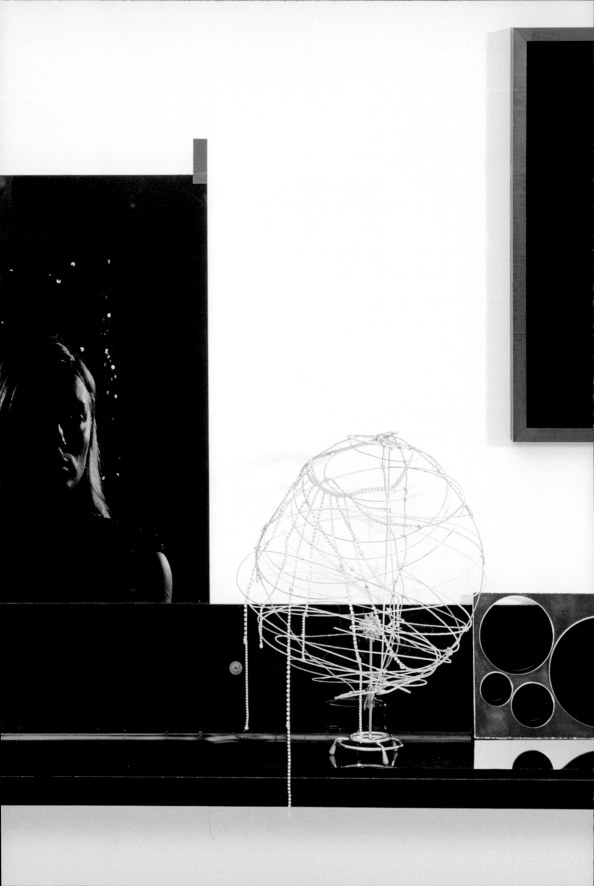

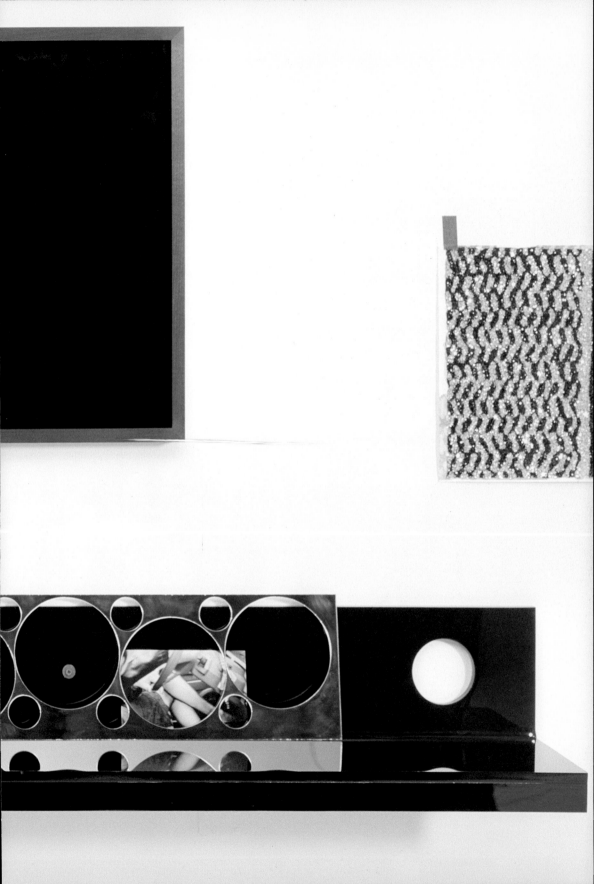

THE GREAT WHITE

Katharina Sieverding: *The Great White Way Goes Black*, 1977/2004

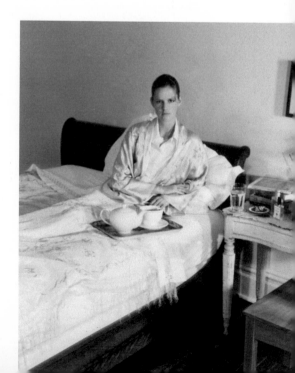

T. J. Wilcox, *Stephen Tennant Homage,* 1998
¬ Carlos Pazos, *Milonga,* 1980

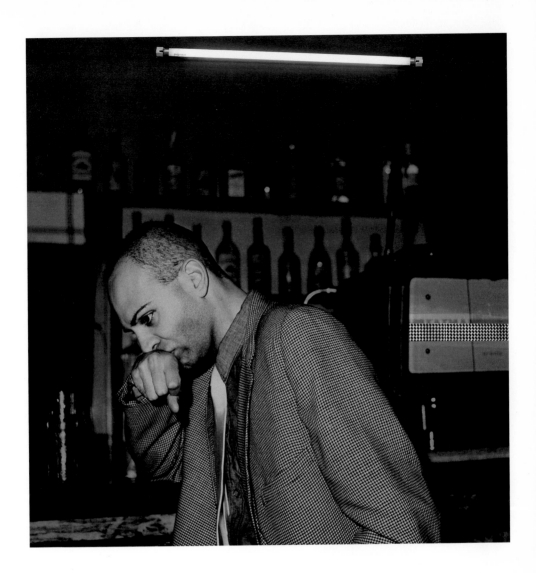

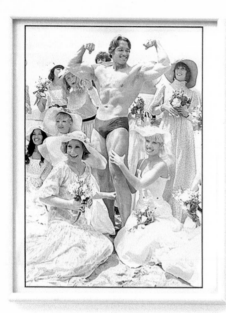

"IF I SEE A GIRL WITH BIG TITS I'M GOING
TO STARE AND STARE AND I'M GOING TO
THINK IN MY MIND WHAT I AM GOING TO
DO WITH HER IF I WOULD HAVE HER."
Arnold Schwarzenegger, 1977

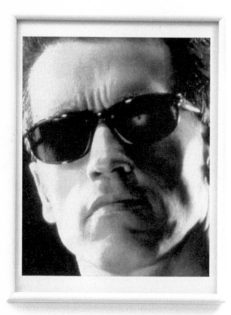

"MY RELATIONSHIP TO POWER AND
AUTHORITY IS THAT I'M ALL FOR IT.
NINETY-FIVE PERCENT OF THE PEOPLE
IN THE WORLD NEED TO BE TOLD WHAT
TO DO AND HOW TO BEHAVE."
Arnold Schwarzenegger, 1990

Jonathan Horowitz, *The Governator*, 2003

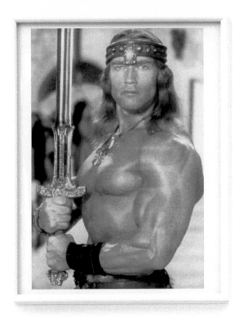
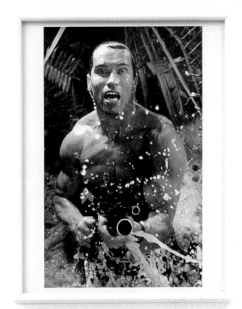
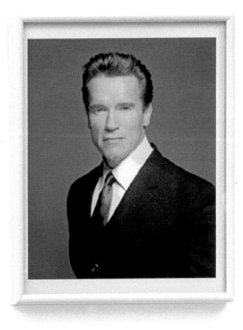

Bernhard Martin, *Single Disco (Whisperclub)*, 1999

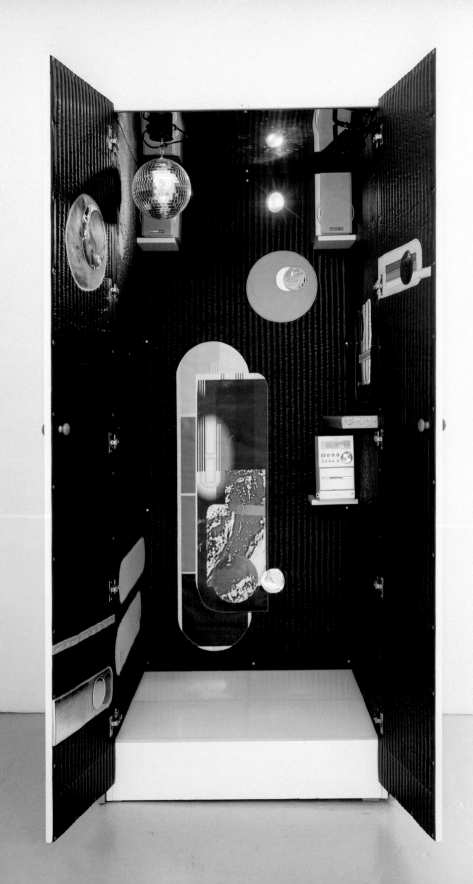

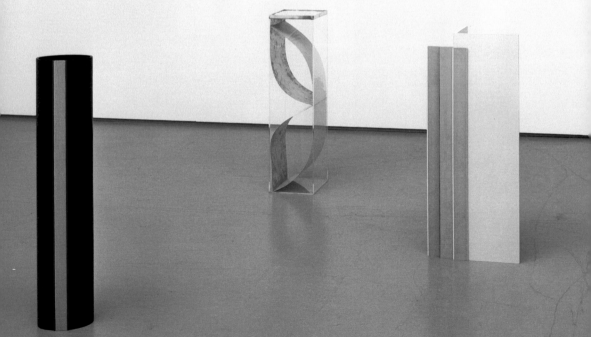

Nicole Wermers, *French Junkies #1, #9, #3, 2002, Untitled, 2003*
¬ Brice Dellsperger, *Body Double 15*, 2001

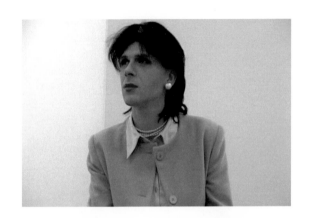

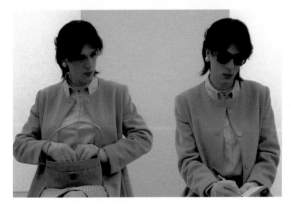

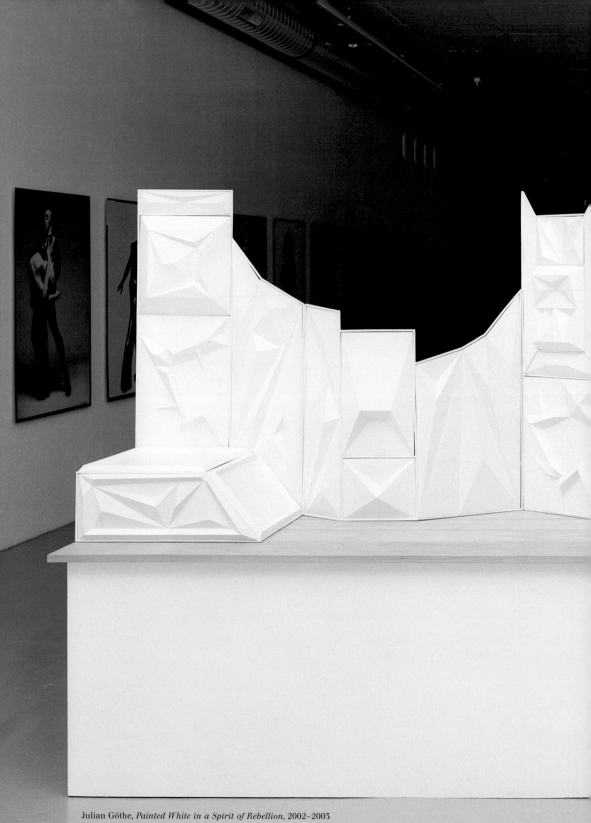

Julian Göthe, *Painted White in a Spirit of Rebellion*, 2002–2003
¬ Fergus Greer/Leigh Bowery, Selection from Sessions, 1989–1994

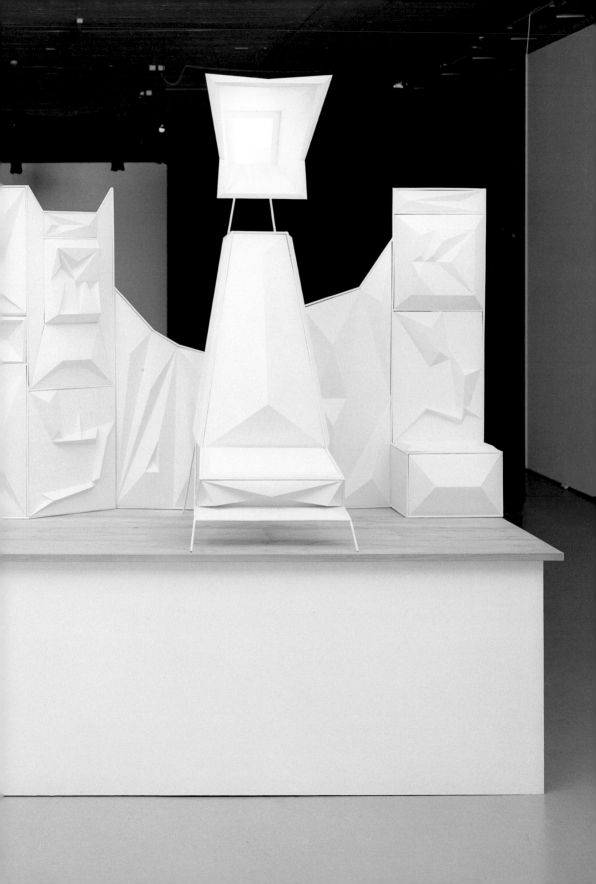

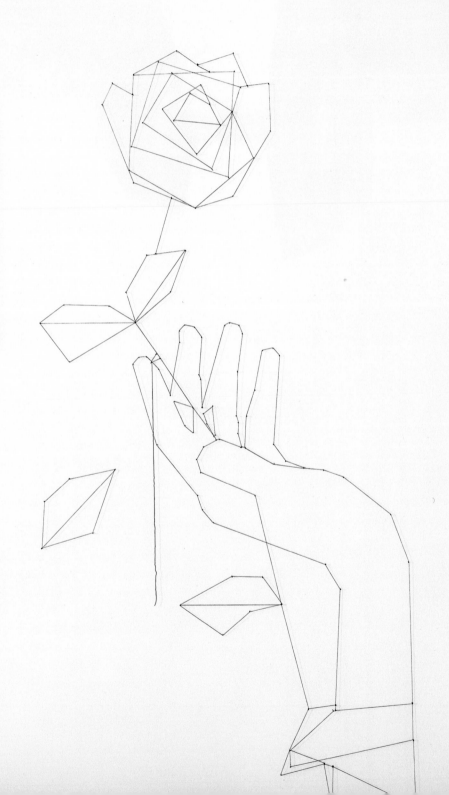

Christian Flamm, *Relindis Agethen,* 2004

Marc Camille Chaimowicz, *Partial Eclipse*, 1980–2003

Shannon Bool, *Fired from Walmart*, 2004
¬ Meret Oppenheim, *Slip Mandrill*, 1940/2003

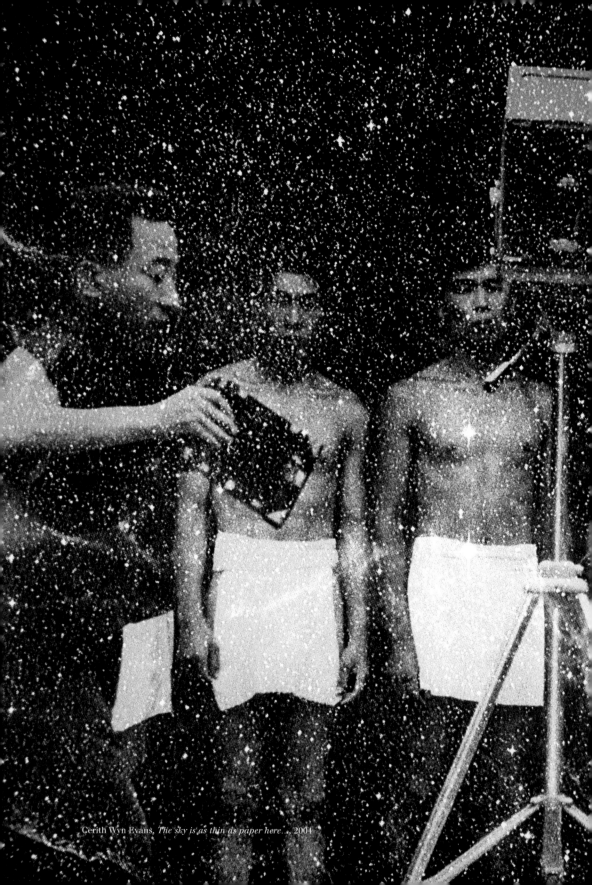

Cerith Wyn Evans, *The sky is as thin as paper here...*, 2004

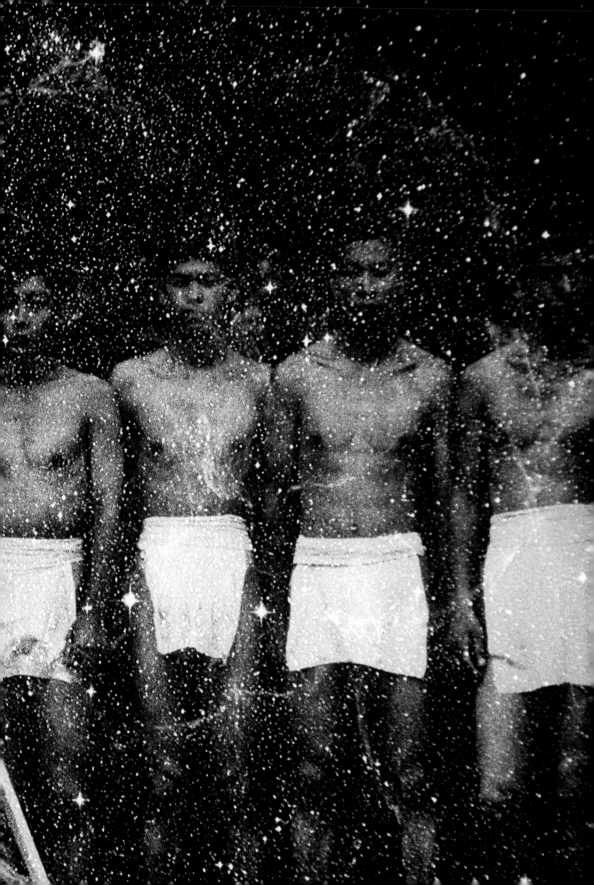

Voy a hacer de mi una estrella

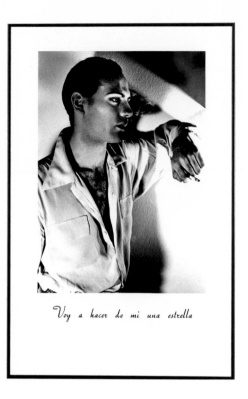

Voy a hacer de mi una estrella

Carlos Pazos, *Voy a hacer de mi una estrella*, 1975

Voy a hacer de mi una estrella

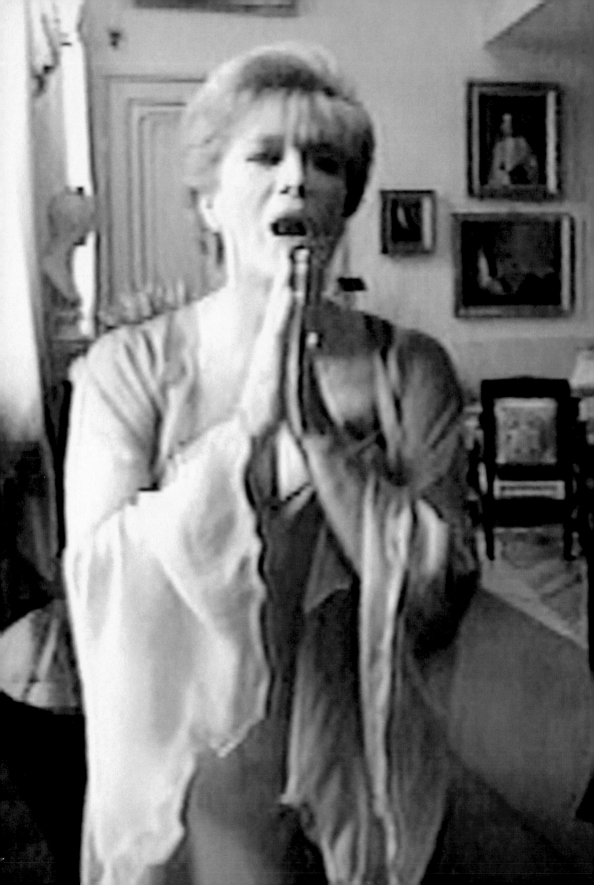

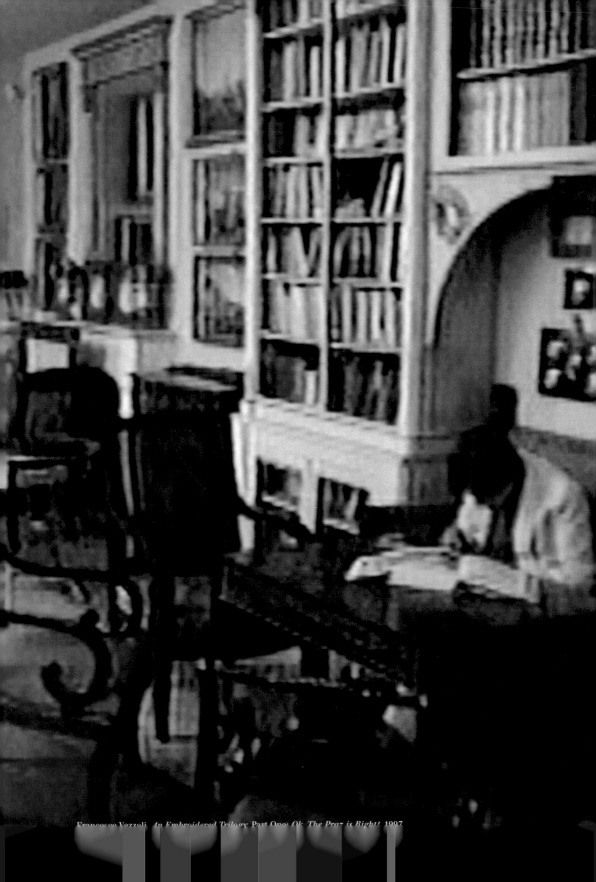

Francesco Vezzoli, *An Embroidered Trilogy, Part One: Ok, The Praz is Right!*, 1997

Jackie Curtis
Shopping Bag
ca. 1973

–
Eisenberg Ice-Brooch
ca. 1935–1942

Minaudière
ca. 1930's/1940's

–
John Edward Heys
GODDESS
Homage to
Jackie Curtis,
Holly Woodlawn,
Candy Darling,
Cookie Mueller,
Diana Vreeland,
Ellen Stewart and
Charlotte von
Mahlsdorf and the
photographers who
took these portraits
2000

John Edward Heys
Lavender Box
(Homage to Cookie
Mueller – New York-
Amalfi-Positano-
Capri, inspired by
Alba Clemente)
ca. 2003

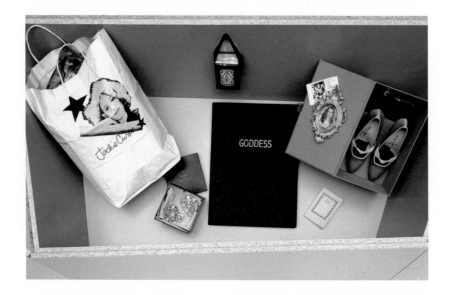

–
Jobriath
Jobriath
1973

–
Larry Levan
Live at the
Paradise Garage
2000

–
Oh Muvie
(d.i. Elfi Mikesch)
Oh Muvie presents
Rosa von Praunheim
Carla Aulaulu
in Oh Muvie
1969

–
Gilles Larrain
Idols
1973

–
Edith Head
(with Jane Kesner
Ardmore)
The Dress Doctor
1959

–
Cecil Beaton
Cecil Beaton's
Fair Lady
1964

–
Mark Leckey
Costume Designs
2002

–
General Idea
FILE Megazine
Glamour Issue
1975

–
Jobriath
Creatures
of the Street
1974

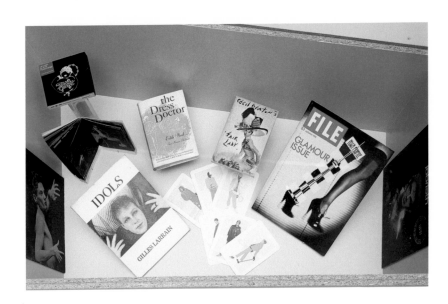

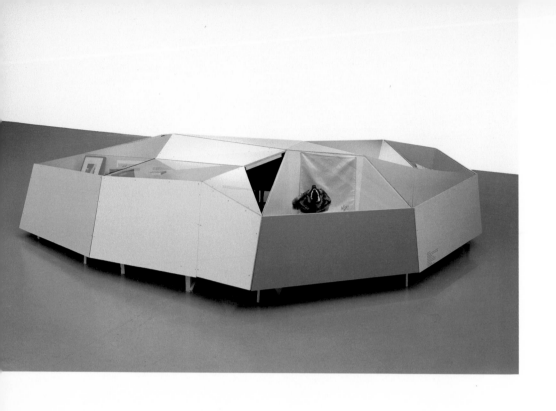

Daniel Robert Hunziker & Tim Zulauf, Klassenfahrt/KMU Produktionen, *Glamour Eiland*, 2004
¬ Jeffrey Vallance, *Elvis Sweatcloth I,* 1993

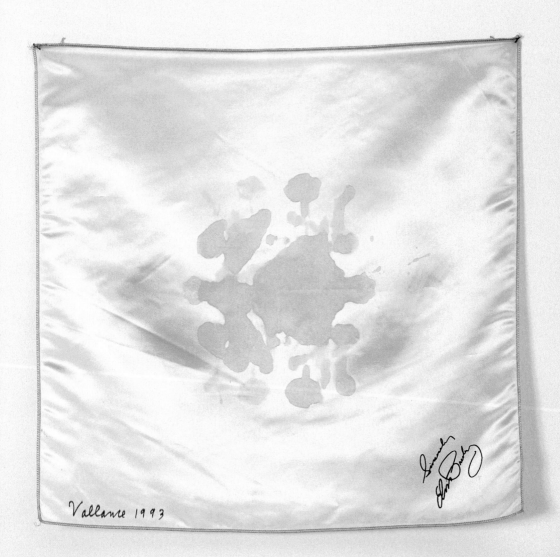

Vallance 1993

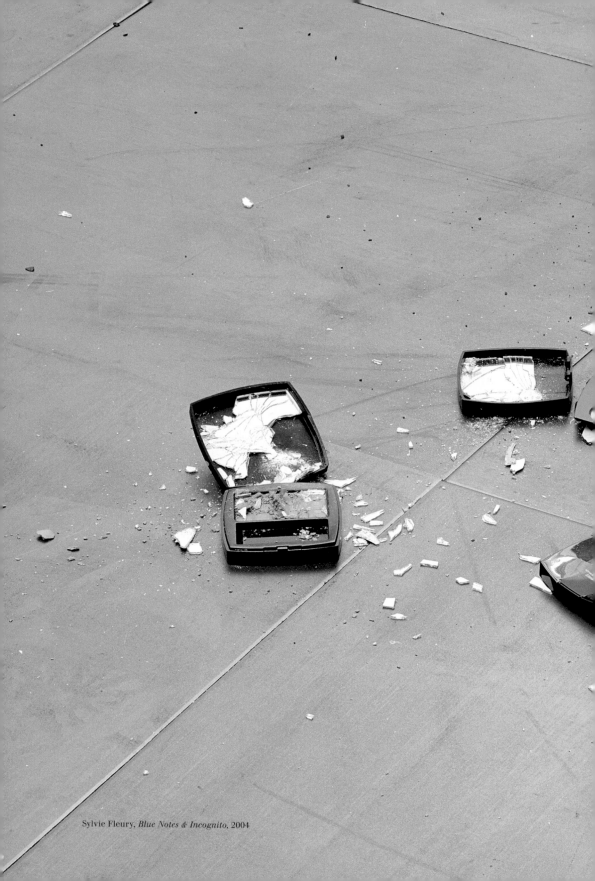

Sylvie Fleury, *Blue Notes & Incognito*, 2004

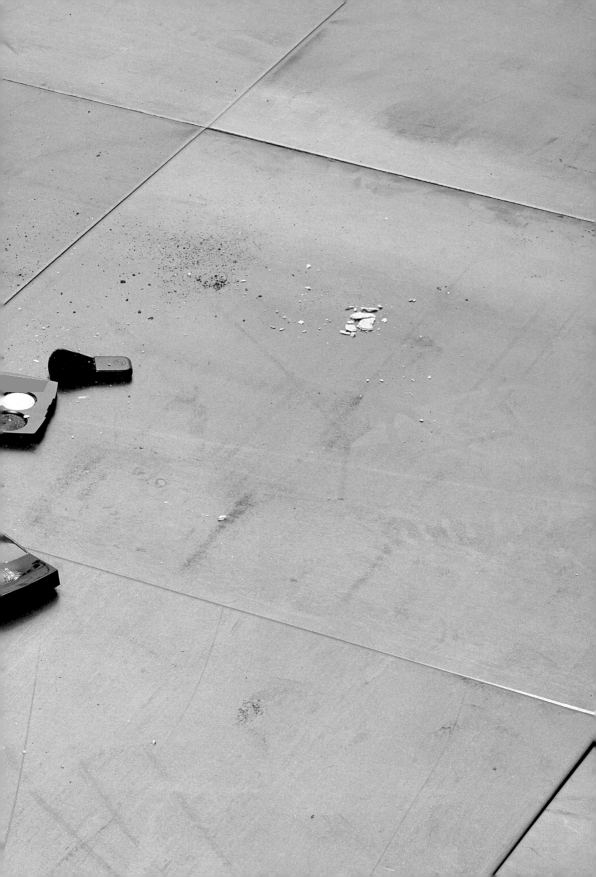

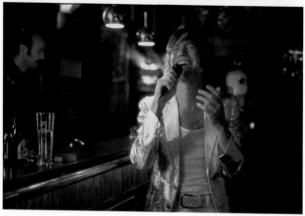

Janet Cardiff & George Bures Miller, *The Berlin Files*, 2003

Franz Gertsch, *Irène III*, 1981

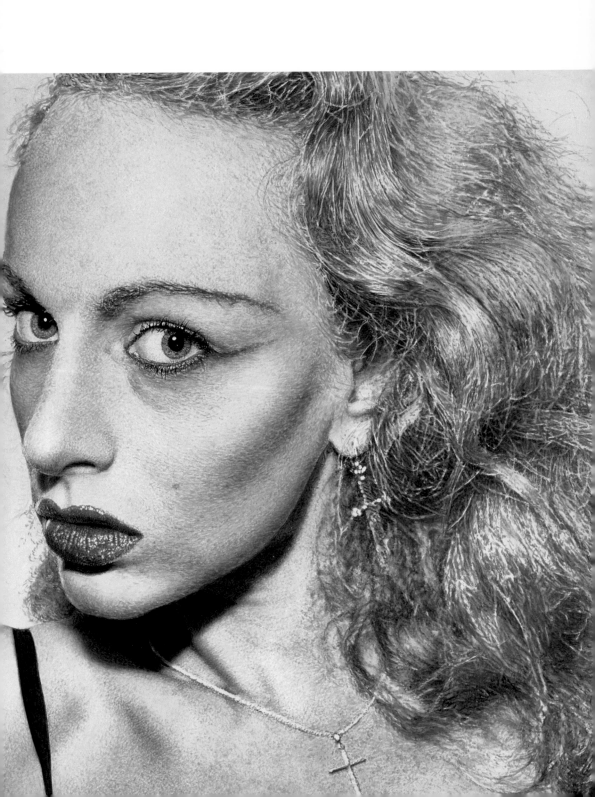

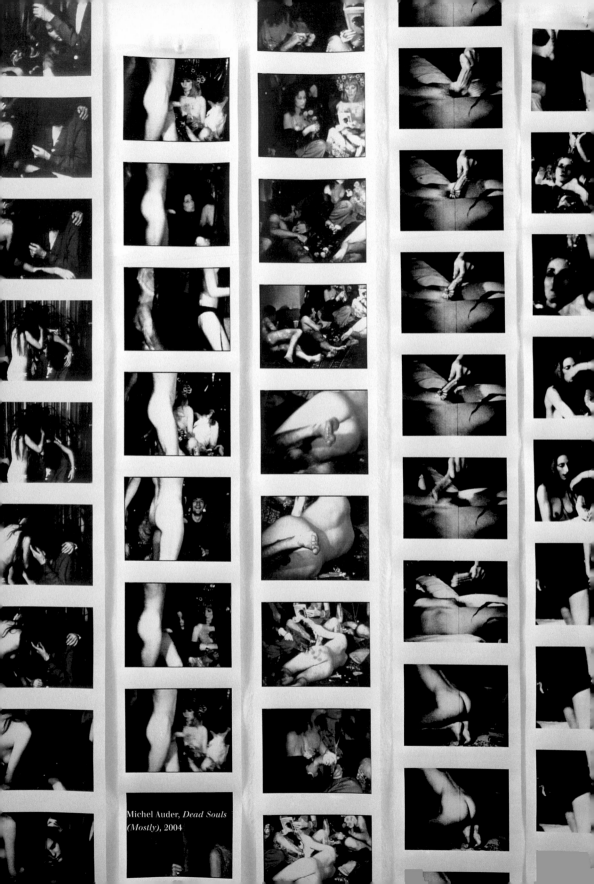

Michel Auder, *Dead Souls (Mostly)*, 2004

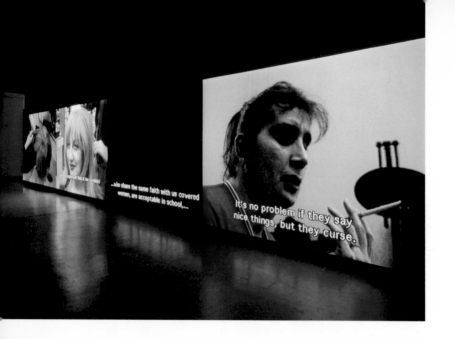

Kutlug Ataman, *Women Who Wear Wigs,* 1999
¬ Sanja Iveković, *Make Up – Make Down,* 1976

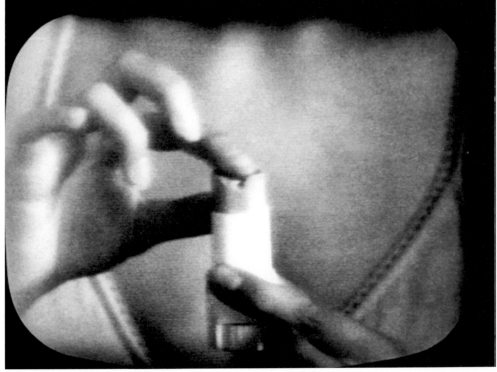

Urs Lüthi, *Tell Me Who Stole Your Smile*, 1974

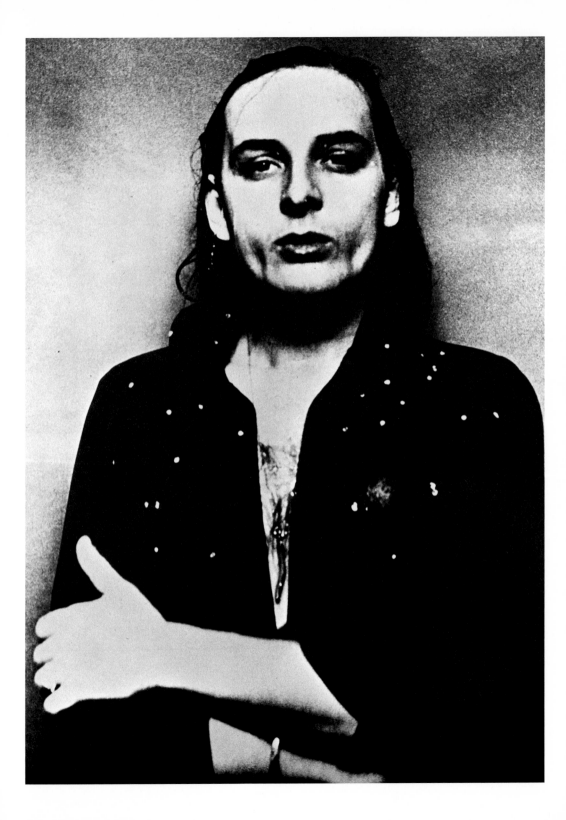

James Lee Byars, *The Wings for Writing,* 1972

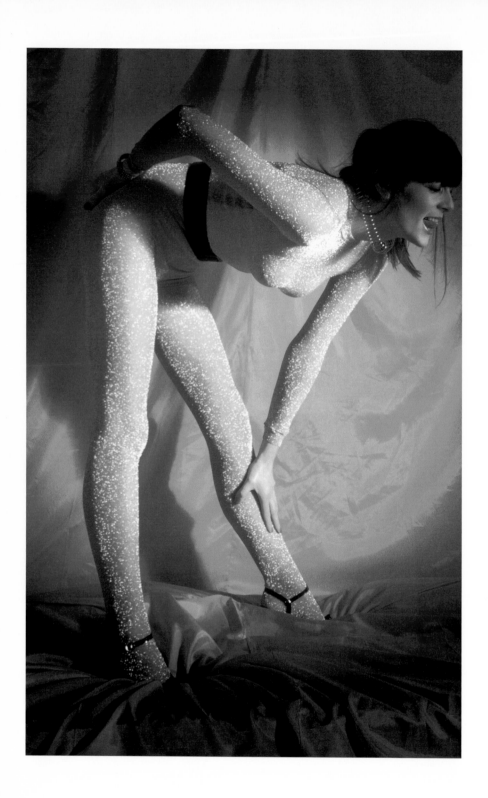

Cosey Fanni Tutti, *Life Forms (Detail)*, 1973–1979

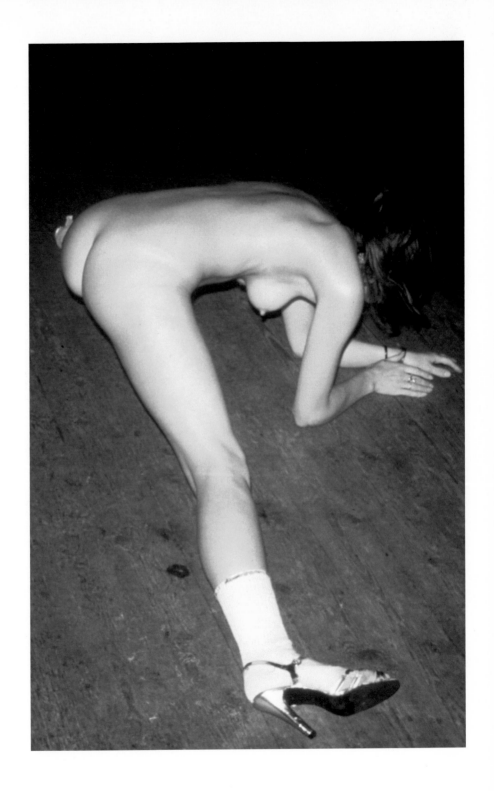

141

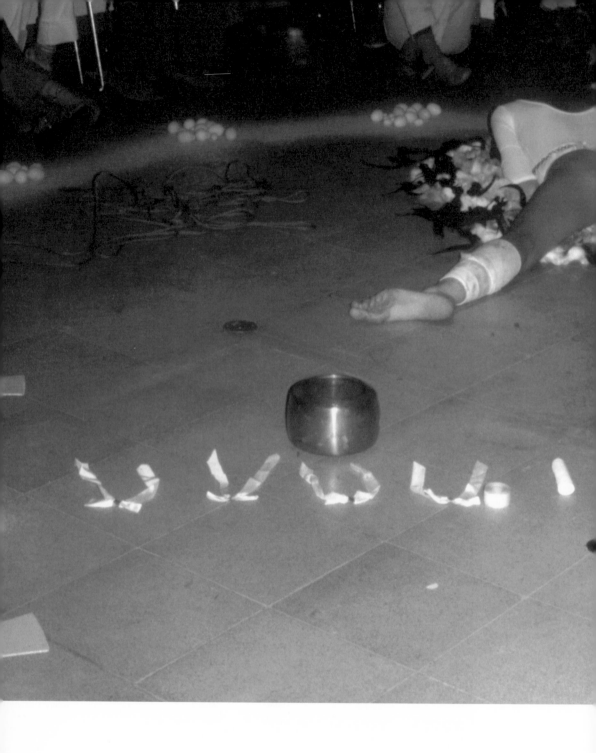

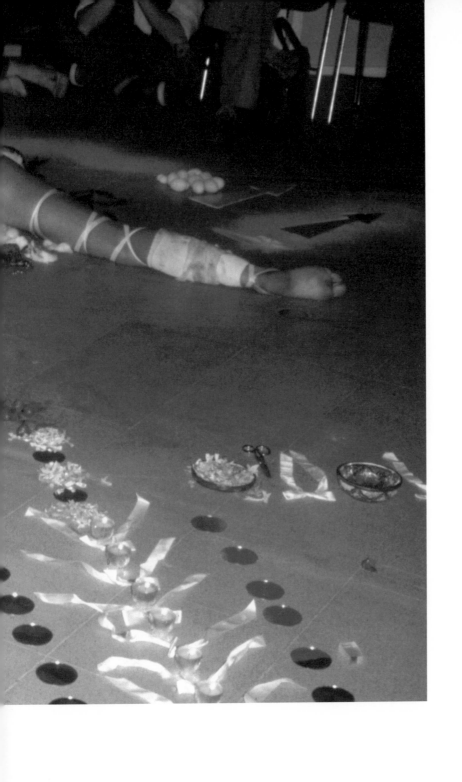

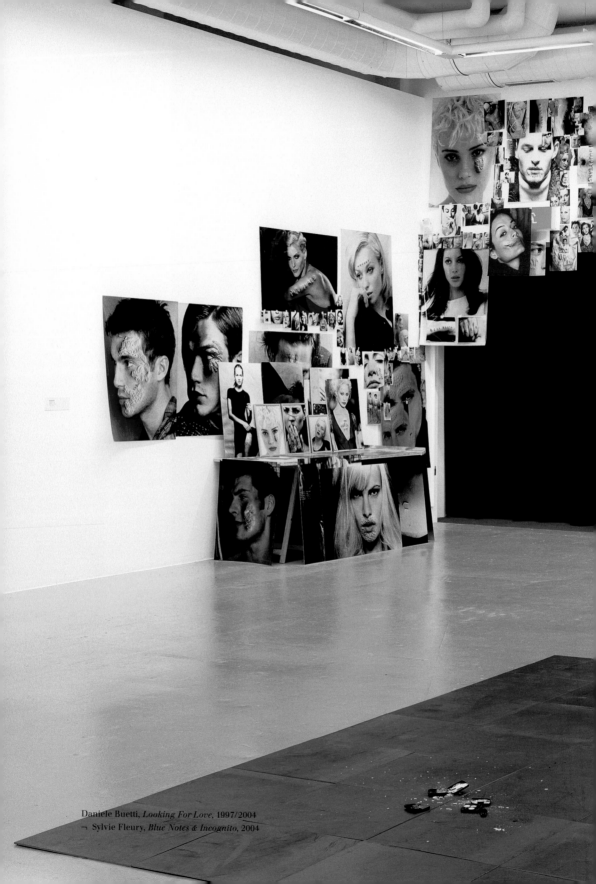

Daniele Buetti, *Looking For Love*, 1997/2004
¬ Sylvie Fleury, *Blue Notes & Incognito*, 2004

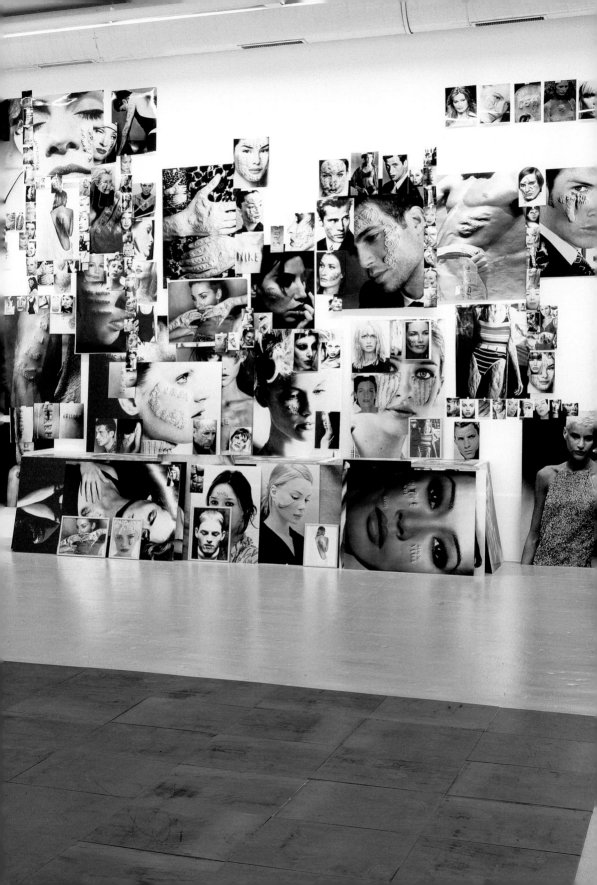

James Lee Byars, *Is*, 1989

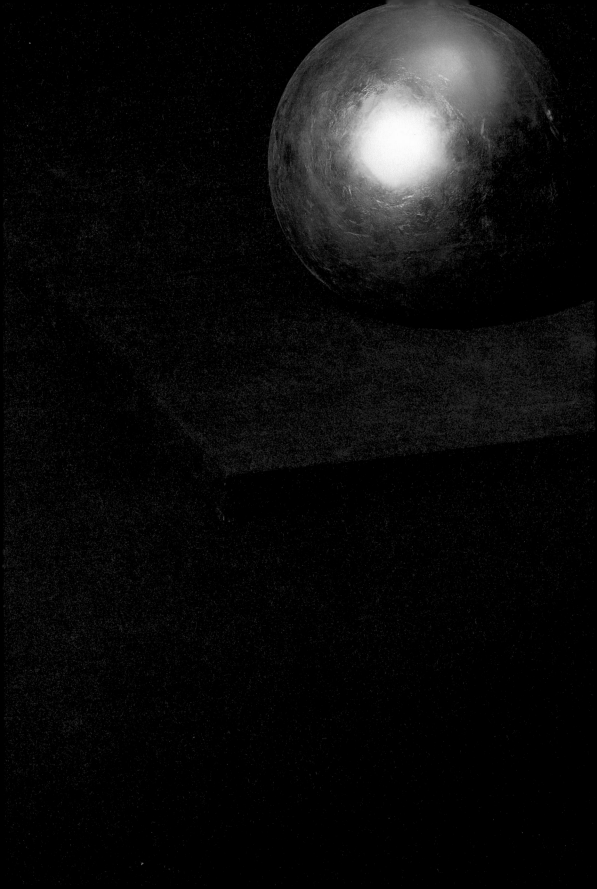

Manon, *La Stanza Delle Donne*, 1990

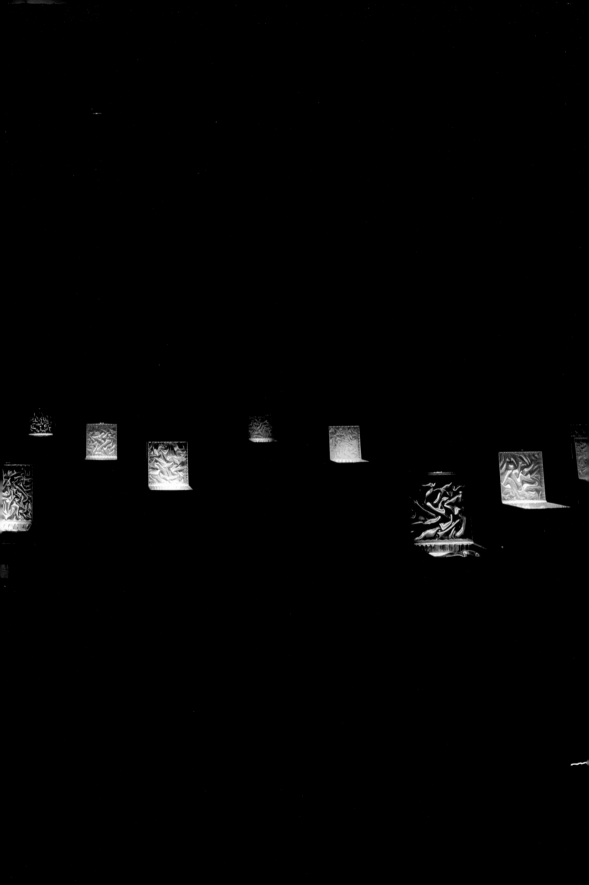

Manon, *La Stanza Delle Donne* (Detail), 1990

—

THE
FUTURE
HAS
A SILVER
LINING

—

Genealogies of Glamour

Tom Holert & Heike Munder
–
GLAMOUR-GENEALOGIEN: EINE (EIN)FÜHRUNG

¬ Local boys will spend a quarter/
Just to shine the silver bowl/
Living hard will take its toll/
Illegal fun/
Under the sun

(Steely Dan, «Glamour Profession», 1980)

¬ Die Ausstellung *The Future Has a Silver Lining. Genealogies of Glamour* hatte verschiedene Ausgangspunkte. Im Zentrum jedoch stand von Anfang an das Erstaunen darüber, wie ungeschrieben die Geschichte der Beziehungen von bildender Kunst und Glamour ist.

Obwohl es hier weder einen klar definierten Ursprung noch einen sinnvoll eingrenzbaren Kanon gibt, erweist sich Glamour als wichtige strategische Kategorie ästhetischer Praxis, in der Ablehnung wie in der Umarmung, in der Kritik wie in der Aneignung. In diesen Funktionen und Bedeutungen kaum gewürdigt und analysiert, war es unser Anliegen, die innere Widersprüchlichkeit und Pluralität des Verhältnisses von Kunst und Glamour zu entfalten. Wie werden die Zumutungen der massenkulturellen Modelle von Schönheit und Überlegenheit künstlerisch reflektiert? Welchen Einfluss hatten und haben die Inszenierungen von Filmstars und Popmusikern auf das Selbstverständnis und die Selbstbilder von KünstlerInnen? Wie und unter welchen Umständen treten künstlerische Arbeitsweisen und die Arbeit am kommerziellen Glamour in Kontakt zueinander? Inwiefern ist die Beschäftigung mit Glamour notwendigerweise eine Beschäftigung mit den Archiven und Katalogen des Glamourösen, also ein Aufgabenfeld der Genealogen?

¬ Die ausgestellten Werke gaben auf diese Fragen keine einfachen Antworten. Im Gegenteil, sie warfen eine endlose Reihe weiterer Fragen auf, die ein ums andere Mal verdeutlichten, wie komplex der Zusammenhang von Kunst und Glamour ist. Es gibt einen Glamour der Dinge, einen Glamour der Persönlichkeit, einen Glamour der Gemeinschaft. Die glamouröse Form vereint konsequent ästhetische und ökonomische Daten, Vorstellungen vom *living large,* vom Leben auf grossem Fuss, ausgestattet mit luxuriösen Kleidern, kostbaren Accessoires, opulenten Wohnungen wie Filmsets und grenzenlosen sexuellen Möglichkeiten. Solche Bilder des Glamour sind in der Popkultur der Gegenwart offenbar unverzichtbar, auch wenn sie zunehmend wie Pflichtübungen in ostentativem Konsum von Waren und Körpern erscheinen.

¬ Glamour überschreitet schnell die Grenze zum Vulgären, wandelt sich vom Instrument der neoaristokratischen Distinktion zu einem Stigma geschmacklosen Reichtums. Die Lächerlichkeit, die Entgleisung, der Absturz sind in den Manövern der Glamour (sehn)süchtigen stets präsent. Glamour kann kippen, umschlagen, scheitern: Aus einem Attribut für überlegene Schönheit und gesellschaftliche Macht, durch das man sich abhebt und womöglich den

Besitz eines exklusiven Geheimnisses andeutet, wird unversehens die Berufskleidung von Sexarbeiterinnen. Wo die Ausbeutung von Körpern und Begehren besonders flagrant ist, sind es auch die Inszenierungen im Modus des Glamour.

¬ Man muss nicht unbedingt moralische Kategorien wie «Würde» bemühen, um auf die Verluste und Ängste zu verweisen, die jeder glamouröse Auftritt in sich birgt. Aber es ist unmöglich geworden, ein naiv-bejahendes Verhältnis zu Glamour aufrechtzuerhalten, seit kaum mehr bestritten werden kann, dass die Hoffnungen auf eine Befreiung durch Konsum ebenso Vergangenheit sind wie manche Selbstermächtigungsangebote des Glamourösen. Löst das Verlangen nach Teilhabe an Glamour nicht mehr denn je Zustände der Scham, Versagensängste, Paranoia aus? Trotzdem ist selbst jenen skeptischsten künstlerischen Projekten, die sich mit den Affekten und Effekten des Glamourösen auseinandersetzen, immer auch ein Silberstreif eingewebt, und sei es als Spur der Enttäuschung über ein uneingelöstes Versprechen. Das folgende kann als Führung durch eine Ausstellung gelesen werden, die den Silberstreifen und Spuren des Glamourösen in ihren künstlerischen Bearbeitungen und Verwendungen nachgeht.

—

Verausgabungen und Ausnahmezustände

—

Glamourästhetik und Warenästhetik werden oft gleichgesetzt. Glamour wäre dann der Glanz, der die Ware veredelt und mit magischen Attraktionen ausstattet, der das Begehren weckt und dessen Erfüllung im Kaufakt suggeriert, aber gleichzeitig permanent aufschiebt; die perfekte Illusionsmaschine, die Technologie der Verzauberung als Dienst am Tauschwert. Aber Glamour führt auch an die Grenzen der ökonomischen Rationalität – und bisweilen über diese hinaus. Das Extravagante, Fabulöse, Grelle, auch die Übertreibung und der Exzess, ebenso wie der Zusammenbruch der Inszenierung, gehören zum Repertoire des Glamour. Die Beziehung zwischen dem Ästhetischen und dem Ökonomischen mag hier gänzlich entregelt erscheinen. Aber sie ist weniger aufgehoben worden, als dass sie sich in ständiger Bewegung befindet.

¬ Wieviel kann eine Druckseite tragen, wieviel kann sie ertragen? Darum geht es unter anderem in der Dia-Installation *The sky is as thin as paper here...* (2004) von Cerith Wyn Evans. Der Titel ist ein Zitat von William Burroughs, und er verweist auf den transgressiven, poetischen Akt, auf das energische Aufeinanderbeziehen der Dimensionen (des Papiers und des Himmels). Der Künstler fotografierte Seiten aus Bildbänden über Astronomie («Catalogue of the Universe») und über Shinto-Rituale («Naked Festival»). In der Überblendung der beiden Motivkreise in der Dia-Projektion entstehen neue visuelle Gewichtungen. Die Sterne (die Projektionsflächen der Sonne) besprenkeln die halbnackten Körper der Shinto-Priester, die körperlichen Verausgabungen der männlichen Initiationsriten ragen in die Unendlichkeit des Universums. Ein Star-Exzess, vom verspiegelten Sockel ausprojiziert.

¬ In *The Great White Way Goes Black* (1977/2004) von Katharina Sieverding steht die Künstlerin vor einem undefinierbaren Hintergrund aus Nacht und Schwärze. Die linke Hand an der Stirn, die Augen tiefschwarz geschminkt, die helle Muskulatur von Schulter und Hals deutlich gezeichnet, trägt sie eine rote Schirmmütze, ein halbtransparentes weissgestreiftes Top und ein Glas, gefüllt mit einem weissen Getränk. Es ist die Nacht vom 13. auf den 14. Juli 1977, als in New York der Strom ausfiel und für 25 Stunden der Ausnahmezustand herrschte. Sieverding blickt zur Kamera. Aber die Künstlerin scheint, als ihr eigenes Modell, auch die besondere Situation dieser Nacht und des darauffolgenden Tages selbst in den Blick zu nehmen. Denn New York wurde in diesen Stunden zum Ort der Ausschreitungen und der Überschreitungen, der rassistischen Polizeiübergriffe auf Afro- und Hispanoamerikaner ebenso wie der karnevalesken, improvisierten Feste. Ein Flugblatt der Revolutionary Comunist League zitierte damals einen «Bruder» mit den Worten, «für das Volk war es wie Weihnachten im Juli». Der «grosse weisse Weg» im Titel bezieht sich dabei auf Unterschiedliches: auf den Namen, den die nordamerikanischen Indianer dem Broadway gaben, ebenso wie auf den Weg der weissen Mehrheitsgesellschaft in den USA. Der Blackout im Sommer 1977 erschütterte das Vertrauen in diesen «grossen weissen Weg» wie kaum ein

anderes Ereignis zuvor. Zugleich hat es, bei aller chaotischen Gewalt dieser Stunden, selten so viel Gelegenheiten gegeben, spontanen, unerwarteten Glamour zu produzieren, wie auch diese monumentale vierteilige Textfotografie zeigt, die unter anderem Entwicklungen in der Modefotografie der 1970er Jahre aufnimmt, als Schnappschussästhetik, *directorial mode* und die Andeutung von Drama in die Bildstrecken der High-Gloss-Magazine einzogen.

¬ Wie kaum eine andere besteht Sylvie Fleury seit Jahren darauf, den institutionellen Raum der Kunst mit Objekten, (Marken-) Namen und Aktionen zu füllen, die hier vorgeblich nichts zu suchen haben. Fleury redefinierte den Kunstraum zur Sphäre der Mode und des Konsums. Und sie gab dem Typus des *fashion victim*, der zwar längst ein fester Nebendarsteller im Kunstbetrieb war, eine Hauptrolle. Als Künstlerin, die einkaufen geht und die Resultate ihrer Shopping-Touren im *white cube* abstellt, erklärte man Fleury schnell zur Heldin eines Publikums, das sich mit ihrer Hilfe zugleich der Gewichte der traditionellen Macho-Künstlergesten und der politischen, auch feministischen Konzeptkunst entledigen wollte. In den 1990er Jahren wurde sie so, regelmässige Auftritte in Lifestylemedien inbegriffen, zum Inbegriff für die Ansteckung des Kunstbetriebs durch den Glamour-Virus. Inzwischen, angesichts eines anspielungsreichen, immer wieder überraschenden Werks, zeichnet sich das «Projekt Fleury» zunehmend ab. Es hat eines seiner Zentren in einer konsequenten (Über-) Beanspruchung der Kunst für jene exzessive Glamourbesessenheit, die zumeist unausgesprochen bleibt, aber den Betrieb gleichwohl strukturiert. Wenn Fleury – wie in *Blue Notes & Incognito* (2004) – auf einem Fake-Carl-Andre mit einem Vorschlaghammer Lidschattendosen von Chanel zertrümmert, ist das durchaus als Hommage an den Minimal-Künstler Andre zu verstehen, auch wenn dieser es vielleicht anders sieht. Seine Bodenskulptur wird zum Objekt einer Aggression, geführt mit den Waffen des Luxus,in einem Akt, der Entgrenzung in den Grenzen des Shopping durchexerziert.

¬ Mit seinen luxuriösen, rätselhaften Objekten und seinen zeremoniellen Performances, die er selber *plays* nannte, erwarb sich James Lee Byars (1932–1997) den Ruf eines exzentrisch-enigmatschen

Atmosphärenzauberers. Byars' ästhetische Ökonomie war die eines
Luxus, dessen Bedingungen und Funktionen er allein definierte.
So arbeitete er unter anderem mit Seide, deren Glanz und ephemere
Konsistenz für die Raum- und Selbstinszenierungen dieser rätsel-
haften Künstlerfigur ähnlich zu entsprechen schienen wie das
ebenfalls kostbare Gold, dessen Dichte die Flüchtigkeit der Seide
konterkariert. Beiden Materialien haftet etwas Mystisch-Alchimisti-
sches, etwas Pretiöses an, aber auch das Verschwenderische einer
Liturgie der Fülle. Sowohl *Is* (1989), eine vergoldete Marmorkugel,
als auch *The Wings for Writing* (1972), rote Seidenmanschetten mit
langen Federn, sind Artefakte ästhetisch-ritueller Handlungen, Re-
quisiten der Beschwörung eines ästhetisch konstruierten Ausnahme-
zustands der «Vollkommenheit».

¬ Auf einen Moment der Verzauberung oder Erschütterung
in einer Situation, die merkwürdig fiktive Ausnahmezustände
in leeren Wohnungen und in der Nacht einer Bar umspielt, steuert
auch die Filminstallation *The Berlin Files* (2003) von Janet Cardiff
und George Bures Miller zu. Cardiff und Miller betreiben in ihren
Kooperationen eine vielschichtige Untersuchung der Bedingungen
von Erinnerung und Erzählung, von Selbst- und Fremderleben,
von Autorschaft und Intimität, von Sound und Bild. Mit dieser Film-
installation wird der Vorführraum, der die Architekturen des Kinos
und des Renaissance-Gedächtnistheaters kombiniert, zu einem
Ort, an dem die Erzählung im Raum zu wandern beginnt und die
ZuschauerInnen akustisch umfängt, während sich auf der Bildebene
die Assoziationen aneinanderreihen. Das Prinzip des Labyrinths,
aber auch die Pfadstruktur von Computerspielen, die neurowissen-
schaftliche Bildgebung oder die Raum/Zeit-Krümmungen der
Science Fiction geben Anregungen für Cardiffs und Millers unge-
wöhnliche narrative Strukturen. Als ZuschauerIn in diesem klang-
intensiven, auf körperliche Reaktionen zielenden *environment*,
begibt man sich auf die Suche nach einem besonderen, ausgezeich-
neten Moment der Erfüllung (oder des Scheiterns) in der Selbst-
inszenierung. Mysteriöse Berliner Altbauwohnungen und gefrorene
Felder werden von Fetzen intimer Gespräche erfüllt. Auf dem
vermeintlichen Höhepunkt der Nicht-Handlung sieht und hört man

der Karaoke-Vorstellung eines selbstvergessenen Entertainers im Goldanzug zu. Er interpretiert einen Song von David Bowie, während die Protagonistin im Nebenraum weint. Dann folgt, einer Cod gleich, die Einstellung jenes Weissbildes, das ein Projektor ohne Dia an die Wand wirft.

—

Serielle Selbsttransformation

—

Glamour wurde in den Tagen des klassischen Hollywood als Technik zur visuellen Produktion aussergewöhnlicher Individualität entwickelt, die das Ideal der besonderen, glänzenden Persönlichkeit zur paradoxen, aber auch folgerichtigen Norm der westlichen Massenkulturen werden liess. Anfang der 1970er Jahre, als man auf die frühe Zeit dieser kulturindustriell vermittelten Individualisierungsstrategien bereits nostalgisch zurückblicken konnte, begründeten Musiker wie Roxy Music, David Bowie, Iggy Pop, T. Rex, Queen, Gary Glitter, Alice Cooper, die New York Dolls oder Jobriath in London und New York eine neue Facette in der Kategorie des Glamourösen: Unter dem Namen Glam Rock (oder Glitter Rock) wurde unter Einsatz von Glitzer-Make-up, bizarren Kostümen und theatralischen Bühnenshows eine anspielungsreiche Abkehr von den Ritualen des authentizistischen Rock geprobt. «Für eine kurze Zeit», schreibt der Filmregisseur Todd Haynes, «verkündete die Popkultur, dass Identität und Geschlecht keine unveränderlichen Dinge sind, sondern fliessend und austauschbar. Der Rock'n'Roll bemalte sich das Gesicht und drehte den Spiegel herum, wobei sich alles verzerrte, was irgendwie in Sichtweite war.» Der Fotograf Mick Rock hat die Welt der Glam Rocker mit der Kamera begleitet. Sein Bild von David Bowie in der «Ziggy Stardust»-Phase (1973) war ein Beitrag zur Inszenierung der Majestät des Glam.

 Auf die 1968 politisierten und der Konzeptkunst zuneigenden Zeitgenossen wirkten die Selbstinszenierungen von Urs Lüthi, die in Serien wie *Tell Me Who Stole Your Smile* (1974) ausgestellt und ediert wurden, anstössig. Waren sie nicht einem überholt wirkenden Ideal selbstvergessener künstlerischer Subjektivität verbunden? Vielleicht zeigten sie auch zu deutliche Spuren einer

Anregung durch das Schauspiel der Imagewechsel und Irritationen sexueller Identität, das Glam-Stars wie David Bowie etwa zur gleichen Zeit auf den Popbühnen aufführten, als dass man sie als eine künstlerische Äusserung ernstnehmen wollte. Ein Fehler, denn gerade diese Verbindungen zum Popimaginären der Zeit lassen sich rückblickend als besondere Qualität beschreiben. Wie Bowie wird Lüthi in seinen Serien zur multiplen Kunstfigur. Die Fiktionalisierung der eigenen Person ist dabei eine Chance auf Selbstveränderung, aber auch ein Schwindel der Identität (im doppelten Wortsinn). Exhibitionismus und Maskerade, Humor und Melancholie, Genuss und Sehnsucht werden zu Optionen der Inszenierung, und es stellt sich die Frage: Wer konnte damals und wer kann es sich heute sozial leisten, diese Optionen in Anspruch zu nehmen?

¬ Die Bedeutung der Aus- und Beleuchtung des Selbst wird in Carlos Pazos' *Milonga* aus dem Jahr 1980 allegorisch. Die Neonröhre, Accessoire der kühlen Raumästhetik in den Jahren von Punk und New Wave, aber auch Künstler der Minimal Art und ihrer Nachfolger (Dan Flavin, Bruce Nauman), ist Bestandteil eines fotografischen Selbstporträts des Künstlers in melancholischer Pose am Tresen. Wie Katharina Sieverding, Michel Journiac, Manon, Jürgen Klauke oder Urs Lüthi hat Pazos in den 1970er Jahren die serielle Inszenierung und Transformation der eigenen Person betrieben – mit Performances und Fotoarbeiten. Im Werkkomplex *Voy a hacer de mi una estrella* (1975), der zur Zeit seiner Entstehung auch Performance-Anteile besass, orientierte sich Pazos deutlich am *glamour shot* Hollywoods der 1920er bis 1950er Jahre, um aus sich «einen Star zu machen». In den 1970er Jahren ist der Bezug auf den Typus des *latin lover* und andere Starinszenierungen des klassischen Hollywood nicht nur nostalgisch, sondern auch in Hinblick auf die Möglichkeiten einer sexuellen Politik zu sehen. Aus Filmgeschichte, Pop und Subkulturerfahrungen wurde ein Gegenentwurf zu den herrschenden Verhältnissen (hier die Ausläufer der repressiven Gesellschaft im Spanien Francos) entwickelt. Dabei betont Pazos' queere Aneignung gegebener Glamour-Schemata die Erfahrung von Entfremdung, verunsichert aber auch Identitätsvorstellungen.

¬ Will man verstehen, wie weit die Entgrenzung von Vorstellungen über sexuelle Identität, den Status des Körpers, die Funktion von Kleidung und die Prinzipien der Performance gehen kann, ist Leigh Bowery (1961–1994) eine Schlüsselfigur. Der Modemacher, Performer, Musiker, Clubbetreiber und Allround-Exzentriker war im London der 1980er und frühen 1990er Jahre eine auffällige, extreme Erscheinung. «Dress as though your life depends on it, or don't bother» («Kleide dich, als würde dein Leben davon abhängen, oder lass es sein»), lautete ein Motto von Bowerys serieller Selbsttransformation. Seine skulpturalen Choreographien mit Körpermasse und Stoffgebirgen fanden vor Live-Publikum, vor der Kamera oder vor den Augen des Malers Lucian Freud statt, dessen Modell Bowery war. In den Jahren bis zu seinem Tod entstand auf diese Weise eine Fülle von Bildern, die jenen Prozess dokumentieren, der Bowery in ein theatralisches Jenseits von *drag* führen sollte. Bis heute lassen sich Modedesigner wie John Galliano, Jean-Paul Gaultier, Alexander McQueen oder Vivienne Westwood von diesem grossen Abweichler inspirieren. Fotografiert wurde Leigh Bowery von Fergus Greer, der für Magazine wie *Vogue* und *Vanity Fair* arbeitete und arbeitet, ein Fotograf, mit dem Bowery regelmässig bei der Produktion und Dokumentation seiner Selbstschöpfungen kooperierte.

¬ Den Akt einer forcierten Verführung re-inszeniert Brice Dellsperger in seiner Arbeit *Body Double 15* (2001), dem Remake einer berühmten Sequenz aus Brian de Palmas *Dressed to Kill* aus dem Jahr 1980. Angie Dickinson spielt in dieser Szene eine Frau, die sich im Metropolitan Museum of Art in New York von einem Fremden durch die Galerien verfolgen und schliesslich verführen lässt, bevor sie von einem Serienmörder in *drag* getötet wird. Brice Dellsperger hat diese Verfolgungsjagd im Museum Wiesbaden nachgestellt. Er selbst spielt die Rolle sowohl der Verfolgten wie des Verfolgers, wobei es sich in diesem Fall nicht um Frau und Mann, sondern um identische Figuren, um Doppelgänger handelt. Mit dem Doppelgängertum geht eine (virtuelle) Verdoppelung des Künstlers ebenso einher wie die Aufhebung der sexuellen Differenz. Dellsperger wird zum Doppel-Körper, der die Räume einer Institution für moderne Kunst zur Bühne eines Dramas in *drag* macht.

Architektur, Design, Display
—

Zu den Bedingungen des glamourösen Auftritts gehören nicht zuletzt Bauten und Bühnen, konkrete Räume, die zum Ort phantastischer, auch phantasmatischer Akte werden können: Grand Hotels, Opernhäuser, Diskotheken, Rockbühnen, Clubs, Laufstege, Filmsets, Schaufenster, der *white cube* der modernen Kunst, aber auch Privatwohnungen. *Painted White in a Spirit of Rebellion* (2002/2003) von Julian Göthe ist ein rätselhafter Hybrid aus Skulptur und Displayarchitektur, aus reiner Form und virtueller Anwendung. Gebaut aus Papier und Draht, vermittelt das Objekt widersprüchliche Empfindungen und Assoziationen – von zerbrechlicher Kreatürlichkeit und bösartiger, aber auch lustvoller Gewalt. Die formalen und inhaltlichen Referenzen reichen vom bizarren *stile novo* des italienischen Möbeldesigners Renzo Zavanella bis zu den Körperarchitekturen des Body Building. Das blendende Weiss lässt an die weissen «Kleider» der Architektur etwa Le Corbusiers denken und damit an die in der Geschichtsschreibung nur allmählich akzeptierte Verschränkung von Mode und Moderne. Die gleichberechtigte Zurschaustellung von Schauseite und Rückseite vermittelt darüberhinaus einen Sinn für das, was in der Inszenierung normalerweise unsichtbar bleibt, jedoch das Begehren strukturiert und nährt.

¬ Das *Brutalist Bulletin Board* (2001) von Tom Burr beteiligt sich ebenfalls an dem Diskurs über die architektonischen Komponenten von Glamourkonstruktionen. Seine Gegenüberstellung von Fotografien der maskulinen Körper/Leder-Inszenierung des Sängers Jim Morrison mit Bildern des «Brutalism» genannten Baustil der Nachkriegszeit, der für Parkhäuser oder auch im Sozialwohnungsbau typischwurde, macht den Rockstar als sexuelle, womöglich sexy «Architektur» sichtbar. Zur Veranschaulichung dieser These bedient sich Burr der Methode der Pinnwand. Weil das *bulletin board* zugleichan den «Bilderatlas» des Kulturhistorikers Aby Warburg erinnert, kann hier von Mythenforschung in der (Pop)Moderne des 20. Jahrhunderts gesprochen werden.

¬ An den Grenzen von Einrichtungsgegenstand und Skulptur bewegen sich die *French Junkies* (2002) von Nicole Wermers.

Die entfunktionalisierten Standaschenbecher sind gleichermassen Destillate und Reorganisationen von Gebrauchsdesign. Wermers «schneidet» aus kommerziellen Umgebungen wie Boutiquen oder Hotellobbys signifikante Formpartikel und Materialmuster heraus und setzt diese, dem Prinzip der Collage verpflichtet, zu Meta-Designgegenständen zusammen. Die Faszination für die Oberflächenbeschaffenheiten, Farbwerte und Linienführungen ihres Ausgangsmaterials, des auf Attraktion, Verführung und Profitsteigerung programmierten Designs, wird nicht verleugnet. Dennoch entsteht durch das Verfahren der Collage ein Raum für subtile Distanzierungsmanöver.

¬ Mit den Übergängen zwischen Politik und Mode, Aktivismus und Glamour beschäftigt sich Josephine Meckseper. In Fotografien, Videos, Textilarbeiten, Zeitschriftenprojekten und Wand-Assemblagen wie *Shelf No. 11b* (2003) wird zur Darstellung gebracht, wie sich Begriffe und Bilder des Politischen unter dem Eindruck von Werbung, Mode oder Popästhetik verändern. Die Formensprache der Protestkultur, aber auch der grossen Parteien, erscheint diesem Ansatz zufolge weitgehend abgelöst von Inhalten und zunehmend in Parametern der Glamourproduktion erfassbar. Bilder von Demonstrationen fügen sich dann scheinbar bruchlos in die dekorativ-elegante Kunststoffarchitektur von Display-Elementen. Ist den *politics of style* ein *political style* gefolgt? Wo trifft das kollektive auf das individualistische narzisstische Erleben?

¬ Die *Single Disco (Whisperclub)* (1999) von Bernhard Martin kommentiert ironisch den Widerspruch von kollektivem Disco-Erlebnis und gleichzeitiger akuter Vereinzelung. Die Ein-Personen-Diskothek ist eine lustig-verzweifelte Lösung dieses eigentlich unlösbaren sozialen Dilemmas. Kann man sich allein in einer solchen Druckkammer des Hedonismus amüsieren? Welchen Anteil hat die Gemeinschaft oder die Idee von Gemeinschaftlichkeit bei der Konstruktion der Erfahrung von Glamour? Ist dies die Box für den selbstbezüglichen Ecstasy-Trip? Martins Ikea-Schrank mit integriertem Vergnügungssortiment thematisiert die architektonisch-räumlichen Bedingungen, unter denen sich Glamour überhaupt ereignen kann.

¬ Einen anderen Fall von Star-Architektur bearbeitet Jonathan Horowitz. Mit Arnold Schwarzeneggers Wahl zum Gouverneur nahm zum zweiten Mal nach Ronald Reagan ein Hollywood-Star das höchste politische Amt im US-Bundesstaat Kalifornien ein. Dieser Wechsel vom Unterhaltungsgeschäft in die Politik – hat er Modellcharakter? Horowitz, der sich seit Jahren mit den manipulativen Strategien und dehumanisierenden Effekten der Massenmedien beschäftigt, verweist in *The Governator* (2003) auf den frauenfeindlichen und autoritären Subtext der Karriere Schwarzeneggers. Den Bildern von überlegener Männlichkeit in den Rollen des Kampfroboters oder Urmenschen wird durch die beigefügten Zitate jede ironische Qualität genommen. Dass Schwarzeneggers politischer Erfolg auf der Bestätigung reaktionärster Klischees von Männlichkeit beruhen könnte, ist eine der verstörenden Schlussfolgerungen, die Horowitz nahelegt.

–

Repertoire, Archiv, Erinnerung

–

Die Erkundung der hybriden – theatralischen, kommerziellen, künstlerischen – Topographien des Glamour vollzieht sich regelmässig in den Verfahrensweisen der Inventarisierung und Rekonstruktion historischer oder zukünftiger Modelle. Glamour ist nie Schöpfung *ex nihilo,* sondern immer abgeleitet. Glamouröse Sensationen verdanken sich der Erinnerung an reale oder fiktive Geschehnisse, der Sammlung und Neuordnung der (verlorenen) Bestände. *Partial Eclipse* (1980–2003) von Marc Camille Chaimowicz, eine Arbeit, die aus 180 Dias besteht, ist eine Meditation über den Verlust. Verloren wurden Erinnerungen an Interieure, Körper, Gerüche, Emotionen. Die Erinnerungsarbeit verläuft über visuelle Fragmente, stillebenhafte Bilder von Pflanzen, Menschen und Möbeln. Chaimowicz hat diese Bilder über einen grösseren Zeitraum gemacht, nachdem Vorläufer der Dia-Installation erstmals 1980 und danach in unterschiedlichen Versionen als Teil einer Performance mit Sound präsentiert waren. Der Versuch, sich einer verblassten Erinnerung mit Hilfe ästhetischer Surrogate, auch fetischhafter Stellvertreter, zu vergewissern, ist eng mit einem

Glamour verbunden, der den Zauber intimer Szenen und Szeno-
grafien gegen die lauteren, rauheren Regimes des Glamourösen setzt.
Chaimowicz bewegt sich hier in der Tradition des Dandys und
der literarischen Vergegenwärtigungen vergangener Stimmungen
und Gefühle bei Marcel Proust.

¬ Lange Zeit ein unermüdlicher visueller Chronist seiner
Umgebung, begann Michel Auder um 1970, als die ersten tragbaren
Videokameras erhältlich wurden, ein grosses Archiv des New Yorker
Boheme-Underground anzulegen – in Form von Videotagebüchern.
In den späten 1960er Jahren war Auder als Mitglied von Zanzibar,
einer Pariser Gruppe von Filmemachern um Philippe Garrel, die als
die «Dandys von 1968» bezeichnet wurden, in Kontakt mit der
Warhol-Welt geraten. Mit Viva, einem der «Superstars» der Factory,
zog er nach New York, ins Hotel Chelsea. Filmenderweise interagier-
te er mit Protagonisten der Szene wie Taylor Mead, Gerard Malanga,
Ondine, Warhol, Donald Cammell oder Alice Neel. Jonas Mekas
schildert, wie Auders Videokamera «immer dabei war, immer auf
Aufnahme geschaltet, als Teil der Einrichtung, als Teil seines
Lebens, seiner Augen, seiner Hände». Häufig wurde das Material erst
Jahre später ausgewertet und öffentlich gemacht. Viele Stunden
dieser *video chronicles,* die Alltagshandlungen, banale Dinge,
Gespräche, Spaziergänge zeigen, warten noch darauf, gesichtet zu
werden. Für die Ausstellung hat Auder Kontaktstreifen von Screen-
shots ausgewählter Szenen seines visuellen Tagebuchs zusam-
mengestellt, *Dead Souls (Mostly)* (2004), Extrakte aus einem privat-
öffentlichen Archiv der glamourösen Gesten.

¬ T. J. Wilcox kombiniert in seinen Filmen gefundenes Film-
material, selbstgedrehte Sequenzen auf 8 Millimeter und animierte
Passagen. Sie werden zunächst auf Video kopiert und bearbeitet;
abschliessend wird eine 16-Millimeter-Kopie erstellt. Die materiel-
len Spuren dieses mehrstufigen Vorgehens, das Zerdehnen der
Zeit durch *slow motion* und die eher beiläufig gehaltene Projekti-
onssituation spielen eine wichtige Rolle für Wilcox' Verständnis
der Visualisierung und Vertonung von persönlicher und kollektiver
Vergangenheit. *The Funeral of Marlene Dietrich* (1999) montiert
Bilder, die Wilcox ansonsten nicht «loswerden» würde, zu einer

filmischen, Vergangenheit, Gegenwart und Zukunft verschränkenden Rekonstruktion und Re-Fiktionalisierung jener Phantasien, die die Dietrich anlässlich ihrer eigenen Begräbnisfeier gehegt haben könnte. Traumähnlich, romantisch, witzig, *over the top* und verhalten parodistisch wird die Erinnerung an den Star und dessen Selbstmystifikation erfunden. In *Stephen Tennant Homage* (1998) widmet sich Wilcox in ähnlicher – Nostalgie, Kolportage und Celluloid-Materialität verbindender – Manier einer Dandy-Ikone des 20. Jahrhunderts, Stephen Tennant.

¬ Einen flüchtigen Moment im «Jackie 60», nach Aussagen von Zeitzeugen einer der letzten wirklich glamourösen, seit 1999 nicht mehr existierenden Clubs in New York, hat 1996 der Fotograf Allen Frame eingefangen. Die beiden Personen in *John and Alba* scheinen das Gefühl der raren Atmosphäre und besonderen Gesellschaft, in der sie sich aufhalten, zu verkörpern; gleichzeitig ist bereits eine Sehnsucht nach dem verlorenen Moment zu spüren. Wie viele andere Dokumente des Glamour, begehrt Frames Fotografie gegen diesen Verlust auf, um ihn im selben ästhetischen Augenblick zu ratifizieren.

¬ Als Chronist und Stilist sucht Christian Flamm nach charakteristischen, auch widerständigen Momenten von Stil und Stilbewusstsein. Als zarte Wandzeichnung aus schwarzem Faden tritt die Hand mit Rose in Flamms *Relindis Agethen* (2004) in Erscheinung. Wie bei einer Taschentuchstickerei ist hier das Formrepertoire aufs Nötigste verknappt. Flamm, der nicht nur mit Stickereien, sondern u. a. auch mit Scherenschnitten an einer Grammatik der Posen und Gesten arbeitet, welche gegenwärtige subkulturelle Formationen mit den Traditionen von Boheme und Dandytum verbindet, überführt das romantische Motiv in ein Piktogramm für Eleganz, Elegie und dandyeske Grazie, haarscharf an der Grenze zum Kitsch.

¬ Bewusster oder unbewusster Ausgangspunkt aller Glamour-Inszenierungen sind die Filmproduktionen der grossen Hollywood-Studios der 1920er bis 1940er Jahre. Von Diana Vreeland wissen wir, dass die Erfolgsformel des klassischen Hollywood in der «totalen Konzentration auf eine Sache» lag, und «diese Sache war das Wort,

Glamour». Massgeblich wurde diese Erfolgsformel von Foto-
grafen entwickelt und umgesetzt, die von den Studios beschäftigt
wurden, um Publicity-Fotos der SchauspielerInnen zu machen,
bisweilen auch Aufnahmen von den Dreharbeiten. Die Geschichte
der Konstruktion der glamourösen Stars ist ohne diese *glamour
shots* nicht zu denken. Weit mehr als ein Werbemittel, hatten diese
kleinen, mit grossen Plattenkameras hergestellten Wunder aus
Licht, Glanz und Schlagschatten entscheidenden Anteil an der Ikoni-
sierung der Schauspieler. Zudem entstanden sie oft unabhängig
von den Dreharbeiten und lieferten damit auch gewissermassen
eine erste Interpretation der betreffenden Filme. Christoph Schifferli
hat aus seiner reichen Sammlung von Vintage-Film-Stills eine
Auswahl getroffen, die bisweilen etwas vom Kanon der Glamour-
fotografie abweicht, der mit FotografInnen wie George Hurrell, Don
English, Edward Steichen, Cecil Beaton oder Ruth Harriet Louise
verbunden wird. Hier sieht man zumeist die Bilder anonym
gebliebener Fotografen, vermeintlich untypische Motive ebenso
wie einschlägige Glamour-Posen.

¬ Mit einem grossen Vitrinenobjekt hat Daniel Robert
Hunziker, der als Bildhauer in gegebene Raumverhältnisse inter-
veniert, eine Bühne für die Inszenierung von Kunstwerken,
 Konsumobjekten und Dokumenten geschaffen, die unterschied-
liche Versionen und Lesarten des Glamourösen anbieten.
Die Vitrine wurde speziell für die Ausstellung produziert und steht
in enger Verbindung zu dem Theaterstück *Glamour Eiland,* das
Tim Zulauf und Klassenfahrt/KMU Produktionen im Rahmen des
Zürcher Gemeinschaftsprojekts «Doing Glamour» für das Theater-
haus Gessnerallee entwickelt haben (so sind Puppen der drei
SchauspielerInnen des Stücks in den Hohlräumen unterhalb der
Vitrine zu erkennen). Hunzikers kristallines Gebilde nimmt unter
anderem Sammlungsbestände und eigene Produktionen des
Schauspielers und Künstlers John Edward Heys auf. Heys, der die
Geschichte des Underground-Glamour im New York der späten
1960er bis späten 1990er Jahre miterlebt und mitgeprägt hat, in
seinen eigenen Worten, «he experienced, encountered, created, and
lived glamour for over fifty years beginning with the baths he shared

171

with his beloved and beautiful mother from the ages three through nine years old, and continuing with his personal Italian stallion foot fetishist who performed as such usually on early Sunday mornings as the sun was rising over the artists's East Village penthouse in the late 1990s in N.Y.C. Concurrent genealogies include being beaten into excellence by the genius Charles Ludlam, acting with the legendary Ondine in the revival of 'Glamour, Glory & Gold', consuming cocktails with Jackie Curtis and Lucy on the swan bed on 14th Street, and moonlight rides with Alba Clemente.»

¬ Neben den Stücken aus der Sammlung Heys kam eine von den Kuratoren der Ausstellung getroffene Auswahl von Publikationen und Werken von Cecil Beaton, Man Ray, Edith Head, Gilles Larrain, Larry Levan, Jobriath, Meret Oppenheim, Shannon Bool, Mark Leckey, Rosa von Praunheim, General Idea, Jeffrey Vallance, Wols und anderen. Der subjektive Griff in den Fundus des Glamour zog, gleich einem referentiellen Kraftzentrum, Linien in und durch die gesamte Ausstellung – die Andeutung eines Archivs, die Vorstufe eines Werkzeugkastens, auch Materialien für Thesen über die Vielfalt der Genealogien des Glamourösen, den Surrealismus ebenso durchquerend wie die *Camp*-Ästhetik und queere Popkulturen.

–

Hommage

–

Untrennbar mit dem archivalischen Zugriff verbunden ist die Hommage – jene Form der Erinnerung und Verehrung, die mit dem Wunsch einhergeht, die betreffenden Personen im eigenen und kollektiven Gedächtnis dauerhaft einzutragen. In einem Pantheon zu eigenen Bedingungen hat Manon mit *La Stanza Delle Donne* (1990) achtzehn Frauen, von denen sie auf die eine oder andere Weise beeindruckt war und beeinflusst wurde (Nico, Vita Sackville-West, Jane Bowles und andere) in einem mit schwarzen Bühnenmolton ausgeschlagenen Raum je einen schwarzen Sockel mit schwarzen Schatullen gewidmet. Die Schatullen sind mit Seide ausgeschlagen, jeder Frau ist eine andere Farbe zugeordnet.

¬ Die Schwarzweissporträts prominenter Persönlichkeiten in der Serie *Ohne Titel* (2003) von Cerith Wyn Evans sind dem Bild-

lexikon «Portrait of a Greatness» von Yousouf Karsh aus dem Jahr 1959 entnommen. Die lexikalische Erfassung von «Grösse» und «Berühmtheit» ähnelt der Hommage, wobei die Registratur der Persönlichkeit in einem standardisierten Verfahren die Hommage gewissermassen entsubjektiviert. Auf dem (nicht sichtbaren) Verso der Fotografien sind Kurzbiografien zu lesen, die aber, der Text/Bild-Abfolge der Publikation verpflichtet, nicht mit den umseitig gedruckten Porträts korrespondieren. Evans' Interesse für die Zweidimensionalität und Materialität des bedruckten Papiers, die noch durch die kreisrunden *cut-outs* betont werden, korrespondiert mit der «Ambivalenz» der kulturellen Konstruktion von *celebrities*, hier von Vertretern unterschiedlicher kultureller und ästhetischer Felder wie den Regisseuren René Clair und Walt Disney, dem Dichter Robert Frost oder dem britischen Königspaar.

¬ Diana Vreeland, langjährige Chefredakteurin der US-amerikanischen *Vogue* und anerkannte Hohepriesterin des *chic*, wurde 1975 von Peter Hujar (1934 – 1987) in ihrer Wohnung fotografiert, so dass sich Porträt und Hommage ergänzen. Hujar war in den 1970er und 1980er Jahren mit Robert Mapplethorpe und Nan Goldin der wichtigste Fotokünstler im Umfeld des Clubs Max's Kansas City und der Szene im East Village. Hujar setzte den queeren Underground New Yorks im Modus der klassischen Porträtfotografie ins Bild. Die Schwarzweissaufnahme von Vreeland, die ihrerseits zwischen Fashion-Overground und Underground-Boheme pendelte, bringt deren legendäre aristokratisch-richterliche Autorität zur Geltung, aber auch ihr Alter. Im Zusammenspiel mit dem gestreiften Bezug des Diwans und dem Muster des Kleides entsteht eine komplexe Verbindung von Persönlichkeitsmerkmalen und dekorativen Elementen.

¬ *An Embroidered Trilogy* (1997 – 1999) ist eine Videoinstallation von Francesco Vezzoli, bestehend aus drei Filmen, die von drei RegisseurInnen (John Maybury, Lina Wertmüller, Carlo Di Palma) gedreht wurden und die drei italienischen *grandes dames* huldigen: Iva Zanicchi, Gastgeberin der TV-Gameshow «OK! The Prize Is Right»; der Komikerin Franca Valeri, die sich auf theatralische Parodien von Schauspielerinnen wie Silvana Mangano spezialisiert hat; sowie

Valentina Cortese, einer quintessentiellen Diva, als die sie z. B. 1973 in François Truffauts «Die amerikanische Nacht» auftrat. In allen drei Filmen befindet sich der junge Künstler im gleichen Raum wie die verehrten Frauen. Während diese singen oder sich zu Popsongs in theatralische, auch verzweifelte Posen werfen, sitzt Vezzoli konzentriert, in stiller Verehrung über seine Stickarbeit gebeugt. «Ich glaube, es hat etwas mit meiner Besessenheit mit Schönheit, meiner Sehnsucht nach Liebe, meiner homosexuellen Identität zu tun», antwortet Vezzoli auf die Frage, warum er sich so hingebungsvoll der Kunststickerei widmet. Die opulenten Interieurs der Filme werden zu Orten einer utopischen Intimität von Star und Fan. Methodisch schreitet Vezzoli von der Verehrung zur Kooperation, indem er die symbolischen Frauengestalten des Kinos, der Oper und des Fernsehens davon überzeugt, an seinen Fantasien teilzuhaben. Diese Fantasien bedienen offenbar sehr gezielt die Klischees vom weiblichen Masochismus und weiblicher Selbstaufopferung, aber Vezzoli setzt diesem Stereotyp seine offensive Verehrung entgegen.

¬ Auch *Francesco by Francesco* (2002), Vezzolis Zusammenarbeit mit Francesco Scavullo (1929–2004), entsprang dem Wunsch, ein Idol in die eigene Produktion zu integrieren. Scavullo war ein Meister des fotografischen Glamours. Drei Jahrzehnte betreute er als verantwortlicher Fotograf das monatliche Coverfoto von *Cosmopolitan,* arbeitete aber auch – neben grossen Auftraggebern wie *Vogue* oder *Harper's Bazaar* – in den 1970er Jahren früh für Andy Warhols *Interview.* Francesco Scavullo hat sich seit den 1940er Jahren virtuos der verschiedenen Glamour-Idiome bedient, bis sein Stil so entwickelt war, dass Glamourisierung und «Scavulloisierung» allgemein als Synonyme angesehen wurden. In der Ausstellung waren Beispiele seiner Arbeit mit Pop- und Undergroundstars (Divine, David Bowie, Grace Jones, Candy Darling, Bette Midler u.a.) vertreten.

–

Kritik des öffentlichen Schönheitsbildes

–

Während ein Fotograf wie Scavullo ein Leben lang als Autor an der Entwicklung der Schönheitsnorm arbeitete, stellt sich die Lage auf der

Seite der von dieser wechselnden Norm ideologisch angerufenen und unterworfenen, das heisst «subjektivierten» Individuen anders dar.

¬ Eine bedeutende Rolle für die feministische Medienkunst und Repräsentationskritik spielt seit den 1970er Jahren Sanja Iveković. Im Unterschied zu den meisten anderen KünstlerInnen dieser Ausstellung kommt Iveković nicht aus einem US-amerikanischen oder westeuropäischen Kontext, sondern begann ihre Karriere im sozialistischen Jugoslawien Titos. Ihre hier gezeigten Collageserien *Eight Tears* (1976) und *Before and After* (1976) sowie das Video *Make Up – Make Down* (1976) befassen sich mit der kapitalistischen Produktion von Bildern der Weiblichkeit durch Werbung und Kosmetikindustrie, die auch im Zagreb der 1970er Jahre nicht von der Hand zu weisen war. Iveković konfrontiert das Helena-Rubinstein-Gesicht, an dem eine dekorative Träne herabläuft, mit kleinen, ebenfalls den illustrierten Magazinen entnommenen Sinnbildern für «Mutterschaft», «Familie» oder «Beruf»; sie verwirrt das Werbeversprechen von der Perfektionierung des Aussehens mittels kosmetischer Massnahmen mit Bildern, die dessen Vorher/Nachher-Logik dementieren; und im Video zeigt sie die tägliche, aufwendige, auch rituelle Arbeit bei der Herstellung eines «weiblichen» Gesichts, ohne dass dieses noch zu sehen wäre.

¬ Welche Alltagserfahrungen Frauen, die Perücken tragen, in der türkischen Gesellschaft machen, ist Gegenstand der Videoinstallation *Women Who Wear Wigs* (1999) von Kutlug Ataman. In vier simultanen Projektionen berichten die Frauen über die unterschiedlichen Gründe für ihr Ersatzhaar (die Folgen einer Chemotherapie, die Maskerade einer Regimekritikerin, die Arbeit als transsexuelle Prostituierte und die Notwendigkeit für eine Muslimin, an einer türkischen Universität ohne Kopftuch studieren zu müssen). Für Ataman liefern die mündlichen Berichte seiner Gesprächspartnerinnen die eigentliche Geschichtsschreibung der gesellschaftlichen Normen. Die Perücke kann zum Versteck der Identität werden, aber auch ein Mittel, den herrschenden Vorstellungen von Attraktivität zu genügen. Sie ist in den vier Erzählungen eine Prothese des Überlebens, ein Instrument der Anpassung, aber auch Hilfsmittel der Selbsttransformation.

¬ Daniele Buetti begibt sich in seinem Werkkomplex *Looking for Love* (1997–2004) in die Oberflächen der Magazinfotografie, in die Fotomodell-Häute, um ihnen hinterrücks Ornamente, Logos und Markennamen einzugravieren, die wie ritualistische Narben, neotribalistische *brandings* oder wirklich schlimme Verletzungen aussehen. Die unberührte Mimik der Fotografierten kontrastiert mit den offensichtlich «schmerzhaften» Eingriffen. Die subkutane Tätowierung scheint gar nicht bemerkt zu werden oder längst verkraftet zu sein. Buetti hat seine Frottagen wiederum abfotografiert, so dass die Oberfläche des Bildes unbeschadet erscheint und die Fotografien wieder in die Verwertungskreisläufe eintreten können.

¬ Eindringliche, fotorealistische Bilder von zweifelsfrei glamourösen Personen und Situationen hat Franz Gertsch in den 1970er Jahren gemalt. Als Beobachter und Chronist einer Gemeinschaft jugendlicher Bohemiens, die er oft im privaten Rahmen, bei der Vorbereitung aufs Ausgehen, beim Geniessen der eigenen Attraktivität zeigt (und auf monumentale Bildformate brachte), hat Gertsch – lange in ihrer Bedeutung unterschätzte – Bilder einer Generation zwischen Politisierung und Popkultur geschaffen. Das vergleichsweise kleine Porträt von *Irène III* (1981) lässt das Gesicht der Frau in nuancierter Ton-in-Ton-Malerei strahlen, die Helligkeit umfängt sie und scheint zugleich von ihr, einer früheren Zürcher Edelprostituierten, auszugehen.

¬ «Ich habe mich nie wirklich mit ‹Weiblichkeit› identifiziert; auch als ich als Fotomodell und Striptease-Tänzerin arbeitete, hatte ich nie das Gefühl, dass ich richtig hineinpasse», sagt Cosey Fanni Tutti. International bekannt geworden mit Throbbing Gristle, einer Industrial/Noise-Band, war sie bereits seit den frühen 1970er Jahren Mitglied der Performance/Mail-Art-Gruppe COUM, aus der später TG hervorgehen sollte. Mit sexuellen und politischen Überschreitungen, die 1976 in der skandalträchtigen Ausstellung «Prostitution» im Londoner ICA gipfelten, provozierte COUM die britische Kunstszene. *Life Forms (Detail)* (1973–1979) dokumentiert in jeweils drei Farbfotografien die Arbeitsfelder einer Performerin, die sowohl als Künstlerin wie auch als professionelle Stripperin und Nacktmodell tätig gewesen war. Dazu erläu-

tert Cosey Fanni Tutti auf drei Texttafeln ihre Situation auf diesen Feldern, die alle auf je eigene Weise die Institutionalisierung und Objektivierung von weiblichen Körpern und «Weiblichkeit» betreiben. Bezeichnenderweise hat der Begriff «Glamour» einen festen Ort in der Sexindustrie. Seit den 1940er Jahren wird Glamour mit Pinup-Fotografie assoziiert. Und heute dient *glamour photography* als Euphemismus für das Geschäft der Hardcore-Pornographie.

—

Coda

—

Etwas von der kategorischen Ambivalenz des Glamourkonzepts ist im Titel der Ausstellung angedeutet: Auf einem Billboard, das in einer der Schlussszenen des Paul-Verhoeven-Films *Robocop* (1987) im Hintergrund zu erkennen ist, kann man lesen: «The Future Has a Silver Lining», die Zukunft hat einen Silberstreif. Schwierig, sich noch eine silberne Zukunft auszumalen angesichts einer posthuman-apokalyptischen Science-Fiction-Stadtlandschaft, in der diese Botschaft wie ein Hohn oder aber ein letztes Aufbegehren utopischem Geistes prangt.

¬ Der stählerne, mattschimmernde Technokörper des Robocop repräsentiert einen zerstörerischen Glam, der alle anderen Glanzsorten absorbiert und vernichtet zu haben scheint, während die Zeile «The Future Has a Silver Lining» an das Versprechen einer Zukunft erinnert, die verheissungsvoll glänzt. Die utopische, ebenso wie die dystopische Dimension sind in den Erfahrungen von und mit Glamour stets kopräsent. Glamour verursacht immer (soziale, ökonomische, ästhetische) Kosten, die zu tragen häufig denen auferlegt ist, die sich am meisten nach ihm verzehren. Glamour ist ein Wechsel auf die Zukunft, der nur in einigen, den seltensten Fällen eingelöst werden kann.

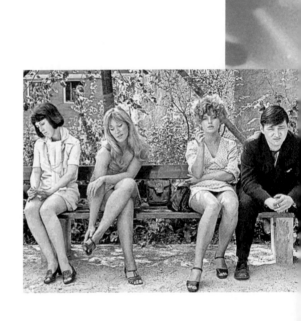

Von links nach rechts:
Coco Chanel ¬ Unbekannt ¬ *Naomi Sims Astride a Crocodile,* Fotograf: P. Beard ¬ Alain Delon ¬ Monica Vitti in *L'Avventura,* Regisseur:
M. Antonioni ¬ P. Pasolini ¬ Monica Vitti in *L'Avventura* ¬ Grace Jones ¬ Standfoto aus *Katzelmacher,* Regisseur: R. W. Fassbinder ¬
Roxy Music ¬ Standfoto, Regisseur: P. Pasolini

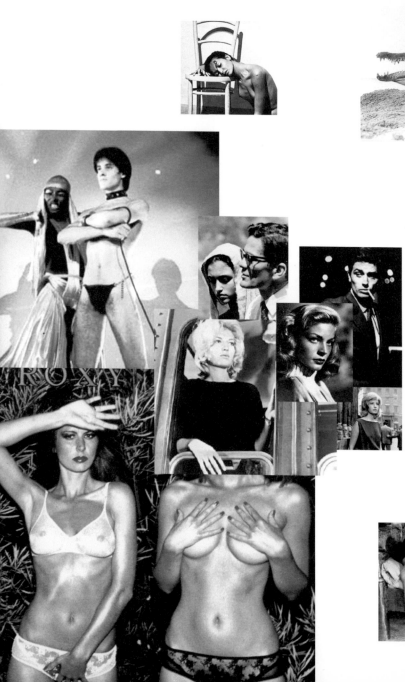

Ian Penman

–

OHNE ZEICHEN

Ich schrieb ihr:

¬ Ich habe den Überblick verloren, tatsächlich. Glaub mir, das ist kein Scherz.

¬ Ich habe an dieser Sache gearbeitet (an unserem Thema: Glamour), beinahe das ganze Jahr über, habe so viel Material zusammengetragen, dass es für ein ganzes Buch reicht – Notizen, Spekulationen, Fallstudien –, aber ich spüre, dass sie sich mir jeden Tag stärker entzieht, zu einer Art krankhaften Verirrung wird, die sich als endlos erweisen wird oder mich ganz und

gar verschlingen. Ich verliere mich immer wieder, Mal für Mal, wenn ich mich um jeden Preis an das Wesentliche der Sache erinnern will, wenn ich an den kleinen Schnittwunden sauge, die Papierkanten in meine Finger geritzt haben, Papierkanten in meine Finger geritzt haben, weil ich der körnigen Oberfläche zu nahe gekommen war…

¬ Ach, wie wünschte ich mir, Du, die Andere, wärst hier und wir könnten uns einen Film von Wong Kar-Wai ansehen und uns wenigstens auf dieses Eine verständigen (fällt Dir nicht auch *In The Mood For Love* ein, wenn ich das Wort «Glamour» sage?), und alles würde mir wieder so klar werden wie zuvor.

¬ (Was, wenn es beim Glamour etwas «Verdrängtes» gäbe, wenn dies eines jener Dinge wäre, gegen die ich arbeite oder die gegen mich arbeiten? Dann wäre sicher ein Ereignis wie der Selbstmord von Leslie Cheung das geeignete Objekt einer solchen Untersuchung, und wir könnten uns dem zuwenden, was wir tatsächlich am besten beherrschen: der Trauerarbeit. Welcher Film war das wieder, den Du so mochtest und den ich für Dich besorgen sollte? Er war von einer Regisseurin und die Art, wie sie die Körper junger Männer im klaren Licht der Mittagssonne Nordafrikas gefilmt hat… einen Moment lang hatte man den Eindruck, man sähe etwas Frisches, etwas Neues, Glamour gewissermassen von der anderen Seite aus betrachtet, aber es war kein klischeehafter Zugriff auf dieses prächtig asketische Thema…)

¬ Doch mir scheint, ich habe die Hoffnung darauf verloren, dieses strahlende Plastikding bergen und sie eine Nacht lang in irgendeinem sicheren Hafen für Begriffe festbinden zu können. Es ist, als versuchte ich, gegen den Wellenschlag anzuschreiben…

¬ Und plötzlich keine Antwort mehr von meiner entfernten Anderen, die sonst in solchen Momenten immer mit mir oder durch mich spricht. Letztes Jahr wollte sie gar nicht mehr aufhören, zu sprechen oder zu singen: von Andy Warhol, von Nina Simone, von Roxy Music – jeweils auf ihre Weise exemplarische Formen von Glamour. Dann, Mitte September, brach sie einfach ab, ohne dass ich einen Seufzer der Erschöpfung gehört hätte. Und seither ist sie verstummt. Ich weiss nicht, warum sie nicht mehr da ist; mein Gefühl sagt mir, dass es irgendwas mit einer Art Überlastung zu tun hat oder mit einer Überdosis; oder mit etwas, das Derrida vielleicht (mit aller Vorsicht vermutet) eine «Apokalypse» des Glamour nennen würde. Möglich, dass mich letztlich allein schon mein Versuch, den Kampf aufzunehmen, erledigt hat: Ich hätte wohl meinen normalen (trivialen, popkulturellen, glamourösen) Beat niemals verlassen dürfen. Das Gerede über Enthauptungen und Folter und menschliche Überreste macht mich krank, wirklich krank. Ich hab das Gefühl, dass alles wegrutscht und…

¬ Jeder Versuch, mich auf ein Bildnis von Glamour zu konzentrieren, wird von jenen anderen Bildern aus dem Irak zugeschüttet. Heute: das Online-Video einer Enthauptung. Das Feilschen um die Überbleibsel. Hunde, die nach Genitalien schnappen. Hier geschieht etwas von weitläufigerer Bedeutung – das Einläuten eines neuen Zeitalters, in dem aus dem so genannten «Krieg» ein Wettkampf der Bilder wird, ein Wettkampf der Filme, der Videos, der Inszenierungen, der Gelegenheiten. Zeitgleich mit der Epoche des «nu glamor», des «neuen Glamour». Oder ist das ein und dasselbe? Zwei Seiten derselben epochalen Wende? GLAMWAR.

●

Ich gebe zu, ich bin versucht, für immer zu verschwinden, irgendwann in naher Zukunft, ohne Spuren zu hinterlassen. Ehrlich gesagt, ist das ein Gedanke, der mir zurzeit Erleichterung verschafft; auch wenn ausgerechnet Du weisst, dass Ehrlichkeit kaum meine starke Seite war. (Kann man überhaupt «ehrlich» sein und gleichzeitig Glamour lieben?) Erinnerst Du Dich an meine Chet-Baker-Anekdote? Über die falschen Tränen? Lang, lang ist's her, das war genau meine Vorstellung von dunklem Glamour (der mir, zugegebenermassen, nicht besonders gut steht). Aber dann hast Du… ach, nein, dies ist vermutlich nicht der richtige Ort für solche Bekenntnisse, für solche «Ehrlichkeit»! Und schon gar nicht, bis wir uns über die grundlegenden Begriffe einig geworden sind. (Wie auch immer. Wenn eines meiner grössten Probleme mit dem – von mir so bezeichneten – «nu glamor» sein unverdienter, aber nicht zu leugnender Status weltweiter Allgegenwart ist: Auf welche Art des Verschwindens könnte ich ihm denn überhaupt noch entrinnen?)

¬ Schon indem ich Deine Stimme nachahme, fühle ich mich wahrer; vielleicht könnte ich es dadurch sogar schaffen, diesen ungeheuren, ALLumfassenden Notizen ein bisschen Sinn zu entreissen. (Du würdest nicht glauben, wieviel ich jetzt schon abgespeichert habe: einen ganzen Ordner voll mit unseren geheimen E-Mails), alles aus diesem weltweiten Internichts, dieser Leere des Multitasking, dieser Ödnis, diesem allsehenden All – der grausame Weltenbann des «nu glamor» 2004 (findest Du nicht, da gehört ein TM-Zeichen dahinter, hier, am Ende von allem? Oder vielleicht sogar… als Ende von allem?)

●

Noch einmal, von einer anderen Seite her gesehen.

¬ Okay: Da kommen welche zu mir und sagen: DO YOU BELIEVE IN MAGIC?

¬ Und wie: Ich sage JA, ja zum GLAMOUR. Ich habe immer daran geglaubt. Jedenfalls bis vor ein paar Monaten, aber das ist eine andere Geschichte – und zwar genau diejenige, die ich hier (zweifellos vergeblich) zu erzählen versuche. Ich glaube, es ist genau der

Unterschied, der mich von vornherein scheitern lässt. Denn zuvor hatte ich nie Schwierigkeiten bei der Vereinnahmung einer bestimmten Auffassung von Glamour. Doch jetzt – wo Glamour zu etwas Globalem, Gegebenem, Erwartetem, Vorhersehbarem geworden ist, zu etwas, das Profis auf jede beliebige Leerfläche auftragen, das pure Oberfläche ist und keinerlei Subtext aufweist… nun ja, es kommt mir jedenfalls so vor, als gebe es in diesem Bereich keine Subjektposition mehr, aus der heraus ich mich bequem zu Wort melden wollte. Früher konnte ich Gemeinsamkeiten mit mir so fernen Adressen finden wie: Genet oder Pasolini oder Nina Simone oder Grace Jones… denn schliesslich schuf uns «glamour» den Raum, in dem wir unsere gegenseitigen Wünsche in Echos unserer eigenen Wünsche übersetzen konnten.

¬ Also, wie viele?

Beginnen wir mit drei breiten Strichen, mindestens.

¬ GLAMOUR,

wie in der Theorie und Praxis der ZAUBEREI.

¬ (Wozu ich mich, wie es üblich ist, nicht äussern werde. Aber, na, Du weisst schon: von Doctor Dee über Aleister Crowley bis Coil: Du weisst schon. Und falls nicht… na ja, wie Du noch sehen wirst, dreht sich alles darum, wie Du durch eigene Anstrengung hierher oder dorthin gelangst. In dieser Hinsicht könnte sich die Kontaktaufnahme mit Deinem «glamour» als das Schwierigste erweisen, was Du je tun wirst, die am härtesten errungene Sache der Welt: in dieser Welt oder der nächsten oder irgendeiner anderen. Wir werden unweigerlich noch einmal zu diesem Punkt zurückkehren. Oder wir werden erleben, wie dieser Punkt sich als Holzweg herausstellt.)

¬ GLAMOUR,

wie auch in den populären Werken und Wirkungen der VERZAUBERUNG.

¬ …von denen Du, bist Du ihnen erst einmal verfallen, Dein Leben lang besessen sein wirst. In meinem Fall also etwa: Billie Holiday, Film Noir, Francis Bacon, Fassbinder, die ersten drei Alben von Roxy Music und so fort. Soweit ich das sagen kann, sind das alles Dinge, VON DENEN ICH MICH NIE WIEDER ERHOLEN WERDE. Für den Rest meines Lebens werde ich ein Verfolgter sein. (Und das mit Freuden: Ein solcher «glamour» kann, unter anderem, der sicherste Schutzschild auf der Welt sein.) Aber ja, JA, das Erarbeiten der Bedeutung und Erkennen jener Kräfte, die zu diesen frühen Verführungen führten, dürften mich leichthin (leichthin?) für den Rest meines zögernd voranschreitenden Lebens beschäftigen. Wie man von H nach… G gelangt. Oder von B nach… H. In der einen Minute wandert das Auge die Oberfläche eines erhabenen Bildes ab; in der nächsten wendet es sich zur oberen Ecke, das ganze Wesen des Glamour unrettbar aufgelöst, innerhalb von sechzig Sekunden, schiesst es sich in Deinen Arm… (Immerdasgleiche: Glamour kann auch Absturz sein, genau wie ein Blick nach OBEN.)

Aber solche Beispiele – Billies einzigartige, unnachahmliche, unerwartete Klangfarbe; Fassbinder nackt und verschreckt in seinem Beitrag im Film *Deutschland im Herbst* – lösen noch immer etwas in mir aus, es ist mir fast unmöglich, das zu übergehen. Dass diese Worte hier und heute so unwahrscheinlich (und überstark) klingen, ist zumindest ein eindeutiges Resultat. Was Glamour eben sein kann: das Herausholen einer intimen Klangfarbe, DIE VOLLSTÄNDIG DIR ENTSPRICHT.

¬ GLAMOUR,

wie auch in… tja: Dir, meine Liebe!

¬ «You're highbrow, holy/With lots of soul/Melancholy… shimmering» («Du bist intellektuell, heilig/ mit einer Menge Wehmut… schimmernd»).

Anders gesagt, so anders wie nur menschenmöglich – das, was man früher das «echte» oder das «eigene» Leben nannte. Wo ich Dir in die Augen geschaut habe, mich so bewegt habe, um Deine nächste Sonntagmorgenträne fortzuwischen, den Glamour plötzlich erkannt habe, den Glamour eines unglaublichen und überstrahlenden – nein, ich bin einfach nicht bereit, das offenzulegen: nicht hier und nicht jetzt. Glamour als Wunde im Gesicht, als Klopfen in der Brust, als Stocken des Blutkreislaufs, keine Masken mehr ausser dieser EINEN MASKE, IN DER WIR UNS BEIDE WIEDERFINDEN, eine Spannung in unserer Erinnerung wie bei einem gerissenen Stromkabel, das ungeschützt und bedrohlich in die tintenrote Nacht baumelt…

¬ Ich erinnere mich an diese eine Nacht auf dem Rücksitz eines Taxis: Ich hatte etwas zu Dir gesagt und mich gleich gefragt, woher in aller Welt diese Worte kamen. Als hätte allein Dein Gesicht diese völlig unbedachten und verblüffenden Worte aus mir herausgezogen und -gelockt, und mit ihnen bildete sich gleich ein neues «Ich» heran, wie bei einem Stern, der seine eigene Galaxie hervorbringt. In einer anderen Nacht, als ich Dir gerade die Chet-Baker-Anekdote erzählte, starrte ich Dir ernst in die Augen und war kurz vor meiner klingenden «Pointe» als… nein. Ich kann das nicht wiederholen, nicht ohne Deinen Glanz, der mich umgibt wie ein Wald aus gefährlicher, spaltbarer Hitze.

¬ Erinnerst Du Dich auch daran, wie wir *Eureka* gesehen haben? Hinterher trafen wir Nic Roeg: Er erinnerte sich noch wegen unseres fröhlich trunkenen Interviews an mich. Das war doch wohl wie «Triff den Zauberpriester» – oder? Solche Nächte sind nicht zu planen: Nächte, die sich, auch wenn sie tatsächlich zu Ende gehen, bei einem späteren Rückblick anfühlen, als hätten sie eigentlich auf einer bestimmten Ebene nie aufgehört und als würden sie das auch in Zukunft nicht tun: Ein seltsamer Lichtbogen, der die bekannten Naturgesetze Lügen straft…

¬ Ich habe das mulmige Gefühl (und spüre tatsächlich leichte Übelkeit im Magen), dass es nie wieder so gut werden wird wie damals. Keine *Eurekas* mehr, nie mehr: nein. Zufällig ist gerade letzte Woche eine

neue Kopie von *Performance* auf den Markt gekommen. Kannst Du Dir auch nur VORSTELLEN, dass irgendetwas in dieser Art heute gemacht würde? Beispielloser Glamour. Äusserster Fall von Einzigartigkeit. Ein Universum, aus eigener Vorstellungskraft geboren. Als reichte es, sich eine Welt vorzustellen, um sie ins Dasein zu rufen. Und ist das nicht auch etwas, das uns immer zu einer bestimmten Sorte Popkultur hingezogen hat? War nicht das die Hoffnung, das Versprechen, das Wagnis? Ganz sicher weiss ich, dass alles, was ich mir über bestimmte Glamourbegriffe vorstellen kann, in diesem einen überreichen, unerschöpflichen ZAUBERWERK von einem Film enthalten ist. Crowley, Anger, LSD, die Stones in ihrer Hochphase, Film als Verwünschung und Verzauberung, Polysexualität, das Durchschreiten des Spiegels… ein gefährliches Spiel mit diesen gewaltigen Mächten.

●

Ich schrieb ihr:

¬ Ich fühle mich vollends verdreht, bringe nichts mehr heraus: kein Treibstoff, kein Funke, kein Zauber. Hätte ich bloss die Kraft dazu, dann würde ich das auf Lacan übertragen, auf seine Theorie des Spiegelstadiums und des Blicks zwischen dem «Ich» und seinen Anderen, und wie diese Dynamik ihre dämonische Umsetzung in bestimmten machtvollen Werken des Glamour findet, in der Öffentlichkeit oder auf der Leinwand. Oder in Deinen Augen, wenn wir ineinander schauen und dort Fragen sehen, die in jedem anderen Raum unvorstellbar wären… oder auch, wenn dieser Austausch geschwächt ist, verkannt oder verloren –

¬ Für Dich selbst bist Du gerade SO weit weg. Du bist eine verlorene HOFFNUNG in meinem Innersten.

¬ Erinnerst Du Dich an diese sprechende, klingende Zeile aus «Mother of Pearl», Ferry feuert auf allen Zylindern, das ist jetzt etwa 30 Jahre her: «With every goddess a letdown/Every idol a bring down/It – gets – you – down.» Eine Geste, die sich anheischig macht, den Zauber einer bestimmten Art Glamour zu verleugnen und sich dadurch nur noch verführerischer glamourös macht (und zeigt)… (Wohin sind solche Subtexte verschwunden? Tja, die einfache Antwort lautet: Sie wurden ausbezahlt wie so viele andere Schuldverschreibungen auch. DI$KUTIERE!)

●

TYPISCHES BEISPIEL:

¬ Rita Hayworth hat einmal kleinlaut gesagt: «Sie gehen mit Gilda ins Bett, aber am nächsten Morgen wachen sie mit mir auf.»

¬ (Glamour als ein Köder, der sich umdreht, um Dich zu beissen, und der Dich, *GESTRANDET,* im

enttäuschenden Wirklichen des Morgens danach zurücklässt. Die enthüllte Wahrheit über die Frau als *drag* – in JEDER Hinsicht.)

¬ Hast Du gesehen? JORDAN [geborene Katie Price; ODER: Man setze hier eine Myriade anderer Namen ein] – das Model aus der täglichen Model-Chat-Show, einst «glamor»-Model, jetzt ein Vorzeige-«Glamour»-Model, hat gerade ihre Bekenntnisse veröffentlicht; Titel: «Being Jordan».

¬ Wie wäre es, wenn wir in der verbleibenden Zeit ausschliesslich über dieses «Sein» sprächen? Was ich meine: Ich glaube zu wissen – in welchem Sinn auch immer «Jordan» (der Name? die Person? das Markenzeichen? das Gerücht? das Abbild?) «Sein» hat – das könnte der einzige Ausgangspunkt der Analysen und Auseinandersetzungen werden in diesem Text über das Schicksal dessen, was wir früher einmal liebevoll *Glamour* genannt haben. (Wir verkleideten uns zu Hause, betrachteten uns im Spiegel und erblickten eine Vision von MACHT. Inzwischen ist die Welt eine Welt der UNENTRINNBAREN ÜBERWACHUNG geworden, so dass wir noch einmal GANZ VON VORN in neuen Glamour-Inszenierungen werden Zuflucht suchen müssen.)

¬ Jedenfalls könnte man ja annehmen, mit Jordan trete ein Fall vor uns, der zum leichten und einleuchtenden, sprechenden und lehrreichen Vergleich mit Rita/Gilda einlädt.

¬ Bis auf zwei Dinge. (Da haben wir's: Ja, so einfach ist das. Glamour, jetzt ein grosser, ganz grosser Scherz, lustiger als das SEIN selbst. Nichts als ein Gag wie die übergrossen Schuhe eines Clowns, oder eine Plastik… nase.) Der entscheidende Unterschied – Old Glamour vs nu glamor – besteht darin, dass Rita Hayworth eine echte Schauspielerin war, Gilda aber eine erfundene Rolle. (Und der Glamour kam dann aus dem Licht des anderen, des immateriellen Reichs, das in den materiellen Körper strömte.) «Jordan» dagegen ist eine Rolle, die im wirklichen Leben stattfindet: Es gibt für sie nicht die Alternative von «am Bildschirm» oder «nicht am Bildschirm». Es gibt überhaupt keinen Bildschirm, in ihrer oder in unserer Vorstellung. Kein Bildschirm, der eine Fantasie oder eine Schadenbegrenzung zuliesse, oder wilde, wilde Sehnsüchte jenseits irdischer Mühen. Stattdessen das «echte Leben» mitsamt der tödlichen Langeweile, das einem mit einer einzigen, jedoch zu Buche schlagenden Änderung angedreht wird (hier wird viel angedreht), auf der niedrigsten Ebene von Angebot und Nachfrage – als eine reibungsintensive «Sexiness», die dem Glamour genau all jenes Glitzern «abnimmt», ohne sich dessen ursprünglichem UNHEIMLICHEN Bogenschlag auch nur im mindesten annähern zu können…

¬ Jordan ist Gilda, die versucht, sich die Rolle von Rita Hayworth anzueignen: die versucht, in einen weniger erhabenen Bereich HINABZUSTEIGEN,

wo alles, was überhaupt wichtig ist, Gewicht selbst ist. Statt unsere grossen Erwartungen auf eine noch höhere Stufe zu bringen, fegt es sie in die Niederungen eines Kutschenfahrterlebnisses in trunkener Verzweiflung oder Selbstergebung herab: HIER! SCHAU DOCH, WIE GEMEIN ICH SEIN KANN! Und «Gag» kann man an dieser Stelle auch als Ersatzwort für den Freudschen Begriff der «Fehlleistung» oder Parapraxis verstehen: Was uns hier «nur» als eine Pointe präsentiert wird, ist in Wirklichkeit ein hochverschlüsselter Ausdruck bis zum Äussersten heruntergeschraubter Erwartungen: NICHTS GEHT MEHR! Die Ökonomie der Träume, zusammengedrängt auf einen NUR-NOCH-WENIGE-TAGE-Ausverkauf. Nepp, Abzocke, in jeder Schattierung des Wortes. Eine Enthüllung findet nicht statt, denn der Akt BEGINNT schon mit dem längst Entblössten. VOR DEINEN AUGEN, wie man heute als junger Dienstleister sagt. Glamour bezeichnete früher einmal die einmalige Verhüllung eines Gegenstands, die das geistige Auge in alle möglichen unvorhersehbaren Richtungen lenkte. Heute ist das eine aggressive, eine brutale Verkaufsstrategie. ALLES NACKT. Das kostbare Modell oder Paradigma des Glamour ist schliesslich nicht mehr, als es die beschönigende Beschreibung vom «GLAMOR MODEL» einmal bezeichnet hat.

¬ Das einzige, was an Jordan «dran ist», sind ihre eigenartig übergrossen Brüste: eine Fleisch gewordene, doppelte Plakatfront. (Gäbe es hier nur genügend Raum, dann könnten wir eine an Derrida angelehnte Diskussion führen: das Paar gegen das Eine: ob die «Vervollkommnung» oder Vergrösserung der Brüste nicht eigentlich – man nenne es, wie man will – Macht, Glamour, Schönheit verringert? Ob nicht ein gewisser machtvoller Glamourbegriff überhaupt erst aus dem Punctum verschleierter Unvollkommenheit[en] entstehen kann? Da wir, anders gesagt, des Gewöhnlichen bedürfen, bevor wir je zum angemessen unheimlichen Reich des «wahren» Glamour vordringen können.) Sie strahlen nichts aus, ziehen aber aller Augen in ihren Fluchtpunkt, ganz wie andere brutal rauschende MARKENZEICHEN. Wie ein optisches Folterinstrument: HIER MUSST DU HINSTARREN. Rita/Gilda (gewöhnlich > unheimlich; Morgenröte > Noir; gewöhnliche Schönheit > Glamour) hielt die Macht der Nacktheit noch für sich in Reserve. Es gab nicht einfach eine Website, kein Markenzeichen, keinen Namenszug. Der «Namenszug» war ein Raster oder eine Matrix aus Licht. Unstofflich, schwerelos: die Befreiung des zwanghaften Sehens. Unsere Sicht, zutiefst verstrickt in der Alltagswirklichkeit, wird mit einem Mal ERHOBEN, aufgesprengt, erleuchtet... andere Welten kommen ins Spiel. Der Wunsch ruft nach der Welt.

¬ Wenn man jetzt zu Jordan hinüberschaut, dann sieht man da ein «Reales», wie es unechter nicht vorstellbar ist. Nur dass es hier gar nicht um die Vorstellungskraft geht. Es geht eher um eine dürftige,

eingedickte Auffassung dessen, was MÄNNER TATSÄCHLICH WOLLEN. Innerhalb dieser zirkushaften Bühneninszenierung von Sexualität als Pawlowschem Speichelfluss – als EINseitigem Sehen – ist es eben ihre FALSCHHEIT, die als Verführung wirkt: Was man TATSÄCHLICH will. Was uns in die tief verwirrende Leere der Reflexion stösst, in der das offenbar gewordene Reale tatsächlich so über alle Massen UNWIRKLICH ist, dass... tja, wo sind wir hier eigentlich? Was sehen wir uns hier an? Was tun wir eigentlich hier? Mit welcher Ökonomie des Blicks haben wir es hier zu tun? (Mit einer, die einen an Ort und Stelle belässt, statt anderes oder anderswo zu denken? Ebenso wie sie, ökonomisch gesehen – und das müssen wir uns jederzeit als Gegenwirklichkeit ins Gedächtnis rufen – alles, was gestaltlos, unkontrollierbar, vielfach gewundene Unordnung des Begehrens war, zum plastischmnemonischen, randscharfen Markenzeichen werden lässt; und das ist kein reiner Zufall, innerhalb dessen, was wir die Herrschaft der Globalisierung nennen, nein, das glaube ich nicht.)

¬ Dieser auf Schlagzeilen fixierte «nu glamor» verlangt lediglich, dass wir anerkennen, dass es nichts anderes gibt als das tyrannisch anspruchslose Reale, dieses auf Effekte versessenen «nu glamor», der wiederum... Du kannst mir folgen? Eine Wiederholung, die sich zu einem perfekten runden O schliesst. Ein durch und durch leerer Wirbelsturm aus «Multitasking» und «Rebranding», in dessen Mitte sich eine riesige Leere verbirgt.

¬ Es geht hier aber auch nicht nur um die Girls: Da braucht man nur einem Quentin Tarantino zuzuhören, wie er seine beispiellose Fantasielosigkeit als den seit Jahrzehnten sehnlichst erwarteten Durchbruch im Filmgeschäft durchpeitscht. Schnitt auf den Schnitt... und die Wunde, das Aufschlitzen, die Blutfontäne und, ja, die Enthauptung. Keine Sorge – ist ja nur ein Film. Nur ein Cartoon. Ist ja nur Gewalt: Da ist nichts Heimliches, Heiliges oder Beunruhigendes zu vermuten. Muss man gar nicht erst so verpacken, dass wir eventuell zweimal nachdenken müssten: nichts als VERKAUFEN VERKAUFEN VERKAUFEN, rund um die Welt. Jahrzehnte filmischer Merkwürdigkeiten hastig zusammengerafft zu einer Handvoll leicht wiedererkennbarer Schnipsel, die als Markenzeichen taugen. Schnellimbiss-Film. Nichts, was des Nachts irgendeinem Unterbewussten irgendwas zu tun gäbe, nichts, das so wäre wie die Tränen, die sich in die schwarz/weissen Wangen einer Anna Karina eingraben. Quentins Vorstellung weiblicher Selbstermächtigung – ein heisser Feger in Rennfahrerklamotten, der eine mathematisch-pornografische Reihe von Köpfen abschlägt – erinnert ein bisschen an Britneys Überzeugung, «Dekonstruktion» sei, wenn man schon vor dem Auftritt wenig trägt, was man sich dann auf der Bühne noch ausziehen könnte. Britney und ihre Popschwestern GLAUBEN wirklich und wahrhaftig (und

das ist das Gruselige: Sie glauben das TATSÄCHLICH), dass ihr Herumhüpfen in klischeehafter Unterwäsche die absolute «Ermächtigung» bedeutet. So geht Britneys präpubertäres Publikum mit der entschiedenermassen abgenutzten Vorstellung nach Hause, man könne sich durchstrippen bis zur letztendlichen Befreiung. Ökonomische Erwägungen bleiben ohnehin aussen vor.

¬ Es GIBT aber tatsächlich eine tiefere, dunklere Bedeutungsebene, die sich hier verbirgt, und die eine Welt betrifft, die diese Kinder erben werden: Das ist die ökonomisch erschreckende Welt. Das Verzweifelte hinter jedem kleinen, kalkulierten Schockeffekt, dessen sich Britney bedient, legt davon Zeugnis ab. Ihre «Pseudo»-Hochzeit in Las Vegas kündet von einer Welt, in der man durchaus sein Innerstes zu verhökern hat, wenn man die Bedingungen eines schnell zurückgezogenen oder neu formulierten Vertrages erfüllen will. Popstars pflegten ja Wegwerfkultur zu erzeugen. Jetzt ist es die Wegwerfkultur, die ihre Popstars erzeugt (nach ihrem Ebenbilde). Die Botschaft, die hinter Popstar-Millionären lauert, die in ihrer schlingernden Laufbahn zur Erzeugung halbwegs spürbarer Markttreaktionen zu Stripperinnen-Taktiken Zuflucht nehmen müssen, IST tatsächlich erschreckend, wenn man sich nur eine ausreichend lange Pause gönnt, um darüber nachzudenken. Das macht aus dem vormals unerreichbaren Reich des Pop-Glamour die Entsprechung einer Frauenleiche, die jemand im mexikanischen Hinterland verscharrt hat. Etwas, das in den Händen anonymer Makler der Macht erschreckend wegwerfbar wirkt. Eine Botschaft, eine Warnung: Du bist nicht mehr wert als ein x-beliebiger Fleischfetzen, den man, wann und wo immer man will...

¬ KOMM ZUR WELT... das ist das eine. Aber «‹wirklich› werden... oder auf der Müllkippe landen» ist hier der eigentliche Subtext.

¬ *Klimper:* Bargeld ist das vermeintliche Allheilmittel; dabei ist exponierter Besitz bloss eine besondere Art, nicht zeigen zu müssen, dass man letztlich keine Angst hat vor dem grossen Kapital.

¬ In der seltsamen Logik des *Klimper* mag man sich beispielsweise in Flimmer und Knete, Brandy und Schampus für eine Million Dollar einwickeln... und trotzdem singt oder rappt man dann immer noch über eine Welt der Ludenlogik und der Nuttenökonomie. (Erschreckend... oder erschrocken?) HALT DICH AN DIE REALITÄT, das hört man überall – und ich könnte schon ein Buch über diese kleinen Wörter schreiben, so widersprüchlich, giftig, verwirrend und gefährlich sind sie.

¬ Seien es nun Jordan oder Britney (oder Condy?), auf die eine oder andere Art sind es doch immer wieder gewisse symbolisch ausweichende oder neblige oder zweischneidige Begriffe, die dominieren. Nicht der Glamour des Realen (all diese Momente in unseren Leben, in denen wir uns fühlen wie eine Million Dollar), sondern ein gewisser «glamor», der dich mit der Nase

mitten in die nüchterne Realität der BARGELD-Logik des Markts stösst. Entsprechend streben die heutigen Pop Kids gleich von vornherein nach dem ENDpunkt des Erfolgs, nach seinen äusseren Zeichen, ohne sich irgendwie näher damit abzuplagen, einen besonders anspruchsvollen, interessanten oder innovativen Weg dahin zu finden. Brot und Spiele. Blut und Unterwäsche. Lecks und Schüsse in den Schritt... und täglich ein neues Paar Turnschuhe, als Garantie für den Abstand.

¬ BLOSS KEIN FLECK AUF DEM REALEN. Und wenn das Reale fleckenfrei ist...

¬ Es gibt keinen Schirm mehr – keinen «Kontrollschirm der Fantasie». Es gibt keinen «fiktionalen» Bereich mehr, jenseits dessen dann irgendwo, vergraben (unter dem Bettlaken), das Reale läge. Lovely Rita hatte in diesem Sinne kein Markenzeichen – ausser ihrer «Aura»: der Aura des Glamour. So war es einmal: Rita hatte Glamour wie Indianer Rabenfedern. Das gab uns das Gefühl, es gäbe irgendwo noch Orte, an denen ein glaubhaft unglaubliches Licht scheine... Und anstelle dieses einen, symbolisch fixierten Bildschirms haben wir jetzt eine unbegrenzte Anzahl von Einzelschirmen, die nichts mehr ausblenden, weil sie alles und jedes einblenden können (immerwährende Bildschirmanzeige, unmittelbar, allgegenwärtig): Die Anstrengung der Läuterung ist in einen Zustand der Unordnung gefallen. Tückischer Seelenmakel des immer schon ENThüllten.

●

Ich schrieb ihr:

¬ Ich schätze, dass ich noch immer an das glaube, was Benjamin eine «profane Illumination» genannt hat: In weltlichen Fassungen eines verschobenen oder abgeschobenen Heiligen, das UNS DIE AUGEN ÖFFNEN kann, indem es unser «Ich» befreit.

¬ Meine anderen Namen kennst Du auch alle –

¬ (Erinnerst Du Dich? Wie ich einmal so hartnäckig versucht habe, Dir dieses Buch zu beschaffen, Klossowskis Buch über de Sade? Eine Erstausgabe, die ich, natürlich!, selbst gern besessen hätte. Doch es gibt da noch jenen grösseren Genuss des SCHENKENS – auch das gehört zu dem, was Glamour einmal war, glaube ich – etwas, das man umso mehr besass, je mehr es einem gelang, es FORTZUGEBEN. Einige Dinge entziehen sich der Berechnung – es gibt Formen glamourösen Austauschs, auf denen kein Preisschild klebt, die nicht in alten ökonomischen Szenarien aufgehen. Ich denke noch immer an Deine Finger (ich sehe sie noch) und Deine Augen in diesem Buch, als seien seine Seiten die Blätter von... nein.)

¬ «Oh mother of pearl:
I wouldn't trade you for another girl
Oh mother of pearl:
Lustrous lady of a sacred world.»

Also: In der halbwertvollen Zeit unserer schrumpfenden nu world hat sich Glamour in den Schatten von Jordans Brüsten verzogen. Wer will die denn schon? Die Leute – die «Öffentlichkeit», die sogenannte – scheint sie zu fordern; aber wir wissen doch auch, dies ist keineswegs dasselbe wie das, was alle Einzelnen als Einzelmomente erleben, in denen sie sich tatsächlich gewisse Kleinigkeiten in ihrer erfüllten, glorreichen und unvollkommen einzigartigen Existenz wünschen, oder? (Kein fairer Handel, oh nein.)

¬ Der neue «glamor» ist ein mitleidloses KOMM AUF DIE WELT, ohne jede zärtliche oder private Sprachregelung, und es sagt: Das hier IST alles, was es gibt. NA DANN… wach auf (und ZAHL DEINE RATE) zur «Wirklichkeit»: etwas Aufdringliches, gleich vor Deiner Nase, unausweichlich, aber irgendwie auch seltsam nah am Vergessenwerden; eine visuelle Fahrstuhlmusik, in gewisser Weise auch besessen von der Macht der Kriegspropaganda; 1001 Stückchen glitzernden Mülls. Eine kalte, niedrig brennende Flamme… für kalte, abgedimmte Zeiten. Der alte GLAMOUR war ein Schleier mit vielerlei Facetten; «nu glamor» dagegen ist ein Ding, das in einem Sack strampelt.

¬ Der alte Glamour war magisch, stand noch in direkter Verbindung zu Bittgebeten und Beschwörungen; zu alten Göttern und Göttinnen, die trotz der Jahrhunderte christlicher Unterdrückung hervorschimmern. Der neue glamor ist ein mieser Zaubertrick… ohne jeden Zauberer; keine Tauben; kein Schrankkoffer mit seiner wollüstigen Guillotine im Inneren, ohne überhaupt einen Schnitt: alles, was übriggeblieben ist – die halbnackte Assistentin, die mit den Armen wedelt, in einem völlig entleerten Raum pompös heraufbeschworener Entleibungsakte.

¬ Der alte Glamour bedeutete: etwa dieses Foto, das Dich erst nach und nach seinen zweiten Sinn erschliessen liess, doch war der zweite Sinn dann (auch) der endgültige; das Bild, das Dich zum Nachdenken brachte, durch das aus Fühlen Denken wurde, aus Denken Fühlen, eine grosse Leistung der Vergeistigung, etwas Unheimliches, nie Dagewesenes und Unvorhersehbares: ein Modefoto, das eher den Charakter eines Kunstwerks oder eines Traums oder eines Ödipusdramas hatte; ein Werbefoto, das eher den Eindruck einer zutiefst unorthodoxen Ikone zu vermitteln wusste; ein Hauptdarsteller, dessen verblüffende Gleichgültigkeit dem Feuer in seinen Augen Zunder gab…

¬ Dagegen nu glamor: ein apokalyptischer Hagel der Trivialitäten, Tausend identische Popstimmchen in identisch makelloser EINHEITLICHER Schlampenhaftigkeit, wie die Titelseite eines Käseblatts, das zwischen falschen Brüsten und gefälschten Kriegsbildern keinen Unterschied kennt…

¬ Der alte Glamour dagegen war… ach nein – besser hier und jetzt damit aufhören. ES ENTZIEHT SICH jedwelchem Definitionsversuch, jedem Versuch, seiner Herrschaft über unsere Lebenszeit Einhalt zu gebieten. Schon kurz nach meinem Versuch, eine Beschreibungsebene zu finden, siehe oben, setzt mein Unbehagen ein.

¬ DU KANNST ALL DAS SEIN, WAS DU SEIN WILLST… jetzt, da ich nicht mehr über Dich wache.

●

Wie hiess noch dieser französische Fotograf, der es Dir so angetan hatte? Es war ein Modefotograf der siebziger Jahre, aber seine Bilder hatten tatsächlich eine erotische Unheimlichkeit wie nur irgendetwas von Duchamp oder Klossowski. (Wie hiess der noch? Er ist schon tot, oder? Aber er lebt weiter… überall um uns herum, in verwässerten Versionen allerdings.) Das alles war so ödipal: daran erinnere ich mich noch. Seine Models waren wie Puppen: Puppen, die einen so erschreckten, dass es einen über die Klippe trieb… und einige dieser Bilder scheinen mir unvergesslich, ich ordne sie Dir zu, den seltsamen Nachmittagen, die wir miteinander verbrachten, natürlich, nur eine von vielen Arten, wie es gelingt, dass unsere allzu kurze gemeinsame Zeit sich ins Unendliche verlängern lässt, eine Art, die mich an einen Lieblingsausdruck von Blanchot erinnert: «die entfernte Nähe». Ist das nicht fast die Kurzformel, diese drei kleinen Wörter, für alles, was unter der schönen alten Legende des Glamour für uns verborgen lag? Die – entfernte – Nähe? Eines Tages werde ich allein im Auto vor einer roten Ampel sitzen und mich in eins dieser Bilder gleiten lassen: Deine elegante Hand, wie sie das Buch aufschlägt und dann… treten wir in diese andere Welt, in dieses andere Leben ein, wo – nein. Halt. Noch mal.

¬ Heute habe ich an der Kasse im Supermarkt, beim Warten auf meinen Akt der Überweisung und Extrapunktebezahlung, die feierlich arrangierten Titel der Zeitungen und der Klatschblätter abgescannt. Hier also unsere Welt von heute, in Stereo: In einer Zeitung wartet ein Mann darauf, dass man ihm den Kopf abhackt; und SHOCK STAR SWEAT PATCHES steht auf einem Magazin, das sinnigerweise HEAT heisst. HITZE. Sollte mit all dem nicht längst aufgeräumt worden sein – so zumindest hatte man uns doch so hochoffiziell unterrichtet (als hätte die jede Vorstellung überschreitende elfte Stunde auf ein NEUES elftes Gebot hingedeutet?) – nach dem 11. September? Ist nicht eher alles noch viel verzweifelter, viel verzweifelter allesfressend geworden?

¬ Dieses ganze Irakzeugs war mein Ende, das ist mir jetzt klar; und das ist auch ALLES, was ich sehe: jedes Mal, wenn ich für diesen Text versuche, mich nur auf Jordan oder Britney oder Beckham zu konzentrieren, kommen all die «Folter»-Bilder zu mir zurück. Und, schlimmer noch, es gibt Zeiten (zum Beispiel, wenn Britney ihre sexuell nicht eindeutig kodierten Tänzer in Paradeformation anführt, faschistische Perfektion: in Tarnanzug und G-String), wo ich mich

nicht mehr erinnere, was der Unterschied zwischen ihnen ist. Für mich sieht das alles aus wie Bilder AUS EIN UND DEMSELBEN KRIEG.

¬ Aus einem bestimmten Blickwinkel allerdings fragt sich, ob nicht das, was ich tue, auf meine eigene nette post-Baudrillardsche Art, nicht einfach ein weiterer Beitrag zu diesem ganzen «Stereo»-Durcheinander ist? Wenn ich sage, dass Britneys Roboter-Formationstanz des SEX-als-VERÄUSSERUNG eine ebenso grosse Bedrohung für westliche Ethikvorstellungen darstellt wie unser Verhalten im Irak? Ich weiss, weder Britney noch die Soldaten dort kann man wirklich individuell «verantwortlich» nennen: Sie folgen beide nur einem vorbestimmten SKRYPT… – und das, DAS ist irgendwie tausendmal schlimmer. Es ruft noch weit mehr die Aussicht auf ein trauriges MORGEN wach. Auf einen einzigen, weltgrossen MARKT: in Tarnanzug und/oder G-String (… Du weisst schon, was ich meine).

¬ Die Militarisierung von Sex? Die Sexualisierung des Krieges? Die Marktdurchdringung von Spionage und Überwachungstechniken? Unterhaltung als eine extrem verfeinerte Form der «Folter»? Britneys aktuelle Tournee, The Onyx Hotel, ist zum Beispiel NICHTS als ein Sperrfeuer verhältnisloser Schocks: und das sind keine Schocks, wie sie Kunst oder etwas glaubhaft Erotisches austeilen; sondern Schocks, die einen BETÄUBT zurücktaumeln lassen. Schock als so etwas wie visuell choreographierte «Folter»: Hieb Hieb Hieb; Schlag Schlag Schlag. Das gibt der Klage über die «Oberflächlichkeit» des Popwelt-Glamour einen ganz neuen und unangenehmen Beigeschmack: Es landet alles auf der Oberfläche, der Haut. Die Narben der Diven der Vergangenheit (Nina Simone, Aretha Franklin, Billie Holiday) blieben in unseren Seelen zurück. Das ist vorbei. Man schaue nur dieser Generation von selbsternannten Diven in die Augen (sie lassen «Diva» wie die Bezeichnung für einen Militärschlag klingen) und erschauere über das, was man dort antrifft: NICHTS. Schlimmer noch: Weltmarktbeherrschung FÜR nichts und wieder nichts. Für den Wert von Nichts. Zur Beförderung des Nichts. Für einen Nachgeschmack von Nichts. Denk nur an die Gewagtheit, die Schmerzhaftigkeit, die Ambitioniertheit der Lieder, die Nina Simone sang… und schau Dir dann nur das angeberische Robotergehabe dieser neuen (De-)Generation an. Denk an Britneys brutal zynisches «Hit Me»-Video, wo sie in diesem pornomässigen Schoolgirl-Röckchen herumtanzt – und dann stell Dir vor, starke, kampferprobte Frauen wie Aretha oder auch Grace Jones hätten so tief sinken können. Unmöglich. Das wäre nie durchgegangen! Sie behielten die Kleider an, und sie hatten einfach tausendmal mehr Macht. Hinter diesen geschlossenen Augen, hinter diesen verweigerten Leben lagen Geheimnis, Reserve und Myriaden unvorstellbarer Wunschfelder. Wir wussten nie, wohin sie uns entführen: Welche Welt sie uns vorstellbar machen würden. Von der Oberfläche bis hinauf zu den Sternen.

•

Okay. Zurück zum Zeichenbrett.

¬ Zu Zeiten, in denen alles immer schlimmer zu werden scheint, gelingt es uns kaum, uns so etwas wie den Glamour der Zukunft vorzustellen; also sinkt man zurück in modernistische Nostalgiebäder. Uns fällt Louise Brooks ein, Roxy Music, Walter Benjamin (ET AL…) und stellen uns vor: Dass es so etwas nie wieder geben wird.

¬ Aber genau darin liegt das Rettende, das siegreiche Paradoxon: Wenn Glamour überhaupt durch irgendetwas bestimmt ist, dann ist es WIEDERGÄNGEREI (was ganz und gar nicht dasselbe ist wie Wiederentdeckung), eine Geisterwissenschaft; und also unmöglich in irgendein Archiv des Vergangenen abzuspeichern. Seine Natur ist sein Fortleben (im Sinne der Logik des «Überlebens», wie sie Derrida skizziert hat). Und das SEHEN allein kann dem Geisterspuk kein Ende bereiten; darum kann Glamour nie versiegen: Es muss da irgendwo im Hintergrund immer noch mehr davon geben. (Zu weiteren versöhnlichen Aspekten modernistischer Nostalgie vgl. neuere Veröffentlichungen von Susan Buck-Morss und Sylviane Agacinski.)

¬ Es gibt immer mehr; es gibt immer ein «Zukünftiges» und/oder ein «Was bleibt»…

¬ Eine Austreibung der Nostalgie wird es nicht geben; sie garantiert eine bestimmte Art modernistischen Überlebens. Und wenn ich DOCH immer wieder auf bestimmte Gegenstände oder Richtungen zurückkomme – Benjamins «Kunstwerk im Zeitalter seiner technischen Reproduzierbarkeit»; das Roxy-Music-Album For Your Pleasure – dann ist das keine hilflos-hoffnungslose wehleidige ICH GEBE AUF-Nostalgie. Es ist vielmehr ein aktiv unerschrocken gegangener Umweg; unvollendet, weil unvollendbar; die eigentliche Trauerarbeit. Das Klischee trifft zu: Die wahre Liebe endet nie. Sie sucht einen heim und wird betrauert, aber es ist ein Trauern als Bekräftigung, unbegrenzte Gastfreundschaft, Geben/Nehmen/Wiederbelebung. Logik der GABE.

¬ Die Vorstellung, man könnte Glamour (oder auch das Unheimliche) etwa irgendwie BEHERRSCHEN, ist an sich schon vollkommen lä-cher-lich. Eine bestimmte Klangfarbe, eine ANSPRACHE des Anderen, des «Du», des TEUERSTEN, des Unersetzlichen, des IMMERDAR Unersetzlichen, der Beweis, dass Glamour nicht einfach irgendetwas Triviales ist, mit dem sich nur die Jugend oder die Hohlköpfe abgeben, dass es ein Lebenswerk ist –

¬ HIER STEHE ICH ALSO WIEDER IN MEINEM TRAUERGEWAND.

•

Gestern schaltete ich als kurze Ablenkung den Fernseher an, und da sehe ich in der Kinderstunde

diese aufgebretzelte junge Kinderfernsehmoderatorin,
gestylt (denn heute ist klarerweise jeder gestylt: Das
meinte ich ja mit dieser neuen Epoche des Glamour,
dieser Apokalypse des Glamour: es gibt nichts mehr,
das nicht schon fertiggestylt wäre, es gibt ein ALL,
ein Überall des Glamour, es ist bis zum letzten Zenti-
meter seines leeren Allesfresserlebens durchgestylt:
und natürlich, wenn Glamour überall ist, gibt mir das
ein Gefühl, als sei er in Wahrheit nirgends), tja, wie
ich schon sagte, click, und da ist dann dieses aufge-
bretzelte junge Moderatorengirl, das haargenau aussieht
wie jede andere hergelaufene aufgebretzelte junge
Moderatorin, jedes x-beliebige Girlgroup-Mitglied, jede
Schauspielerin (also glattes blondes Haar, ironisches
Nostalgie-T-Shirt, hipstermässige Vintage-Jeans) und
in diesem speziellen Fall sticht mir ihr pinkfarbenes
T-Shirt entgegen, als wollte es mich LÄCHERLICH
machen, mein ganzes Projekt ins Lächerliche ziehen,
meine erlesene und glanzvolle Vergangenheit,
meine Seele: ja –
¬ *GLAMOUR,* steht darauf gedruckt.

●

 Ich schrieb ihr:
¬ Weisst Du noch, wie Du mich in diesem Hotel-
zimmer am Ende der Welt darum gebeten hast, Dir
einen Hinweis darauf zu geben, was vermitteln kann,
wie ich mich selbst sehe? Ich habe geantwortet:
«Alain Delon in Godards *Nouvelle Vague,* vor allem
dieser wunderbare Moment, wenn sie ihn fragt, was er
so macht und er antwortet: ‹Ich ziehe den Hohn auf
mich›…»
¬ Damals hatte ich all diese – wie ich dachte –
glamourösen Vorstellungen von Märtyrertum, von
einem Heiligenleben, von der vollkommenen Indiffe-
renz – und Du hast mich da an Ort und Stelle in zwei
Hälften gespalten und mich AUF DEN BODEN zu-
rückgeholt, oder sagen wir lieber: nach Hause geholt,
hinein in einen Glamour, der auf dem beruht, was
man dem anderen hier und jetzt sagen kann, auf dem,
was man will, wirklich will – und seitdem hat sich
einfach alles aus dem entwickelt, was Du dann
gesagt hast:
¬ Du hast gesagt:…
¬ Ach, nein: Diese Worte gehören Dir ganz allein.
Eines Tages mögen sie vielleicht einmal von meinem
Grabstein hinablächeln wie eine zerpflückte Rose,
aber vorerst –
–

Übersetzung Clemens Krümmel

DEFINITION – TRANSGENDERISM

«Transgenderismus» ist der Oberbegriff
für die verschiedenen Wege, die Grenzen des (biologi-
schen und sozialen) Geschlechts zu überschreiten
und die eigene äussere Erscheinung und das eigene
Verhalten in Hinsicht auf Geschlechternormen zu verän-
dern. Zu den Transgendern zählen Cross-Dresser und
Leute in *drag;* Intersexuelle, die mit mehrdeutigen
oder multiplen Genitalien geboren wurden und die
sich – häufig gegen ihren Willen – einer Operation und/
oder Hormontherapie unterziehen; aber auch Transse-
xuelle, die eine solche chirurgische und/oder hormo-
nelle Veränderung auf eigenen Wunsch vornehmen las-
sen. Der Begriff umfasst gleichermassen Leute, die
öffentlich sichtbar sind (wie professionelle Drag- und
Transsexuellen-DarstellerInnen oder SprecherInnen
der jeweiligen Gemeinschaften), und solche, die öffent-
lich un-sichtbar sind (wie Leute, die ihren Transgen-
derismus erfolgreich verbergen, oder Leute, deren
Gender-Erscheinung für die Öffentlichkeit so überzeu-
gend ist, dass Fragen des Transgenderismus sich im
Alltag nicht stellen). Ich beziehe den Begriff auch auf
Leute, die sich sozial zu sehr unter Druck gesetzt
fühlen, als dass sie jemals ihre Wünsche, die eigene
Gender-Erscheinung zu verändern oder zu verwirren,
ausleben würden. Gewöhnlich wird solchen Leuten
von den Transgender-Communities vorgehalten, sie
würden sich verleugnen. In der Folge werden sie von
den Gemeinschaften so lange nicht vertreten oder über-
haupt als Transgender anerkannt, bis sie ein klares
Coming-Out-Interesse artikulieren oder eine physische
Geschlechtsumwandlung betreiben. Ich gehe davon
aus, dass wir «selbstaktualisierten» Transgender, die wir
unsere Wünsche physisch ausagieren, die Ausnahme
und nicht die Regel sind und dass die fortwährende
Selbstunterdrückung wohl die verbreitetste Form
von Transgender ist. Gewiss, solche spezifischen For-
men der Selbstunterdrückung werden in und durch die
Bedingungen der sozialen Unterdrückung erlernt.
Die «Legitimierung» der bestehenden Selbstunterdrück-
ung als einer Form von Transgender ist deshalb eine
wichtige Komplizierung der (nicht immer herausfor-
dernden) Beziehung von Transgender zu konventionel-
len Geschlechternormen, weil mit ihr auch die
Ängste und Gefahren reflektiert werden, die darin liegen,
öffentlich mit Gender-Tabus assoziiert zu werden.

– *Terre Thaemlitz*

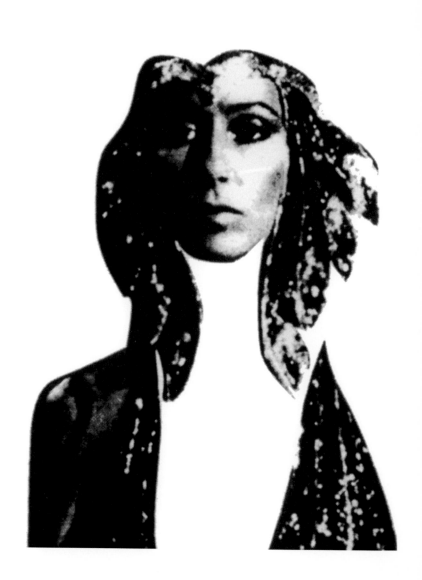

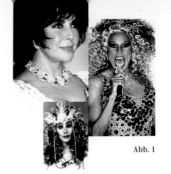

Abb. 1

Abb. 2

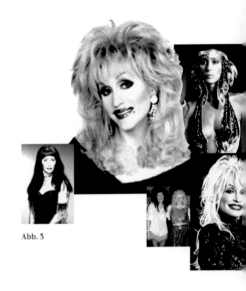

Abb. 3

Abb. 1
–
Glamour-Schatten:
Elizabeth Taylor, RuPaul und
Cher (von links nach rechts)

Abb. 2
–
Wen kümmert's? Merkwürdig,
irgendjemand, irgendwo…
Dolly Parton (links) mit profes-
sionellen Parton-DarstellerInnen

Abb. 3
–
Glamour-Implosion
(von links nach rechts):
Professioneller Transgender-
Cher-Darsteller, professioneller
Transgender-Dolly-Parton-
Darsteller, Cher, Dolly Parton,
selbstgestrickt-tragische Cher
und Dolly.

Abb. 4
–
Dem Thema Feuer geben: Anti-
Rauchen-Plakate der Amerikani-
schen Krebsgesellschaft, ca. 1970

Abb. 4

Terre Thaemlitz

—

VIVA McGLAM?

—

IST TRANSGENDER-SELBSTDAR-STELLUNG EINE KRITIK AN ODER DIE KAPITULATION VOR LUXUSFIXIERTEN GLAMOUR-MODELLEN?

Das englische Wort *glamour* hat seine Wurzeln im schottischen *grammar* im Sinne von *gramarye,* was soviel wie «Magie» bedeutet. Da dieser Text in Deutsch erscheinen soll, möchte ich mich nicht zu lange mit englischer Semantik aufhalten – ich glaube allerdings, das auch im deutschen Wort «zaubern» eine Beziehung zwischen Glamour und Magie mitschwingt bzw. angedeutet

ist. Sagen wir einfach, dass unsere Vorstellungen von Glamour weitestgehend immer noch um Bezauberung, Illusion, mysteriöse und schwer greifbare Faszination oder magische Anziehungskraft kreisen…
und, wie alles Magische, ist Glamour ebenfalls eng verknüpft mit Gaukelei, falschen Vorspiegelungen und Betrug. Jede Gesellschaft hat ihre Hohepriester des Glamour und ihre Zauberer und Zauberinnen – diejenigen, die sich mit Hilfe grösstenteils leerer/nichtiger Geheimnisse von anderen absetzen beziehungsweise über andere erheben. Im alten Westeuropa (?) waren das ursprünglich die heidnischen und nichtchristlichen in der «schwarzen Kunst» Bewanderten – Dorfälteste, Ratgeber und Heiler. Im Laufe der Jahrhunderte wurden sie durch christliche Magier, Priester und andere Erfüllungsgehilfen des Papstes abgelöst – nach wie vor der mächtigste und prunkvollste Magier von allen. *Gramarye* und Vergöttlichung spielten auch eine wichtige Rolle für den Machterhalt der herrschenden Klasse in der westlichen Zivilisation. Genau wie der Vatikan bediente sich die Oberschicht der Prachtentfaltung als Mittel, die unteren Klassen mit Einblicken in den Himmel auf Erden zu blenden – ein derart fremdländischer und unerreichbarer Lebensstil, dass er nur Ergebnis einer Vergöttlichung sein konnte. Es ist der Zauber dieser Prachtentfaltung, der unsere gegenwärtige Vorstellung von Glamour bestimmt, den wir eher mit Reichtum als mit Magie assoziieren. Diese Definitionsverschiebung vom Allegorischen zum Materiellen deckt sich mit Veränderungen darin, wie und zu welchem Zweck Magie eingesetzt wird. Sie markiert die «Zivilisierungsschlacht» in Westeuropa, über deren Brutalität wir an jedem 1. April lachen, wenn wir uns gegenseitig Streiche spielen. Kaum jemandem ist bewusst, dass auf den 1. April das traditionelle heidnische Neujahr fällt, einer der heiligsten Tage im vorchristlichen Kalender. Der Ausdruck *april fools* bezeichnet diejenigen, die diesen Tag feiern, also die Anhänger vorchristlicher Religionen. Der Brauch, sich in den April zu schicken, entstand aus der christlichen Tradition, Heiden zu verfolgen und deren Zusammenkünfte zu stören.

Dass darüber kein Zweifel aufkommt: Anders als viele meiner queeren Schwestern und Brüder habe ich keine romantische Neigung zum Heidentum, auch nicht zum Christentum oder anderen, die mit irgendwelchen Naturalismen oder Spiritualismen hausieren gehen. Für mich sind sie alle gleich öde und gleich gefährlich. Es steht allerdings ausser Frage, dass die historische Verfolgung von Heiden eindeutig mit der Verfolgung von «Sodomiten» und anderen «sexuell Abartigen» verknüpft war, die wir heute als Lesben oder Schwule bezeichnen würden und von denen viele als Hexen oder Hexer gefoltert und

ermordet wurden. Um noch einmal kurz auf englische Semantik zurückzukommen: Der Beleg dafür, wie oft «sexuell Abartige» öffentlich verbrannt wurden, ist die Tatsache, dass das britisch-englische Wort für einen kleinen Zweig oder Kienspan, *faggot*, sich als abfällige Bezeichnung für Lesben oder Schwule erhalten hat. In diesem Sinne ist die Geschichte von Glamour oder *gramarye* zugleich eine Geschichte der Verfolgung wie des Widerstands – zum luxusorientierten Glamour von heute gab es damit eine Art von Glamour, der zumindest eine Zeitlang als Bedrohung für Monotheismus, Klassenherrschaft und die neu aufkommenden Gesellschaftsordnungen, die im heutigen postindustriellen Kapitalismus mündeten, galt. Wenn wir die historischen und sozialen Fuktionen von Glamour erörtern, gehören dazu nicht nur der Gegensatz zwischen dem Glamourösen und Unglamourösen, sondern auch seit langem bestehende Gegensätze zwischen verschiedenen Formen von *gramarye* selbst. In ein und derselben Gesellschaft finden wir zahlreiche historische Gemeinsamkeiten und Konflikte. In den *queer communities* spiegelt sich diese historische Vielfalt ebenfalls wieder, von affektierten *glam-queens* bis zu Heiler-Performern à la AA Bronson.

Mir als Transgender stellen sich, wenn ich über das Verhältnis zwischen Glamour und Transgender nachdenke, gewisse Fragen: Hat Glamour unbedingt etwas mit Gender-Selbstdarstellung zu tun? Ist *glam* bei Transgendern eine Kritik an oder die reine Kapitulation vor der sozialen Einseitigkeit eines luxusbesessenen Haute-Couture-Glamours? Wenn man bedenkt, dass es der Mehrheit sowohl der Mann-zu-Frau-Transgender (MzFs) wie der Frauen nicht gegeben ist, sich ein Glamour-Image zuzulegen, und die feministische visuelle Theorie viele soziale Prozesse hinter der Darstellung des weiblichen Körpers aufgedeckt hat, können diese Theorien da auch die Darstellung/Repräsentation von Transgender-Körpern erklären?
–

Hat Glamour unbedingt etwas mit Gender-Selbstdarstellung zu tun?
–

Frag irgendeinen X-Beliebigen nach irgendwem, den er glamourös findet, und er wird mit hoher Wahrscheinlichkeit eine Frau nennen – vielleicht eine Schauspielerin, eine Sängerin, einen Showstar oder eine Angehörige der königlichen Familie. Man darf also wohl davon ausgehen, dass Glamour heute weitgehend eher mit femininem Image als mit maskulinem Image verbunden wird und darin ein Konstrukt von Weiblichkeit ist – und eine feministische Streitfrage. Die Kritik vieler Mainstream-Feministinnen an unrealistischen weiblichen

Schönheitsidealen hat sich immer gegen die Idee von Glamour gerichtet, besonders gegen die Art und Weise, wie Glamour in den Medien zum Einsatz kommt, um den weiblichen Körper zum Objekt zu machen. In ähnlicher Weise hat feministische Kunst besonders eine antiglamouröse Bildersprache herangezogen, um Glamour zu neutralisieren und den weiblichen Körper in unspektakulär-prosaischer Weise darzustellen (wie Yve Lomax und Mary Yates), oder der magischen Anziehungskraft des Glamour kunstvolle Antibilder grotesker Deformierungen entgegengesetzt (wie die Fotos von Cindy Sherman aus den frühen 1990er Jahren). Die wenigen Männer dagegen, die wir mit Glamour verbinden, werden ebenfalls weitgehend mit einem femininen Image assoziiert, von Dandys bis zu Glam Rockern. Wenn wir an Männer mit Glamour denken, denken wir an Modedesigner, Hairstylisten, Schauspieler, Musiker, Künstler und Männer jedes anderen Berufs, bei dem man ein starkes Übergewicht an exaltierten Tucken unterstellt. Ja, meine Lieben, ich glaube, man darf mit Sicherheit behaupten, dass der moderne luxusbesessene Glamour ins Feminine lappt – eine Tatsache, die dann bedeutsam wird, wenn wir über die Beziehung zwischen Glamour und Körper nachdenken und versuchen, diese Beziehung kritisch zu analysieren oder für uns nutzbar zu machen.

Es ist nicht zu übersehen, dass innerhalb der Transgender-Communities die Vorstellung von Glamour fast ausschliesslich mit MzFs und femininem Image assoziiert wird. Die Verbindung zwischen MzFs und Glamour rührt zum Teil von alten Traditionen her, die Frauen öffentliche Bühnenauftritte untersagten, wodurch es erforderlich war, dass alle weiblichen Rollen von Männern gespielt wurden. Die Extravaganz des Theaters bot MzFs historisch einen kulturell akzeptablen Punkt kultureller Sichtbarkeit, auch wenn diese Akzeptanz auf die Bühne beschränkt blieb. Die Geschichte der Frau-zu-Mann-Kultur (FzM-Kultur) hat dagegen wenig mit Glamour zu tun. Die FzM-Kultur beschränkt sich hauptsächlich darauf, dass Frauen als Männer «durchzugehen» versuchen, etwa in Männerberufen oder in der Armee – das sogenannte *passing*. Während sich viele Elemente der MzF-Kultur im Zusammenhang mit Ideen von Spektakel und Parodien von Weiblichkeit entwickelten, entwickelte sich die FzM-Kultur im Rahmen des Antispektakulären und der Assimilation an Männlichkeit. Die Probleme des *passing* unter FzMs unterscheiden sich auch darin von denen der MzFs, dass sie eng an den Kampf um das Recht auf Arbeit und Privatbesitz für Frauen gekoppelt sind. Die Requisiten, die erforderlich sind, wenn FzMs sich der männlichen Arbeiterklasse anzuschliessen versuchen (im typischen Fall, indem sie sich in eine ökonomisch

schwache, körperliche Arbeit leistende Arbeiterklasse einreihen), sind deutlich andere als die, deren sich MzFs bedienen, von denen viele im Alltag ohnehin bereits dieser männlichen Arbeiterklasse angehören. Als materielle Strategie zur Transformation des Körpers kommt Glamour daher in FzM-Communities kaum zum Tragen. Darüber hinaus lehnen FzMs normalerweise jeden femininen Schnickschnack wie Abendkleider, Accessoires, Schmuck, Kosmetik und ähnliches ab. Selbst wenn FzMs sich gewisser Zeichen von Luxus bedienen, wie in der Kultur der Onabe in Japan, lesbische Wirtinnen in edlen Herrenanzügen, die Getränke an ihre feminin gekleideten weiblichen Gäste ausschenken, liegt ihre Magie darin, wie überzeugend sie sich als «ganz normaler Mann» präsentieren. Das ist eine Illusion ganz anderer Art, als Glamour sie bietet, der mit dem Image von etwas Irrealem oder Unerreichbarem arbeitet. Daher ist bei Diskussionen über Glamour die Abwesenheit von FzM-Content komplexer als MzF-Show-Queens, die sich ins Rampenlicht drängen (es ist wichtig, dies festzuhalten, weil die Dominanz von MzF-Fragen in den meisten Diskussionen unter Transgendern einen gewissen Grad von «männlicher» Vorherrschaft und Frauenfeindlichkeit in Transgender-Communities hineinträgt). Das Scheinwerferlicht auf MzFs mag aus dem Publikum warm und freundlich aussehen, aber auf der Bühne kann es versengen, blossstellen und vor allem blenden.

–

<u>Ist Camp-Glam eine Kritik an oder reine Kapitulation vor der sozialen Einseitigkeit eines luxusorientierten Haute-Couture-Glamours?</u>

–

Heutzutage sind die Tunten die Bewahrer des Glamour. Die Diven. Die Drag Queens und MzF-Transsexuellen. Innerhalb dieser Communities beschlich mich immer ein gewisses Unbehagen angesichts einer weitverbreiteten Tendenz, unser eigene Vorstellung von *gramarye* in eine billige Imitation der «wirklich Glamourösen» zu fassen – Prominente und Models, deren magische Anziehungskraft auf dem Zauber des Luxus beruht. Es fällt auf, dass die *gramarye* einiger Magier mächtiger ist als die von anderen, abhängig vom sozialen System, aus dem sie ihre Repräsentationsmacht beziehen. In diesem Sinne sind Transgender-Communities nur bedingt glamourös. Die meisten Menschen würden zustimmen, dass die Schauspielerin Elizabeth Taylor einen wahrhaft glamourösen Lebensstil hat, wohingegen Transgender, Sängerin und Celebrity RuPaul eine andere Art von Glamour beschwört. (Die Quelle von Chers Macht dürfte irgendwo dazwischen zu lokalisieren sein.) [Abb. 1] RuPaul operiert zwar in Celebritykreisen, aber ihr

offenes Transgendertum und ihre Homosexualität lassen etwas Übergreifendes und Betrügerisches an ihrem Glamour durchblicken. Trotz RuPauls «Echtheit» ist das Image von Glamour, das sie vermittelt, nie so «echt» wie das von Liz – RuPauls Popauftreten erzeugt Zweifel und Spannungen, die möglicherweise auf eine früher einmal dagewesene Bedrohung hindeuten – einen historischen Konflikt zwischen den *gramaryes*, durch die der Transgenderkörper sowohl «Aussenseiter» wie «Verlierer» wurde. So gesehen, offenbart die Pop-Glam-Diva ein Moment der Destabilisierung, eine soziale Infiltration, die eine kurze Infragestellung der Macht erkennen lässt, und in diesem aufblitzenden Infragestellen steckt vielleicht irgendwo das Potenzial zum Widerstand... So ähnlich wird es uns jedenfalls immer gesagt.

Uns wird gesagt, dass wenn irgendeine Drag Queen den Status einer Popcelebrity errungen hat (heterosexuelle männliche Komiker in Frauenkleider beiseite gelassen), dies automatisch die herrschende Kultur in Frage stellen würde und damit ein fabelhafter Anlass zum Feiern wäre. Es ist gewissermassen ein Markenzeichen der Gay-and-Lesbian-Pride-Bewegung. Es ist ein Anzeichen für die zunehmende öffentliche Akzeptanz der Anliegen von Queers und Transgendern. Es ist der Beweis, dass wir es «geschafft haben» (eine Deklaration des Angekommenseins, von der ich immer schon fand, dass sie mit der anderen omnipräsenten Schwulen-und-Lesben-Losung «wir sind überall» nicht ganz vereinbar ist). Aber ist das tatsächlich so? Solange die öffentliche Akzeptanz einer MzF nach ihrer Fähigkeit gemessen wird, glamourösen Anforderungen an Körper und Stil gerecht zu werden, die für die meisten «echten» Frauen unerreichbar bleiben, bitte ich euch, dem Transgender-Verfasser nachzusehen, dass er sich durch RuPaul nicht *mehr* repräsentiert fühlt, als meine Mutter sich durch Marilyn Monroe oder Prinzessin Di repräsentiert fühlt.

Glamour ist ein zweifelhaftes Forum für kritische Politik, weil er soziale Distanz, nicht soziale Integration bedeutet. Das Versprechen der Pop-Glam-Diva ist nicht das Versprechen auf soziale Transformation, sondern auf individuelle Transformation, durch die der Ausgebeutete zum Ausbeuter wird. Es ist das Versprechen der sozialen Mobilität der/des Einzelnen, keine soziale Verbesserung oder Kritik an der Klassengesellschaft. Es ist mehr oder weniger der «amerikanische Traum». Ein Traum, dessen Zauber nicht auf die seltsamen Lebensziele einer Transgender-Dolly-Parton-Imitatorin beschränkt ist, sondern sich auch auf die noch seltsameren Träume all derer erstreckt, die ihren Arbeitsmarkt konstituieren – diejenigen, die dafür bezahlen, sie zu sehen. [Abb. 2]

Es ist wichtig, hervorzuheben, dass Glamour auf der Magie des Luxus beruht – ein Repräsentationsinstrument, das mit Illusion arbeitet –, was nicht bedeuten muss, dass diejenigen, die diesen Zauber ausüben, tatsächlich das Luxusleben führen, das sie vorspiegeln. Besonders in unserer von Replikaten und Duplikaten gekennzeichneten postmodernen Ära verweist die kommerzielle Verfügbarkeit von Glamour-Ware zum Billigpreis auf die illusorische Natur von Glamour. Glamour signalisiert Klasse, schlägt sich aber nicht unbedingt in Klasse nieder. Das beste Beispiel: Die vielleicht grösste Glamour-Lifestyle-Industrie im Westen ist Sexarbeit – ein eindeutig deklassierter Lebensstil für die Beteiligten. Sexarbeiter und Sexarbeiterinnen, Stripper und Stripperinnen und andere, die «nicht jugendfreie» Unterhaltung bieten, arbeiten mit Glamour – über Kleidung, Kosmetik, Schönheitsoperationen, Glitzerlicht und Musik –, um «Freier» dazu zu bringen, kurzzeitig an einem glamourösen Lebensstil zu partizipieren. Durch diese soziale Transaktion werden die Sexarbeiter und Sexarbeiterinnen selbst zu Luxuswaren zum Billigpreis. Und eine der grössten Illusionen überhaupt ist dabei die völlig verdrehte Art und Weise, eine gnadenlos ausgebeutete Sexarbeiterklasse als symbolischen Ausbeuter hinzustellen, der die magische Gabe hat, «gute Männer» zu verführen und zu korrumpieren. Natürlich ist die kriminelle *gramarye* des Sexarbeiters machtlos gegen die Wucht der gesellschaftlichen Ächtung, und es sind immer die Sexarbeiter, die weit schwerwiegendere strafrechtliche Folgen zu tragen haben als die Freier. Bei der Sexarbeit sind die Glamoureffekte immer im Fluss – die Illusion ermächtigt und trügt den Magier, der sie ausübt. Nach meiner Erfahrung als DJ in einem Club für transsexuelle SexarbeiterInnen in New York war es offensichtlich, dass selbst unabhängige Mädchen, die keinen Zuhälter bezahlen mussten, ihre Luxuskörper, die ständig Minus machten, weil Kosmetik, Hormonbehandlungen, Operationen, Drogen und andere Instandhaltungsarbeiten, die von Nöten waren, um Rauch und Spiegel (oder Koks und Spiegel) aufrechtzuerhalten, so ins Geld gingen, lediglich *leasten*. Obwohl ich ein Fürsprecher der Legalisierung von Sexarbeit bin, erscheinen mir die vorherrschenden Repräsentationssysteme, deren sie sich bedient, einschliesslich Glamour (besonders im Westen), als unrealistische Mittel für Sexarbeiter, psychologische oder materielle Selbstverwirklichung zu finden. Für viele von ihnen, die Selbstermächtigung durch Sexarbeit für sich in Anspruch nehmen, wird Glamour zum Opiat, durch das sie die emotionalen und körperlichen Belastungen zu kompensieren versuchen.

Eine Alternative zu diesem ziemlich trostlosen und resignativen Glamour-Ansatz ist *Camp*. Man denke an die 120 Kilo schwere Komikertunte, die der Welt befiehlt, sie nicht ernst zu nehmen (obwohl meiner Erfahrung nach gerade die campen 120-Kilo-Drag-Queens zumeist die professionellsten und ernsthaftesten Bühnenstars sind). Man könnte argumentieren, dass sie konventionelle Sichtweisen des weiblichen Körpers satirisch ins Gegenteil verkehrt. Trotzdem finden wir auch in dieser Welt des Camp wenige Zeichen, die auf eine Welt ausserhalb eines luxusbesessenen Glamour verweisen. Die Camp-Queen orientiert sich ebenso am Warenfetischismus wie die «echte» Glam-Queen, wenn nicht noch mehr (Leigh Bowery zum Beispiel). Ihr Modell von Körperdarstellung ist immer noch auf Verpackung fixiert.

Und dann gibt es da noch das hässliche Entlein, dessen billige Pailletten nichts weiter beschwören als die totale Abwesenheit von Glamour. Das hässliche Entlein ist eine Glamour-Implosion, in der die Zeichen für Glamour in sich selbst zusammenstürzen. [Abb. 5] Andererseits entzieht es sich auch wieder nicht den Lockungen des Glamour, das hässliche Entlein sagt damit nur aus, dass es das Unglamouröse, das Unreiche, das Unprofessionelle und Unattraktive darstellt.

Was natürlich die Realität für die meisten unter uns ist. Die unrealistischen weiblichen Schönheitsideale einer Gesellschaft werden noch unrealistischer, wenn sie von Nicht-Frauen angestrebt werden. Viele Transgender verlassen niemals ihre Wohnung, ziehen sich im Geheimen und allein an, weil sie die körperlichen und verbalen Angriffe fürchten, die von Fremden genauso kommen wie von Freunden und Menschen, die man liebt. Andere verstecken ihr Transgendertum, indem sie in «Schutzraum»-Clubs eintreten, wo sie ihren Drag aufbewahren und sich umziehen, wenn sie sicher drinnen sind. Hinzu kommt, dass trotz der immer noch vorherrschenden Legende vom Karriereschwulen ohne Frau und Kinder, für den Geld keine Rolle spielt, die Realität immer noch so aussieht, dass die Mehrheit der Schwulen und Lesben weiterhin unter der Armutsgrenze lebt, wobei Transgender am unteren Ende angesiedelt sind, nur FzMs haben es noch schlechter. In der Realität bringt Transgender nicht viel Glamour oder *gramarye* mit sich – nur die Machenschaften einer schamhaften «Geheimgesellschaft» mit vielen mysteriösen Zeremonien in dunklen Ecken. Wenn die Mehrheit der Transgender-Körper – selbst von ihresgleichen – ungesehen bleibt, was bedeutet es da überhaupt, die Darstellungen des Transgender-Körpers zu diskutieren? Woran wollen wir einen solchen Körper überhaupt identifizieren?

Davon ausgehend, dass es der Mehrheit der MzFs wie der Frauen nicht gelingt, sich ein Glamour-Image zuzulegen und dass feministische visuelle Theorien viele soziale Prozesse hinter den Darstellungen des weiblichen Körpers offengelegt haben – können diese Theorien dann auch die Darstellungen von Transgender-Körpern erklären?

–

Ein grosser Teil der feministischen visuellen Theorie konzentriert sich auf den Subjekt/Objekt-Widerspruch, der in dem bekannten Zitat von John Berger umrissen ist:

«Eine Frau muss sich unentwegt selbst beobachten... Von frühester Kindheit an hat man ihr beigebracht und sie dazu überredet, sich ständiger Selbstkontrolle zu unterwerfen. Und so kommt sie dazu, den Prüfer und die Geprüfte in ihr als die beiden wesentlichen, doch immer getrennten Komponenten ihrer Identität als Frau anzusehen.»
– John Berger (u.a.), *Sehen. Das Bild der Welt in der Bilderwelt* (1972), übers. von Axel Schenck, Reinbek bei Hamburg: Rowohlt, 1974, S. 43.

Ebenso ergibt sich sowohl für MzF- wie für FzM-Transgender ein ungeheures Mass an Selbstüberwachung, besonders bedingt durch den sozialen Druck, als Mann beziehungsweise Frau «durchgehen» zu müssen. Die Transgender-Identität erfordert also ein ähnlich multiples Bewusstsein von sich selbst als *Prüfer* und *Geprüftem*. Der entscheidende Unterschied tritt jedoch auf, wenn wir darüber nachdenken, wie sich die Subjekt/Objekt-Formel zum physischen Körper verhält.

Für Frauen bleibt der physische Körper vereinbar mit den Zielobjekten der Überwachung. Ob eine Frau als «weiblich» oder «unweiblich» beurteilt wird, der physische Frauenkörper bleibt sichtbar und als das Ziel solcher Qualitätsurteile identifizierbar. Im Falle des Transgender-Körpers ist der physische Körper jedoch nicht vereinbar mit dem Anliegen der Überwachung. Wenn zum Beispiel eine MzF als «weiblich» oder «unweiblich» («passabel» oder «unmöglich», «umwerfend» oder «unansehnlich») beurteilt wird, ist das Ziel solcher Qualitätsurteile nicht der Transgender-Körper, sondern der Frauenkörper. Ähnlich ist es für FzMs, deren «Männlichkeit» daran gemessen wird, wie es ihnen gelingt, Bilder eines Männerkörpers zu beschwören. Sowohl das Ge- wie das Misslingen des Erscheinungsbilds eines Transgender zeigen, dass ein anderer Körper erwartet wird, als der, den wir vor uns haben. Als Transgender gewöhnen wir uns daran, uns selbst im Verhältnis zu einem fremden Körper zu überwachen. Der physische Transgender-Körper existiert also auf einer sozialen Ebene, die unsichtbar bleibt und die nicht berücksichtigt wird, weder vom Transgender selbst noch von anderen Betrachtern. Trotz der vielen Überprüfungsprozesse, die dazu gehören, eine Transgender-Identität zu formen, bleibt in den meisten Fällen der physische Transgender-Körper

selbst völlig unüberprüft. Während ein grosser Teil der Identitätspolitik sich darum dreht, dass eine entrechtete Gruppe um «Sichtbarkeit» kämpft, scheint in den Transgender-Communities der Kampf um «Sichtbarkeit» nicht mehr als ein Kampf um eine alternative «Unsichtbarkeit» zu sein. Ich finde diese alternative Unsichtbarkeit inspirierend, weil sie, wenn man es positiv sieht, impliziert, dass der Transgender-Körper sich den dominierenden Repräsentationssystemen entzogen hat und unterhalb der Radargrenze operiert. In dieser Erkenntnis liegt potenzielle Freiheit – keine transformatorische oder erlösende Freiheit vielleicht, aber eine Freiheit für den Moment. Ein Zauberbann, um jeden Zauberbann zu brechen.

Diesen Gedanken entwickelte ich angesichts einer Serie ziemlich harmloser Plakate, die mir seit meiner Kindheit im Gedächtnis geblieben sind. Es war eine Anti-Raucher-Kampagne der *American Cancer Society* (ACS). [Abb. 4] Die Plakate wurden von den Gesundheitsämtern ausgegeben und hingen überall in öffentlichen Schulen, Bibliotheken, Krankenhäusern, Ämtern und Behörden. Unglücklicherweise findet sich im Archiv der ACS nichts über die Produktion dieser Kampagne, es existieren also keine genauen Angaben über den Fotografen, die Menschen auf den Fotos oder auch nur das Veröffentlichungsdatum (das scheint entweder Ende der 1960er oder Anfang der 1970er gewesen zu sein – ich erinnere mich, die Plakate noch bis Mitte der 1980er hängen gesehen zu haben). Man darf mit Sicherheit annehmen, dass die ACS die Plakate als simplen Kontrast zwischen Text und Bildern gedeutet sehen wollte – ein Kontrast, an dem besonders der Einsatz eines derart krassen Sarkasmus in einer Kampagne der öffentlichen Wohlfahrt bemerkenswert ist. Denkt man länger darüber nach, stellt die Serie jedoch ein wundersames Triptychon dar, das einige überlappende und komplexe Repräsentationsprobleme/ Themen wie Klasse, Ökonomie und Gender/Geschlechteridentität enthält – Fragen der Repräsentation, die einen Eiertanz in der Grauzone zwischen schwarzem Humor und Stumpfheit versuchen. Mir scheint, diese Spannung ergibt sich daraus, dass nicht klar ist, ob Bilder in ihrem Repräsentationspiel aktive oder passive Rollen spielen… dieselbe Frage, die sich auch bei vielen Transgender-Körpern stellt.

Das offensichtlichste Repräsentationsthema, das von den Plakaten aufgegriffen wird, ist die Zugehörigkeit zu einer Klasse ein Thema, das zwei Zusammenhänge in sich trägt. Der erste Zusammenhang ist jener zur Werbung. Die Bilder der ACS antworten unübersehbar auf die für damals typischen Hollywood-Glamour-Anzeigen der Tabakindustrie, indem sie den Spiess einfach umdrehen. Dieser

Angriff auf die Welt der Werbung impliziert einen aktiven Versuch, solche Fragen der Repräsentation anzusprechen. Sollte das jedoch der Fall sein, versagen die Plakate insofern, als es ihnen nicht gelingt, zu fragen: «Was ist eigentlich glamourös/lässig-elegant/distinguiert?» («what is glamorous/debonair/sophisticated?»). Statt die Art von Bildern, die von der Werbung erzeugt werden, zurückzuweisen oder Alternativen anzubieten, zeigen sie uns einfach Bilder, von denen auch die Werbeindustrie sagen würde, dass sie alles andere als glamourös/lässig-elegant/distinguiert sind. Dominierende ökonomische und Klassenunterschiede bleiben intakt, wenn sie nicht sogar verstärkt werden. Dieses Problem wird durch den zweiten Zusammenhang noch verschlimmert, nämlich der Präsentation. Die Plakate hingen üblicherweise in deprimierenden Amtszimmern, die zumeist von den unteren Einkommensklassen frequentiert wurden. Ich wage zu behaupten, dass in diesem Kontext jede Ironie der Klassenunterschiede, wie sie in Werbespielchen eingesetzt wird, verschwendet ist.

Ehe ich fortfahre, sollte ich vielleicht noch anmerken, dass zwei zentrale Annahmen, von denen ich bei diesen Plakaten ausgehe, möglicherweise beide unzutreffend sind (die ich euch jedoch bitte, um der Argumentation willen, als gegeben hinzunehmen). Erstens bin ich seit meiner Kindheit davon ausgegangen, dass es sich bei dem Modell sowohl für das «Glamourös» (glamorous) – wie für das «Lässig-elegant» (debonair)-Poster um den Komiker Don Knotts handelt (manchen vielleicht bekannt als der nervige Nachbar aus *Matlock* oder der Vermieter Mr. Roper aus *Herzbube mit 2 Damen*), während das «Kultiviert» (sophisticated)-Plakat entweder ein unbekanntes Modell oder ein dokumentarisches Archivfoto zeigt. Des Weiteren nehme ich an, dass das «Glamourös»-Foto an Frauen gerichtet ist, eigentlich jedoch einen Transgender zeigt. Unglücklicherweise war die ACS trotz mehrerer Nachfragen nicht in der Lage, eine dieser Annahmen zu bestätigen oder zu widerlegen. Solange nicht das Gegenteil bewiesen ist, werde ich meine Annahme, dass es sich bei dem Modell auf dem «Glamourös»- und dem «Lässig-elegant»-Foto um Knotts handelt, rechtfertigen wie folgt: Beide Bilder sehen aus wie er, von vorne und im Profil; und dass ein bekannter Schauspieler für Mann/Frau-Fotos posiert hat, scheint mir der plausibelste Grund dafür zu sein, in eine Kampagne, die ansonsten mit Fotos im Dokumentarstil arbeitet, ein Transgender-Bild einzufügen (besonders, wenn es sich um eine staatliche Kampagne handelt, die normalerweise über den kleinsten gemeinsamen Nenner ihre Adressaten zu erreichen versucht). Wenn es Knotts ist, sind das «Glamourös»- und das «Lässig-elegant»-

Foto in diesem Sinne ganz klar «gestellt» und nicht «dokumentarisch». Darüber hinaus ist auf beiden der Textblock etwa gleich gross, was vermuten lässt, dass sie zusammen designt wurden, wogegen das «Kultiviert»-Plakat nicht denselben Gestaltungsregeln folgt und das Foto eindeutig eine andere Person zeigt. Die Anonymität des Modells auf dem «Kultiviert»-Foto gibt ihm ausserdem einen mehr dokumentarischen Touch. Das alles unterscheidet das «Kultiviert»-Plakat vom «Glamourös»- und «Lässig-elegant»-Plakat und lässt sogar vermuten, dass es zu einer früheren oder späteren Zeit entstanden ist als die anderen beiden. Wir haben also innerhalb einer Serie eine ungewöhnliche Repräsentations-Verschiebung von der Star- zur Dokumentarfotografie oder umgekehrt. In beiden Fällen ist die Herangehensweise an Fragen der Repräsentation auf den drei Plakaten uneinheitlich – ein Schnitzer, den man in einer zusammenhängenden Bilderkampagne selten sieht. Es ist ein gedankenloser Wechsel, der offenlegt, wie wir die Prozesse, durch die wir den Körper überprüfen und darstellen, «ungedacht machen», was es den Leuten ermöglicht, ohne es zu merken oder stutzig zu werden, den Sprung von «Fiktion» zu «Tatsache» zu vollziehen. Ob diese Bilder «dokumentarisch» oder «Starfotografie» sind, scheint zentral dafür zu sein, inwieweit diese Bilder Fragen der Repräsentation aktiv oder passiv aufgreifen.

Die Plakate verkomplizieren sich noch mehr, wenn man ihre Repräsentation der Geschlechtertrennungen betrachtet. Auf die Frage zurückkommend, ob Glamour unbedingt an Gender-Selbstdarstellung geknüpft ist, sehen wir hier Glamour ganz klar mit Weiblichkeit assoziiert. Ungewöhnlich an dieser Bilderserie ist jedoch, dass der Körper, der dazu ausgesucht wurde, Weiblichkeit zu repräsentieren, keine Frau ist, sondern eine schlampige Drag Queen – ungeschminkt, auf dem Kopf eine Perücke wie ein Mopp, unter der man deutlich den Haaransatz sieht. Auf den ersten Blick scheint sich das «Glamourös»-Plakat auf dieselben simplen Gegensätze von Text und Bild zu verlassen, wie wir sie auch bei dem «Lässig-elegant»- und dem «Kultiviert»-Plakat finden. Geht man vom Text aus, wird man sofort darauf gestossen, dass hier eins fehlt: das Bild einer glamourösen Frau. Aber wenn man es genau nimmt (und hier kommen wir zu den früher angesprochenen Unterschieden zwischen den Subjekt/Objekt-Widersprüchen für Frauen und Transgender), müsste das Gegenteil einer unglamourösen Drag Queen eigentlich die glamouröse Drag Queen sein und nicht eine glamouröse Frau. Trotzdem darf man mit Sicherheit sagen, dass die meisten Leute, die das Plakat sehen, das Bild nur mit Vorstellungen von einer glamourösen Frau verbinden und die Existenz eines solchen nahe-

liegenderen Transgender-Gegenteils gar nicht erst in Betracht ziehen. Das Plakat ist eindeutig auf die Überwachung von Frauen gemünzt und appelliert an die Prozesse ihrer Selbstüberwachung, indem es sagt: «Rauch nicht, oder du wirst am Ende derartig unglamourös aussehen». Das «Lässig-elegant»- und das «Kultiviert»-Plakat appellieren in ähnlicher Weise an den Sinn für Selbstüberwachung bei Männern (ein Thema, das feministische und Gender-Theorien bedauerlicherweise oft ausklammern). Anders als auf dem «Glamour»-Plakat bleiben die physischen Körper der männlichen Modelle jedoch vereinbar mit den Zielobjekten des Überwachungsakts – die Modelle sind Männer, und die Bilder arbeiten mit gängigen Vorstellungen von kultivierten und schicken Männern.

Durch wiederholte Konfrontation mit diesen Plakaten in Wartezimmern beim Arzt und anderswo, wo ich nichts Besseres zu tun hatte, ausser zu gucken und mir Gedanken zu machen, begann ich nach und nach zu sehen, dass Repräsentationsprozesse um Transgender-Körper immer in Ablenkungen von materiellen Körpern wurzeln und daher eher die sozialen Prozesse um den Körper repräsentieren als den eigentlichen physischen Körper einer Person. Tatsächlich ergibt sich die historische Kluft zwischen Feministinnen und Transgendern genau aus diesem Unterschied. Denn der ständige feministische Vorwurf an die Transgender-Bewegung ist ja, dass die meisten Transgender im Leben kein höheres Ziel kennen, als bevormundenden und konservativen Vorstellungen von der «richtigen Frau» beziehungsweise dem «richtigen Mann» nachzueifern und damit politisch hoffnungslos reaktionär und nicht zu gebrauchen sind. Natürlich ist dieser Vorwurf nicht völlig von der Hand zu weisen. Die Mehrheit der Transgender geht an das Verhältnis zwischen ihrem Geschlecht und ihrem Identitätsgeschlecht tatsächlich mit enttäuschend essentialistischen Begriffen heran, etwa «im falschen Körper geboren» zu sein usw. Der daraus folgende Drang, ihre Körper «richtigzustellen», ist der Drang nach «Normalisierung» im Sinne der dominanten Kultur und führt oft zu einer krampfhaften Fixierung auf das aller-«normalste», einfachste und eindimensionalste Modell ihres «anderen Geschlechts» – dessen Image fast immer ein reaktionäres Klischee ist.

Ich habe kein Interesse daran, einen solchen essentialistischen Standpunkt zu verteidigen, aber ich kann damit sympathisieren. Es ist wichtig, sich vor Augen zu halten, dass Transgender von Geburt an mit denselben dominierenden kulturellen Ideologien indoktriniert sind wie alle anderen, und eine Assimilation solcher rückschrittlichen Modelle von Geschlechtsidentität durch Transgender entspricht der

Positionierung des Transgender innerhalb der dominanten Kultur. Die Sehnsucht vieler essentialistischer Transgender, ihre Körper zu transformieren (und in den meisten Fällen zu transzendieren), erfordert oft ein Höchstmass an psychologischer Verdrängung bezüglich des eigenen physischen Körpers – diese Verdrängung ist oft sogar kulturell verordnet, da Transsexuelle sich in den meisten Ländern einer klinischen Untersuchung zur Feststellung einer abweichenden Geschlechtsidentität unterziehen müssen, ehe sie eine operative Geschlechtsumwandlung vornehmen lassen dürfen. Aber ungeachtet der konformistischen Tendenzen und der Konventionalität der Wunschkörper solcher Transgender darf man nicht vergessen, dass die Prozesse der Körpertransformation ungeheuer viel Mut erfordern und immer das hohe Risiko eines Fehlschlags bergen. Sich vom Hausmann in eine Hausfrau zu verwandeln oder umgekehrt klingt für einige vielleicht nicht sehr feministisch, aber die radikale Abkehr vom «ursprünglichen Geschlecht», die zu einer solchen physischen und sozialen Transformation gehört, ist unzweifelhaft eine extreme Zurückweisung gesellschaftlich festgelegter Geschlechterrollen – selbst wenn das Ergebnis die Flucht in eine zweite gesellschaftlich festgelegte Geschlechterrolle ist. Darin zeigt sich klar eine Gemeinsamkeit mit dem feministischen Kampf um «Wahlfreiheit». Eine andere Parallele zwischen Feminismus und uns Transgendern ist die, dass sowohl Frauen wie Transgender darauf konditioniert sind, extreme Scham über ihre Körper zu empfinden. Ja, für «durchgehende» FzMs und MzFs, die sich zu sehr schämen oder fürchten, um sich ihren Partnern als Transgender zu erkennen zu geben, kann die Geheimhaltung im Genitalbereich sogar eine Frage von Leben und Tod sein, weil sie bei versehentlicher Enttarnung mit brutalen Vergeltungsmassnahmen rechnen müssen. Glücklicherweise sehen die meisten Leute nur das, was sie sehen wollen, und in diesem heiklen Kontext kann die Ablenkung durch Glamour – fingerdickes Make-up, aufgetürmtes Haar, Glitzerklamotten und Accessoires – gelegentlich helfen, MzFs zu «normalisieren» und als «richtige Frauen» zu tarnen. In solchen Fällen bietet Glamour eine seltsame Übererfüllung der Gender-Merkmale – ein dünner Schleier von Super-weiblichkeit, der so verwirrend ist, dass er den Transgender-Körper darunter effektiv verbirgt (solange keine anderen Tunten in der Nähe sind, die den Glamour in einen *queeren* Kontext setzen).

Durch das genauere Herausarbeiten spezifischer gesellschaftlicher Zusammenhänge wie dieser werden der Gender-Diskurs und die Diskussion über die Repräsentation des Körpers möglicherweise das ewige feministische Dilemma überwinden, wie man Menschen

begreiflich machen soll, dass Gender-Fragen nicht ausschliesslich «Frauen-Fragen» sind, sondern die Gesellschaft insgesamt betreffen. Ein zentrales Problem ist natürlich, dass letztlich die überwältigende Mehrheit der Frauen ihre «Gender-Fragen» mit denselben essentialistischen Begriffen wie Männer angehen – sie stellen nicht die Idee einer definitiven Weiblich/Männlich-Binarität, die Transgender ausschliesst, in Frage, sondern nur die sozialen Kodierungen, die sich aus dieser Binarität in bezug auf Männer und Frauen ergeben. Transsexuelle, Intersexuelle oder andere Geschlechteridentitäten werden als reine statistische Anomalien betrachtet, deren Seltenheit nur die biologische Normalität bestätigt, sich als Frau oder Mann zu definieren. All das der Tatsache zum Trotz, dass bei Transgendern etliche reale physische Gegebenheiten bestehen, die die Mann/Frau-Binarität einschlägig widerlegen.

Ein zweites Problem ist, dass wir Transgender unsere eigenen Essentialismen konstruieren. Glamour selbst wird zu einem beidseitig verwendbaren «Meta-Essentialismus», der dem einen MzF die Assimilation und Akzeptanz als «Show-Queen» bei schwulen Transgendern erleichtert und gleichzeitig dem anderen MzF seine «Normalisierung» als «heterosexuelle Frau» in einem nichtschwulen Umfeld. Diese ganzen konkurrierenden Essentialismen erschweren Allianzen über die Grenzen der Community hinaus (von Allianzen innerhalb der Grenzen der Community reden wir erst gar nicht).

Ein Weg, diese Essentialismen zu dekonstruieren, besteht darin, den Kontexten, die sie mit Energie speisen, den Stecker herauszuziehen, sie mit anderen Kontexten kurzzuschliessen und zuzusehen, wie die Leitungen durchbrennen… nicht um die Sichtweisen der einen oder der anderen Gruppe zu diskreditieren, sondern um die praktischen Grenzen der Techniken von Kommunikation und gegenseitiger Annäherung des kritischen Denkens zu identifizieren. Diese Grenzen zeigen dann vielleicht neue Wege für die Kommunikation der Communities untereinander auf. Man denke an die «Vaginal Iconology»-Bewegung in den 1970ern, in der Künstlerinnen den Versuch unternahmen, die weiblichen Genitalien wieder in die Kunst zurückzuholen. Damit stellten sie nicht nur das Phallozentristische der westlichen Kunst in Frage, sondern lehrten Frauen auch etwas über ihre Körper. In ihrem Vortrag bei der Sexuality Conference der N.O.W. (National Organisation for Women) in New York 1973 schlug die Erotikkünstlerin Betty Dodson einen zeitgemässen ästhetischen Rahmen für die weiblichen Genitalien vor. In ihrer Präsentation zeigte sie Dias ihrer eigenen Arbeit, medizinische und anatomische Zeichnungen der weiblichen Genitalien (viele davon inkorrekt) und Fotografien der Genitalien von Frauen, die

an ihren Körper-Workshops teilgenommen hatten (etikettiert als «klassisch», «barock» usw.). Wie man hört, gab es am Schluss stehende Ovationen von tausend Frauen, von denen viele noch nie ihre eigene Vagina gesehen hatten, erst recht nicht die einer anderen. Indem sie die Verschiedenartigkeit der weiblichen Genitalien sichtbar machte, zerstörte Dodson die Mythen von der Homogenität des weiblichen Körpers und stellte damit auch die Homogenität der Konstruktion weiblicher Geschlechtsidentität an sich in Frage. Das gelang ihr, indem sie zunächst von ihrem eigenen Selbstbild (ihrer Kunst) aus zu den Erwartungen an weibliche Körper (klinische Bildersprache) und dann zu den Bildern unterschiedlicher Frauenkörper selbst (ungeschönte, ungestellte Fotos) zurückging. Ich persönlich finde diese Bewegung ausserordentlich wirkungsvoll und inspirierend (wenn auch gelegentlich etwas überkandidelt und allzu beschäftigt mit «Mütterangelegenheiten» – hmmm… dasselbe könnte man auch über Drag Queens sagen…).

Aber was, wenn wir versuchten, die «Vaginal Iconology»-Methode, Darstellungen von Frauenkörpern zu dekonstruieren und für eine auf Transgender-Körper anwendbare «Ikonologie von Transgender-Genitalien» zu übernehmen? Kann man den Weg zurückverfolgen von den Erwartungen an männliche und weibliche Körper zu den diversen Transgender-Körpern und das anscheinend unheilbar Unsichtbare sichtbar machen? Oder würden wir feststellen, dass die Transgender-Körper selbst uns nur wieder an Idealbilder von Männern und Frauen zurückverweisen, wie in den Selbstporträts des extrem «passablen» FzM-Bodybuilders und Fotografen Loren Cameron? Welche Unterschiede in der Rezeption können wir angesichts der komplexen Beziehung von Transgendern und Medizin erwarten, wenn wir neben die von Dodson verwendeten graphischen Darstellungen der Vagina grafische Darstellungen und Fotografien von operativ veränderten Transgender-Genitalien stellen? Wie würden solche Bilder innerhalb der Transgender-Community selbst gesehen werden, zu der nicht-operierte Drag Queens und Drag Kings, die nicht die Absicht haben, ihre Genitalien chirurgisch verändern zu lassen, ebenso gehören wie Transsexuelle, die sich auf eigenen Wunsch einer hormonellen und operativen Geschlechtsumwandlung unterziehen, sowie Intersexuelle, die mit multiplen oder nicht eindeutigen Geschlechtsmerkmalen geboren wurden und ohne ihre Zustimmung unters Messer kamen? Schon die Tatsache, dass innerhalb der Transgender-Community eine operative Geschlechtsumwandlung im typischen Fall der Lebenstraum für Transsexuelle und der Alptraum für Intersexuelle ist, führt uns zu einer Auffassung vom «Körper», die zu verworren ist, um sie so einfach

zu einem gemeinsamen Ursprung zurückverfolgen zu können. Was ist ein «natürliches» Transgender-Genital? Das vor der Operation? In was würde es sich dann bei Nicht-Intersexuellen vom männlichen oder weiblichen Genital unterscheiden? Anders als die «Vaginale Ikonologie», die von der naturalistischen Vorgabe ausgeht, dass es einen «Frauenkörper» gibt, den man in aller Verschiedenheit abbilden und feiern kann, und zwar so, dass es alle Schwestern eint, scheint eine «Ikonologie der Transgender-Genitalien» uns eher vom Naturalismus, von schwesterlicher Gemeinsamkeit wegzuführen und hin zu Verschiedenheiten, die uns kulturell entzweien.

Für mich selbst liegt die Kraft des Transgendertums – wenn es überhaupt eine gibt – in dieser Ambivalenz und Gespaltenheit. Es ist nicht die Kraft der Abgrenzung oder Unterscheidung von anderen Gendern, sondern eher die Kraft, die man daraus zieht, Repräsentationssysteme der Abgrenzung und Unterscheidung der Gender zusammenbrechen zu sehen. Es ist nicht die Kraft der Umwandlung, sondern die Kraft des fliessenden Übergangs. Es ist weder ein «drittes Geschlecht», das Einigkeit verspricht, noch ein Zwischending aus allen Geschlechtern. Es ist definitiv ein Anschlag auf den Mythos der sozialen Einheit. Für die Transgender-Community ist es die Möglichkeit, solche Akte des Übergangs als soziale Prozesse zu de-essentialisieren. Das ist so harte Realität wie ein Faustschlag ins Gesicht (wie viele von uns leider aus Erfahrung wissen). Je mehr man sie zu definieren versucht, desto flüchtiger und trügerischer wird sie.

Natürlich gehören zu Glamour Illusion (oder Ausflucht) und Betrug, aber in ganz anderer Absicht. Mit Glamour bedient man sich der Illusion, um bestehende Vorstellungen zu zementieren. Glamour nährt sich von vorhandenen Sehnsüchten und sichert den unerträglichen Status quo. Transgender-Glamour scheint mir die grösstmögliche Verinnerlichung solcher Systeme seitens einer unterdrückten Klasse darzustellen. In MzF-Communities wird Glamour gedankenlos vergöttert, konsumiert und verdaut. McGlam – diese homogenisierte Drive-in-Drag-Kultur, die man in jeder Stadt der westlichen Welt findet (und mittlerweile auch in vielen der östlichen Welt). Wie Fast Food ist sie überall zu haben, in Massen genossen, sogar ganz nett, aber definitiv nicht zum täglichen Konsum vorgesehen. Die Schwestern kriegen den Fettrappel von dem ganzen Glamour-Dreck, mit dem man sie vollstopft… können wir in unseren Küchen nichts Besseres zusammenrühren? Möchte jemand Rezepte tauschen?
–

Übersetzung Clara Drechsler

Abb. 1
–
Eve Arnold, Silvana Mangano,
1956, S/W-Fotografie, aus:
Eve Arnold: In Retrospect,
New York: Alfred A. Knopf 1995

Abb. 2
–
Edward Steichen, Der erste
Abguss von Constantin Brancusis
Vogel im Raum, ca. 1925,
S/W-Fotografie

Abb. 3
–
Constantin Brancusi, *L'Oiseau
dans l'espace* (auch: *L'Oiseau vol*),
1927, S/W-Fotografie

Abb. 4a
–
Cecil Beaton, Fotomodell vor
Number 1 (1950) von Jackson
Pollock, Fotografie für «The New
Soft Look», *Vogue,* 1. März 1951

Abb. 4b
–
Cecil Beaton, Fotomodell vor
Autumn Rhythm: Number 30
(1950) von Jackson Pollock,
Fotografie für «The New Soft
Look», Vogue, 1. März 1951

Abb. 5
–
Edward Steichen, Marlene
Dietrich, 1935, S/W-Fotografie

Abb. 6
–
Klaus Müller-Laue, Frieda Grafe
und Josef von Sternberg, 1969

Abb. 7
–
Norman Solomon, Dreharbeiten
von Jack Smiths *Flaming
Creatures*, Dia, 1962 © N. Solomon
& The Plaster Foundation

Abb. 8
–
Gilles Larrain, «Wally»
(The Cockettes), Farbfotografie,
aus: G.L., *Idols,*
New York/London: Links 1973

Abb. 9
–
Morris Lapidus, The
Fontainebleau Hotel (1954) und
dahinter das Eden Roc (1955),
Miami Beach (Foto courtesy of
the archive of Morris Lapidus)

Abb. 10
–
General Idea, *FILE Megazine:
Glamour Issue,* Herbst 1975

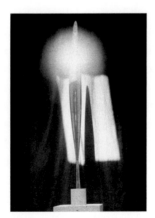

Abb. 3

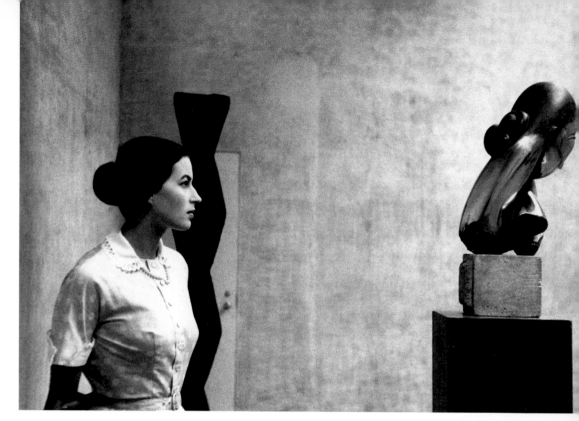

Abb. 1

Abb. 9

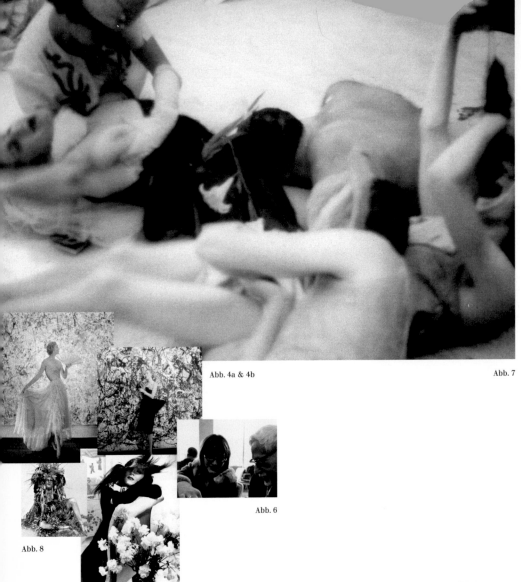

Abb. 4a & 4b

Abb. 7

Abb. 6

Abb. 8

Abb. 5

Abb. 10

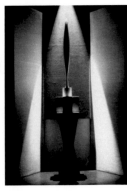

Abb. 2

Tom Holert

—

SILVER CUBE

Transfusion

—

Eine grandiose Fotografie von Eve
Arnold aus dem Jahr 1956 zeigt
die Begegnung zweier Stars aus
eigentlich getrennten Welten auf
dem Territorium des Guggenheim
Museum in New York. Die schöne
italienische Filmschauspielerin
Silvana Mangano, auf einem frühen
Höhepunkt ihres Ruhms, steht vor
einer Skulptur des Bildhauers
Constantin Brancusi, konzentriert
auf das Bild der glänzend polierten
Nackenansicht von *Mlle Pogany*
aus dem Jahr 1913. Die Büste ruht

auf einer Marmorplinthe, und die Schauspielerin, deren Figur überdies die Silhouette von Brancusis *Endloser Säule* (1918) im Hintergrund wiederholt, scheint mit dem Kunstobjekt in einen stummen Dialog eingetreten zu sein. Ein mögliches Thema dieses Zwiegesprächs: Was heisst es, für Fotografen Modell zu stehen? Denn nicht nur eine Filmschauspielerin wie Mangano, auch die «haute sculpture»[1] von Brancusi war auf die Kamera ausgerichtet. Brancusis Bildhauerei bildete dabei sowohl den Rahmen für Inszenierungen in der Mode, wenn ein Couturier wie Paul Poirier bereits 1912 seinen Pariser Salon mit einer polierten Brancusi-Bronze schmückte, als auch das Objekt aufwendiger fotografischer Inszenierungen durch den Künstler selbst wie durch andere Fotografen.

So hatte Edward Steichen, der sich immer wieder zwischen künstlerischer und kommerzieller Fotografie hin- und herbewegte, früh damit begonnen, Brancusi und seine Skulpturen zu fotografieren. Nach seiner piktorialistischen Periode machte Steichen in den 1920er und 1930er Jahren nicht nur Bilder von Fotomodellen und Stars aus verschiedenen Bereichen der Hoch- wie der Populärkultur. Er wandte sich auch anderen Gegenständen zu, Dingen und Pflanzen, oder eben den Skulpturen von Brancusi, die er nun im Modus des *glamour shot* fotografierte.

Wie eine ausserweltliche Erscheinung inszenierte Steichen um 1925 auf diese Weise eine polierte Bronzefassung von Brancusis *Vogel im Raum*. Die Skulptur reckt sich in einer Nische aus Licht und Schatten der Quelle der Beleuchtung entgegen, einer Öffnung im Dach oder gar einem Scheinwerfer. Das Helldunkel modelliert eine mystisch-mysteriöse, schlanke Plastizität, die an Bilder der *femme fatale* oder eines unheimlichen Bösewichts in den Filmen der 1920er Jahre erinnert. Zugleich strahlt die exzentrische Komposition eine Eleganz und opulente Gelassenheit aus, wie sie auch die Glamour-Fotografien kennzeichnet, die Steichen in den Folgejahren von Filmstars wie Marlene Dietrich machen sollte.

Offenbar hatten sich mit Brancusi, der die fotografische Inszenierung seiner Werke sehr ernst genommen und bestimmte plastische Effekte durchaus in Hinsicht auf die fotografische Reproduktion kalkuliert haben dürfte, und Steichen, dem eklektischen Allroundtalent ohne Berührungsängste mit der kommerziellen Sphäre, zwei Grenzgänger zwischen den

1
—
Vgl. Reinhold Hohl,
Die «Haute Sculpture» (1986), in:
Skulptur. Von der Renaissance bis zur Gegenwart. 15. bis 20. Jahrhundert, Köln (u.a): Taschen 1999, S. 435.

Feldern der modernen Kunst und der Kulturindustrie, dem
Purismus der Form und dem Glanz des grossen Auftritts gefun-
den. Dreissig Jahre später könnte die Magnum-Fotografin
Eve Arnold von dieser Verbindung gewusst haben. Indem sie
Mangano und Brancusi auf diese Weise im Bild zusammen-
führte, deutete Arnold in jedem Fall auch an, wie die beiden
(und die institutionellen Felder, die sie hier «repräsentieren»)
interagieren. Ähnlich wie die Gemälde von Jackson Pollock, die
einige Jahre zuvor von Cecil Beaton mit weiblichen Fotomodel-
len für eine Modestory über «The New Soft Look» für die US-
amerikanische *Vogue* vom März 1951 fotografiert worden waren,
geraten die Kunstwerke in den Einflussbereich der massenme-
dialen Glamourproduktionen. Beatons Pollock-Fotografien sind
ein klassisches Beispiel für das ungelöste Verhältnis zwischen
künstlerischer und glamouröser Praxis, für eine nicht ungefähr-
liche «Transfusion», von der die Filmkritikerin Frieda Grafe
in bezug auf Glamour gesprochen hat (davon unten mehr).
Rückblickend scheinen sich die Pollocks und die *Vogue*-Models
sehr viel selbstverständlicher in ein gemeinsames Epochen-
bild zu fügen; zwar ist die Spannung nicht aufgehoben, die
Einsicht in einen wechselseitigen Vampirismus, in diese eigen-
artige Zugewinngemeinschaft in der Ökonomie der Aufmerk-
samkeit aber fällt aus heutiger Sicht, spätestens nach den
heftigen Auseinandersetzungen, wie sie um das Verhältnis von
Mode und Kunst noch in den 1990er Jahren geführt wurden,[2]
spürbar leichter. Trotzdem bleiben die Verhältnisse proble-
matisch.

–

Keine einfache Beziehung

–

«El arte contra el glamour», steht als Titel über einem Artikel
in der spanischen Kulturzeitschrift *El Cultural,* «Kunst versus
Glamour». Der dazugehörige Text kündigt Ausstellungen von
NachwuchskuratorInnen an, die sich mit Street Art und den
Symbiosen von Kunst und Wissenschaft beschäftigen. «In
diesen Zeiten der Ausstellungen à la mode, der glamourösen
Galeristen, der edlen Eröffnungen und der Kuratoren, die sich
in elegante Maschinen des Kunstkommissariats verwandelt
haben», sei es eine Wohltat, atmet der Autor auf, junge Ausstel-
lungsmacherInnen nach der Wahrhaftigkeit der Kunst suchen
zu sehen statt Kunst als blosses Medium zu betrachten.[3]

2
–
Vgl. z. B. Jack Bankowsky, Editor's
Letter: The Art / Fashion Thing,
und Bruce Hainley, All the Rage.
The Art / Fashion Thing, in:
Artforum, Vol. 34, No. 7,
March 1996, S. 2, und S. 70–78.

3
–
«En estos tiempos de exposiciones
fashion, galeristas glamourosos,
curators convertidos en elegantes
máquinas de comisariat y *verni-
sages* de buen tono (…)»
José Marín-Medina, El arte
contra el glamour, in: *El Cultural,*
22. Juli 2004, S. 29.

In dieser Konstruktion von Glamour als dem Anderen der Kunst wirkt die Angst vor dem gefährlich-verführerischen Zauber fort, der in der Etymologie des Wortes «Glamour» verborgen ist.[4] Wo Glamour mit der Kunst ein Bündnis eingeht, steht er sinnbildlich für deren Verfall zu willfähriger Kommerzialität und politischem Opportunismus. Glamour wird zum Symptom des Niedergangs und der Auflösung der Kunst in einer von ökonomischen Prinzipien bestimmten visuellen Kultur. Kunst selbst kann dann ihrerseits in den Dienst der Werbung und des Konsums gestellt werden, wenn es darum geht, einem Produkt die «Konnotation von Prestige, Tradition und Authentizität» zu verleihen.[5] Eine Ausstellung wie *The Future Has a Silver Lining,* die sich dem Verhältnis von Kunst und Glamour widmet, verhandelt demnach ein offenes Geheimnis.

Glamour kann eine Funktion und ein Effekt des Kunstbetriebs sein, eine Qualität eines Kunstwerks beschreiben, aber auch den ästhetisch bearbeiteten und reflektierten Gegenstand einer künstlerischen Praxis bilden. In bezug auf Kunst – das heisst, in bezug auf einzelne Kunstwerke, bestimmte KünstlerInnen und Kunstmilieus sowie den Kunstbetrieb als solchen – wird spätestens seit den 1980er Jahren, als mediengewandte Künstlern wie Jeff Koons oder Damien Hirst die Szene zu dominieren begannen, immer häufiger in Begriffen von «Glamour-Faktor» oder «Glamourisierungspotenzial» gesprochen. Eine derartige Terminologie macht Glamour zu einer Eigenschaft, mit der man aktiv etwas, zum Beispiel «Kunst», ausstattet oder überzieht. Dem Glamour-als-Anwendung steht der stumm-verzückte Ausdruck im Gesicht eines Menschen gegenüber, der gerade eine Person oder ein Geschehen erlebt, denen der Glamour nicht hinzugefügt wurde, sondern deren Glanz, Zauber oder Scheinen (drei Bedeutungen des Wortes «Glamour») inhärent zu sein scheint, auch wenn die Schminke noch so sehr aufträgt.

Dieser letzte, «inhärente» Glamour, der nicht mit einem ominösen «Glamour von innen» verwechselt werden sollte, aber den manche «authentisch» nennen würden, ist weit schwieriger zu produzieren und zu kontrollieren als jener Miet-Glamour, um den sich Event-Manager und andere vermeintliche Glamour-Profis bemühen. Einer der interessantesten Widersprüche von Glamour besteht gerade in der Tatsache, dass er einerseits das Synonym für radikale Künstlichkeit und Gemacht-

4

Webster's Dictionary, 1913: \Gla'mour\, n. (Scot. Glamour, glamer; cf. Icel. Gl['a]meggdr one who is troubled with the glaucoma (?); or Icel. Gl[=a]m-s?ni weakness of sight, glamour; gl[=a]mr name of the moon, also of a ghost [...] Perh., however, a corruption of E. Gramarye.) 1. A charm affecting the eye, making objects appear different from what they are; 2. Witchcraft; magic; a spell; 3. A kind of haze in the air (...); 4. Any artificial interest in, or association with, an object, thorugh which it appears delusively magnified or glorified (...); eine berühmte Definition stammt von Sir Walter Scott: «Glamour, in the legends of superstition, means the magic power of imposing on the eyesight of the spectators, so that the appearance of the object shall be totally different from the reality» (in einer Anmerkung zu Scotts Gedicht *The Lay of the Last Minstrel* von 1802).

5

Marita Sturken/Lisa Cartwright, *Practices of Looking. An Introduction to Visual Culture,* Oxford: Oxford University Press 2001, S. 213.

heit ist, andererseits aber deswegen noch lange nicht zuverlässig programmiert und funktionalisiert werden kann – jedenfalls nicht, wenn die Ansprüche an einen glamourösen Auftritt durch vorangegangene Erfahrungen eines «inhärenten» Glamour gestiegen sind.

Heute würde niemand mehr die Existenz des Kunst/ Glamour-Nexus abstreiten, auch wenn diese Beziehung nicht frei von Konflikten ist. Mit grosser Selbstverständlichkeit produziert der Kunstbetrieb glamouröse Situationen der oben angedeuteten Art, und die Kunst wird dabei nicht selten zur Kulisse oder eben zum «Medium» anderer, etwa ökonomischer und politischer, Interessen. Aufwendige gesellschaftliche Inszenierungen in Museen und Galerien, auf Messen und Auktionen sind an der Tagesordnung, auch in Zeiten der wirtschaftlichen Krise. Stadtverwaltungen und Sponsoren versuchen, die Eröffnung eines Museumsneubaus, die Ausrichtung einer Biennale oder die Einwerbung einer Blockbuster-Ausstellung kulturökonomisch maximal auszuwerten. Institutionen der Hochkultur stellen ihre Infrastrukturen der Mode, der Popmusik, dem Kino zur Verfügung, während die Organe der Massenmedien ihrerseits den Wert spektakulärer Kunstereignisse immer mehr zu schätzen zu wissen. Und Jahrzehnte nachdem Pablo Picasso, Salvador Dalí, Jackson Pollock, Yves Klein, Niki de Saint-Phalle oder Andy Warhol ihre gelegentlichen Jet-Set-Auftritte hatten, wird heute in Zeitschriften und im Fernsehen über StarkünstlerInnen und Künstlerstars, aber auch über KuratorInnen, KunstkommissarInnen und andere Akteure des künstlerischen Feldes so selbstverständlich berichtet wie über *celebrities* aus dem Unterhaltungsgeschäft. Glamour ist zu einer zweiten Natur der Kunst geworden.

–

Beweggründe

–

Doch greift eine solche Charakterisierung, wie eingängig sie auf den ersten Blick erscheinen mag, zu kurz. Weder gibt es «die» Kunst, noch existiert «der» Glamour. In beiden Fällen handelt es sich um Entitäten (sehr unterschiedlichen Zuschnitts), die nicht aufhören, sich zu verändern. Und verändern tut sich eben darum auch ihr Verhältnis. Diese Dynamik soll nun nicht durch die Konstruktion einer linearen Erzählung von etwaigen Ursprüngen des Glamour oder der Kunst und ihrer Beziehung verdeckt

werden. Viel mehr interessiert den Genealogen, wie die Stränge, die der Begriff des Glamourösen und die unterschiedlichsten Glamour-Praktiken im kulturellen Gewebe des 20. Jahrhunderts bilden, rekonstruiert werden können, ohne deren innere Spannung und Konfliktgeladenheit stillzulegen.

6
–
Giorgio Agamben, *Die kommende Gemeinschaft* (2001), a.d. Italienischen von Andreas Hiepko, Berlin: Merve 2003, S. 53.

Doch was motiviert überhaupt ein solches Interesse und ein solches Vorgehen? Die entscheidenden Gründe, sich mit den Vergangenheiten und Gegenwarten, den Herkünften und Perspektiven des Glamourösen zu beschäftigen, sind nicht zuletzt in individuellen, intimen wie (halb)öffentlichen, Erfahrungen mit Glamour zu suchen. Von solchen Erfahrungen können viele berichten. Aufenthalte in glanzvollen sozialen und räumlichen Umgebungen; eine unerwartete und riskante Geste des Widerstands gegen einen verordneten Konsens; Begegnungen mit «glamourösen» Persönlichkeiten, wo auch immer sie leben, unter uns oder auf Bühne und Leinwand; Begebenheiten auch, die wegen ihrer anmutigen Beiläufigkeit oder ihrer atemberaubenden Seltenheit im Gedächtnis bleiben; Momente, in denen plötzlich alles richtig ist und man nicht mehr fragen muss, warum eigentlich?

Glamour mag als Ideal von Persönlichkeit, Selbstbewusstsein und Gemeinschaftlichkeit funktionieren, an dem man sich orientiert und das euphorisiert. Oft steht Glamour vielleicht gar nicht im Zentrum der Aufmerksamkeit, sondern fungiert als eine Art Supplement. In diesen Fällen gibt sich das Glamouröse erst im nachhinein als das Merkmal der Unterscheidung zu erkennen, welches die wunderbare Abweichung in die Normalität einschreibt. Dieses Supplement ist jener «geringfügigen Verrückung» vergleichbar, von der Giorgio Agamben im Kontext seiner Diskussion des Messianismus und der «kommenden Gemeinschaft» spricht. Hier läge die entscheidende Veränderung nicht in den Dingen, sondern an deren Rändern. Dort, an den Rändern, «schillert» sie als eine Potenz. Wie jene – ein wenig strahlendere – Aureole eines auserwählten Heiligen, die keinen substantiellen Unterschied zu anderen Aureolen anzeigt, sondern der Glückseligkeit lediglich etwas «mehr Glanz *(clarior)* verleiht».[6]

Neben solchen kleinen Unterschieden, die ermächtigen und Glück bereiten und die man deshalb auch als Liebesbeweis, als Evidenz einer besonderen Zuwendung verstehen kann, werden durchaus niederschmetternde Erfahrungen mit Glamour

assoziiert. Denn Glamour operiert immer auch als kalt-verführerische Norm, der man sich im Zweifel unterwirft – ängstlich, fügsam, entmächtigt. Sowohl das Glücksversprechen, die eudämonistische Dimension des Glamourösen, als auch die fatale Faszination, in der sich das Glamouröse eher als eine Disziplin, ein Zwang, eine Ordnungskraft erweist, wirken auf die Auseinandersetzungen ein, die in der Kunst mit und um das Glamouröse geführt werden. Eine Möglichkeit, diese Auseinandersetzungen und Verhältnisse kategorial zu fassen, läge nun darin, das Verhältnis Kunst/Glamour über den Leisten vorhandener und in der Vergangenheit sattsam diskutierter Polaritäten wie «Avantgarde und Kitsch» oder «High and Low» zu spannen. Man würde damit tendenziell der Dichotomie «Kunst versus Glamour» folgen, die so gern als Königsweg zu einem von glamourösen (sprich: heteronomen) Zumutungen freien Begriff der Kunst betrachtet wird.

Glamour als Gefährdung der Integrität der Kunst zu begreifen hat nun aber auch einen eigenen Reiz. Denn was, wenn diese der Oberfläche verpflichtete Kategorie, die der Nestor des Modernismus, Clement Greenberg, einmal als «inhuman» bezeichnet hat, eine der zentralen Herausforderungen und Gegenlager der Moderne wäre? Was, wenn Glamour als ästhetische Adaption des Prinzips «soziale Konstruktion», die Autonomie und Selbstbezüglichkeit des Kunstwerks nicht nur mit vulgären Zurschaustellungen körperlicher Schönheit, sozialer Überlegenheit und ökonomischen Reichtums konfrontieren, sondern auf einer anderen Ebene die Selbstverständlichkeit der Dichotomie von Schein und Sein in Frage stellen würde?

–

Glamour und Schein

–

In einem berühmten Abschnitt seiner *Ästhetischen Theorie* erörtert Theodor W. Adorno das Problem des «Scheins». Statt den ästhetischen Schein als blosse Illusion und Vermitteltheit (heute würde man vielleicht sagen: *Medialität*) zurückzuweisen, unterstreicht Adorno die Dialektik der modernen Kunst. Wie «Tiere ein angewachsenes Geweih» versuche die moderne Kunst den «Scheincharakter» abzuschütteln.[7] Der Generalverdacht, der dem Schein oder dem scheinhaften Kunstwerk entgegengebracht wird, verweist zurück auf Vorstellungen von einer buchstäblichen, substantiellen, reinen Kunst. Damit wird jedoch der

7
–
Theodor W. Adorno, *Ästhetische Theorie*, hg. von Gretel Adorno und Rolf Tiedemann, Frankfurt am Main: Suhrkamp 1973, S. 157.

immanente Scheincharakter, die konstitutive «phantasmagori-
sche Seite der Kunstwerke» in der Moderne unterschlagen,
die technologische Verstärkung der «Illusion des Ansichseins
der Werke».[8] Denn für Adorno ist der Schein der eigentliche
Ausweis der Kunst. Die Dialektik, die den «Schein» rettet, damit
die Kunstwerke durch ihn gerettet werden können (beispiels-
weise vor den Prätentionen des Gehalts), vollzieht sich im Wi-
derstreit zwischen dem Schein und der Rebellion gegen ihn. Die
Dialektik des Scheins hat es nicht zuletzt mit einem ästhetischen
Moralismus zu tun, der den Schein als Inszenierung, Arrange-
ment und Trug anzuklagen versucht. Adorno ist dabei der
schärfste, aber auch der verständigste Kritiker jenes widerstän-
digen Scheins der «Autonomie» (des Kunstwerks und der künst-
lerischen Sphäre), der sich dem «totalen» beziehungsweise
«ubiquitären» Schein der kapitalistischen Gesellschaftsordnung
entzieht.[9]

Vom Schein, welcher den abstrakten, nicht seienden
Geist «als Seiendes» im Kunstwerk «vor Augen stellt»,[10] unter-
scheidet Adorno den «Glanz». Obwohl beide den gleichen
Ursprung im althochdeutschen «skîn» haben, lässt sich die phi-
losophische Bedeutung von Schein (insbesondere im hegeliani-
schen Verständnis der im Kunstwerk sinnlich scheinenden
Idee) nicht mit der des «Glanzes» verwechseln. Glanz indiziert
die Warenform. Glänzend ist das Spiegellabyrinth des Kaufhau-
ses. Glänzend und glitzernd sind diejenigen spektakulären
Momente eines Jazz- oder Swingsongs, die Adorno 1941 «musical
glamor» genannt hat, «die zahllosen Passagen […], die eine ‹now
we present›-Haltung zu vermitteln scheinen».[11] Um Glanz be-
müht ist auch die Kultur selbst. Die Wahrheit über diesen «Glanz
der Kultur» machen nach Adorno gerade jene sichtbar, die sich
in Abwehr der «Archetypen des Vulgären», der «grinsenden
Reklameschönheiten», die «allzu blendenden Zähne anschwär-
zen»,[12] die Verweigerer der Glanz-Norm.

Im Augenblick, in dem vom Schein zum Glanz gewech-
selt wird, wechselt Adorno das Gender-Register (das zuvor
kaum eine Rolle gespielt hat). Die Kritik am «Vulgären», dem
«verkäuflichen Gefühl», das nichts weiter ist als eine «subjektive
Identifikation mit der objektiv reproduzierten Erniedrigung»,
aktiviert Bilder von «grinsenden Reklameschönheiten» – und des
Übermasses an «weiblichem Glanz», das in ihnen sichtbar wird.
Unter dem Vorzeichen technisch verstärkter Phantasmagorie ist

8
–
Ebd.

9
–
Vgl. ebd., S. 337.

10
–
Vgl. ebd., S. 165.

11
–
Theodor W. Adorno (mit George
Simpson), On Popular Music, in:
*Studies in Philosophy and Social
Science*, vol. IX, 1941, S. 17–48,
hier: S. 28.

12
–
Vgl. Adorno, *Ästhetische Theorie*,
S. 556f.

dieser vermeintlich «weibliche Glanz» eine Domäne dessen, was in den 1920er, aber vor allem 1930er und 1940er Jahren als «Glamour»-Ästhetik, als Grammatik des *glamour shot* entwickelt wurde. Fotografen wie Alfred Cheney Johnston, Ruth Harriet Louise, Laszlo Willinger, Ted Allan, Clarence Sinclair Bull, George Hurrell oder Otto Dyar entwickelten diese Grammatik. In Wechselbeziehung mit illustrierten Fan-Magazinen der Filmindustrie wie *Motion Picture, Movie Life, Movie Star Parade, Photoplay, Screenland* oder *Screen Stars* programmierten die Studiofotografen von MGM oder Warner Bros. eine spezifische, quasi-skulpturale Wahrnehmung der Stars als licht- und schattengeborene Figuren.[13] Zentriert um das Konzept (und den Code) «Glamour» wurde mit jenem «künstlichen Aufbau der ‹personality›» begonnen, den Walter Benjamin 1935/36 als Reaktion auf das «Einschrumpfen der Aura» gelesen hat. Der «Zauber der Persönlichkeit» sollte so erhalten werden – vergeblich.[14] Eine der ersten Filmsoziologinnen, Margaret Farrand Thorp, bestätigt 1939 auf der Grundlage ihres Studiums von Fan-Magazinen, «dass es für einen glamourösen Star heute das wichtigste ist, eine Persönlichkeit zu besitzen». Und sie fügt hinzu: «Dieses Beharren auf der Persönlichkeit inmitten einer standardisierten Gesellschaft ist rührend.»[15]

—

Verfremdungseffekte

—

In einem berühmten Foto, das Edward Steichen 1935 von Marlene Dietrich gemacht hat, wird der Auftritt der quintessentiellen Repräsentantin des Hollywood-Glamour als kontrastreiches Spiel von Weiss- und Schwarzwerten organisiert, wobei der Blick unweigerlich die weisse, gepolsterte Lehne des Sessels und die schwarze, anatomisch merkwürdig bald gestaucht, bald gedehnt wirkende Rumpfmasse der Schauspielerin empor zum durch Arme und Kopfbedeckung gerahmten Gesicht mit den halbgeöffneten, etwas schläfrigen Augen wandert, die den betrachtenden Blick erst fesseln, wenn man ihres Blicks gegenwärtig wird. Eigentlicher Fixpunkt der Komposition ist aber der wie pailletiert wirkende, geflochtene Hut, auf dem ein Glanzlicht liegt, welches die lasziv-überhebliche Miene der Dietrich fortsetzt und konzentriert.

Eine ausgefeilte, geradezu surrealistische Glamour-Konstruktion, die weitgehend denaturalisiert, seltsam monströs

13

—

Vgl. David Fahey/Linda Rich, *Masters of Starlight. Photographers in Hollywood*, New York: Ballantine 1987, S. 14 f.

14

—

Walter Benjamin, Das Kunstwerk im Zeitalter seiner technischen Reproduzierbarkeit, in: Walter Benjamin, *Gesammelte Schriften*, 1–2, Frankfurt am Main: Suhrkamp 1974, S. 492.

15

—

Margaret Farrand Thorp, *America at the Movies* (1939), with an introduction by J.P. Mayer, London: Faber and Faber 1946, S. 51.

erscheint. Bezogen auf die Fotografie wirkt sie wie die perfekte Entsprechung des ikonisch-fetischistischen Bildes der «isolierten, glamourösen, ausgestellten, sexualisierten» Frau im Spielfilm, das Laura Mulvey in ihrem klassischen Essay über «Visuellen Genuss und narratives Kino» theoretisiert. Der Film, in dem ein solches Bild erscheint, werde für den «Moment eines starken sexuellen Eindrucks […] ins Niemandsland ausserhalb von Zeit und Raum» katapultiert; die Illusion und die Erzählung würden unterbrochen zugunsten von *flatness,* der «Qualität eines Scherenschnitts oder einer Ikone».[16] Mulvey feiert diesen Moment der Unterbrechung des filmischen Zeit-Raums jedoch nicht als einen protofeministischen Triumph. Statt dessen erklärt sie das Bild der glamourösen Frau im Spielfilm zum Auslöser entweder einer fetischistischen männlichen Schaulust oder einer sadistischen Erniedrigung – beides Reaktionsweisen, um der Kastrationsangst zu begegnen, die durch das flach-ikonische Frauenbild ausgelöst wird.

Aber wie zweidimensional, wie ikonisch, wie passiv dem aktiven männlichen Blick ausgesetzt ist das Bild der glamourösen Frau beziehungsweise das glamouröse Frauenbild wirklich? Arbeiten das Medium, die Technologie und der Diskurs des Glamourösen ausschliesslich einem heterosexistischen, patriarchalen, sadistischen Voyeurismus zu? So berechtigt die feministische Kritik der fetischistisch-sadistischen Blickkonstruktion im Hollywood-Spielfilm sein mag, erscheint das Glamouröse damit nicht ausreichend erfasst zu sein, weder seine Faszinationsstruktur noch seine tatsächlichen Handlungsangebote. Mulvey deutet diese Potenziale immer wieder an, wenn sie von den Momenten des Ich-Verlusts im Kino spricht, von der Suspension des perspektivischen Illusionsraums durch die Präsenz des glamourös fotografierten Stars. Der Trug der glamourösen Inszenierung überlagert den grundsätzlichen Trug von Illusionismus und narrativer Fiktion. Das heisst auch: Glamour-Momente können de-realisierend wirken, wie Verfremdungseffekte, und transzendieren somit die materielle Wirklichkeit des Apparats.

Hinter dieser Transzendierung steht unter anderem eine spezifische Konzeption von (autoritärer) Autorschaft. Glamour als das Produkt eines starken künstlerischen Willens, einer geradezu demiurgischen Kraft – so stellt sich dies aus der Sicht manches Glamour-Produzenten dar. Das Foto von Edward

16
–

Laura Mulvey, Visual Pleasure and Narrative Cinema (1975), in: Laura Mulvey, *Visual and Other Pleasures,* Houndmills (u.a.): MacMillan 1989, S. 14–26, hier: S. 19f.

Steichen lässt keinen Zweifel an der Verfügungsgewalt, die der Fotograf über sein Modell besitzt. Josef von Sternberg, der Regisseur, der Marlene Dietrich «gemacht» hat («Marlene, das bin ich»), berichtet freimütig von der Folter der gelassenen Posen, die er seinem Star zumutete. Von Sternberg schreibt aber auch, dass Glamour ein «elastisches Konzept» sei, ein «visuelles Stimulans» wie aus Seifenblasen. Nicht das «Objekt vor der Linse», sondern der Künstler, der das Modell manipuliere und ins Licht hinausstelle, sei für den «Glamour einer Fotografie» verantwortlich. [17] Aber von Sternberg hat seinem Bild der Glamour-Macht, der einseitig ausgeübten Manipulation und Verantwortung nicht ohne Grund die Formulierungen von Glamour als «elastischem Konzept», als «Spiel fliessender Werte» und kunstvollem Arrangement in einem geistigen Raum vorangestellt. Die Verhältnisse von Er- und Entmächtigung, von Autorschaft und *agency,* von Aktivität und Passivität im Glamour – als «elastisches Konzept» betrachtet – dementieren die Kulturkritik, die Glamour einfach «inhuman» nennt oder für Neid und Unterwerfung verantwortlich macht.

Die Filmkritikerin Frieda Grafe näherte sich von Sternberg auf überraschende Weise, ohne deshalb zur blossen Apologetin eines zweifelhaften Glamour-Autoren-Bildes zu werden. In ihrem Manuskript zu einem Vortrag von 1998 zu von Sternbergs The Devil Is a Woman aus dem Jahr 1935 schrieb sie, von Sternberg habe den «fotografischen Schönheitsbegriff» zum «Glamour» weiterentwickelt, «seiner von der Kamera produzierten Schönheitsformel.» [18] Doch obwohl dies eine Verengung auf die Ausstrahlung auf Frauen nahelegt, ist für Grafe die Attraktion dieses Glamour nicht eindeutig. Sie entdeckt bei von Sternberg etwas

… bis dahin Unsichtbares, eine Art kondensierter Aura, die visuelle Wirkungen hervorruft, die in ihren Fusionen nicht mehr geschlechtsspezifisch zu beschreiben sind und die von der veräusserlichten Innerlichkeit herrühren müssen. Unbewusstes tritt durch die mechanische Wiedergabe in den Bereich des Sichtbaren und erlangt dadurch den Status von Bewusstheit. Indem Sternberg mit Marlenes Assistenz, unter ihrem höchst professionellen körperlichen Einsatz Glamour produzierte, schuf er ein neues Bild von Weiblichkeit, das männliche und weibliche Imagination gleichermassen tangierte. [19]

Diese neue Sexualität hat wenig mit Diven-Verehrung zu tun. Marlene Dietrich ist ihrem Regisseur vielmehr vorgekommen wie ein Frauendarsteller: «Sternberg sah sie immer in drag» (Grafe), weshalb die Kleider der Dietrich, ihre Herrenanzüge

17
—
The Von Sternberg Principles, in: *Esquire,* No. 250, Vol. 40, October 1963 (übersetzt als Josef von Sternberg, Glamor, in: *Filmkritik,* 13. Jg., H.2, Februar 1969, S. 130–132).

18
—
Frieda Grafe, Die Haut vom Kino. Zu *The Devil Is a Woman* von Josef von Sternberg (1998), in: Frieda Grafe, *Filmfarben,* Ausgewählte Schriften in Einzelbänden, 1, Berlin: Brinkmann & Bose 2002, S. 103.

19
—
Ebd., S. 104.

und ihre Roben, zu einem wichtigen Teil der Künstlichkeit ihrer Erscheinung, aber auch zum «Indiz einer tiefgreifenden kategorialen Krise» wurden: «Glamour, in der von Sternberg geschaffenen Einmaligkeit», schreibt Grafe, «ist bisexuell, ein Effekt aus entgegengesetzten Prinzipien, für die sich alle möglichen Prinzipien anbieten – Licht/Schatten, Idee/Form, Innen/Aussen –, deren Transfusion, die durch die Dynamik des bewegten Bildes geschieht, eine schillernde Totalität ergibt.»[20]

«Schillernde Totalität» trifft – gerade in Abgrenzung von Adornos «totalem Schein» – recht gut, wieviel Ungelöstes im Begriff des Glamourösen steckt und wie wenig sich die *Funktionen des Glamourösen* und *Glamour-als-Funktion* eindeutig bestimmen lassen. Die Glamour-Transfusionen setzen eine Transformation der (sexuellen) Identität, womöglich gar ihre Auflösung in Gang. Die Konstruktion jenes flachen, ikonischen, scherenschnitthaften Bildes, von dem Laura Mulvey spricht, kann zugleich eine Dekonstruktion sein, die Öffnung eines Raums der unvorhergesehenen Persönlichkeiten und Gemeinschaften.

–

Fremder Glamour

–

Glamour ist, vielleicht gerade wegen dieser Möglichkeiten, in der Vergangenheit und Gegenwart immer wieder der Bezugspunkt von subkulturellen, bohemistischen, dissidenten Zusammenhängen gewesen, in denen seine Konstruktionsprinzipien analysiert und neue Wirkungen erprobt werden. Glamour – insbesondere ein historisch gewordener Glamour und dessen Archive – kann als Ressource für Widerstandsakte dienen. Die US-amerikanische Performance-Künstlerin Jacki Apple blickt 1999 im Gespräch mit dem Künstler Mike Kelley auf die feministische Kunstpraxis der 1960er und 1970er Jahre zurück: «Die Frage war: Konnte Macht im selben Bezugssystem existieren wie Schönheit, so wie sie kulturell definiert ist – als Glamour?» Und die Antwort lag in einer Hinwendung zu vergangenen Modellen einer «Koalition» von Macht und Schönheit, «zu den machtvollen, glamourösen Filmstars der 1940er Jahre».[21]

Weniger nach Modellen von Macht und Schönheit als nach Subtexten des klassischen Hollywood-Glamour suchten das Underground-Kino und die Performances von Jack Smith. Seit den späten 1950er Jahren orientierte sich Smith unter anderem an der «visuellen Entdeckung», die ein Altmeister der

20

–

Ebd., S. 106.

21

–

Zitiert nach Mike Kelley, Cross-Gender/Cross-Genre (1999/2000), in: Mike Kelley, *Foul Perfection. Essays and Criticism*, hg. von John C. Welchman, Cambridge, MA/London: The MIT Press 2003, S. 100–120, hier: S. 118 f. (Anm. 41).

Glamourfabrikation wie Josef von Sternberg jedem «Geschich-
tenerzählen» vorgezogen habe.[22] Für Smith war von Sternbergs
«visuelle Phantasiewelt» gerade nicht das Modell technischer
Perfektion, sondern der unvollkommene, dafür jedoch einzig-
artige und persönliche Ausdruck eines idiosynkratischen Werte-
systems. Smiths «Montezland» oder «Cinemaroc» ist ein Ersatz-
oder Meta-Hollywood, nicht nur Phantasiewelt, sondern ein
Produktionskontext, ein Praxisfeld zu eigenen Bedingungen.
Hier liess Smith seine Laiendarsteller, seine *creatures,* diese un-
mittelbaren Vorfahren der *superstars* aus Warhols Factory, in
Filmen wie *Flaming Creatures* (1962–63) oder *Normal Love*
(1963–64) Tableaus orgiastischer Überschreitung errichten.
So entstand «eine völlig neue Form des Kino-Glamour – eine,
die dem Glamour Hollywoods alles und nichts verdankt», wie
J. Hoberman schreibt.[23]

Die überlieferten Texte des Glamour wurden dekonstru-
iert, was in ihnen verborgen war, hervorgekehrt und betont:
«visuelle Textur, androgyne sexuelle Präsenz, exotische Schau-
plätze» (P. Adams Sitney);[24] das Ergebnis war eine karnevaleske,
aber zutiefst ernst gemeinte Travestie von Glamour: *«Berührung
mit etwas, was wir nicht sind, nicht kennen, nicht denken, nicht
fühlen, nicht verstehen»* und was deshalb eine *«Erweiterung»*
darstellt.[25] Glamour in diesem Sinn als ein Medium oder eine
Methode zu denken, um sich von der Disziplin, die Glamour
eben auch ist, zu lösen, macht ihn zur ästhetischen Kategorie
eines Ausnahmezustands. «Glamorous rapture, schizophrenic
delight, hopeless naivete and glittering technicolored trash!»[26]
konfrontieren den ästhetischen Code, die «Grammatik» zur Her-
stellung von Lichtgestalten und Glanzeffekten, mit der Auf-
hebung dieses Regelwerks und der Ausserkraftsetzung dieses
Wissens als dessen unerwarteter Aufwertung. So kann Jack
Smiths Verehrung der «falschen» Vorbilder wie Josef von Stern-
berg oder Maria Montez als Redefinition von Glamour betrachtet
werden, als Ausdruck eines «‹fremden› Glamour» – ähnlich wie
die Performances der bärtigen Crossdresser und Hippiefrauen
der Queer-Theatre-Gruppe The Cockettes aus San Francisco in
den späten 1960er und frühen 1970er Jahren oder Charles
Ludlams Ridiculous Theatrical Company.[27] Glamourös, das war
– zumindest in den USA – lange Zeit auch gleichbedeutend mit
unausgesprochener Homosexualität, mit (europäischer) De-
kadenz, mit dem Femininen. Damit war Glamour, wo er aus den

22

Jack Smith, Belated Appreciation
of V.S. (1963), in: J. Hoberman/
Edward Leffingwell (Hg.),
*Wait for Me at the Bottom of the
Pool. The Writings of Jack Smith,*
New York/London:
High Risk/P.S.1 1997, S. 41–43,
hier: S. 42.

23

J. Hoberman, On Jack Smith's
Flaming Creatures *(and Other
Secret-Flix of Cinemaroc),*
New York: Granary/Hips Road
2001, S. 10.

24

P. Adams Sitney, *Visionary Film:
The Avant-Garde 1943–1978,*
2. Auflage, New York: Oxford
University Press 1979, S. 353.

25

Jack Smith, The Perfect Filmic
Appositeness of Maria Montez
(1962), in: Hoberman/Leffingwell
(Hg.), *Wait For Me at the Bottom
of the Pool,* S. 25–35, hier: S. 34.

26

Ebd., S. 26.

27

Zum Zusammenhang des quee-
ren New Yorker und Westcoast-
Underground der 1950er bis
1970er Jahre, zwischen Jack
Smith, Andy Warhol, den
Cockettes, Glamrock und Charles
Ludlam vgl. den Reader, der die
Veranstaltung *Re-Make/Re-Model*
während des Steirischen Herb-
stes in Graz 1999 dokumentiert:
Diedrich Diederichsen, Christine
Frisinghelli, Christoph Gurk,
Matthias Haase, Juliane Reben-
tisch, Martin Saar, Ruth Sonder-
egger (Hg.), *Golden Years.
Materialien und Positionen zu
Subkultur und Avantgarde
zwischen 1959 und 1974,*
Graz: Edition Camera Austria
(im Erscheinen).

vorgesehenen Bahnen ausbrach, für eine patriarchale, hetero-sexistische Gesellschaftsordnung bedrohlich. Traditionell richtet die Schönheitsindustrie ihre Glamour-Appelle an die Adresse von Frauen; sie sind die Hauptzielgruppe der Modezeitschriften und der Kosmetikanzeigen, der Aufforderungen zu Diäten und chirurgischen Eingriffen; sie werden in ein Wechselbad von kurzfristiger Wunscherfüllung im Konsum und dem abrupten Entzug der gerade erworbenen Freiheitsgefühle geworfen, so-bald ihnen wieder ein neues Produkt verkauft werden soll. Frauen, so formuliert Daniel Harris, werden heute durch die Mode- und Kosmetikindustrie zu «kinetischen Skulpturen» ob-jektiviert, die das Thema Sexappeal durch eine rein «ästhetische» Vision ihrer selbst ersetzen.[28] Man kann zu solchen Beobachtun-gen stehen, wie man will, sie unterschätzen aber in jedem Fall die karnevaleske Dimension von Glamour. So habe es beispiels-weise der Gebrauch des Kostüms im klassischen Hollywood gerade Frauen ermöglicht, soziale Unterschiede zu parodieren, umzukehren und zu denaturalisieren, wie Sarah Berry in einer Studie über das Modekonsum-System der 1930er Jahre schreibt.[29] Ähnliches gilt für andere Aneignungen der Glamour-Repertoires. Insofern ist Glamour nicht nur eine Technologie sozialer Kontrolle, sondern auch ein Instrument der sozialen Veränderung.

—

Semantische Konjunkturen

—

Die erstaunliche Widersprüchlichkeit und Mobilität des Gla-mourkonzepts ist auch in der Geschichte seiner schwankenden Akzeptanz und kulturellen Einbettung begründet. «Glamour ist etwas, das sich immer gut verkauft, aber frage zehn Leute, was Glamour ist, und du wirst zehn verschiedene Antworten er-halten.»[30] Dieses milde Paradox, dem noch heute viele beipflich-ten werden, stammt von Peter Gowland. Mitte des letzten Jahr-hunderts arbeitete Gowland als Fotograf von weiblichen Pin-ups; 1957 veröffentlichte er *How to Take Glamour Photos*, ein Hand-buch für Fotoamateure. So selbstverständlich diese Anleitung zur Nacktfotografie den Begriff «Glamour» im Titel trug, so wenig bedeutete Glamour zu diesem Zeitpunkt offenbar, was er einmal bedeutet hatte – als Leitbegriff jener Ära, in der Norma Shearer, Gloria Swanson, Rudolph Valentino, Marlene Dietrich, Greta Garbo, Joan Crawford oder Katherine Hepburn wie

28
—
Daniel Harris, *Cute, Quaint, Hungry and Romantic.* The Aesthetics of Consumerism, New York: Da Capo 2000, S. 230.

29
—
Sarah Berry, *Screen Style. Fashion and Feminity in 1930s Hollywood*, Minneapolis/London: University of Minnesota Press 2000, S. XXI.

30
—
Peter Gowland, *How to Take Glamour Photos*, Greenwich, CN: Fawcett 1957, S. 5.

ultimative Verkörperungen der merkwürdig unfassbaren, unbestimmbaren Qualität des Glamourösen erschienen.

Dass der Begriff in den 1950er Jahren aus dem Kontext der grossen Studioproduktionen Hollywoods und dem Olymp ihrer gottgleichen Stars in die Schmuddelsphäre der Nacktfotografie abwandern konnte, verweist auf eine signifikante Verschiebung innerhalb der Ästhetik der Massenkultur. Glamour war, so stellt 1947 der britische Lexikograph Eric Partridge fest, zu einem «Modewort» geworden. Das mit ihm Bezeichnete konnte ein Mädchen sein oder ein Gigolo, der Presse jedenfalls war ein vielfach einsetzbarer Terminus zugefallen: «*Glamour* hat seinen Weg über den Theaterklatsch, die Filmbesprechungen und den übrigen gerade gängigen Journalismus gefunden.» [31] Glamour, eine der Schlüsselkategorien, mit denen die Kulturindustrie seit den 1920er Jahren sich selbst und ihre Produkte zu beschreiben versuchte, [32] machte offenbar eine Funktions- und Bedeutungsveränderung durch. Zumindest fügte sich der Begriff nicht mehr nahtlos in die traditionelle Semantik, deckte nun ein weiteres Feld von Bedeutungen ab, parallel und in Reaktion auf die Veränderung der Medien- und Konsumlandschaft der Kriegs- und Nachkriegsjahre.

Jetzt, gegen Ende der Ära des Studiosystems und zu Beginn des Fernsehens, im Nachkriegsjahrzehnt einer prosperierenden US-amerikanischen Gesellschaft, war die Epoche der Gowlands und der Fotoamateure, aber auch eines neuen Typs von Filmstar angebrochen. Über zwei Jahrzehnte hatte man Glamour mit der perfekten und veredelnden Inszenierung von Körpern und Oberflächen identifiziert – eine visuelle Technologie, die fotografische und filmische Bilder radikal künstlicher Schönheit produziert hatte. Mit dem Untergang der grossen Studios geriet auch die kulturelle Konzeption des Stars und die an Art-Deco-Klassizismus und barocker Musical-Opulenz orientierte Bildästhetik Hollywoods in die Krise. Statt Studiofotografen wie George Hurrell, Edward Steichen oder Ruth Harriet Louise nahmen jetzt *Life*-Reporter und Paparazzi das *Naked Hollywood* (so der Titel eines bahnbrechenden Fotobuchs von Weegee aus dem Jahr 1953) ins Visier. Die pseudoaristokratischen Inszenierungen von Glamour mussten einem neuen, «demokratischeren» System von Darstellungen weichen. [33]

Glamour wurde jetzt zu verschiedenen Preisen angeboten, auch im Discount. Er stieg in der Genre-Hierarchie des

31
–
Eric Partridge, *Usage and Abusage: A Guide to Good English*, London: Hamish Hamilton 1947, S. 361 (zit. n. Réka C.V. Buckley/Stephen Gundle, Flash Trash. Gianni Versace and the Theory and Practice of Glamour, in: Stella Bruzzi/Pamela Church Gibson [Hg.], *Fashion Cultures. Theories, Explorations and Analysis*, London/New York: Routledge 2000, S. 331 f.)

32
–
«What made Hollywood unique was its total concentration on one thing. That thing was the word ‹glamour› – a word that Hollywood popularized and that Hollywood will always evoke.» (Diana Vreeland, *Romantic and Glamorous Hollywood Design*, New York: The Costume Institute/ The Metropolitan Museum of Art 1974 o.S.)

33
–
Vgl. Fahey/Rich, *Masters of Starlight*, S. 22 ff.

Kinos hinab auf die B- und C-Ebene, wurde weit mehr als zuvor zum Werbeargument für Kosmetika und andere Massenprodukte. In Miami baute der Architekt Morris Lapidus Hotels wie das *Fontainebleau* (1954) – ein Ensemble schwelgend-kurviger Bühnen für die Selbstdarstellungen und Konsuminteressen einer neuen Mittelklasse. Die Architektur wurde gezielt als Filmset konzipiert und verschaffte der Generation, die die Grosse Depression und den Zweiten Weltkrieg überstanden hatte, Inszenierungsmöglichkeiten und ein neuartiges Nahverhältnis zu Glamour. Denn dieser war nun nicht mehr ausschliesslich in einer exklusiven Sphäre der Stars angesiedelt, sondern wurde zunehmend zugänglich für die Mitglieder der prosperierenden Mittelklasse.

Zugleich qualifizierte sich Glamour in der Krise als Gegenstand eines Camp-Geschmacks. Dieser machte die Abwertung zum Ausgangspunkt einer mal morbiden, mal melancholischen, mal frenetischen Neubewertung und Rekontextualisierung des Glamourösen. Die Drag-Szene begann, ihre Repertoires durch eine interpretierende Aneignung des nun scheinbar nutzlosen Glamour-Archivs Hollywoods zu entwickeln. Glamour stand plötzlich zur Verfügung, auch für gegen-glamouröse Manöver.

Etwa zum gleichen Zeitpunkt und mit teils ähnlichen Intentionen wie der Camp-Underground entdeckten die bildenden Künstler Glamour für sich. Die britische Pop Art betrachtete Glamour Ende der 1950er Jahre – dokumentiert in Richard Hamiltons berühmter Liste der Ingredienzen von Pop aus dem Jahr 1957 – [54] als einen Bestandteil der «Pop Art», also sowohl der «Kunst» der Populärkultur wie der in Auseinandersetzung mit der Populärkultur entstehenden bildenden Kunst. Andy Warhol, von Jack Smith beeinflusst, begann in den frühen 1960er Jahren mit seiner jahrzehntelangen Konstruktion einer parallelen Glamourdimension, in der die Ikonen und Produktionsstätten der populären Unterhaltungskultur untersucht, nachgeahmt und überformt wurden. Im Unterschied zu den Abgrenzungskämpfen der modernistischen Kunst war mit Pop Art und Postmoderne die Beziehung zwischen bildender Kunst, Mode, Film, Popmusik, Werbung, Design und Identitätspolitik in die Phase einer ständigen Interaktion eingetreten, wie das zuvor ansatzweise im Surrealismus, mit Man Ray, Dalí oder Meret Oppenheim, der Fall gewesen war.

54
—
Richard Hamilton, «Letter to Peter and Alison Smithson», in: *Collected Words 1953-1982*, London 1982, hier zitiert aus: David Robbins (Hg.), *The Independent Group: Postwar Britain and the Aesthetics of Plenty*, Cambridge, MA/London: The MIT Press 1990, S. 182.

Meta-Glamour, Gegen-Glamour

—

35
–
General Idea, FILE Megazine:
Glamour Issue, vol. 3, no. 1,
Autumn 1975.

Im Herbst 1975 erschien eine weitere Ausgabe des *FILE Megazine,* das von der kanadischen Künstlergruppe General Idea seit 1970 herausgebracht wurde. Auf dem Cover stand «Glamour Issue», und die drei Mitglieder von General Idea, AA Bronson, Jorge Zontal und Felix Partz, die bereits in Maskierungen, Travestien und Aneignungen der Repräsentationssysteme der Massenkultur erprobt waren, versprachen ihren LeserInnen «die Geschichte des Glamour und die Rolle, die er in unserer Kunst gespielt hat».[35] Glamour wird als radikal entleerte Künstlichkeit, als eigenschaftslos und immobilisierend definiert. Mit der Rhetorik eines Lifestyle-Ratgebers und dem Pathos eines avantgardistischen Künstlermanifests erklären General Idea, Glamour habe den Marxismus als «das einzige revolutionäre Statement des 20. Jahrhunderts» abgelöst. Dem Mythos verwandt, verkleinere Glamour die Wirklichkeit, mache sie auf einen Blick sichtbar. Die objektivierenden Funktionen von Glamour werden unmittelbar auf die Rationalität des Ökonomischen bezogen: «Glamour handelt ökonomisch. Es löscht die Komplexität des menschlichen Bildes und menschlicher Handlungen aus und lässt nur Essenzen davon zurück.»

Der anti-authentizistische Glamourbegriff von General Idea muss vor dem Hintergrund der verschiedenen Prozesse der künstlerischen Aneignung und politischen Umwidmung etwa im Kontext der *queer culture* gesehen werden. In den vorangegangenen Jahrzehnten liessen diese Prozesse eine Idee von Gegenglamour entstehen, die sich immer wieder neu in der Auseinandersetzung mit den Glamourversionen der Warenästhetik als solcher formierte. Glamourproduzenten im Kunstbereich wurden, wie Andy Warhol, zu *art directors* und Unternehmern höherer und niedrigerer Glanzsorten. Mit anderen Worten: Versteht man, wie General Idea, Glamour als eine Kategorie, in der sich Ästhetik und Ökonomie unauflöslich verschränken, dann sind die ästhetischen Aneignungen und Umwidmungen von Glamour auch Interventionen auf der Ebene des Ökonomischen.

Glamouröse Inszenierungen können Gegensätzliches bewirken, sie sind, bei aller vermeintlichen Eindeutigkeit, immer auch dialektisch zu lesen. Ihr Schillern und Scheinen mag den Blick auf soziale Verhältnisse im gleichen Moment verstellen wie schärfen. Tendenziell unterläuft das Begehren nach

Glamour ein Denken und Handeln in politischen Kategorien.
Doch sobald seine zentrale Rolle für die Logik des Kapitalismus
erkannt und reflektiert wird, gewinnt es eine politische Valenz.
Glamour ist zugleich die symbolische Oberfläche von Macht und
Reichtum wie das ewig unerfüllte Versprechen auf – zumindest
symbolische – Umverteilung des gesellschaftlichen Wohlstands.

All diese gegenläufigen Botschaften und Effekte sind
in der Kunst der Gegenwart und ihren Vorläufern in den Nach-
kriegsjahrzehnten präsent. Bisweilen wird die Sehnsucht
nach den (vergangenen) Utopien des Glamour in einer Gegen-
wart, für die Glamour zum allgegenwärtigen Appell der Selbst-
optimierung geworden ist, ein Gegenstand künstlerischer
Praxis. Dann wieder erscheint Glamour als unhintergehbare
Folie individueller Obsessionen und Abhängigkeiten. Zwischen
Meta-Glamour und Gegen-Glamour, zwischen der Selbstins-
zenierung als Star und der Kritik einer auf Glamour fixierten
Subjektivität entwickelt sich in der bildenden Kunst ein Umgang
mit Glamour, der diesen aus den Funktionen des Warenverkehrs
und der Tauschwertproduktion für einen kurzen Moment her-
ausnimmt. In den künstlerischen Produktionen und Zeugnissen,
die *The Future Has a Silver Lining* versammelt hat, sind solche
meta- und gegen-glamourösen Strategien allgegenwärtig:
in den Gesten der Hommage (Manon, Francesco Vezzoli, T. J.
Wilcox), den Reflexionen über die Architektur und das Design
des Stars und des Glamour (Tom Burr, Nicole Wermers,
Josephine Meckseper, Julian Göthe, Bernhard Martin), der
ästhetischen Analyse von Verausgabung und Ausnahmezustand
(Cerith Wyn Evans, Katharina Sieverding, Janet Cardiff / George
Bures Miller, Sylvie Fleury), der Archivierung von Erinnerun-
gen an glamouröse Momente (Marc Camille Chaimowicz,
John Edward Heys, Michel Auder, T. J. Wilcox), der seriellen
Selbsttransformation (Urs Lüthi, Carlos Pazos, Leigh Bowery,
Brice Dellsperger) oder der Kritik des öffentlichen Schönheits-
bildes (Sanja Iveković, Kutlug Ataman, Daniele Buetti). Glamour
erscheint hier immer weniger als ein frei verfügbares ästheti-
sches Idiom denn als ein Ensemble kultureller Praktiken, die
zwischen dem Ästhetischen und dem Ökonomischen vermit-
teln. Der Blick geht auf die Konstruktionspläne des Glamourösen,
auf seine Zusammensetzungen, auf die Arbeit, die in seine Her-
stellung eingegangen ist, auf die Subjektivierungen unter seiner
Beigabe und seinem Einfluss. Für einen kurzen Moment…

Biographies
/
Biografien

—

List of works
/
Werkliste

—

Impressum

Kutlug Ataman

—

*1961 in Istanbul (Turkey)
Lebt und arbeitet / lives and works in Barcelona, London and Istanbul

Einzelausstellungen / Solo Exhibitions
(Auswahl seit 2000 / Selection since 2000)

2004 Lehmann Maupin, New York ¬ Serpentine Gallery, London ¬ GEM, Museum voor Aktuele Kunst, The Hague
2002 *Never My Soul!* Lehmann Maupin, New York ¬ *Long Streams,* Nikolaj, Copenhagen ¬ Context Europa / Impulses from the Balkans ¬ Theater Des Augenblicks, Vienna ¬ *Women Who Wear Wigs,* Istanbul Contemporary Arts Museum ¬ *A Rose Blooms in the Garden of Sorrows,* BAWAG Foundation, Vienna
2001 Tensta Konsthal ¬ *Women Who Wear Wigs,* Lehmann Maupin, New York ¬ *semiha b. unplugged,* Gallery Akinci, Amsterdam
2000 The Lux Gallery, London

Gruppenausstellungen / Group Exhibitions
(Auswahl seit 1999 / Selection since 1999)

2004 *Turner Prize,* Tate Britain, London ¬ *Monument to Now,* DESTE Foundation, Athens ¬ *Flowers Observed, Flowers Transformed,* ¬ The Warhol Museum, Pittsburgh ¬ *Documentary Fictions,* CaixaForum, Barcelona ¬ Neue Kunsthalle III, Kunsthalle Mannheim ¬ Athens Concert Hall, Athens
2003 Istanbul Biennial ¬ *Fast Forward,* Sammlung Goetz Collection, ZKM, Karlsruhe ¬ *Testimonies: between Fiction and Reality,* National Museum of Contemporary Art, Athens ¬ *le Printemps du Septembre,* Toulouse ¬ *Image Stream,* Wexner Center for the Arts, Columbus, Ohio ¬ Deste Foundation, Athens ¬ *Die neue Kunsthalle,* Kunsthalle Mannheim ¬ *Witness, The Curve,* Barbican Art Gallery, London ¬ Tate Triennial, Tate Britian, London
2002 Documenta 11, Kassel ¬ Biennale de São Paulo, Brazil ¬ *FAIR,* Royal College of Art, London
2001 Istanbul Biennale ¬ Berlin Biennale ¬ *Narrative Affinities,* GB Agency, Paris
2000 *Enter Gallery,* City Museum of Art, Helsinki ¬ Cranbrook Museum of Art, Detroit, Michigan ¬ Museum Moderner Kunst, Austria
1999 Kunstmuseum, Bonn ¬ Venice Biennale ¬ Centre des Arts Contemporains Genève ¬ Up To Date: Fondazione Trussardi, Milan ¬ La Biennale de Montreal ¬ Manifesta 2, Luxembourg

Michel Auder

—

*1944 in Soissons (France)
Lebt und arbeitet / lives and works in New York

Einzelausstellungen / Solo Exhibitions
(Auswahl seit 1982 / Selection since 1982)

—

2002 *Michel Auder: A Retrospective,* The Rennaissance Society, Chicago
2001 *Integrity Maintained,* Rooseum – Center for Contemporary Arts, Malmö ¬ *Portrait of Alice Neel,* Video Gallery, Philadelphia Museum of Art, Philadelphia
2000 AC Project Room, New York ¬ Kunsthalle St. Gallen
1999 halle für kunst, Lüneburg ¬ Robert Prime, London
1998 *5 Ring Circus,* AC Project Room, New York
1996 Transmission Gallery, Glasgow
1995 *A Personal Narrative of Travel to Bolivia,* Nicole Clagsbrun

Gallery, New York
1991 *Selected Vide Works 1970–1991,* Anthology Film Archives, New York
1982 *Hallwalls,* Buffalo, New York

Gruppenausstellungen und Filmvorführungen / Group Exhibitions and Public Screenings (Auswahl seit 1980 / Selection since 1980)

2002 *St. Petrischnee,* migros museum für gegenwartskunst, Zurich
2001 *Televisions,* Kunsthalle Wien
1999 *Re-Make, Re-Model. Secret Historiesof Art, Pop, Life and the Avant-garde,* Steirischer Herbst, Graz ¬ *The American Century: Art and Culture 1900–2000, Part II: 1950–2000,* Whitney Museum of American Art, New York ¬ Galerie Daniel Buchholz, Cologne ¬ *All my Worldly Possesions,* Neuer Aachener Kunstverein ¬ *Hollywood Realism,* with Jeremy Blake, Venetia Kapernekas Fine Arts, New York
1998 *Cindy Sherman Retrospective,* Museum of Contemporary Art, Los Angeles ¬ *Inglenook,* Feigen Contemporary, New York ¬ *The Cultured Tourist,* Leslie Tonkonow Artworks & Projects, New York
1996 *Cindy Sherman,* Museum of Modern Art, Shiga ¬ Museum of Contemporary Art, Tokyo ¬ Gallery Froment Puttman, Paris ¬ *Voyeurs Delights,* Franklin Furnace, New York ¬ *The Real, The Fictional, The Virtual,* Les Rencontres Internationales de la Photographie, Arles ¬ *Adriane Lopez-Huici and Michel Auder,* AC Project Room, New York
1995 *Mondo Cane V.R.,* International Video Week, Saint-Gervais, Geneva ¬ *Video Viewpoints,* Museum of Modern Art, New York ¬ *Pure Hginterland,* Randolph Street Gallery, Chicago ¬ *Better Living Through Chemistry,* Randolph Street Gallery, Chicago
1994 *Screen Life,* Studio Guenzani, Mailand ¬ *Selected Video Works from 1970–1993,* Nicole Klagsbrun Gallery, New York
1993 *Diaries,* Long Beach Museum of Art, Long Beach ¬ *The Rome Project,* David Winton Bell Gallery, Brown University, Providence
1988 *The Arts for Television,* Stedelijk Museum, Amsterdam & Museum of Contemporary Art, Los Angeles ¬ *Twilight,* Festival Belluard Bollewerk, Fribourg ¬ The Kitchen, New York ¬ B.R.T. Television, Brussels
1987 *L'Epoque, La Morale, La Mode, La Passion,* Centre Georges Pompidou, Paris ¬ *Lite Night TV,* Manhattan Cable Television, New York
1986 *Fragments / Text / Notes / Documents …,* Los Angeles Contemporary Exhibitions, Los Angeles ¬ *Mediated Narratives,* Institute of Contemporary Art, Boston ¬ The Kitchen, New York ¬ *Famous For Thirty Seconds* (Artists in the Media), Artists Space, New York
1985 *Anthology Film Program,* Millenium Film Workshop, New York ¬ *Video Viewing Room,* P.S.1, New York ¬ *Transference,* White Columns, New York
1984 *Video: Heroes / Anti-Heroes,* Contemporary Arts Museum, Houston ¬ *Cindy Sherman Survey,* Allen Memorial Art Museum, Akron ¬ *Secondo Festival Internazionale del Video,* Campo Bario, Rome ¬ Metro Pictures, New York
1983 *17th São Paulo International Biennal,* São Paulo ¬ *Progressive Video,* Jon Leo Gallery, New York ¬ Squat Theatre, New York ¬ The Kitchen, New York ¬ *New Soap Video,* Institute of Contemporary Arts, Boston
1982 A.F.I. National Video Festival, John F. Kennedy Center for the Performing Arts, Washington D.C. & The American Film Institute ¬ Campus, Los Angeles ¬ The Kitchen, New York
1981 The Kitchen, New York
1980 The Kitchen, New York

Shannon Bool

—

* 1972 in Comox (Canada)
Lebt und arbeitet/lives and works in Frankfurt a. M.

Einzelausstellungen/Solo Exhibitions
(Auswahl seit 2002/Selection since 2002)

2004 *Waxing the Sublime,* schnittraum, Cologne
2003 *Fresh and Upcoming,* Frankfurter Kunstverein
2002 *Wet Buildings,* Fahrradhalle, Offenbach

Gruppenausstellungen/Group Exhibitions
(Auswahl seit 2001/Selection since 2001)

2004 *The Savoy,* Collective Gallery, Edinburgh ¬ *Gravenhurst
Contemporary Art Center* ¬ *c/o atle gerhardson, Berlin* ¬
The Studio, Karin Günther, Nina Borgmann Gallery,
Hamburg
2003 *Heute,* Hessisches Ministry for Art and Science, Wiesbaden
2002 *Aus,* Frankfurt a. M.
2001 *Domesticities,* Concourse Gallery, Vancouver

Leigh Bowery

—

* 1961 in Sunshine (Australia)
† 1994 in London

Leigh Bowery was a performance artist, fashion designer, night-
club sensation, art object, and above all an icon whose influence
traversed the music, art, film and fashion worlds. Perhaps he is best
known for his role as muse and nude model for some of Lucian
Freud's paintings. Between 1988 and 1994 Fergus Greer photo-
graphed Bowery in his extraordinary clothes. Bowery remains an
inspiration to many contemporary fashion designers.

Daniele Buetti

—

* 1956 in Fribourg (Switzerland)
Lebt und arbeitet/lives and works in Zurich

Einzelausstellungen/Solo Exhibitions
(Auswahl seit 1999/Selection since 1999)

—

2004 FRAC, Fonds Régional d'Art Contemporain, Marseille ¬
Museum Henie Onstad, Hovikodden, Oslo ¬
EACC, Espai d'Art Contemporani de Castello ¬ Galerie
arsFutura, Zurich ¬ Gallery Espai Lucas, Jofrens 6, Valencia
¬ Galerie Eugen Lendl, Graz
2003 Kunstverein Freiburg, Fribourg i. Br ¬ Helmhaus, Zurich ¬
Galerie Bernhard Knaus, Mannheim
2002 Aeroplastics Contemporary, Brussels ¬ Galerie Reinhard
Hauff, Stuttgart ¬ Galerie Sfeir-Semler, Hamburg
2001 Galerie arsFutura, Zurich ¬ B & D Studio Contemporanea,
Milan ¬ Galeria Ad Hoc, Vigo
1999 Galerie arsFutura, Zurich ¬ Museo Nacional Centro de Arte
Reina Sofia, Madrid ¬ B & D Studio Contemporanea,
Milan ¬ museumsakademie/Galerie Helen Adkins, Berlin ¬
espai Lucas, Valencia

Gruppenausstellungen/Group Exhibitions
(Auswahl seit 2000/Selection since 2000)

—

2004 *The Laboratorium,* Galerie im Kornhauskeller, Ulm ¬
Gegen den Strich, Kunsthalle Baden-Baden ¬ *SPAM–Kunst
und Werbung,* Museum für Moderne Kunst, Bozen ¬
Antico Monastero delle Agostiniane, Bellinzona ¬

Kunsthaus Baselland ¬ *Comment rester Zen,* Museum am
Ostwall, Dortmund ¬ *O.K. America!,* Apex Art Gallery, New York
2003 *Talking Pieces,* Städtisches Museum Leverkusen Schloss
Morsbroich, Leverkusen ¬ *Durchzug/Draft,* Kunsthalle
Zurich ¬ *Shopping,* Passanten Foundation, Tilburg ¬
Grey Art Gallery, New York ¬ *Fuckin' Trendy,* Kunsthalle
Nuremberg ¬ *Bellissima,* Galerie der Hochschule für Grafik
und Buchkunst, Leipzig ¬ *Comment rester Zen,* Centre
Culturel Suisse, Paris ¬ *The Daimler Chrysler Collection,*
Museum für neue Kunst, Karlsruhe ¬ *Cold Play-Set 1,*
Fotomuseum Winterthur
2002 *The day after,* Gallery Cokkie Snoei, Rotterdam ¬
Zeitgenössische Fotokunst aus der Schweiz, Neuer Berliner
Kunstverein ¬ *Fe-Male,* Centro d'Arte Contemporanea,
Bellinzona ¬ *Smax,* Villa de Bank, Enschede ¬
Self/In Material Conscience, Fondazione Sandretto
(Guareno), Turin ¬ Art Unlimited, Art Basel ¬ *Skin talks,*
Musée de la Civilisation, Quebec ¬ *Wild Thing,* Galerie Claire
Fontaine, Luxembourg ¬ *Ikonen – Kunst und Kult,* Coninx
Museum, Zurich
2001 Project Room at espai Lucas, ARCO, Madrid ¬ *Close Up,*
Kunstverein Hannover, Hanover ¬ 24th International Biennial
of Graphic Art, Ljubljana ¬ *Face Off,* Aeroplastics
Contemporary, Brussels ¬ *GeldLust: Modell Banking,*
Kunsthalle Tirol, Innsbruck ¬ *Totemica – Feticci e Rituali
del Contemporaneo,* Casa del Mantegna, Mantua
2000 *Reality Bytes – Der medial vermittelte Blick,* Kunsthalle
Nuremberg ¬ *Close Up,* Kunstverein Freiburg/Kunsthaus
Baselland, Muttenz ¬ *Le Siècle du Corps,* Musée de l'Elysée,
Lausanne ¬ *cross female,* Künstlerhaus Bethanien, Berlin ¬
Körper, Hüllen, Oberflächen, Museum für Kunst und Gewerbe,
Hamburg ¬ *EX25,* Museum für Gestaltung, Zurich ¬
Logos, Anuncios y Cintas de Video, Gallery Helga de Alvear,
Madrid ¬ Observatori 2000, Valencia

George Bures Miller

—

* 1960 in Vegreville (Canada)
Lebt und arbeitet/lives and works in Berlin

Einzelausstellungen/Solo Exhibitions
(Auswahl seit 2001/Selection since 2001)

2004 *Janet Cardiff & George Bures Miller: Recent works,*
Sheffield Galleries and Museum Trust, Millenium Galleries
¬ *Janet Cardiff & George Bures Miller,* Luhring Augustine,
New York ¬ *Janet Cardiff & George Bures Miller,* Galerie
Barbara Weiss, Berlin
2003 *Janet Cardiff. A Survey of Works including Collaborations
with George Bures Miller,* Castello di Rivoli, Turin ¬
Janet Cardiff and George Bures Miller, Astrup Fearnley
Museum, Oslo ¬ *Janet Cardiff & George Bures Miller:
The Berlin Files,* Portikus, Frankfurt am Main ¬
The Paradise Institute, Belkin Art Gallery (with Janet Cardiff)
¬ *The Paradise Institute and other works by Janet Cardiff
and George Bures Miller,* Walter Phillips Gallery,
BanffCentre, Banff ¬ *Forty-Part Motet,* Pori Art Museum
(with Janet Cardiff)
2002 *Janet Cardiff and George Bures Miller,* Hamburger Bahnhof,
Berlin ¬ *The Paradise Institute,* Luhring Augustine,
New York (with Janet Cardiff) ¬ *The Paradise Institute,*
National Gallery of Canada, Ottawa (with Janet Cardiff) ¬
The Paradise Institute, Plug In ICA, Winnipeg (with Janet
Cardiff) ¬ *Janet Cardiff. A Survey of Works including
Collaborations with George Bures Miller,*
Musée d'Art Contemporain, Montreal
2001 *The Paradise Institute,* Canadian Pavilion, 49. Biennale, Venice
(with Janet Cardiff) ¬ *Muriel Lake Incident,*
Southern Alberta Art Gallery, Lethbridge (with Janet Cardiff)

Gruppenausstellungen / Group Exhibitions
(Auswahl seit 2000 / Selection since 2000)

2004 *Videodreams,* Kunsthaus Graz (mit Janet Cardiff) ¬
Silver, Art Gallery of Greater Victoria, B.C. (with Janet Cardiff)
2003 *Walk Ways,* Western Gallery, Western Washington University,
Bellingham, Washington ¬ *On Stage,* Villa Merkel, Esslingen
(with Janet Cardiff) ¬ *Brightness – works from the Thyssen-
Bornemisza Contemporary Art Foundation,* Museum of
Modern Art Dubrovnik ¬ *Performative Installation #1.
Gegeben sind… Konstruktion und Situation,* Galerie im
Taxispalais, Innsbruck (withJanet Cardiff) ¬ *Media Art /
Sammlung Goetz,* ZKM Karlsruhe (with Janet Cardiff)
2002 *Walk Ways,* Portland Institute of Contemporary Art, Portland,
Oregon ¬ *On Stage,* Kunstverein Hannover
(with Janet Cardiff) ¬ Sidney Biennal (with Janet Cardiff)
2000 *Between Cinema and a hard place,* Tate Modern, London
(with Janet Cardiff) ¬ *Sculpture,* Luhring Augustine Gallery,
New York (with Janet Cardiff)

Tom Burr
—

*1963 in New Haven (USA)
Lebt und arbeitet / lives and works in New York

Einzelausstellungen / Solo Exhibitions
(Auswahl seit 1992 / Selection since 1992)
—

2004 Galleria Franco Noero, Turin
2003 *Die Ställe,* Christian Nagel, Cologne ¬
The Screen, Institute for Visual Culture, Cambridge
2002 Greene Naftali, New York ¬
Piscine, Gallery Almine Rech, Paris
2001 *Brutalism,* Galerie Neu, Berlin
2000 *Low Slung,* Kunstverein Braunschweig
1999 Gallery Alemine Reich, Paris
1998 Galerie Neu, Berlin ¬ Gallery Marta Cervcra, Madrid
1997 *Stainless,* American Fine Arts, New York
1995 American Fine Arts, New York
1994 American Fine Arts, New York
1992 White Columns, New York

Gruppenausstellungen / Group Exhibitions
(Auswahl seit 1996 / Selection since 1996)
—

2004 It's All an Illusion. A Sculpture Project, migros museum
für gegenwartskunst, Zurich ¬ Whitney Biennal, New York
2003 Galleria Franco Noero, Turin ¬
Le Rayon Noir, Circuit, Lausanne
2002 Whitney Museum, New York ¬ *My Head is on Fire but
My Heart is Full of Love,* Charlottenborg
2001 *Partnerschaften,* NGBK, Berlin ¬
Deliberate Living, Greene Naftali, New York ¬
American Fine Arts, New York
2000 *Quiet Life,* Ursula Blickle Stiftung, Kraichtal ¬ *Sightings,*
Bard College, Annandale- on- Hudson
1998 *Model,* Österreichische Galerie Belvedere, Vienna ¬
Andrew Kreps Gallery, New York ¬
Parasite, The Drawing Center, New York
1997 *Sans Titre,* Froment + Putman, Paris
1996 *Disappeared,* Randolph Street Gallery, Chicago ¬
American Fine Arts, New York ¬
Ideal Standart Life, Spiral Garden, Tokio
1995 Birgit Küng, Zurich ¬ *Architectures of Display,* Toshiko Mori,
New York ¬ *Platzwechsel,* Kunsthalle Zurich and Schweizer
Landesmuseum ¬ *Mapping: A Response to MoMA,* American
Fine Arts, New York

James Lee Byars
—

*1932 in Detroit (USA)
† 1997 in Cairo

Einzelausstellungen / Solo Exhibitions
(Auswahl seit 2000 / Selection since 2000)
—

2004 *Exhibition of the Letters of James Lee Byars,* MASS MoCA,
North Adams, Massachusetts ¬ Devon Borden Hiram Butler
Gallery, Houston ¬ *Leben, Liebe und Tod: Das Werk von James
Lee Byars,* Schirn Kunsthalle Frankfurt
2003 *James Lee Byars. The Moon Books: Above and Below,*
Michael Werner Gallery, New York
2002 *James Lee Byars: The Angel,* Timothy Taylor Gallery, London
2001 Er Rashid Galerie, Düsseldorf ¬ *James Lee Byars. Works
on paper from 1960s and 1990s. Sculpture from the 1990s,*
Rhona Hoffman Gallery, Chicago ¬ *James Lee Byars.
Briefe an Joseph Beuys,* Museum für Kommunikation
Frankfurt ¬ Low Gallery, Los Angeles
2000 *The Treasures of James Lee Byars,* Toyama Memorial House,
Saitama *James Lee Byars. The Poetic Conceit and Other
Black Works,* Michael Werner Gallery, New York

Gruppenausstellungen / Group Exhibitions
(Auswahl seit 2000 / Selection since 2000)
—

2004 *Singular Forms (Sometimes Repeated): Art from 1951 to the
Present,* Solomon R. Guggenheim Museum, New York ¬
brillant(e), Kunst Meran im Haus der Sparkasse, Meran
2003 *Louise Bourgeois, James Lee Byars – Il disparut dans le
silence total,* Centre Pompidou, Musée national d'art moderne,
Paris ¬ *Himmelsschwer. Transformation der Schwerkraft,*
Landesmuseum Johanneum, Graz ¬ *Das Nichts oder das
Unbegreifliche des Unendlichen?,* Neues Museum Weserburg,
Bremen ¬ *OUTLOOK International Art Exhibition Athens
2003,* Arena – Society for the Advancement of Contemporary
Art in Athens
2002 *Take One, Two, Three… aus der Sammlung Speck,* Cologne,
K21 im Ständehaus, Düsseldorf ¬ *Les années 70: l'art en
cause,* capcMusée d'art contemporain, Bordeaux
2001 *The Place of Happiness,* Watari-Um, Watari Museum of
Contemporary Art, Tokyo ¬ *El instante eterno. Arte y espiritu-
alidad en el cambio del milenio,* Espai d'Art Contemporani de
Castelló ¬ *Wertwechsel. Zum Wert des Kunstwerks,* Museum
für Angewandte Kunst, Cologne ¬ *Beau Monde. Toward a
Redeemed Cosmopolitanism,* Site Santa Fe ¬ *The Inward Eye.
Transcendence in Contemporary Art,* Contemporary Arts
Museum, Houston
2000 *L'Opéra. Un chant d'Etoiles / Opera. Tastbare emotie,*
La Monnaie / De Munt, Brussels ¬ *Tomorrow for ever,*
Galerie Sfeir-Semler, Hamburg ¬ *Das fünfte Element –
Geld oder Kunst,* Kunsthalle Düsseldorf ¬
Cosmos. From Romanticism to the Avant-garde, 1801–2001,
Palazzo Grassi, Venice ¬ *Sinn + Sinnlichkeit. Körper und Geist
im Bild,* Neues Museum Weserburg, Bremen ¬ *Himmelfahrt,*
Diözesanmuseum Freising, Freising ¬ *Food for the Mind.
Die Sammlung Udo and Anette Brandhorst,* Staatsgalerie
moderner Kunst, Munich ¬ *Et l'art se met au monde.
Prologue pour la Biennale,* Nouveau Musée, Institut d'art
contemporain, Villeurbanne

Janet Cardiff

—

*1957 in Brussels (Canada)
Lebt und arbeitet/lives and works in Berlin

Einzelausstellungen/Solo Exhibitions
(Auswahl seit 2001/Selection since 2001)

—

2004 *Janet Cardiff & George Bures Miller,* Luhring Augustine,
New York ⌐ *Walking throu',* Space in Progress, Thyssen-
Bornemisza Art Contemporary Space in Progress and
Akademie der bildenden Künste Wien, Atelierhaus, Space
in Progress 2, Vienna (with George Bures Miller) ⌐
Her long black Hair. An Audio Walk in Central Park, presented
by Public Art Fund, New York ⌐ *Laura: a web project,*
Vancouver Art Gallery ⌐ *Janet Cardiff & George Bures Miller,*
Galerie Barbara Weiss, Berlin

2003 *Janet Cardiff & George Bures Miller,* Astrup Fearnley Museum,
Oslo ⌐ *Janet Cardiff & George Bures Miller: The Berlin Files,*
Portikus, Frankfurt am Main ⌐ *Janet Cardiff. A Survey of
Works including Collaborations with George Bures Miller,*
Castello di Rivoli, Turin ⌐ *Janet Cardiff & George Bures
Miller,* Whitechapel Art Gallery, London ⌐ *The Paradise
Institute and other works by Janet Cardiff and George Bures
Miller,* Walter Phillips Gallery, Banff Centre, Banff ⌐
Forty-Part Motet, Pori Art Museum

2002 *Janet Cardiff and George Bures Miller,* Hamburger Bahnhof,
Berlin ⌐ *The Paradise Institute,* Luhring Augustine, New York
(with George Bures Miller) ⌐ *The Paradise Institute,* National
Gallery of Canada, Ottawa (with George Bures Miller) ⌐ *The
Paradise Institute,* Plug In ICA, Winnipeg (with George Bures
Miller) Kunstmuseum des Kantons Thurgau ⌐ *Janet Cardiff.
A Survey of Works including Collaborations with
George Bures Miller,* Musée d'Art Contemporain, Montreal

2001 *Drogan's Nightmare,* National Gallery of Canada, Ottawa ⌐
The Paradise Institute, 49. Biennale, Venice, Canadian Pavilion
(with George Bures Miller)

Gruppenausstellungen/Group Exhibitions
(Auswahl seit 2000/Selection since 2000)

—

2004 *Videodreams,* Kunsthaus Graz (with George Bures Miller) ⌐
Die zehn Gebote, Hygiene Museum, Dresden ⌐ *Janet Cardiff,
Laura Kikauka, John Körmeling,* Power Plant Art Gallery,
Toronto ⌐ *Silver,* Art Gallery of Greater Victoria, B.C.
(with George Bures Miller)

2003 *Walk Ways,* Western Gallery, Bellingham ⌐ *On Stage,* Villa
Merkel, Esslingen ⌐ *Brightness – works from the Thyssen-
Bornemisza Contemporary Art Foundation,* Museum of
Modern Art Dubrovnik ⌐ *Performative Installation #1.
Gegeben sind… Konstruktion und Situation,* Galerie im
Taxispalais, Innsbruck (with George Bures Miller) ⌐ *Fast for-
ward. Media Art/Sammlung Goetz,* ZKM I Zentrum für Kunst
und Medientechnologie Karlsruhe (with George Bures Miller)

2002 *Sydney Biennal* (with George Bures Miller) ⌐ *hautnah.
Die Sammlung Goetz,* Museum Villa Stuck, Munich ⌐
Walk Ways, Portland Institute of Contemporary Art, Portland,
Oregon (with George Bures Miller)

2001 *Acadia,* The National Gallery of Canada, Ottawa ⌐ *01.01.01:
Art in Technological Times,* SFMOMA, San Francisco ⌐ *Black
Box, Der Schwarzraum in der Kunst,* Kunstmuseum Bern ⌐
Looking At You, Kunsthalle Fridericianum, Kassel (with
George Bures Miller) ⌐ *New Traveling Exhibitions of
Contemporary Art,* Independent Curators International,
New York (with George Bures Miller) ⌐ *Record All-Over,* 9.
Biennale de l'image en mouvement, Mamco, Geneva ⌐
Museum unserer Wünsche, Museum Ludwig, Cologne

2000 *Between Cinema and a hard place,* Tate Modern, London
(with George Bures Miller) ⌐ *Mixing Memory and Desire,*
Kunstmuseum Luzern ⌐ *Sculpture,* Luhring Augustine
Gallery, New York (with George Bures Miller)

Marc Camille Chaimowicz

—

*in Paris (France)
Lebt und arbeitet/lives and works in London and Dijon

Einzelausstellungen/Solo Exhibitions
(Auswahl seit 1971/Selection since 1971)

—

2003 Cabinet Gallery, London

2002 Ikon, Birmingham ⌐ Cabinet Gallery, London

2001 *Dessins et Rideaux de Scène,* E.S.A.A.T, Roubaix

2000 *Celebration? Realife Revisited, 1972/2000,* Cabinet Gallery, London
⌐ *Celebration? Realife Revisited 1972/2000* ⌐ *"I love Dijon",*
Le Consortium, Dijon ⌐ *Pendulum,* Artconnexion. Lille ⌐
Pendulum Polaroids, The Laboratory at the Ruskin School, Oxford

1998 *Painting Amongst Other Things,* L'Arthothèque de Nantes ⌐
The British School, Rome

1997 *La Suite de Varsovie de Marc Camille Chaimovicz,* ⌐
FRAC Bourgogne, Dijon

1996 *Peintures & Objects,* Joseph de Duterte Gallery, Rennes ⌐
A Quotidien des Choses, Interface, Appartment Gallery, Dijon

1994 *Peinture & Objects,* Le Consortium, Dijon ⌐ *Le Quartier,*
Centre d'Art Contemporain, Quimper

1993 *The Warsaw Suite,* Centre for Contemporary Art, ⌐
Ujazdowski Castle, Warsaw

1990 *Cinq paravents,* Musée Historique des Tissus, Lyon ⌐
Oeuvres sur Papier, Art Concept Gallery, Nice

1988 *Chemins de Croix,* Pour l'Art Contemporain, Bourbon-Lancy ⌐
Recent Drawings and Prints, Robert Steele Gallery, Adelaide

1987 *Autour de cinq Paravents,* Musee des Beaux Arts, Dijon

1986 Galeria Optica, Montreal ⌐ Centre de Gravure, Geneva

1985 *Cafe du Rêve,* Gallery de France, Paris

1984 *Six Works,* Musée d'Art d'Histoire, Geneva ⌐
Le Consortium, Dijon

1983 *12 Detector Textiles,* Gallery Bertin, Lyon ⌐ *Past Imperfect,
1972–82,* Bluecoast Gallery, Liverpool

1981 *Maquettes…,* Nigel Greenwood Gallery, London

1980 *Partial Eclipse,* de Appel, Amsterdam

1979 *Sceens…,* Nigel Greenwood Gallery, London

1978 Galleria Cannaviello, Rome and Milan

1977 Galleria Cavallino, Venice

1972 *Celebration? Realife, Inaugural Show,* Gallery House, London
⌐ *Enough Tyrrani,* Serpentine Gallery, London

1971 *Sweetness,* Sigi Krauss Gallery, London

Gruppenausstellungen/Group Exhibitions
(Auswahl seit 2000/Selection since 2000)

—

2004 *It's All an Illusion. A Sculpture Project,* migros museum für
gegenwartskunst, Zurich

2002 *St. Petrischnee,* migros museum für gegenwartskunst, Zurich
⌐ *Hotel Sub Rosa,* Marc Foxx Gallery, Los Angeles ⌐ Galerie
Neu, Berlin

2001 *Art I Accio* El Museu D'Art Contemporani de Barcelona ⌐
*Out of Actions: Between Performance and the Object,
1949–1979,* Museum of Contemporary Art, Tokyo ⌐ *Bankside
Browser,* Tate Gallery of Modern Art ⌐ *Portrait D'Une
Collection Rapide,* Interface, Dijon ⌐ *Village Disco,* Cabinet
Gallery, London

2000 *Live in your head, Concept and Experiment 1965–75,* ⌐
Whitechapel Gallery, London

Cosey Fanni Tutti

—

*in Hull (England)
Lebt und arbeitet/lives and works in London

Ausstellungen, Aktionen und Performances/Exhibitions, Actions and
Performances (Auswahl seit 1995/Selection since 1995)

2004 *Confessions,* Cabinet Gallery, London
2003 *Independence,* South London Gallery, London ¬ *Confessions–
Projected,* Flourish Nights, Glasgow
2002 *Hotel Sub Rosa,* Marc Foxx Gallery, Los Angeles ¬
In Conversation with Artist Andre Stitt, Courtauld Institute of
Art, London ¬ *Selflessness, No. 1,* Live Art Action, Disneyland,
California ¬ *Selflessness, No. 2,* Live Art Action, Beachy Head,
Sussex ¬ *TG24,* Cabinet Gallery, London
2001 *Re-Viewed,* Station Gallery, Frankfurt
2000 *Village Disco,* Cabinet Gallery, London ¬ *Live in Your Head,*
Whitechapel Art Gallery, London ¬ *Volume,* P.S.1 Gallery,
NewYork ¬ *Protest & Survive,* Whitechapel Art Gallery,
London
1999 *Out of Actions,* MOCA Tokyo ¬
Out of Actions, MOCA, Barcelona
1998 *Out of Actions,* MOCA, Los Angeles ¬ Out of Actions, MOCA,
Vienna
1997 *Popocultural,* City Art Gallery, Southampton
1996 *Popocultural,* S.London Gallery London
1995 *Smut Fest,* Confessions Gallery, Islington, London ¬
Witches & Torture, Mail art exhibition, Rintein

Filme und Videos/Films and Videos

—

2003 *Confessions Projected*
2002 *Selflessness, No. 1,* Live Art Action
¬ *Selflessness, No. 2,* Live Art Action
1993 *Metaphysical*
1987 *A Study in Scarlet*
1986 *Pussy Got the Cream*
1985 *Diorama*
1984 *Inside Rooms: 26 Bathrooms*
1983 *Shadow from Light*
1982 *Elemental 7*
1981 *Red Tape 3* ¬ *Psychic Rally in Heaven* ¬
Mission of Dead Souls
1980 *Oundle School* ¬ *In the Shadow of the Sun* ¬
Phoelix ¬ *Heathen Earth* ¬ *Rafters*
1979 *The Silent Cry*
1977 *After Cease to Exist* ¬ *Come play with me* ¬ *The David
Galaxy Affair* ¬ *Secrets of a Super Stud* ¬ *Hardcore*
1976 *Sex Angle* ¬ *Rectum as Inner Space* ¬ *Satin Party* ¬
I'm Not Feeling Myself Tonight
1975 *Omissions* ¬ *Custers Thirteen* ¬
Can You Keep it up Allright? ¬ *Cease to Exist,* No1 ¬
Teenage Sin ¬ *Coumndensation Mucus*
1974 *Stocking Top an Swing*

Brice Dellsperger

—

*1972 in Cannes (France)
Lebt und arbeitet/lives and works in Paris

Einzelausstellungen/Solo Exhibitions
(Auswahl seit 1996/Selection since 1996)

2004 Team Gallery, New York ¬ Video works, the gallery Sketch,
London
2003 Gallery Lisa Ruyter, Vienna ¬ Gallery Air de Paris ¬
Obsession, Gallery Yvon Lambert, Paris ¬ Anderson Gallery,
Des Moines ¬ Midway, St. Paul (with Jean-Luc Verna)
2002 Le Parvis, Pau ¬ Team Gallery, New York
2001 *Nowhere, and fast…,* La BoX, Bourges ¬ *Body Double 13,*
Le Studio, Gallery Yvon Lambert
2000 *Cinéma Le Brady,* Gallery Air de Paris
1996 *Body Double,* Gallery Air de Paris

Öffentliche Vorführungen/Public Projections
(Auswahl seit 2000/Selection since 2000)

2004 *Video Killed the Radio Star!,* migros museum für gegenwartskunst,
Zurich ¬ *Corpo d'artista 3, Re/Make- Re/Model,* Libera
Universita Omosessuale, Bologna ¬ Art Film, Basel ¬ 19th
Turin Gay and Lesbian Film Festival ¬ *PLAYLIST,* Palais de
Tokyo, Paris ¬ 5° Quinzaine de cinéma lesbien gay bi trans,
Gallery St Pierre, Bordeaux
2003 Musée des Beaux-Arts, Rouen ¬ Festival Images en région,
Vendôme
2002 *Mediascope,* MOMA, New York ¬ Cinémathèque, Luxembourg ¬
Maya Deren Theater, New York ¬ Courthouse Theater, New York
2001 Point Ligne Plan, Fémis, Paris
2000 *I love Dijon,* Le Consortium, Dijon

Gruppenausstellungen/Group Exhibitions
(Auswahl seit 2004/Selection since 2004)

2004 *The rose garden whithout thorns,* Galerie Lisa Ruyter, Vienna
¬ *Grotesque, burlesque et parodie,* Centre d'art Contemporain
de Meymac ¬ *Dis(covered)desires,* Laznia Centre for
Contemporary Art, Gdansk ¬ *Videotrafic, 15 french artists,* Ram
Foundation, Rotterdam ¬ *Body Bilder,* Kunsthalle Palazzo,
Liestal ¬ *Body Display,* Performative Installation #4,
Secession, Vienna

Cerith Wyn Evans

—

*1958 in Wales (United Kingdom)
Lebt und arbeitet/lives and works in London

Einzelausstellungen/Solo Exhibitions
(Auswahl seit 1996/Selection since 1996)

2004 Centre Pompidou, Paris ¬ Kunstverein Frankfurt ¬ *Sunrise
and Other Ruins,* Galerie Daniel Buchholz, Cologne ¬
Meanwhile Across Town, Centre Point, London ¬ *Rabbit's
Moon,* Camden Arts Centre, London
2003 *Look at that picture…How does it appear to you now? Does it
seem to be Persisting?,* White Cube, London ¬ Galerie Neu,
Berlin ¬ *mini MATRIX,* Berkeley Art Museum, San Francisco
2002 *Cerith Wyn Evans Screening.* Galerie Daniel Buchholz,
Cologne
2001 Galerie Daniel Buchholz, Cologne ¬ Kunsthaus Glarus ¬
Gallery Georg Kargl, Vienna ¬ *Cerith Wyn Evans The Art
Newspaper project:* Venice Biennale
2000 *Cleave 00. Art Now,* Tate Britain, London ¬ *Has the film
already started?,* Galerie NEU, Berlin
1999 Asprey Jacques Contemporary Art Exhibitions, London

1998 British School at Rome in collaboration with Asprey Jacques
Contemporary Art Exhibitions, Rome ¬
Centre for Contemporary Art, Kitakyushu
1997 Deitch Projects, New York
1996 *Inverse Reverse Perverse*, White Cube/Jay Jopling, London ¬
Studio Casa Grande, Rome

Gruppenausstellungen/Group Exhibitions
(Auswahl seit 2000/Selection since 2000)
–

2004 *Eclipse: Towards the Edge of the Visible*, White Cube, London
¬ *Black Friday: Exercises in Hermetics*, Revolver, Frankfurt ¬
The Ten Commandments, Deutsches Hygiene-Museum,
Dresden ¬ *Drunken Masters*, Galeria Fortes Vilaça, São Paulo
¬ *Making Visible*, Galleri Faurschou, Copenhagen ¬
Marc Camille Chaimowicz, Angel Row Gallery, Nottingham ¬
Doubtful Dans Les Plis Du Reel, Gallery Art & Essai, Rennes
¬ *Hidden Histories*, New Art Gallery Walsall ¬ *Ulysses*,
Galerie Belvedere, Vienna ¬ *Sans Soleil*, Galerie Neu, Berlin
2003 *Take a Bowery: The Art and (larger than) Life of Leigh
Bowery*, MCA Sydney ¬ *Wittgenstein Family Likenesses*,
Institute of Visual Culture, Cambridge ¬ *St. Sebastian.
A Splendid Readiness For Death*, Kunsthalle Vienna ¬
Further: Artists from Wales, 50th Venice Biennale/
Aberystweth Arts Centre, Aberystweth/Glynn Vivian Art
Gallery, Swansea/National Museum & Gallery of Wales,
Cardiff ¬ *Adorno*, Frankfurter Kunstverein ¬ Galleria Lorcan
O'Neill, Rome ¬ *Independence*, South London Gallery, London
¬ *Addiction*, 15 Micawber Street, London ¬ *Utopia Station*,
50th International Venice Biennale ¬ *Light Works*, Taka Ishii
Gallery, Tokyo ¬ *Someone to Share My Life With*, The
Approach, London ¬ *The Straight or the Crooked Way*, Royal
College of Art Galleries, London ¬ *Edén*, La Colección Jumex,
Mexico City
2002 Documenta, Kassel ¬ *Mirror: Its Only Words*, London College
of Printing, The London Institute, London ¬ *Shine*, The Lowry
Centre, Manchester ¬ *My Head is on Fire but My Heart is
Full of Love*, Charlottenborg Museum, Copenhagen ¬
Lost Past/2002–1914, various locations including Merghelynck
Museum, Ypres ¬ *Screen Memories*, Contemporary Art Center,
Art Tower Mito, Tokyo ¬ *Iconoclash. Image Wars in Science,
Religion and Art*, Center for Art and Media, Karlsruhe ¬
Void Archive, CCA, Kitakyushu ¬ *It's Only Words*, Mirror
Gallery, London Institute, London ¬
ForwArt, Palais des Beaux-Arts, Brussels ¬ *In the Freud
Museum*, Freud Museum, London
2001 Extended Media Gallery, Zagreb ¬ International Triennale
of Contemporary Art, Yokohama ¬ *There is something you
should know*, EVN Sammlung, Österreichische Galerie
Belvedere, Vienna ¬ *Gymnasion*, Bregenzer Kunstverein,
Bregenz ¬ *My Generation 24 Hours of Video Art* Atlantis
Gallery, London ¬ *Wir, Comawoche*, Film Screening,
Metropolis Cinema, Hamburg ¬ *Wales – Unauthorised
Versions*, House of Croatian Artists, Zagreb ¬
How do you change... Institute of Visual Culture, Cambridge
¬ *Bridge the Gap*, CCA, Kitakyushu ¬ *Dedalic Convention*,
MAK, Vienna ¬ *Zusammenhänge in Biotop Kunst*, Kunsthaus
Muertz ¬ *The Stunt/The Queel*, London Institute, RAMC,
London ¬ *What's Wrong*, Trade Apartment, London
2000 *Sensitive*, Printemps de Cahors, Saint-Cloud ¬
Rumours, Arc en Reve Centre d'Architecture, Bordeaux ¬
La Ville, le Jardin, la Mémoire 1998–2000, French Academy at
Rome, Villa Medici, Rome ¬ *Ever get the feeling you've been...*,
A22 Projects, London ¬ *There is something you should know*,
Die EVN Sammlung im Belvedere, Vienna ¬ *Out There, White
Cube?*, Hoxton, London ¬ *The British Art Show 5*, Scottish
National Gallery of Modern Art, Edinburgh ¬
The Greenhouse Effect, Serpentine Gallery, London ¬
Lost, Ikon Gallery, Birmingham

Christian Flamm
–

*1974 in Berlin (Germany)
Lebt und arbeitet/lives and works in Berlin

Einzelausstellungen/Solo Exhibitions
(Auswahl seit 1997/Selection since 1997)

2004 La legge da me non scritta, Galleria Fonti, Naples
2002 Take Care of Yourselves, asprey jacques, London
¬ *Meine Sorgen will Ich haben!*, Ascan Crone, Hamburg
2001 *Urlaub vom Ich*, Galerie Neu, Berlin
2000 *Phasen von Schweigen*, Gallery Nomadenoase, Hamburg
¬ *Wir müssen miteinander reden*, Galerie Neu, Berlin
1999 *Umsonst ist das Leben*, Frankfurter Kunstverein
1998 *Der Apfel fällt nicht weit vom Stamm*, Künstlerhaus
Stuttgart 1997
1997 *Freihand*, Kunstakademie, Stuttgart

Gruppenausstellungen/Group Exhibitions
(Auswahl seit 1997/Selection since 1997)

2003 *Deutsche Malerei*, Frankfurter Kunstverein, Frankfurt a. M.
2002 *Zusammenhänge herstellen*, Hamburger Kunstverein ¬
*Christian Flamm, Thilo Heinzmann, Michel Majerus,
Antje Majewski, Nader*, asprey jacques, London ¬ Gallery
Georg Kargl, Vienna
2001 *Come in*, Institut für Auslandsbeziehungen, Moskau,
St Petersburg *Klara*, Galerie Ascan Crone, Hamburg ¬
Hallucinating Love, asprey jacques, London
2000 *Deutsche Kunst in Moskau*, Central House of Artist, Moskau
¬ *ars viva*, Kunsthaus Dresden ¬ *ars viva*, Kunstverein
Freiburg
1999 *German Open*, Wolfsburg ¬ *ars viva*, Casino Luxemburg
1998 *40 Kalorien*, Galerie Nomadenoase, Hamburg ¬
*Kunst – Christian Flamm trifft Birgit Mergerle und
André Butzer in der Galerie ¬ Kienzle und Gmeiner*, Berlin ¬
Akademie Isotrop, Gunter Reskis Laden, Berlin

Sylvie Fleury
–

*1961 in Geneva (Switzerland)
Lebt und arbeitet/lives and works in Geneva

Einzelausstellungen/Solo Exhibitions
(Auswahl seit 1998/Selection since 1998)
–

2004 Galerie Eva Presenhuber, Zurich
2003 Galerie Mehdi Chouakri, Berlin ¬ Galerie Philomene Magers,
Munich
2002 Galerie Thaddaeus Ropac, Paris
2001 *Crash Test* Series, Art + Public/Cabinet PH, Geneva ¬ Centre
d'art contemporain, Le Havre ¬ *Identity, Pain, Astral
Projection*, Le Magasin, Grenoble ¬ *Sylvie Fleury. 49000*,
ZKM, Karlsruhe ¬ *Heels' n Wheels*, Gallery Specta,
Copenhagen
2000 Galerie Hauser & Wirth & Presenhuber, Zurich ¬ Elisabeth
Cherry Contemporary Art, Tuscon
1999 Villa Merkel, Esslingen ¬ ACE Contemporary Exhibitions,
Los Angeles ¬ *John M Armleder/Sylvie Fleury*, Artspace &
Auckland Art Gallery ¬ Ace Gallery, New York ¬ Art+Public,
Geneva ¬ Philomene Magers Projekte, Munich
1998 *All you need*, Side 2 Gallery, Tokyo ¬ *Life can get heavy, mas-
cara shouldn't*, Laure Genillard Gallery, London ¬
First Spaceship on Venus and Other Vehicles, 24. Biennale
de São Paolo ¬ *Hot Heels*, migros museum für gegenwarts-
kunst, Zurich

Gruppenausstellungen / Group Exhibitions
(Auswahl seit 2001 / Selection since 2001)
–

2004 *L'air du temps: Collection printemps / été 2004,* migros museum für gegenwartskunst, Zurich

2003 *Urban Diaries – Young Swiss Art,* Sala de exposiciones de la Consejería de las Artes, Madrid ¬ 20th Anniversary Show, Monika Sprüth – Philomene Magers, Cologne ¬ *Comment Rester Zen,* Centre Culturel Suisse, Paris ¬ *BREATHING THE WATER,* Galerie Hauser & Wirth & Presenhuber, Zurich ¬ *Coollustre,* Collection Lambert en Avignon

2002 *Shopping,* Tate Liverpool ¬ *Shopping,* Schirn Kunsthalle, Frankfurt ¬ *Fusion Cuisine,* Deste Foundation. Centre for Contemporary Art, Athens ¬ *Sylvie Fleury. H.R. Giger – Beauty and Horror,* Kunstpanorama Lucerne ¬ *Salto Naturale,* KISS, Kunst im Schloss Untergröningen, Untergröningen ¬ *Reflexions,* Galerie Philomene Magers, Munich

2001 Sonje Art Centre, Corea ¬ *Art > Music. Rock Pop Punk Techno,* MoMa, Sydney ¬ Sammlung DaimlerChrysler New Zero, Haus Huth, Berlin ¬ *Milano Europa 2000. Fine secolo. I semi del futuro,* Padiglione d'Arte Contemporanea, Milan ¬ *Printemps de septembre. Fantastique,* Toulouse ¬ *Speed,* Galerie Mehdi Chouakri, Berlin ¬ *The overexcited Body.* Arte e Sport nella Società Contemporanea, Palazzo dell'Arengario, Milan ¬ *Press Art* (Sammlung Peter und Anette Nobel), Centre Pasqu'Art, Bienne ¬ *Biennale Leuven,* Stedelijk Museum Leuven ¬ *The better you look, the more you see,* Galerie Medhi Chouakri, Berlin ¬ *Shoes or no shoes?,* Caermesklooster. Provincial Centrum voor Kunst en Cultur, Ghent ¬ *Geometrie & Gestus,* Galerie Thaddaeus Ropac, Salzburg ¬ *Die Kunst des Autos,* Kunsthalle Dominikanerkirche, Osnabrück ¬ *WertWechsel. Zum Wert des Kunstwerks,* Museum für Angewandte Kunst, Cologne ¬ *Customized.* Art Inspired by Hot Rods, Low Riders and American *Car Culture,* California Center for the Arts, Escondido

Allen Frame
–

*1951 in Mississippi (USA)
Lebt und arbeitet / lives and works in New York

Allen Frame grew up in the Mississippi Delta, graduated from Harvard University and moved to New York in 1977. His first solo show in New York was in 1981, and since then he has had solo shows in Paris, Budapest, New York and Zurich. In the 1980s he also worked in theatre, directing works by Porty Oliveira, David Wojnarowicz, Phillip Walker and Bertie Marshall. He has performed in his own autobiographical theatre works that use photography as slide projections. In 1990 with Nan Goldin he created the 70-minute slide show about AIDS called *Electric Blanket,* which he and Frank Franca have continued to expand and tour internationally. He has also been the curator of numerous exhibitions, including a retrospective of the work of Darrel Ellis at Art in General in New York. He teaches photography at the International Center of Photography, School of Visual Arts and Pratt Institute in New York. He has written articles for *The New York Times* and is a contributing editor for *Bomb Magazine.*

General Idea
–

General Idea was formed in 1969 by
AA Bronson, Felix Partz and Jorge Zontal.

AA Bronson, born Michael Tims, Vancouver, Canada, *1946.
Felix Partz, born Ronald Gabe, Winnipeg, Canada, 1945–94.
Jorge Zontal, born Slobodan Saia-Levy, Italy, 1944–94.

Einzelausstellungen / Solo Exhibitions
(Auswahl seit 2000 / Selection since 2000)
–

2003 *General Idea Editions 1968–1995,* Blackwood Gallery, University of Toronto ¬ Agnes Etherington Art Gallery, Kingston ¬ Leonard and Bina Ellen Art Gallery, Concordia University, Montreal ¬ Mount Saint Vincent University Art Gallery, Halifax ¬ McMaster Museum of Art, Hamilton ¬ *General Idea: Editions and Ephemera (1968–1995),* 871 Fine Arts, San Francisco

2002 Gallery Frédéric Giroux, Paris ¬ *A Day without Art,* National Gallery of Canada

2001 *Negative Thoughts,* Museum of Contemporary Art, Chicago ¬ *Boutique Coeurs Volants,* Florence Loewy, Paris ¬ *Black Floaters,* Susan Hobbs Gallery, Toronto

2000 *Fin de Siecle,* Plug In, Winnipeg ¬ Camden Arts Centre, London

Gruppenausstellungen / Group Exhibitions
(Auswahl seit 2000 / Selection since 2000)
–

2003 *Extra Art,* Institute of Contemporary Arts, London ¬ *Multiformity: Multiples from the MCA Collection,* Museum of Contemporary Art, Chicago ¬ *Public Affairs,* Kunsthaus Zurich ¬ *Mirror Image,* UCLA Hammer Museum, Los Angeles; Center for Curatorial Studies, Bard College ¬ *Art & Economy,* Deichterhallen, Hamburg ¬ *Thinking in Painting,* Stampa Galerie, Basel ¬ *Kunst Nach Kunst,* Neue Museum Weserburg Bremen ¬ *Rapture: Art's Seduction by Fashion since 1970,* Barbican Gallery, London

2001 *Shopping,* Generali Foundation, Vienna ¬ *Tele(visions),* Kunsthalle Wien, Vienna ¬ *Video Time,* Museum of Modern Art, New York ¬ Walker Art Center, Minneapolis, USA ¬ Centre Georges Pompidou, Paris ¬ Miami Art Museum, Miami

2000 *Loose Ends,* Museum of Modern Art, New York, USA

Franz Gertsch

—

*1930 in Mörigen (Switzerland)
Lebt und arbeitet/lives and works in Rüschegg

Einzelausstellungen/Solo Exhibitions
(Auswahl seit 1995/Selection since 1995)

—

2002 *Patti Smith I–V*, Haus der Kunst, Munich
2001 Centre Culturelle Suisse, Paris
2000 Hess Collection at Vinopolis, London
1999 *Holzschnitte + Malerei 1987–97*, Museum Kurhaus Kleve,
 Kunstmuseum Thun
1997 *Holzschnittwerk*, Hamburger Bahnhof, Berlin ⌐ *Holzschnitte*,
 Kunsthalle Burgdorf ⌐ *Austellung zur Verleihung des
 Kaiserrings*, Mönchehaus-Museum für moderne Kunst, Goslar
1996 MMK Museum für Moderne Kunst, Frankfurt
1995 *Holzschnitte und Malerei auf Papier*, Aichi Prefectural
 Museum of Art, Nagoya

Gruppenausstellungen/Group Exhibitions
(Auswahl seit 1972/Selection since 1972)

—

2000 *Das Gedächtnis der Malerei*, Aargauer Kunsthaus
1999 Biennale, Venice ⌐ *Face to Face to cyberspace*, Fondation
 Beyeler, Basel
1997 Biennale, Lyon ⌐ Biennale, Kwangjiu
1980 MOMA, New York
1978 Biennale, Venice
1972 Documenta 5, Kassel

Julian Göthe

—

*1966 in Berlin (Germany)
Lebt und arbeitet/lives and works in Berlin

Einzelausstellungen/Solo Exhibitions
(Auswahl seit 2003/Selection since 2003)

—

2004 Installation im Foyer (mit Nairy Baghramian), Kunsthalle Basel
2003 *Painted White in a Spirit of Rebellion*, Galerie Daniel Buchholz,
 Cologne

Gruppenausstellungen/Group Exhibitions
(Auswahl seit 2004/Selection since 2004)

—

2004 *Müllberg*, Galerie Daniel Buchholz, Cologne ⌐ *Atomkrieg*,
 Kunsthaus Dresden ⌐ *Atelier Europa*, Kunstverein Munich

Fergus Greer

—

*1958 in United Kingdom
Lebt und arbeitet/lives and works in London and Los Angeles

Fergus Greer studied at St. Martin's School of art and fashion,
London, and then graduated from The Royal Military Academy
Sandhurst. After leaving the army, he worked for a number of
photographers and became Terence Donavan and Richard Avedon's
assistant. After leaving, he started as a freelance photographer, based
in London for the next 6 years (*London Sunday Times Magazine,
Vanity Fair, GQ* and other magazines.) In 1997 he moved to Los
Angeles and started establishing himself as US based photographer,
while still working for European publications. He had exhibitions at
the Saatchi Gallery, Hayward Gallery and Deichtorhallen, Hamburg.

John Edward Heys

—

Lebt und arbeitet/lives and works in Berlin and New York

Kino und Video/Cinema and Video

—

2003 *Agnes und seine Brüder*, director: Oskar Roehler ⌐
 La Marie Maroccan, director: Gallery Heidi ⌐ *Poverty in the
 Penthouse/Pensione Florian*, director: Wolfgang Müller ⌐
 The Final Reward, director: Rachid Kerdouches ⌐ *Triple
 Bogey On A Par Nine*, director: Amos Poe ⌐ *Red Riding Hood*,
 Art Video, director: Huck Snyder

Theater/Theatre

—

The Club at La MaMa, New York: *The Diana Vreeland Story /The
Woman With Perls/Homage to Diana Vreeland* by John Edward
Heys ⌐ Charles Ludlam's Ridiculous Theatre, New York: *Salammbo/
Galas / Le Bourgeois Avant Garde* ⌐ BACA, New York: *Sounds In
The Distance* by David Wojnarowicz ⌐ Front Kino, Berlin: *She Said
My Face Was Like A Roman Coin* by John Edward Heys ⌐
Realitätenbüro, Berlin/Open Gate Theatre, New York:
La Mamounia/Poverty In The Penthouse ⌐ The Performing Garage,
New York: The Roman Polanski Story by Gary Indiana ⌐ Theater for
the New City, New York: *Charlotte In Wonderland* by Winifred
Peckersniffe ⌐ Volksbühne am Rosa-Luxemburg-Platz, Berlin:
Schwarze Seide / Dorothy Parker und das Algonquin ⌐ Westbeth
Theater, New York: *Angels Of Light* ⌐ Palace Theater, San Francisco:
Performed with the original Cockettes & Angels of Light ⌐ Dance
Theatre Workshop: *Edgar Allen:* The Story of Poe by Cookie Mueller
and Mark Baker ⌐ Regie/Direction: New York: Jean Cocteau's
A Human Voice with Alba Clemente

Jonathan Horowitz

—

*1966 in New York (USA)
Lebt und arbeitet/works and lives in New York

Einzelausstellungen/Solo Exhibitions
(Auswahl seit 2000/Selection since 2000)

—

2004 Galerie Barbara Weiss, Berlin
2003 *Silent Movie*, Martix 151, Wadsworth Atheneum Museum
 of Art, Hartford ⌐ *Surreal Estate*, with Rob Pruitt, Gavin
 Brown's Enterprise, New York ⌐
 Büro Friedrich, Berlin ⌐ Yvon Lambert, Paris
2002 *Go Vegan!*, Greene Naftali Gallery, New York ⌐ *Pillow Talk*,
 Sadie Coles HQ, London
2001 Time, Life, People, Kunsthalle St. Gallen ⌐ Yvon Lambert
 Gallery, Paris ⌐ *We the People*, China Art Objects,
 Los Angeles ⌐ *In Person*, Bard College Center for Curatorial
 Studies, Annandale-on Hudson
2000 *The Jonathan Horowitz Show*, Greene Naftali Gallery, New
 York ⌐ *The Universal Calendar / Talking Without Thinking*,
 Van Laere Contemporary Art, Antwerp

Gruppenausstellungen/Group Exhibitions
(Auswahl seit 2000/Selection since 2000)

—

2003 *Love*, Bregenzer Art Association and Magazin 4, Berlin ⌐ *Dust
 Memories*, Swiss Institute, New York ⌐ *Drop Out*, China Art
 Objects, Los Angeles ⌐ *First Person*, Mercer Union, Toronto ⌐
 20th Anniversary Exhibition, Gavin Brown's Enterprise, New
 York ⌐ *Nation*, Kunstverein Frankfurt ⌐ *Parle à Mes Pères*,
 Collection Lambert at PhotoEspaña, Madrid
2002 *Die Wohltat Der Kunst/Just Love Me*, Staatliche Kunsthalle
 Baden-Baden ⌐ *The Object Sculpture*, The Henry Moore
 Institute, Leeds ⌐ *Tableaux Vivants*, Kunsthalle Wien ⌐
 Non-Places, Kunstverein Frankfurt ⌐

Dark Spring, Ursual Blickle Stiftung, Kraichtal ⌐
Zusammenhaenge Herstellen, Kunstverein Hamburg ⌐
Mensaje De Texto, Galeria Helga De Alvear, Madrid
2001 *The Americans,* Barbican Art Gallery, London ⌐ *Casino 2001,*
Museum of Contemporary Art, Gent ⌐ *Tele(visions),*
Kunsthalle Wien ⌐ *4FREE,* Bürofriedrich, Berlin ⌐ *Video
Mania,* migros museum für gegenwartskunst, Zurich ⌐
Annonyme, Rencontres Internationales de La Photographie,
Arles ⌐ *Fresh: The Altoids Curiously Strong Collection,*
1998–2000, The New Museum, New York ⌐ *Desins,* Ecole
Regionale Des Beaux-Artes, Dunkerque ⌐ *Pause,* Marc Foxx
Gallery, Los Angeles
2000 *Over the Edges,* Museum of Contemporary Art, Gent ⌐
Greater New York: New Art in New York Now, P.S.1, New York
⌐ *Making Time; Considering time as a material in contempo-
rary film & video,* Palm Beach Institute for Contemporary Art
⌐ *New York Projects,* Delfina Project Space, London ⌐
Achieving Failure: Gym Culture 2000, Thread Waxing Space ⌐
New Work from New York, Cheekwood Museum of Art,
Nashville ⌐ *Two Friends and So On...,* Andrew Kreps Gallery,
New York ⌐ Marc Foxx Gallery, Los Angeles

Peter Hujar
—
*1934 in Trenton (USA)
† 1987 in New York

Peter Hujar was born in 1934, in Trenton, New Jersey. In 1946 he
moved to Manhattan and became a photographer working for maga-
zines, advertising, and the fashion industry. At the end of the 1960s
he opened his own studio and ever more radically developed his
own approach to photography. He was a close friend of David
Wojnarowicz. †In 1987 Peter Hujar died of AIDS.

Daniel Robert Hunziker
—
*1965 in Walenstadt (Switzerland)
Lebt und arbeitet/lives and works in Zurich

Einzelausstellungen/Solo Exhibitions
(Auswahl seit 1997/Selection since 1997)

2004 *There's no other world out there... there's just this one,*
Kunsthaus Glarus
2003 *Findling,* Fri Art, Fribourg
2002 *Finkenweg 9a,* Aargauer Kunsthaus, Aarau
1999 *Second,* Galerie Brandstetter & Wyss Zurich ⌐
Panels, Kunstraum Aarau ⌐ *Fence,* Stiftung für Eisenplastik,
Sammlung Dr. Hans König, Zollikon
1998 *Ihre/Votre/Your Position,* Forum Schlossplatz Aarau
1997 *Unterführung,* Kleines Helmhaus Zurich ⌐
NonStop, Installation, Wohnzimmer Biel

Gruppenausstellungen/Group Exhibitions
(Auswahl seit 1994/Selection since 1994)

2004 *Geschiebe,* Haus für Kunst, Altdorf
2003 K5 Project Space, Zurich ⌐ Binz 39, Zurich ⌐ *Specificity,*
Riva Gallery, New York ⌐ *Homecoming,* LOOP, Berlin
2002 *Eidgenössischer Wettbewerb für Freie Kunst,* Basel
2001 Centre Pasquart, Biel ⌐ Centro d'Arte Contemporanea,
Bellinzona
2000 *Kuratoriumsausstellung Kanton Aargau,* Aargauer Kunsthaus
Aarau ⌐ Galerie Brandstetter & Wyss, Zurich
1999 *Salon,* Aargauer Kunsthaus Aarau ⌐ *Eidgenössischer
Wettbewerb für Freie Kunst,* Basel ⌐ *'99 respektive 59,
Rücksicht auf 40 Jahre Kunst in der Schweiz,* Aargauer

Kunsthaus, Aarau
1998 Galerie Brandstetter & Wyss Zurich ⌐ *Kuratoriumsausstellung
Kanton Aargau,* Aarau
1997 *Werk- und Atelierstipendium der Stadt Zurich,* Helmhaus
Zurich ⌐ *Eidgenössischer Wettbewerb für Freie Kunst,* Basel
1996 *Enge Unbegehbarkeit, Blick nach oben,* Filiale Erben Basel ⌐
Kuratoriumsausstellung Kanton Aargau, Lenzburg ⌐
Studium Kunst, Kunsthalle Winterthur
1995 *Jahresausstellung,* Aargauer Kunsthaus, Aarau
1994 *Eine Klasse für sich,* Kunsthof Zurich

Sanja Iveković
—
*1949 in Zagreb (Croatia)
Lebt und arbeitet/lives and works in Zagreb

Einzelausstellungen/Solo Exhibitions
(Auswahl seit 1996/Selection since 1996)
—
2004 *Women's House,* Palazzo Ferretti, Geneva
2003 *Women's House,* Museum of Contemporary Art, Zagreb
2002 *Personal Cuts,* NGBK, Berlin
2001 *Personal Cuts,* Galerie im Taxispalais, Innsbruck ⌐
Works of Heart, Josip Racic Gallery, Zagreb ⌐
True Stories, Soros Center for Contemporary Art, Bratislava
2000 *S.O.S.* Nada Dimic, Karas Gallery, Zagreb
1999 *Delivering Facts,* Producing Tears, ROOT 98, Hull ⌐
Repetitio est Mater, ARL, Dubrovnik
1998 *The Face of The Language,* Attack, Ribnjak Park, Zagreb
1997 *Video retrospective,* Meeting Point, SCCA, Sarajevo
1996 *Unstable Images,* Galerija Rigo, Novigrad

Gruppenausstellungen/Group Exhibitions
(Auswahl seit 2001/Selection since 2001)
—
2004 *The Government,* MACBA, Barcelona ⌐ *Repetition: Pride &
Prejudice;* WHW, Galeria Nova, Zagreb ⌐ *Reappearance;* EXIT
Institute in Peja, Kosova ⌐ *Privatization/ Contemporary Art
from Eastern Europe,* Kunst-Werke, Berlin ⌐ *Parallel Action,*
Gallery at The Academy for Fine Art, Leipzig ⌐ *Unbalanced
Alocation of Space,* Gallery for Contemporary Art, Leipzig ⌐
Liverpool International Biennial ⌐ *Love it or Leave it,* Cetinje
Biennial V, Cetinje, Dubrovnik, Tirana
2003 *Phantom der Lust,* Neue Galerie Graz am Landesmuseum
Joaneum, Graz ⌐ *Blut & Honig. Zukunft ist am Balkan,*
Sammlung Essl ⌐ *Formen der organisation,* Kunstraum de
Universität Lüneburg ⌐ *Inventura,* WHW, Gallery Nova,
Zagreb ⌐ *VIII Triennale of Croatian Sculpture,* Gliptoteka,
Zagreb ⌐ *In den schluchten des Balkan,* Kunsthalle
Fridericianum, Kassel ⌐ *Sammlung,* Generali Foundation,
Vienna ⌐ *Now What? Dreamimg a better world in six parts,*
BAK, Basis for aktuale Kunst, Utrecht ⌐ *Parallel Action,* AIF
Austrian Cultural Forum, New York
2002 *Projekt: Broadcasting,* WHW, Technical museum, Zagreb ⌐
Home, SCCA, Sarajevo ⌐ documenta11, Kassel ⌐
Erlauf erinnert sich (2), Erlauf ⌐ *Here Tomorrow,* Museum of
Contemporary Art, Zagreb ⌐ *In Search of Balkania,* Neue
Galerie am Landesmuseum Joanneum, Graz ⌐ *Geschichte(n),*
Künstlerhaus, Salzburg ⌐ *The Misfits,* Art Moscow/Expo Park,
Moscow; Kunstraum Kreuzberg/Bethanien, Berlin ⌐
Populism and Culture; archives of independant art in Austria,
space En Cours, Paris; ERBAN, Ecole Regionale des Beaux-
Arts de Nantes ⌐ *Attitudes 2002,* Contemporary Art Museum,
Kumamoto
2001 *Freedom and Violence,* Center for Contemporary Art,
Ujazdowski Castle, Warsaw ⌐ *Shopping,* Generali Foundation,
Vienna ⌐ *What, How and for Whom,* Kunsthalle, Vienna ⌐
Double Life, Kunsthalle Wien, Vienna ⌐
To Tell a Story, Museum of Contemporary Art, Zagreb

Mark Leckey

—

*1964 in London (United Kingdom)
Lebt und arbeitet/lives and works in London

Einzelausstellungen/Solo Exhibitions
(Auswahl seit 2000/Selection since 2000)

—

2004 Gavin Brown's Enterprise, New York
2003 migros museum für gegenwartskunst, Zurich ¬ Cabinet,
London ¬ *Big Box Statue Action*, Tate Britain, London
2002 Gavin Brown's Enterprise, New York
2000 Gavin Brown's Enterprise, New York ¬
Galerie Daniel Buchholz, Cologne

Gruppenausstellungen/Group Exhibitions
(Auswahl seit 1996/Selection since 1996)

—

2004 Galerie Daniel Buchholz, Cologne ¬ Ipeg. Bildtonmaschine.
Künstlerhaus Bethanien, Berlin ¬ Manifesta 5, San Sebastian
2003 *Soundsystems*, Salzburger Kunstverein, Salzburg ¬ Brighton
Photo Biennal ¬ Liverpool Biennale ¬ *Rhythm is a Dancer*,
Kulturhuset, Stockholm ¬ *Electric Earth*, British Council
touring exhibition, Russia
2002 *Remix*, Tate Liverpool ¬ *Electric Dreams*, Barbican, London
¬ *Hotel Sub Rosa*, Marc Foxx Gallery ¬
Santa Monica Museum of Modern Art, Los Angeles
2001 *The Visitors*. Théatres du Fantastique, Printemps du
Septembre, Toulouse ¬ *Sound & Vision*, ICA, London ¬
Brown, The Approach ¬ *My Generation: 24 hours of video art*,
Truman Brewery, London ¬
Century City, Tate Modern, London
2000 *Protest and Survive*, Whitechapel Art Gallery, London ¬ Pitti
Imagine, Florence ¬ *London Orphan Society*, Openspace,
Milan, toured to ¬ Melbourne in 2001 ¬ *Village Disco*,
Cabinet Gallery, London ¬ *Crash*, ICA, London
1998 David Zwirner, New York
1996 Gavin Brown's Enterprise, New York

Urs Lüthi

—

*1947 in Lucerne (Switzerland)
Lebt und arbeitet/lives and works in Munich

Einzelausstellungen/Solo Exhibitions
(Auswahl seit 2000/Selection since 2000)

—

2004 Galerie Tanit, Munich ¬ Gallery Sollertis, Toulouse
2003 Galerie Bob van Orsouw, Zurich
2002 ¬ Galleria Gianluca Collica, Catania ¬ Galleria Primo Piano,
Rome ¬ Galerie Blancpain-Stepczynsky, Geneva ¬
Musee Rath, Geneva ¬ Studio Visconti, Milan
2001 Biennale, Swiss Pavilion, Venice ¬ Galleria Dieda,
Bassano del Grappa
2000 Studio Casoli, Rome ¬ Spazio Erasmus Brera, Milan
¬ Lenbachhaus, Munich ¬ Swiss Institute, New York

Gruppenausstellungen/Group Exhibitions
(Auswahl seit 1998/Selection since 1998)

—

2003 *Me & More*, Kunstmuseum Lucerne, Lucerne
2001 *Prospekt! Zu einer Sammlung für Gegenwartskuns*t, Aargauer
Kunsthaus ¬ *Enzo Cannaviello, un percorso nella pittura*,
museo dell'arredo contemporaneo, Russi, Italia ¬ *Farbe,
Schwarz–Weiss*, Galerie Maximilian Krips, Cologne ¬
Azerty, Centre Pompidou, Paris 1995 "Hors Limites", Centre
Pompidou, Paris ¬ Gallery Stadler, Paris ¬ *Beyond
Switzerland*, Hong Kong Museum of Art ¬
Biennale, Seoul ¬ Gallery Stadler, Paris ¬ Mamco, Genève ¬

Frac, Bordeaux ¬ Museo de Arte Contemporaneo,
Santiago de Chile
2000 *Tomorrow for ever*, Museum Küppersmühle Sammlung
Grothe, Duisburg ¬ *Das Gedächtnis öffnet seine Tore*,
Lenbachhaus, Munich ¬ *Portofoglio*, Galerie Tanit, Munich ¬
Akademie der Künste, Berlin ¬ *Transacadia- revisited*,
Skulpturhalle, Basel ¬ *Die verletzte Diva*, Kunstverein
Munich ¬ Galerie Maximilian Krips, Cologne. ¬ *Ich ist etwas
anderes*, Sammlung ¬ Nordrhein-Westfalen, Düsseldorf ¬
Project Mnemosyne, Encontros de Fotografia, Coimbra
1999 *Das Versprechen der Fotografie – Die Sammlung der DG Bank*,
Hara Museum of Contemporary Art, Tokyo, Kestner
Gesellschaft, Hanover, Centre National de la Photographie,
Paris, Akademie der Künste, Berlin, Schirn Kunsthalle,
Frankfurt ¬ *Tomorrow for ever – Photographie als Ruine*,
Kunsthalle Krems ¬ *ATTO 1*, Spazio Erasmus Brera, Milan ¬
La razon para la impresion, Museo de la stampa, Caracas ¬
BAD-BAD, that is a good excuse, Staatliche Kunsthalle Baden-
Baden ¬ *Die Macht des Alters – Strategien der Meisterschaft*,
Kunstmuseum Bonn, ¬ Galerie der Stadt Stuttgart.
1998 *Les Rencontres d'Arles*, Arles ¬
Freie Sicht aufs Mittelmeer, Kunsthaus, Zurich ¬
*Das Verschwinden der Kunst wird aus gesellschaftlichen
Gründen auf unbestimmte Zeit verschoben*, Kunstverein Kassel
¬ *Die Macht des Alters, Strategien der Meisterschaft*, Berlin ¬
Hors Contexte, Ecole de dessin, Bayonne

Manon

—

*in St. Gallen (Switzerland)
Lebt und arbeitet/lives and works in Zurich

Ausstellungen/Exhibitions
(Auswahl seit 1974/Selection since 1974)

—

2003 Galerie Baviera, Zurich
2002 *St.Petrischnee*, migros museum für gegenwartskunst, Zurich
2000 *forever young*, Galerie Baviera, Zurich
1999 *Missing Link – Menschenbilder in der Photographie*,
Kunstmuseum, Bern
1998 *Ausstellung der Sammlung*, Kunstmuseum St. Gallen ¬
*Modedesign. Weibliche und männliche Identität in
fotografischen Inszenierungen*, Landesmuseum, Zurich
1996 *Im Kunstlicht*, Kunsthaus, Zurich ¬
Die Durchtunnelung der Normalität, Helmhaus, Zurich
1995 Sammlung Gotthard-Bank, Galleria Gottardo, Lugano ¬
Galleria Matasci, Tenero ¬ Centro d'arte contemporanea,
Bellinzona ¬ *"820 + 816"*, Helmhaus, Zurich
1993 *Neue Jugend für Marlene*, Teil 1 & 2, Galerie Baviera, Zurich
1992 *Photographie in der Schweiz*, Kunstmuseum St. Gallen
1988 Fotoforum Pasquart, Biel
1986 *Mit erweitertem Auge: Berner Künstler und die Fotografie*,
Kunstmuseum, Bern
1985 Musée Cantonal des Beaux-Arts, Lausanne ¬
Das Aktfoto, Stadtmuseum, Munich
1984 Kunsthaus Zurich ¬ Galerie Jamileh Weber, Zurich ¬
Rheinhallen Internationaler Kunstmarkt, Cologne
1981 Museum Exconviente Guadalajara ¬ Kunstmuseum
Düsseldorf ¬ Stiftung für Photographie, Kunsthaus Zurich
1980 Galerie Baviera, Schulze & Baltensberger, Zurich ¬
Fundatie Kunsthuis, Amsterdam
1979 Galerie Ecart Geneva ¬ Galerie Fischer-Kiel, Kiel ¬
Gallery Arcade, Lyon ¬ De Appel, Amsterdam
1978 Galerie Apropos, Lucerne
1977 Biennale 77, Paris
1976 Galerie S.R. Baviera, Zurich ¬ Galerie Kammer, Hamburg ¬
Aktionsgalerie, Bern
1975 Palais de Beaulieu, Lausanne
1974 Galerie Li Tobler, Zurich

Performances / Environments
(Auswahl seit 1974 / Selection since 1974)

2000 Istituto Svizzero, Rom
1997 *Fin de siècle*, Centro d'arte contemporanea, Bellinzona
1996 *Fin de siècle*, mit Franco Vaccari, La Stanza delle donne,
 Palazzo Ducale, Genoa
1995 *Gigolo. Eine Ausstellung für die Nacht*, Galerie Apropos,
 Lucerne
1993 *Die Philosophie im Boudoir*, Museum Baviera, Zurich
1990 *Das Damenzimmer*, Kunstmuseum St. Gallen, St. Gallen
1979 *Sentimental Journey*, Gallery De Appel, Amsterdam ¬ *Traps*,
 Galerie Ecart, Geneva ¬ Symposium international d'Art
 Performance, Lyon
1977 *Walk on the Wild Side*, Kunsthaus Zurich
1976 *Manon Presents Man*, Galerie Jamiléh Weber, Zurich ¬
 Das Leben im Schaukasten, Galerie Pablo Stähli, Zurich
1975 *Das Ender der Lola Montez*, Kunstmuseum Lucerne, Lucerne
1974 *Das lachsfarbene Boudoir*, Galerie Li Tobler Zurich

Bernhard Martin
—

* 1966 in Hanover (Germany)
Lebt und arbeitet / lives and works in Berlin

Einzelausstellungen / Solo Exhibitions
(Auswahl seit 1995 / Selection since 1995)
—

2004 *Bahnhofsviertel*, Galerie Thaddaeus Ropac, Salzburg
2003 *Gartencenter*, Spencer Brownstone Gallery, New York ¬
 My way home, Thaddaeus Ropac Galerie, Salzburg ¬
 Drawings, Unlimited Contemporary Art, Athen ¬
 Oeuvres Récentes, Galerie Thaddaeus Ropac, Paris
2002 *Ich zeige Ihnen gerne meinen Nassbereich*, MAMCO, Geneva
2001 *softcore*, Mannheimer Kunstverein, Mannheim ¬ *PS. 1*,
 MOMA, New York ¬ *Futterstadl*, Galerie Voges + Deisen,
 Frankfurt am Main
2000 *Puderdöschen*, Spencer Brownstone Gallery, New York
1999 *D'anys collaterals*, Gallery Alejandro Sales, Barcelona ¬
 Members Only, Junge Kunst e.V., Wolfsburg
1998 *Untitled Job getting Image I*, Galerie Almut Gerber, Cologne ¬
 Untitled Job getting Image II Serge Ziegler Galerie, Zurich
1997 *Health Pack*, Galerie Voges + Deisen, Frankfurt am Main
1996 *Al Dente*, ID-Galerie, Düsseldorf ¬ *Passanten Herberge*, ACP
 Galerie, Salzburg
1995 *Ein Bad in der Menge*, Galerie Siegfried Sander, Kassel

Gruppenausstellungen / Group Exhibitions
(Auswahl seit 1996 / Selection since 1996)
—

2003 *How high can you fly*, Kunsthaus Glarus ¬
 d*eutschemalereizweitausenddrei*, Frankfurter Kunstverein ¬
 cartoon, Riva Gallery, New York ¬ *Lee 3 Tau Ceti Central
 Armory Show*, Villa Arson, Nizza ¬ *Selected Paintings*, MW
 projects, London ¬ *final cuts*, Union, London
2002 *Dark Spring*, Ursula Blickle Stiftung, Kraichtal ¬
 Die Kunst des Festes, Brixen ¬
 Né un 3 septembre, FRAC Bourgogne, Dijon
2001 *Neue Welt*, Frankfurter Kunstverein ¬ *over*, Unlimited, Athens
 ¬ *Tirana Biennale I* ¬ *I love Dijon*, Le consortium, Dijon
2000 *Camping-Camping*, Volksbad, Nuremberg ¬
 Voilà – le monde dans la tête, Musée D'Art Moderne de la Ville
 de Paris ¬ *Back to Kassel*, Kunstverein Kassel ¬
 Ein|räumen, Kunsthalle Hamburg
1999 *Surprise I*, Kunstraum B2, Leipzig ¬ *Sympathicus*, Städtisches
 Museum am Abteiberg, Mönchengladbach ¬ *Das Lachen des
 Ovid*, Galerie Voges + Deisen, Frankfurt am Main ¬
 Zeichnungen, Galerie Almut Gerber, Cologne
1998 *Revue*, Ein Gastspiel der Galerie Voges + Deisen im Siemens

ArtLab der Galerie Hilger, Vienna ¬ Primavera Allianz-
Niederlassung, Cologne
1998 *Chinese Whispers*, Historiska Museet, Stockholm ¬ *acht mal
 acht mal acht*, Frankfurter Kunstverein ¬ *Themen zur
 Variation*, ACP Galerie, Salzburg
1997 Serge Ziegler Galerie, Zurich ¬ *Gedenkausstellung Harry Kramer*,
 Kunsthalle Lingen ¬ *Von Kopf bis Fuss*, Ursula Blickle
 Stiftung, Kraichtal, Linz ¬ Die Stadt Kunstverein Schloss
 Plön, Plön ¬ *Huge Garage Sale*, MAK Center, Los Angeles
1996 *Förderpreis Saar Ferngas*, Ludwig Haak Museum,
 Ludwigshafen ¬ Skulpturengarten Rupertgasse, Salzburg ¬
 Love Hotel, Documenta Halle, Kassel ¬ *Grüsse aus Frankfurt*,
 Galerie Voges + Deisen zu Gast bei Galerie Vierte Etage,
 Berlin ¬ *Die Skizze*, Galerie Voges + Deisen, Frankfurt am
 Main

Josephine Meckseper
—

* 1964 in Lilienthal (Germany)
Lebt und arbeitet / lives and works in New York

Einzelausstellungen / Solo Exhibitions
(Auswahl seit 1990 / Selection since 1990)
—

2004 *IG-Metall und die künstlichen Paradiese des Politischen*,
 Galerie Reinhard Hauff, Stuttgart
2003 *Lustgarten*, Galerie Borgmann Nathusius, Cologne ¬
 Elizabeth Dee Gallery, New York
2001 *Shine – oder Jedem das Seine*, Galerie Reinhard Hauff,
 Stuttgart
2000 *Lifer*, Cardozo School of Law Gallery, New York
1996 *Intervention*, Stiftung Starke, Berlin
1994 *This is your home*, Stuyvesant Town, New York
1992 *March 1992*, California Institute of the Arts
1990 *Gemelli o dell' Attenzione simultanea?*, Contatto Europa
 Gallery, Mailand

Gruppenausstellungen / Group Exhibitions
(Auswahl seit 2000 / Selection since 2000)
—

2004 *Dresscode*, Kunstverein Neuhausen, Neuhausen / Fildern ¬
 American Idyll, Greene Naftali Gallery, New York
2003 *Fuckin' Trendy*, Kunsthalle Nuremberg ¬ *All That Glitters*,
 Produce Gallery, penrose Gallery, Tyler School of Art, Temple
 University, Philadelphia ¬ *In the Public Domain*, Greene
 Naftali Gallery, New York ¬ *Nation*, Kunstverein Frankfurt ¬
 Growing Up Absurd, Post-La Gallery, Los Angeles ¬ *Wheeling*,
 Cell ¬ Project Space, London ¬ *Girls on Film*, Produce
 Gallery, Tyler School of Art, Temple University, Philadelphia
2002 *Bitch School*, Longwood Arts Project, The Bronx Council on
 the Arts, New York ¬ *Good Vibrations*, Galerie Jette Rudolph,
 Berlin ¬ *Mixing Messages: Graphic Design in Contemporary
 Culture* ¬ Cooper-Hewitt, National Design Museum, New
 York ¬ *Departure Lounge*, Clocktower Gallery, P.S.1
 Contemporary Art Center, New York ¬ *Summer Show*, Greene
 Naftali Gallery, New York ¬
 Scratch, Thread Waxing Space, New York
2001 *Wine, Women & Wheels*, White Columns, New York
2000 *New New York*, Texas Fine Arts Association, Austin ¬ Grok
 Terence McKenna Dead, Feature Inc., New York ¬ *Rob Pruitt's
 Flea Market*, Gavin Brown's Enterprise, New York ¬ *Art
 Auvtion 2000*, Museum of Contemporary Art, Los Angeles ¬
 Wunderbar, W139 Gallery, Amsterdam

Meret Oppenheim

—

*1913 in Berlin (Germany)
†1985 in Bern

Einzelausstellungen/Solo Exhibitions
(Auswahl seit 1995/Selection since 1995)
—

2003 Kunstraum Mi Possehlt, Bonn ⌐ Galerie Joho, Tübingen ⌐ Museum für Kunst und Gewerbe, Hamburg zusammen mit Galerie Levy, Hamburg
2000 Helsinki City Art Museum, Helsinki ⌐ Galerie Levy, Madrid mit Man Ray ⌐ Galerie Levy, Hamburg ⌐ Galeria Punto, Valencia
1998 Kunsthalle, Wilhelmshaven ⌐ Galleria Refettorio delle Stelline, Mailand ⌐ Museum of Contemporary Art-Ludwigmuseum, Budapest ⌐ Städtische Galerie, Fellbach
1997 Joslyn Art Museum, Omaha, Nebraska ⌐ Galerie Krinzinger, Vienna ⌐ Museum voor Moderne Kunst Arnhem ⌐ Upplands Konstmuseum, Uppland ⌐ Rupertinum, Salzburg ⌐ Kunsthalle, Darmstadt ⌐ Kunsthal, Rotterdam
1996 *Meret Oppenheim. Beyond the teacup,* Guggenheim Museum, New York ⌐ Museum of Contemporary Art, Chicago, Illinois ⌐ Bass Museum of Art, Miami Beach, Florida, ⌐ Galerie Hirschmann, Frankfurt
1995 Museo d'Arte, Mendrisio ⌐ Galerie A. von Scholz, Berlin ⌐ Kunstverein Ulm

Gruppenausstellungen/Group Exhibitions
(Auswahl seit 1991/Selection since 1991)
—

1997 ART/FASHION, Guggenheim Museum, New York
1995 *Worlds in a Box,* The South Bank Centre, London; City Arts Centre, Edinburgh; ⌐ Graves Art Gallery, Sheffield; Sainsbury Centre, Norwich; ⌐ Whitechapel Art Gallery, London
1994 *Die Erfindung der Natur,* Museum Sprengel, Hanover ⌐ Badischer Kunstverein, Karlsruhe ⌐ Rupertinum, Salzburg ⌐ *Meret Oppenheim und ihre Freunde zum 80. Geburtstag,* Galerie Renée Ziegler, Zurich
1993 *The Return of the Cadavre Exquis,* The Drawing Center, New York
1992 *Man Ray – Meret Oppenheim, Paintings and Works on Paper,* Kent Gallery, New York ⌐ Galleria Martini & Ronchetti, Genoa ⌐ *Sonderfall? Die Schweiz zwischen Réduit und Europa,* Steinen, Schulzentrum
1991 *Anxious Visions – Surrealist Art,* University Art Museum, Berkeley

Carlos Pazos

—

*1949 in Barcelona (Spain)
Lebt und arbeitet/lives and works in Barcelona

Einzelausstellungen/Solo Exhibitions
(Auswahl seit 2000/Selection since 2000)
—

2004 *Sí, estás,* Galeria Gianni Giacobbi Arte Contemporáneo, Palma de Mallorca ⌐ *Es tarde ya, porque hace rato que te fuiste,* Aula de Cultura, CAAM, Valencia ⌐ *Cupito...¿y por qué no?,* Museo Nacional Centro de Arte Reina Sofia, Madrid
2003 *Chispazos,* Museo de Cáceres ⌐ *Vieux Rancios,* Galería Amparo Gámir, Madrid
2002 *Aquí en la tierra como en el infierno,* MACBA, Barcelona ⌐ Indestructible, Sala Fundació, Eivissa
2001 SINDETIKON, Museo de la Universidad de Alicante ⌐ *Bazar Pazos,* Galería Trinta. Santiago de Compostela ⌐ *Lazos,* Galería Carles Taché, Barcelona ⌐ *Obra Multiplicada,* Fundación Antonio Pérez, Cuenca
2000 *SINDETIKON,* Sala Amarica, Museo de Bellas Arte, Vitoria

Gruppenausstellungen/Group Exhibitions
(Auswahl seit 2000/Selection since 2000)

2004 *Fotografía e Arte. Variacions en España: 1900–1980,* MARCO, Vigo ⌐ *Pezes y personajes, Muñecos, pájaros y zapatos,* Galería Fernando Latorre, Zaragoza
2003 *+ _ 25 Años de Arte en España. Creación en Libertad,* MUVIM y Atarazanas, Valencia ⌐ *Conceptes. Col.lecció Rafael Tous d'Art Contemporani,* Metrònom, Barcelona ⌐ *Pintar Palabras,* Instituto Cervantes, Berlin and New York ⌐ *El Cuerpo como Metáfora,* Casa de Cultura Ignacio Aldecoa, Vitoria ⌐ *Frontera.* Sala Luís de Ajuria, Fundación Sancho el Sabio, Vitoria ⌐ *Piedra de Toque,* Galería Fernando Latorre, Madrid ⌐ *Taché a Pelaires,* Pelaires Centre Cultural Contemporani, Palma de Mallorca ⌐ *MICROPOLITICAS(III),* Espai d'Art Contemporani de Castelló ⌐ *Por orden de aparición: Brossa, Pazos, Colomer,* Galería Trinta, Santiago de Compostela
2002 *Eczema. Del textualisme a la postmodernitat,* Museu d'Art de Sabadell ⌐ *L'Art Conceptual Espanyol en la Col.lecció Rafael Tous,* Centre Cultural Tecla Sala. ⌐ *Gótico pero Exótico.* Centro-Museo Vasco de Arte Contemporáneo, ARTIUM. Vitoria ⌐ *Col.lecció d'Art Contemporani Fundació "La Caixa",* Caixa Forum. Barcelona ⌐ *"Hans Bellmer & More Dolls",* Pollack Fine Arts, Londres ⌐ *Les 7 péchés capitaux,* 7 Galléries éphémères de Vic-Fezensac ⌐ *Espacio íntimo,* Galería Trama, Madrid
2001 *3 Bestiaris,* Contrast, Barcelona ⌐ *Confluencias 1, El desafío de la mirada,* Galería Fernando Latorre, Zaragoza ⌐ *Dos milenios en la historia de España,* Musées Royaux d'Art et d'Histoire, Bruxelles ⌐ *Tu grano de arena,* Galería Trinta, Santiago de Compostela ⌐ *Shoes or no shoes,* Kapelgalerie, Institut Sint-Maria. ⌐ *Claves para la España del siglo XX.* Museo Príncipe Felipe, Valencia ⌐ *La Noche. Imágenes de la noche en el arte español. 1981–2000,* Museo Arte Contemporáneo Esteban Vicente, Segovia ⌐ *Conceptes,* Museu d'Art, Sabadell, Can Palauet, Mataró y Museu de l'Art de la Pell, Vic ⌐ *II Encuentro de Gráfica OKUPGRA,* Sala Zapatería, Casa de Cultura Ignacio Aldecoa, Vitoria
2000 *Dibujos Germinales 1947–1998. 50 artistas españoles,* Sala de exposiciones del Centro de Cultura, Gijón and Sprengel Museum. Hanover ⌐ *CORAZ NADA,* Serrahima Galeria d'Art, Barcelona ⌐ *Distancia Interior,* Galería 44, Barcelona ⌐ *Obra gràfica original,* Tabelaria, Barcelona ⌐ *Recortables,* Metta Galeria, Madrid ⌐ *Arte conceitual e conceitualismos: Anos 70 no acervo do MAC USP.* Museo de Arte contemporânea da Universidade de São Paulo and Centro Cultural FIESP, São Paulo ⌐ *Fora de Camp,* Set Itineraris per l'Audiovisual Català, Centre Cultural de la Caixa, Lleida ⌐ *Colecció. Noves incorpo-racions,* MACBA, Barcelona ⌐ *Indoméstico,* Imatra, Bilbao ⌐ *Dos milenios en la historia de España,* Centro Cultural de la Villa, Madrid ⌐ *Empreintes,* La Reine Margot, Paris ⌐ *Bijoux d'artistes,* Galería Marlborough, Mónaco

Mick Rock

—

*in London (United Kingdom)
Lebt und arbeitet/lives and works in New York

Mick Rock is "The Man Who Shot the 70s", the inimitable rock photographer who launched his career with an unknown David Bowie in 1972. From the first photo shoot he developed a two-year relationship as Bowie's official photographer. During this time Rock documented the rise and descent of Ziggy Stardust, and shot promotional films, album jackets, posters, artwork, videos like *Life on Mars* and *Space Oddity* and thousands of photographs. Recently, Mick Rock has worked with stars like Kate Moss, Michael Stipe and The Yeah Yeah Yeahs. He has produced several highly acclaimed retrospectives of the Glam Rock era, including *Blood and Glitter Glam: An Eyewitness Account,* and a collaboration with David Bowie, Iggy and the Stooges and Psychedelic Renegades/Syd Barrett.

Francesco Scavullo

—

*1921 in New York (USA)
† 2004 in New York

Acknowledged as the dominant photographic influence on American fashion and beauty, Francesco Scavullo has photographed almost every celebrated man, woman and child in the world today. His photographs have graced the covers of magazines such as *Rolling Stone, Life, Time, Harper's Bazaar, Vogue, Glamour, Cosmopolitan, L'Officiel* and *Max*, to name a few. Francesco Scavullo photographed the covers of *Cosmopolitan* for 30 years. He has shot many movie posters, including *A Star is Born* with Barbra Streisand. Francesco Scavullo also shot many album covers. Edgar Winters' *They Only Come Out At Night*, is the first Rock & Roll cover with full drag make-up. Diana Ross' *Diana* album shows her with no make-up, wet hair, wet tee-shirt, and torn jeans.

Katharina Sieverding

—

*1944 in Prague (Czech Republic)
Lebt und arbeitet/lives and works in Berlin and Düsseldorf

Einzelausstellungen/Solo Exhibitions
(Auswahl seit 1997/Selection since 1997)

—

2004 Galerie Grimm Rosenfeld, Munich ¬ Galerie Thomas Schulte, Berlin ¬ P.S.1, New York
2002 Galerie Michael Neff, Frankfurt
2001 Museum Casa di Goethe, Rom
1999 Reichstag, Berlin ¬ Galerie Erhard Klein, Bad Münstereifel ¬ Galerie Franck & Schulte, Berlin ¬ Kunsthalle Budapest, Budapest ¬ CCA Kitakyushu Project Gallery, Kitakyushu
1998 Stedelijk Museum, Amsterdam ¬ Deutsche Guggenheim, Berlin ¬ Residenzgalerie, Salzburg
1997 Galerie Franck & Schulte, Berlin ¬ XLVII. Biennale, Venice ¬ L. A. Louver Gallery, Venice, California ¬ Kunstsammlung Nordrhein-Westfalen, Düsseldorf

Gruppenausstellungen/Group Exhibitions
(Auswahl seit 1995/Selection since 1995)

—

2002 *heute bis jetzt. Zeitgenössische Fotographie aus Düsseldorf,* museum kunst palast, Düsseldorf ¬ *Das zweite Gesicht. Metamorphosen des fotografischen Portraits,* Deutsches Museum Munich ¬ *Dialoghi Europei D'Arte,* Castell dell'Ovo, Naples
2001 *Parallels,* Atlanta College of Art Gallery, Atlanta ¬ *Contemporary Utopia,* Latvian Center for Contemporary Art, Riga ¬ *We Set Off in High Spirits,* Matthew Marks Gallery, New York ¬ *Antagonism,* MACBA, Barcelona
2000 *Das fünfte Element,* Kunsthalle Düsseldorf ¬ *Ich ist etwas anderes. Kunst am Ende des 20. Jahrhunderts,* Kunstsammlung Nordrhein-Westfalen, Düsseldorf ¬ *7 hügel. Bilder und Zeichen des 21. Jahrhunderts,* Martin-Gropius Bau, Berlin ¬ *Arte alemán 1960–2000. La colección Grothe,* Museo Nacional de Arte Reina Sofia, Madrid
1999 XLVIII Biennale, Venice ¬ *Der Weltuntergang & das Prinzip Hoffnung,* Kunsthaus Zurich ¬ *Das XX. Jahrhundert,* Hamburger Bahnhof, Berlin - Neue Nationalgalerie, Berlin ¬ *The promise of photography,* P.S.1, New York, Hara Museum of contemporary art, Tokyo ¬ *Gesammelte Räume - Gesammelte Träume,* Martin Gropius Bau, Berlin
1997 XLVII Biennale, Venice ¬ *Face à l'histoire,* Centre Georges Pompidou, Paris ¬ *Rrose is a Rrose is a Rrose: Gender performance in photography,* Guggenheim Museum, Warhol Museum, Pittsburgh
1995 XLVI Biennale di Venezia ¬ *Burnt whole: Contemporary Artists reflect on the Holocaust,* Washington project of the arts

Francesco Vezzoli

—

*1971 in Brescia (Italy)
Lebt und arbeitet/lives and works in Milan

Einzelausstellungen/Solo Exhibitions
(Auswahl seit 1999/Selection since 1999)

—

2004 Fondazione Prada, Milan
2002 *Francesco by Francesco: A collaboration with Francesco Scavullo,* Galleria Giò Marconi, Milan ¬ *The Needleworks of Francesco Vezzoli,* Galerie fur Zeitgenössische Kunst, Leipzig ¬ *The Films of Francesco Vezzoli,* New Museum of Contemporary Art, New York ¬ Castello di Rivoli Museo d'Arte Contemporanea
2000 *A Love Trilogy–Self-portrait with Marisa Berenson as Edith Piaf,* Spazio Aperto, GAM, Galleria Comunale d'Arte Moderna, Bologna
1999 Anthony d'Offay Gallery, London ¬ *An Embroidered Trilogy,* Centre d'Art Contemporain, Geneva ¬ *An Embroidered Trilogy,* Galleria d'Arte Moderna, Bologna ¬ *An Embroidered Trilogy,* The British School at Rome ¬ *An Embroidered Trilogy,* Galleria Giò Marconi, Milan

Gruppenausstellungen/Group Exhibitions
(Auswahl seit 1999/Selection since 1999)

—

2003 *Il racconto del filo: ricamo e cucito nell'arte contemporanea,* MART, Rovereto
2002 Second Liverpool Biennal of Contemporary Art ¬ *Ipotesi di Collezione,* MACRO – Museo d'Arte Contemporanea, Rome ¬ *Verso il Futuro. Identità nell'arte italiana 1990–2002,* Museo del Corso, Rome ¬ *Opening Show,* Gallery Roma Roma Roma ¬ *Ouverture... arte dall'Italia,* Galleria Comunale d'Arte Contemporanea, Monfalcone ¬ *Penetration,* Friedrich Petzel and Marianne Boesky Gallery, New York ¬ *Melodrama,* Artium, Centro-Museo Vasco de Arte Contemporàneo,Vitoria; Palacios de los Condes de Gabia/Centro Jose Guerrero, Granada ¬ *Spring Forward,* Chanel SoHo, New York ¬ *Campy Vampy Tacky: Leigh Bowery, Brice Dellsperger, Takashi Ito, Michel Journiac, Ugo Rondinone, Francesco Vezzoli, Andy Warhol,* La Criée Centre d'Art Contemporain, Rennes ¬ *De Gustibus – Collezione privata Italia,* Palazzo delle Papesse, Centro Arte Contemporanea, Siena
2001 *East Wing Collection No. 5,* Courtauld Institute of Art, Somerset House, Strand, London ¬ *A Sense of Wellbeing: Loss, History and Desires,* Bagni Imperiali, Karlovy Vary ¬ The 1st Tirana Biennial ¬ *Generator 3,* Baluardo di San Regolo – Giardino Botanico, Lucca ¬ *Haraldur Jònsson, Annika Strom, Francesco Vezzoli,* Chisenhale Gallery, London ¬ *Squatters,* Fundação Serralves, Porto ¬ *Boom! Espresso: Arte oggi in Italia,* Manifattura Tabacchi, Florence ¬ *Biennale di Venezia* ¬ *Bra mot melankoli – Remedy for melancholy,* Edsvik konst och kultur,Sollentuna; Baltic Art Center, Visby ¬ *Magic and Loss–Contemporary Italian Video,* Pandemonium: The London Festival of Moving Image, The LUX Centre, London
2000 *Premio per la giovane arte italiana "Migrazioni",* Centro per l'Arte Contemporanea, Rome ¬ *Generator,* Trevi Flash Art Museum, Trevi (PG); Galleria Loretta Cristofori, Bologna ¬ *Group Show,* Anthony d'Offay Gallery, London ¬ *Art and Facts,* Galleria Franco Noero, Turin
1999 *EXIT,* Chisenhale Gallery, London. ¬ *Videodrome,* New Museum of Contemporary Art, New York ¬ 6th International Istanbul Biennal

Jeffrey Vallance

—

*1955 in Torrance (USA)
Lebt und arbeitet / lives and works in Reseda

Einzelausstellungen / Solo Exhibitions
(Auswahl seit 1995 / Selection since 1995)

2003 Gallery Praz-Dellavalade, Paris
2002 *Clown Stains,* Satellite Space, University of Texas, San Antonio
 ¬ *The Shape of Texas,* Majestic Ranch, Boerne ¬ *Relics from
 LBJ's 1966 Visit to Australia,* Tasmanian Museum and Art
 Gallery, Hobart ¬ *Saami and Aboriginal Flags,* Black Kettle
 Museum, Cheyenne
2001 *The Virgin, the Poet and the President,* Lehmann Maupin,
 New York
1999 *Paranormal Diagrams: Heretical Theories,* The Art Institute
 of Boston, Massachusetts ¬ *Anomalies, and Paranormal
 Diagrams: Heretical Theories,* Rosamund Felsen Gallery,
 Santa Monica
1998 *Paranormal Diagrams: Heretical Theories,* Lehmann Maupin,
 New York ¬ *Jeffrey Vallance: A 25-year Survey,* Galeria Praz-
 Delavallade, Paris ¬ *Jeffrey Vallance / Drawings,* y1, Stockholm
1995 *The World of Jeffrey Vallance,* Santa Monica Museum of Art

Gruppenausstellungen / Group Exhibitions
(Auswahl seit 2000 / Selection since 2000)

—

2004 *This Much Is Certain,* Royal College of Art Galleries, London
2003 *Group Show,* Rosamund Felsen Gallery, Santa Monica ¬ *GNS:
 Global Navigation System,* Palais de Tokyo, Paris ¬ *Min skat-
 tkammare (My Treasury),* The Royal Armory, Swedish Royal
 Palace, Stockholm ¬ *17 Reasons,* Jack Hanley Gallery, San
 Francisco ¬ *The Men's Room,* The Nassau County Museum of
 Art, Roslyn Harbor ¬ *The Greatest Album Covers That Never
 Were,* Track 16 Gallery, Santa Monica
2002 Sydney Biennale 2002 ¬ *Off the Grid,* Lehmann Maupin, New
 York ¬ *Straight to Hell,* Richard Heller Gallery, Santa Monica
 ¬ *Dumbo and Beyond,* Davis Gallery, Austin ¬ *Group Show,*
 Rosamund Felsen Gallery, Santa Monica ¬ *This Won't Do a
 Thing for Your Career, Dahling: Juxtapoz,* Track 16 Gallery,
 Santa Monica ¬ *A Thousand Clowns,* Robert Berman Gallery,
 Santa Monica ¬ *To Whom it May Concern,* Logan Galleries,
 California College of Arts and Crafts, Wattis Institute for con-
 temporary Art, San Francisco
2001 *inSITE2000* The Marriot Courtyard Guadalupe Apparition ¬
 The Magic Hour, organized by Neue Galerie at the
 Kunstlerhaus, Graz
2000 *Jeffrey Vallance: Culture Mix,* film program, MK 2 Project Café,
 Paris ¬ *inSITE2000,* San Diego, California and Tijuana ¬
 Blurry Lines, John Michael Kohler Arts Center, Sheboygan
 Angelico, Siena Heights University, Adrian ¬ *Faith,* Dynamite
 Gallery, Grand Rapids, Michigan ¬
 Made in California: Art, Image and Identity, 1900–2000, Los
 Angeles County Museum of Art

Nicole Wermers

—

*1971 in Emsdetten (Germany)
Lebt und arbeitet / lives and works in London

Ausstellungen / Exhibitions
(Auswahl seit 1999 / Selection since 1999)

2004 Millers Terrasse, London ¬ Secession, Vienna
2003 *Handlungsräume,* Halle für Kunst, Lüneburg ¬ *Renderings,*
 Delfina Gallery, London ¬ *Cinepolis, Hamburger Architektur
 Sommer,* Hamburger Botschaft ¬ *Help,* Gallery Els Hannepe
 Underground, Athens ¬ *Neue Kunst in Hamburg,* Kunsthaus
 Hamburg ¬ *A Nuova Geometria,* Gallery Fortes Vilaces, São
 Paulo ¬ Galerie Borgmann-Nathusius, Cologne
2002 *The Day After,* Gallery Cookie Snoie, Rotterdam ¬ *Ich ging im
 Walde so für mich hin,* Galerie Borgmann-Nathusius, Cologne
 ¬ *Building Anxiety,* Ten in One Gallery, New York ¬
 Dorothea von Stetten Kunstpreis, Kunstmuseum Bonn ¬
 French Junkies, Produzentengalerie Hamburg
2001 Sammlung Karl Ernst Osthaus-Museum, Hagen ¬
 Liminal / Minimal / Nominal. Architectural Traces, John
 Hansard Gallery, Southampton ¬ *F,* Produzentengalerie,
 Hamburg ¬ *German Leitkultur,* Kunsthalle Fridericianum,
 Kassel ¬ *Zero Gravity,* Kunstverein für die Rheinlande und
 Westfalen, Düsseldorf ¬ *A Sport and a Passtime,* Greene
 Naftali Gallery, New York ¬ *Videonale 9,* Bonner Kunstverein
 ¬ *Szenarien oder der Hang zum Theater,* Bonner Kunstverein;
 Stadthaus Ulm ¬
 Szenenwechsel XX, MMK Frankfurt ¬ *Beiträge zu Zwischen-
 räumen der Architektur,* Halle für Kunst, Lüneburg Auswahl
 der Videonale Bonn, Museum Ludwig, Cologne
2000 *And If There Were No Stories,* Stephen Friedmann Gallery,
 London ¬ *Pallisades,* Centre d'Art, Bretigny-sur-Orge ¬
 Include Me Out, Space, Old Street, London ¬
 Papier, Produzentengalerie Hamburg ¬
 Förderkoje auf der Art Cologne, Produzentengalerie, Hamburg
1999 *Know what I mean?,* Goethe Institute, London ¬
 New Contemporaries '999, Liverpool Biennial;
 South London Gallery, London

T. J. Wilcox

—

*1965 in Seattle (USA)
Lebt und arbeitet / lives and works in New York

Einzelausstellungen / Solo Exhibitions
(Auswahl seit 1996 / Selection since 1996)

2004 *A Garland for Ireland,* Temple Bar Outdoors, Dublin
2003 *Garlands,* Sadie Coles HQ, London, China Art Objects,
 Los Angeles
2002 Metro Pictures, New York ¬ *Smorgasbord,* Berkeley Art
 Museum
2001 Sadie Coles HQ, London ¬
 Galerie Daniel Buchholz, Cologne ¬
 Galerie Meyer Kainer, Vienna
2000 Gavin Brown's Enterprise, New York ¬ Kunsthaus Glarus
1999 Galerie Neu, Berlin ¬ Gavin Brown's Enterprise, New York ¬
 Sadie Coles HQ, London ¬ Galerie Daniel Buchholz, Cologne
1998 Institute of Contemporary Arts, London
1997 Galerie Daniel Buchholz, Cologne ¬
 The Death and Burial of the First Emperor of China, Gavin
 Brown's Enterprise, New York
1996 Gavin Brown's Enterprise, New York

Gruppenausstellungen / Group Exhibitions
(Auswahl seit 1997 / Selection since 1997)
—

2004 Whitney Biennial, New York ⌐ *North Fork / South Fork*,
Parrish Art Museum, Southampton, New York
2003 *Drawings*, Metro Pictures, New York ⌐ *Today's Man*, John
Connelly Presents, New York; Hiromi Yoshii, Tokyo ⌐
*My People Were Fair and had Cum in Their Hair (but now
they're content to spray stars from your boughs)*, Team
Gallery, New York ⌐ *Fast Forward*, Media Art Sammlung
Goetz, ZKM, Karlsruhe ⌐ *Somewhere Better Than This Place*,
Contemporary Arts Center, Cincinnati
2002 *Rapture*, Barbican Gallery, London
2001 *W*, Musée des Beaux-Arts, Dole ⌐
The Americans-New Art, Barbican Art Gallery, London
2000 *Greater New York*, PS1, New York ⌐
The American Century – Art & Culture 1900–2000, Whitney
Museum of American Art, New York
1999 *Moving Images*, Galerie für Zeitgenössische Kunst, Leipzig ⌐
Center for Curatorial Studies, Bard College, New York
1998 *El Nino*, Museum Abteiberg, Moenchengladbach ⌐
Dialogues, Walker Art Center, Minneapolis
1997 Venice Biennale ⌐ *Sunshine and Noir*, Art in Los Angeles,
1960–1997, Louisiana Museum of Art, Kunstmuseum
Wolfsburg, Castello di Rivoli ⌐
Whitney Biennial, New York
1996 *Studio 246*, Marc Foxx Gallery, Los Angeles ⌐
Hollywood, LACE, Los Angeles ⌐
Los Angeles Center for Photographic Studies, Los Angeles ⌐
Persona, Kunsthalle Basel, Switzerland; The Renaissance
Society, The University of Chicago ⌐
Affairs, The Institute for Contemporary Art Vienna ⌐
Studio 246, Künstlerhaus Bethanien, Berlin ⌐
Sampler II, David Zwirner Gallery, New York

Wols
—

*1913 in Berlin (Germany)
†1951 in Paris

Much better known as a painter, Wols began his career as a photo-
grapher. He took the name Wols from a torn fragment of a telegram
he had received in order to assist his career within the world
of French avant-garde photography. His real name was Alfred Otto
Wolfgang Schulze. At the age of 23 he had a one man exhibition
at the *Galerie de la Pleiade*, one of the key Paris venues for contem-
porary photography. His new status as a recognised photographer
was confirmed in the same year when he was contracted to photo-
graph the fashion pavilion at the Paris International Exhibition.
As a photographer, Wols was the master of the close-up, frequently
composing his subjects with an unexpected focus, destroying
constructive consistency and dislocating expectations. However his
career came to an end as a result of the Second World War. Wols
died in 1951 from food poisoning.

Author's biographies
—

Tom Holert
—

Was born in 1962. He currently lives and works in Berlin as an
independent scholar in cultural studies and as a journalist; during
the 1990s he was editor at *Texte zur Kunst* and *Spex* in Cologne; he
lectured in Stuttgart, Karlsruhe, Zurich and other places; in 2000
he co-founded the Institute for Studies in Visual Culture (isvc) in
Cologne. His articles and essays have been published in various
magazines and publications such as *Texte zur Kunst*, *Artforum, die
tageszeitung, WoZ, Süddeutsche Zeitung, Literaturen, Jungle World*.
Among the books he published are *Künstlerwissen* (München: Fink
1997), *Mainstream der Minderheiten. Pop in der Kontrollgesellschaft*
(Hg. mit Mark Terkessidis; Berlin/Amsterdam: ID-Archiv 1996), he
Imagineering. Visuelle Kultur und Politik der Sichtbarkeit (Hg.; Köln:
Oktagon 2000), *Entsichert. Krieg als Massenkultur im 21. Jahrhundert*
(mit Mark Terkessidis; Köln: Kiepenheuer & Witsch 2002). In co-
operation with the Institut für Theorie der Gestaltung und Kunst
(ith) he initiated the Zurich projekt *Doing Glamour. Operationen am
Schillern und Scheinen* in August, September and October 2004, in
which the migros museum für gegenwartskunst participated with
the exhibition *The Future Has a Silver Lining*.

Heike Munder
—

Was born in 1969. She is director and curator of the migros
museum für gegenwartskunst in Zurich since 2001. She previously
co-founded the halle für kunst Lüneburg e.V. in Germany with
Bernd Milla, which they ran from 1995 to 2001.

Ian Penman
—

Was born in 1959. He was raised and educated in Norfolk, Cyprus,
Scotland and the Middle East and currently lives in London. In
1977, scheduled to attend art college, he took a "year out" and fetched
up at the *NME*, where his subsequent work achived a certain
notoriety. Since 1985 he has been a successful freelance journalist,
published and reprinted in France, Germany, the US and Japan.
A collection of writings, *Vital Signs. Music, Movies and Other Manias*,
was published in 1998. Penman had articles, essays and reviews in
The Guardian, Uncut, The Wire and other publications. His weblog
"The Pillbox" (http://apawboy.blogspot.com/) was (until it seemingly
stopped in March 2004) one of the more exciting sites on the web.

Terre Thaemlitz
—

Is an award winning multi-media producer, writer, public speaker,
educator, audio remixer, DJ and owner of the Comatonse Recordings
record label. His work critically combines themes of identity politics
– including gender, sexuality, class, linguistics, ethnicity and race –
with an ongoing critique of the socio-economics of commercial
media production. This diversity of themes is matched by Thaemlitz'
wide range of production styles, which include electroacoustic
computer music, club oriented deep house, digital jazz, ambient, and
computer composed neo-expressionist piano solos. (He has released
twelve solo albums, as well as numerious 12-inch EPs, 7-inch
singles, collaborative albums, remixes, and video works. He is a
resident DJ at Club Module in Tokyo, where his "Deeperama" parties
are held bi-monthly.) His writings on music and culture have been
published internationally in a number of books, academic journals
and magazines. As a speaker and educator on issues of non-
essentialist transgenderism and Queer theory, Thaemlitz has parti-
cipated in panel discussions throughout Europe and Japan, as well
as held numerous cross-cultural sensitivity workshops at Tokyo's
Uplink Factory, near his current residence in Kawasaki, Japan.

Kutlug Ataman

–

154

–

Women Who
Wear Wigs
1999
Video installation
ca. 60 min.
Courtesy of the artist
and Gallery
Lehmann Maupin,
New York

Michel Auder

–

2
152
155
263

–

Dead Souls
(Mostly)
2004
Videostills on high
quality printing paper
48 stripes,
ca. 300 x 500 cm
Courtesy of the artist
and Suite 106
Gallery, New York
Photography by
A. Burger, Zurich

Shannon Bool

–

114

–

Fired from Walmart
2004
Gouache on
cardboard
31.5 x 45.5 cm
Lutz Becker, Cologne

Daniele Buetti

–

144

–

Looking for Love
1997 – 2004
Cibachrome prints
mounted on alu-
minium, cibachrome
prints, wood tables
Courtesy of the artist
Photography by
A. Burger, Zurich

Tom Burr

–

89

–

Brutalist
Bulletin Board
2001
B/w photographs,
paper on wood
60 x 500 cm
Thorsten Koch,
Cologne
Photography by
A. Burger, Zurich

James Lee Byars

–

159
146

–

The Wings
for Writing
1972
Silk, feathers
48 x 88 cm
Is
1989
Beaten gold,
marble ball
Diameter: 60 cm
Estate James
Lee Byars, Courtesy
Gallery Michael
Werner, Cologne
and New York
Photography by
A. Burger, Zurich

Janet Cardiff &
George Bures
Miller

–

128
129

–

The Berlin Files
2003
Video and sound,
mixed media
ca. 10 min.
Credits:
Singer in Bar:
John Jones,
Blond Woman:
Isabelle Stoffel,
Lady in Red:
Helen Cho,
Bartender:
Wolfgang,
Piano Player:
Tillman Ritter,
Production:
Isabelle Stoffel,
Cinematographer:
Martin Kukela,
Steadycam:
Patrick Kaethner,
Assistants:
Carlo Crovato, Helen
Cho, Laura Kikauka,
Ester Dittmann,
Barbara Prokop
Rock'n Roll Suicide:
composed by
David Bowie,
Singers:
John Jones,
Janet Cardiff,
Guitarist:
Andreas Fricke,
Bass:
Björn Werra,
Drums:
Jan Peter Eckelmann,
Organ, backing
vocals, orchestration:
Tillman Ritter,
Sound engineering:
Titus Maderlechner,
Stephan Koethe,
Apartment
Composition:
composed and
orchestrated by
Tillman Ritter,
Moabit Kunst,
Orchestra, conducted
by Bernd Wefelmeyer
General thanks to
DAAD, White Trash
Bar, Thomas
Demand, B+W
Speakers
Courtesy of the artist,
Gallery Barbara
Weiss, Berlin and
Gallery Luhring
Augustine, New York

Marc Camille
Chaimowicz

–

108
109
110
111
112

–

Partial Eclipse
1980 – 2003
Slide projection
Collection migros
museum für gegen-
wartskunst, Zurich

Cosey Fanni Tutti

–

4
140
141
142

–

Life Forms (Detail)
1973 – 1979
Photographs
12 parts,
each 52 x 67 cm
Courtesy of the artist
and Cabinet Gallery,
London

Brice Dellsperger

–

3
105

–

Body Double (X)
2000
Video
104 min.
Body Double 15
2001
Video
8:30 min.
Courtesy of the artist
and Gallery Air de
Paris, Paris

Cerith Wyn Evans

–

85
116

–

Untitled
2003
Paper, 9 parts,
each 40 x 38 cm
Courtesy of the artist,
Gallery Neu, Berlin,
Thorsten Koch,
Cologne and Michael
Gerber, Zurich
The sky is as thin
as paper here...
2004
2 slide projections,
dissolve unit
Courtesy of the artist,
White Cube, London
and Gallery Daniel
Buchholz, Cologne

Christian Flamm

–

106

–

Relindis Agethen
2004
Nails, thread
256 x 130 cm
Courtesy of the artist,
Gallery Neu, Berlin
and Gallery Fonti,
Naples
Photography by
A. Burger, Zurich

Sylvie Fleury

–

126
144

–

Blue Notes &
Incognito
2004
Metal plates, make-up
300 x 300 cm
Courtesy of the artist
and Gallery Eva
Presenhuber, Zurich
Photography by
A. Burger, Zurich

Allen Frame

–

John & Alba
New York
1996
B/w photograph
65 x 65 cm
Collection John
Edward Heys,
Berlin/New York

General Idea

–

123

–

FILE Megazine
Glamour Issue
1975
Buchhandlung
Walther König, Köln

Franz Gertsch

–

150

–

Irène III
1981
Gouache on
cardboard
100 x 140 cm
Collection Pierre
Mirabaud, Founex

John Edward Heys

–

122

–

Minaudière
ca. 1930's – 1940's
Evening case,
powder, lipstick,
cigarettes, ice and
faux mother of pearl
in black satin case,
Eisenberg Ice-Brooch
ca. 1935 – 1942
Collection John
Edward Heys,
Berlin/New York
GODDESS
Homage to
Jackie Curtis,
Holly Woodlawn,
Candy Darling,
Cookie Mueller,
Diana Vreeland,
Ellen Stewart and
Charlotte von
Mahlsdorf and
the photographers
who took these
portraits
2000
Lavender Box
(Homage to Cookie
Mueller-New York-
Amalfi-Positano-
Capri, inspired by
Alba Clemente)
ca. 2003
Jackie Curtis
Shopping Bag
ca. 1973
Courtesy of the artist
Photography by
A. Burger, Zurich

Julian Göthe

–

104

–

Painted White in a
Spirit of Rebellion
2002 / 2003
Cardboard, metal
ca. 200 x 412 x 160 cm
Collection
Schürmann,
Herzogenrath and
Courtesy Gallery
Daniel Buchholz,
Cologne
Photography by
A. Burger, Zurich

Fergus Greer/Leigh Bowery

Selection from
Session II
1989
Photograph mounted
on aluminium
121.92 x 152.4 cm
Selection from
Session III
1990
Ph. mounted on alu.
121.92 x 152.4 cm
Selection from
Session IV
1991 – 1992
B/w ph. mounted
on alu.
121.92 x 152.4 cm
Selection from
Session VI
1992
Ph. mounted on alu.
121.92 x 152.4 cm
Selection from
Session VII
1994
B/w ph. mounted
on alu.
121.92 x 152.4 cm
Fergus Greer,
Los Angeles and
The Michael Hoppen
Gallery, London

Jonathan Horowitz

–

98

–

The Governator
2003
Inkjet prints
7 parts, each
28 x 22.5 cm
Collection migros
museum für gegen-
wartskunst, Zurich
Photography by
A. Burger, Zurich

Peter Hujar

–

88

–

Diana Vreeland
1975
B/w photograph
1975
65 x 55 cm
Collection John
Edward Heys,
Berlin-New York
Taylor Mead –
International
Superstar
(FIRST generation
Warhol Factory) and
John Edward Heys
B/w photograph
1971
38 x 30.5 cm
Collection John
Edward Heys,
Berlin/New York

Daniel Robert
Hunziker &
Tim Zulauf,
Klassenfahrt / KMU
Produktionen

–

124

–

Glamour Eiland
2004
Showcase
100 x 500 x 275 cm
Courtesy of the artist
Photography by
A. Burger, Zurich

Sanja Iveković

–

155

–

Make Up -
Make Down
1976
Video
9:20 min.
Eight Tears
1976
Collage on paper
9 parts,
each 51 x 35,5 cm
Before and After
1976
Collage on paper
41 x 57 cm
Collection Museum
of Contemporary Art,
Zagreb

Mark Leckey

–

123

–

Costume Designs
2002
Cardboard
17 x 12.5 cm
Koenig Books,
London

Urs Lüthi

–

157
262

–

Tell Me Who
Stole Your Smile
1974
B/w photographs
8 parts, each
33 x 45 cm
Collection Luis
Bolliger, Zurich,
Courtesy Bob van
Orsouw, Zurich

Manon

–

148
151
153
154

–

La Stanza
Delle Donne
1990
Velvet, cardboard,
wood, metal labels
Caskets, each
10 x 33 x 33 cm
Collection
Kunstmuseum
St. Gallen
Photography by
A. Burger, Zurich

Bernhard Martin

–

101

–

Single Disco
(Whisperclub)
1999
Mixed media
220 x 95 x 95 cm
Collection FRAC
Bourgogne, Dijon
Photography by
A. Burger, Zurich

Josephine
Meckseper

–

91
92

–

Shelf No. 11 B
2003
Perspex, cibachrome
print, silver gelatin
print, mirror, glitter
on paper, adhesive
tape, metal, wire,
strass jewellery,
acrylic, framed
perspex
88.9 x 243.8 x 30.5 cm
Courtesy of the artist,
Gallery Reinhard
Hauff, Stuttgart and
Elizabeth Dee
Gallery, New York
Photography by
A. Burger, Zurich

Meret Oppenheim

–

115

–

Slip Mandrill
1940 / 2003
Torso with fur,
sequined, tulle
36 x 34 x 24 cm
Hundeschnauzenhut
1942 / 2003
Fur, felt, velvet,
artificial dog's snout
26 x 24 x 23 cm
Courtesy of Gallery
Levy, Hamburg

Carlos Pazos

–

7
97
118
119

–

Voy a hacer de mi
una estrella
1975
B/w photographs
20 parts,
each 61.5 x 40.5 cm
Collection Museu
d'Art Contemporani
de Barcelona
Foundation
Milonga
1980
Photograph,
fluorescent bulb
105 x 100 cm
Collection
Contemporary Art,
Fundación
"la Caixa",
Barcelona
Photography by
J. Nieva

Mick Rock

–

6

10

264

–

Debbie Harry
(New York 1978)
1978/2004
Photograph
40 x 30 cm
Bowie
(Earls Court,
London 1973)
1973–2004
Ph. 100 x 70 cm
Bowie in Mirror
(UK 1972)
1972–2004
Ph. 40 x 30 cm
Courtesy of the artist
and Blue Balls
Music, Zurich

**Francesco
Scavullo**

–

9

86

87

–

Candy Darling
(Head)
1969, b/w photograph
27.9 x 35.6 cm
David Bowie
1974, b/w photograph
27.9 x 35.6 cm
Kirk
1974, b/w photograph
36.8 x 38.1 cm
Candy and
Michael J. Pollard
1969, b/w photograph
36.8 x 38.1 cm
Mick Jagger
1973, b/w photograph
27.9 x 35.6 cm
Barbara Streisand
1975, b/w photograph
27.9 x 35.6 cm
Bette Midler
1972, b/w photograph
27.9 x 35.6 cm
Divine
1978, b/w photograph
27.9 x 35.6 cm
Divine
(Full Length)
1978, b/w photograph
27.9 x 35.6 cm
Grace Jones
1979, b/w photograph
27.9 x 35.6 cm
The Motion Picture
Group, Philadelphia,
USA

**Katharina
Sieverding**

–

94

–

The Great White
Way Goes Black
1977/2004
Photograph
300 x 500 cm
Courtesy of the artist
and Gallery Michael
Neff, Frankfurt
am Main
Photography by
Klaus Mettig

Francesco Vezzoli

–

1

120

261

–

Francesco by
Francesco:
Before & Ever After
2002
B/w photograph
je 77 x 59 cm
Courtesy of the artist
and Gallery Giò
Marconi, Milan
An Embroidered
Trilogy
1997 – 1999
Video
ca. 12 min.
Part One:
Ok, The Praz is
Right!
1997
With Iva Zanicchi
directed by
John Maybury
Part Two:
Il Sogno di Venere
1998
With Franca Valeri
directed by
Lina Wertmüller
Part Three:
The End
(teleteatro)
1999
With
Valentina Cortese
directed by
Carlo di Palma
Courtesy of the artist
and Gallery Franco
Noero, Turin

Jeffrey Vallance

–

125

–

Elvis Sweatcloth I
1993
Sweat on satin
55.8 x 55.8 cm
Courtesy of the
artist and Gallery
Rosamund Felsen,
Santa Monica

Nicole Wermers

–

102

–

Untitled
2003
Collage
32 x 21.5 cm
French Junkies #1
2002
Wood, varnish, sand
80 x 17 x 13 cm
French Junkies #3
2002
Chipboard, plastic,
stainless steel
80 x 35 x 24.5 cm
French Junkies #9
2002
Acrylic, copper,
plastic, zinc, sand
77.5 x 24.5 x 21 cm
French Junkies #2
2002
Wood, lacquer,
stainless steel
83 x 34 x 21 cm
French Junkies #6
2002
Plastic, wood,
lacquer, glass
80,5 cm, ø 26 cm
Courtesy of the
artist and
Produzentengalerie,
Hamburg
Photography by
A. Burger, Zurich

T. J. Wilcox

–

96

–

Stephen Tennant
Homage
1998
16 mm film, 12 min.
The Funeral
of Marlene Dietrich
1999
16 mm film, 12 min.
Courtesy of the artist,
Metro Pictures
Gallery, New York
and Gallery Daniel
Buchholz, Cologne

Wols

–

Pavillon
de l'Elégance et
de la parure
1937
B/w photograph
(Reprint 1996,
Griffelkunst)
Private collection,
Berlin

Vintage Film Stills

–

5

84

–

Jean Harlow
1930s
Linda Winters
1930s
Collection
Christoph Schifferli,
Zurich

**Unknown
Photographer**

–

90

–

Jackie. Curtis.
Goddess.
International
Superstar
1971s – 1972
Photograph
43 x 35 cm
321 East 9th St -
Stella, Colette,
Devon, Betty,
and John
1969
Photograph
37 x 43.5 cm
Collection John
Edward Heys,
Berlin/New York

This catalogue is published on the occasion
of the exhibition
The Future Has a Silver Lining.
Genealogies of Glamour
at the migros museum für gegenwartskunst Zurich.

/

Dieser Katalog wurde anlässlich
der Ausstellung
The Future Has a Silver Lining.
Genealogies of Glamour
im migros museum für gegenwartskunst Zürich
herausgegeben.

/

Ein doing glamour Projekt
A doing glamour project
www.doingglamour.com

–
Exhibition/Ausstellung
August 28 – October 31 2004.
–

Curators/Kuratoren:
Tom Holert & Heike Munder
Assistant Curator/Assistenz-Kurator:
Raphael Gygax
Administration/Administration: Rosmarie Battaglia
Trainee/Praktikantin: Judith Welter
Registrar/Registrar: Arthur Miranda
Technical support/Technischer Dienst: Roland
Bösiger, Monika Schori, Nico Canzoniere, Marky
Edelmann, Derek Uttley, Jogrim Erland, Joël Frattini,
Adrian Immer, Gabi Deutsch, Muriel Gutherz
Reception/Kasse: Simone Schardt, Urs Küenzi,
Christian Käser, Valentin Magaro, Christa Michel,
Jacqueline Uhlmann

–
Catalogue/Katalog
–
Published by/Herausgegeben von
migros museum für gegenwartskunst & JRP|Ringier
–

Editors/Herausgeber:
Tom Holert & Heike Munder
Editorial Coordination/Projektleitung:
Raphael Gygax
Copy editing of the German texts/
Lektorat der deutschen Texte:
René Ammann, Doris Senn
Copy editing of the English texts/
Lektorat der englischen Texte:
Rowena Smith, Clare Manchester
Translation from English/
Übersetzung aus dem Englischen:
Clara Drechsler, Clemens Krümmel,
Translation from German/
Übersetzung aus dem Deutschen:
James Rumball, Tirdad Zolghadr
Photographs/Fotos: A. Burger
Concept/Design:
Marie Lusa & Claudia Roethlisberger
Typography/Satz: Peter Ruch
Print/Druck: Druckerei Odermatt AG, Dallenwill

migros museum für gegenwartskunst
Limmatstrasse 270
CH–8005 Zürich
t +41 (0) 1 277 20 50
f +41 (0) 1 277 62 86
info@migrosmuseum.ch
www.migrosmuseum.ch

migrosmuseum
FÜR GEGENWARTSKUNST
ZÜRICH

–
JRP|Ringier Kunstverlag AG
Letzigraben 134
CH–8047 Zürich
t +41 (0) 43 311 27 50
f +41 (0) 43 311 27 51
info@jrp-ringier.com
www.jrp-ringier.com

jrp|ringier

ISBN 2-940271-50-X

–

Thanks to / Dank an

–

HT Transport Berlin ¬ Möbel Transport AG ¬ Kraft
ELS Basel ¬ Kutlug Ataman ¬ Matthew Lusk ¬ Lehman
Maupin Gallery New York ¬ Michel Auder ¬ Suite 106
Gallery New York ¬ Shannon Bool ¬ Lutz Becker ¬
Daniele Buetti ¬ Galerie Ars Futura Zürich ¬ Thorsten
Koch ¬ Galerie Michael Werner Köln & New York
¬ Janet Cardiff ¬ George Bures Miller ¬ Carlo Crovato
¬ Galerie Barbara Weiss Berlin ¬ Gallery Luhring
Augustine New York ¬ Marc Camille Chaimowicz ¬
Cosey Fanni Tutti ¬ Cabinet Gallery London ¬ Brice
Dellsperger ¬ Air de Paris ¬ Cerith Wyn Evans ¬ Juliette
Blightman ¬ Galerie Neu Berlin ¬ Galerie Daniel
Buchholz Köln ¬ White Cube London ¬ Michael
Gerber ¬ René Gloor ¬ Thorsten Koch ¬ Christian
Flamm ¬ Galleria Fonti Naples ¬ Sylvie Fleury ¬
Galerie Eva Presenhuber Zürich ¬ Marc Hahn ¬ John
Edward Heys ¬ Allen Frame ¬ Walther König ¬ Franz
Gertsch ¬ Pierre & Sylvie Mirabaud ¬ Julian Göthe ¬
Sammlung Schürman ¬ Fergus Greer ¬ The Michael
Hoppen Gallery London ¬ Jonathan Horowitz ¬ Daniel
Robert Hunziker / Tim Zulauf, Klassenfahrt / KMU
Produktionen ¬ Sanja Iveković ¬ Museum of Contem-
porary Art Zagreb ¬ Mark Leckey ¬ Franz König ¬ Urs
Lüthi ¬ Fotomuseum Winterthur, Urs Stahel ¬ Galerie
Stähli Zürich ¬ Luis Bolliger ¬ Galerie Bob van Orsouw
Zürich ¬ Manon ¬ Kunstmuseum St. Gallen ¬ Roland
Wäspe ¬ Konrad Bitterli ¬ Bernhard Martin ¬ René
Schmitt ¬ FRAC Bourgogne ¬ Josephine Meckseper ¬
Galerie Reinhard Hauff Stuttgart ¬ Elizabeth Dee
Gallery New York ¬ Galerie Levy Hamburg ¬ Carlos
Pazos ¬ Museu d'Art Contemporani de Barcelona ¬
Fundacion "La Caixa" Barcelona ¬ Mick Rock ¬ Blue
Balls Music Zurich ¬ Motion Picture Group ¬ Katharina
Sieverding ¬ Galerie Michael Neff Frankfurt a. M. ¬
Jeffrey Vallance ¬ Rosamund Felsen Gallery Santa
Monica ¬ Francesco Vezzoli ¬ Galleria Giò Marconi
Milan ¬ Galleria Franco Noero Turin ¬ vim ¬ Nicole
Wermers ¬ Produzentengalerie Hamburg ¬ T. J. Wilcox
¬ Metro Pictures Gallery New York ¬ Christoph
Schifferli ¬ Marion von Osten ¬ Marc Siegel ¬ Institut
für Theorie der Gestaltung und Kunst Zürich (ith) ¬
Jörg Huber ¬ Irène Hediger ¬ Plinio Bachmann ¬
Museum für Gestaltung Zürich

p. 259

–

Gottlieb Duttweiler
Founder of the
Migros company
(1888–1962)

p. 260

–

Jobriath
*Creatures of
the Street*
1974

p. 261

–

Francesco Vezzoli
Il Sogno di Venere
(Franca Valeri)
1998

p. 262

–

Urs Lüthi
*Tell Me Who
Stole Your Smile*
1974

p. 265

–

Michel Auder
Dead Souls (Mostly)
2004

p. 264

–

Mick Rock
Bowie in Mirror
1972

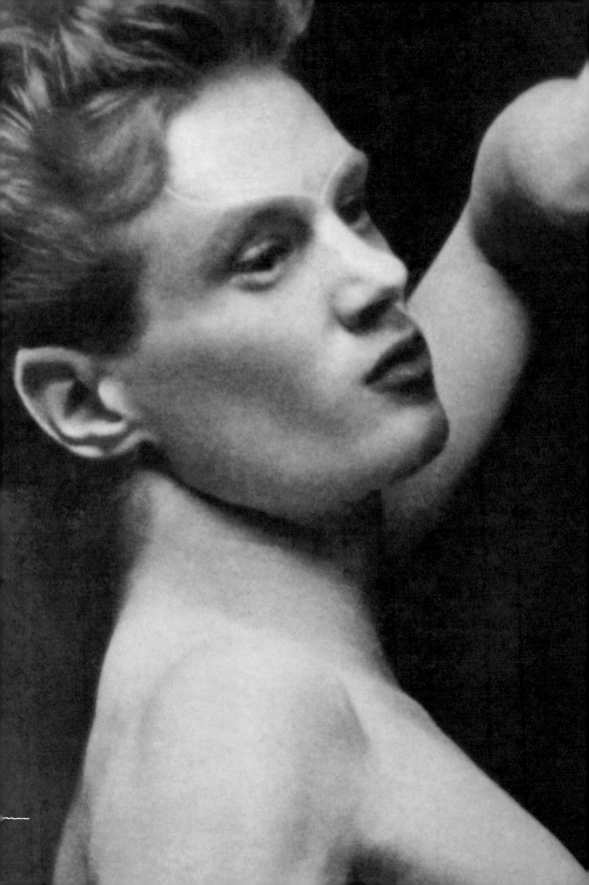

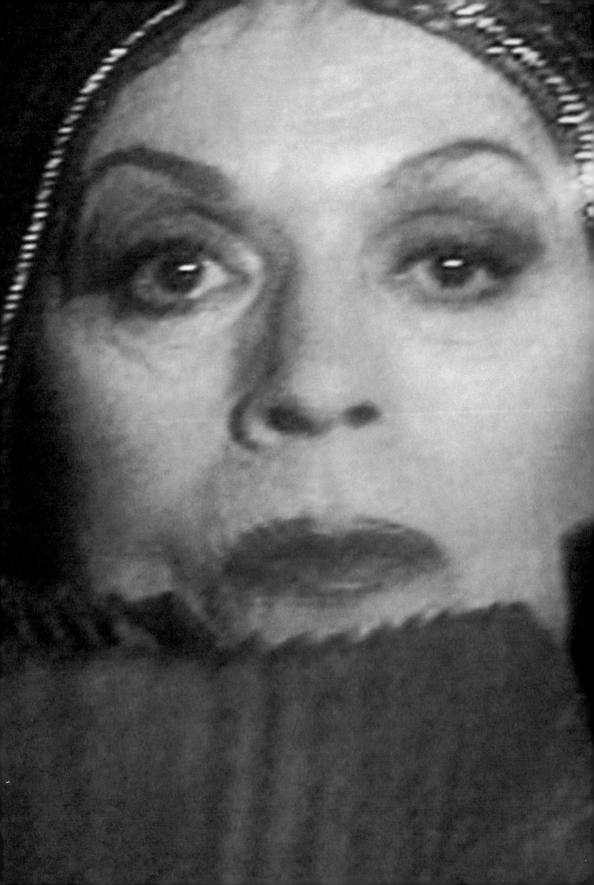

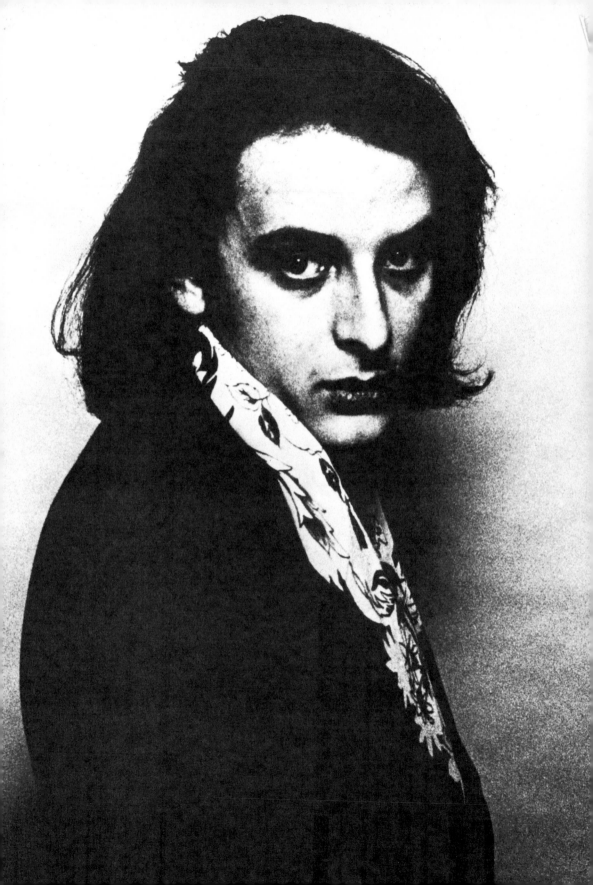